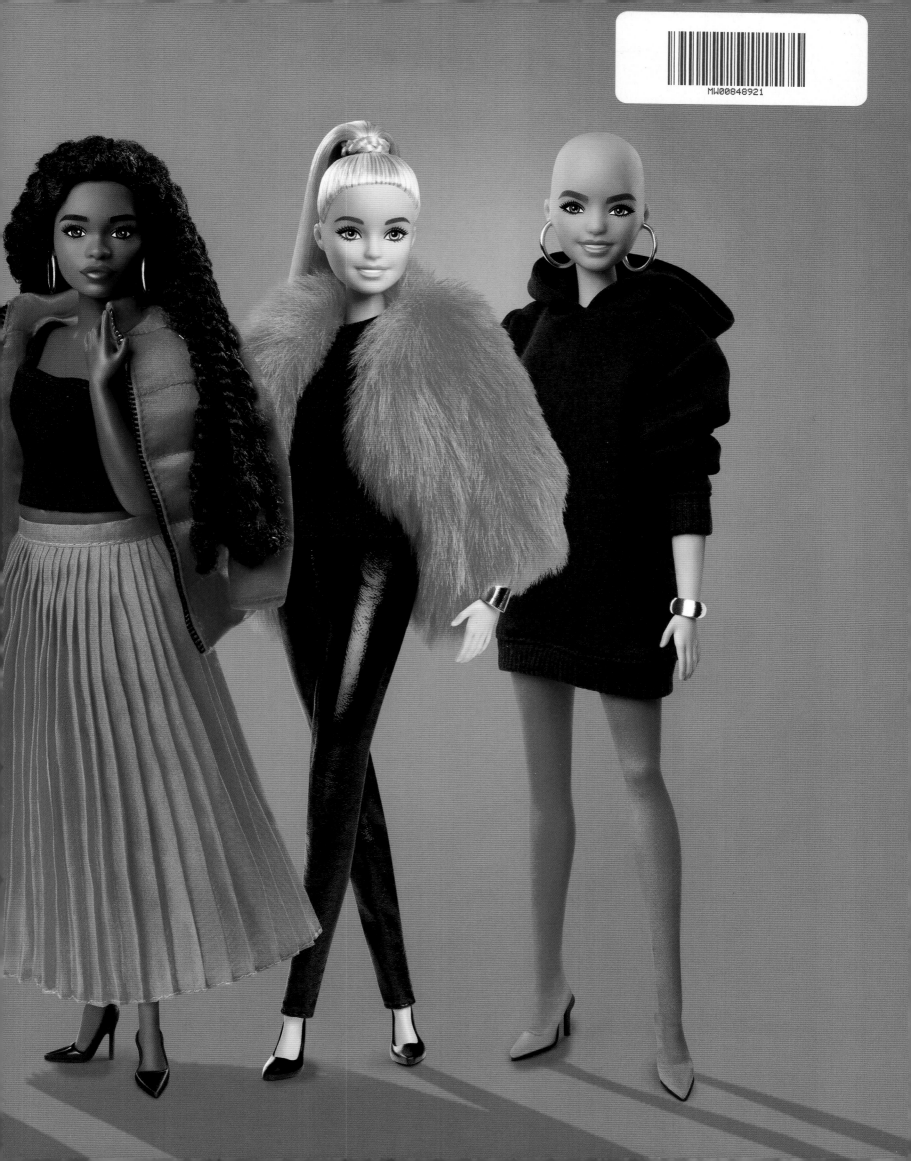

Massimiliano Capella

Barbie™

THE CELEBRATION OF AN ICON

CERNUNNOS

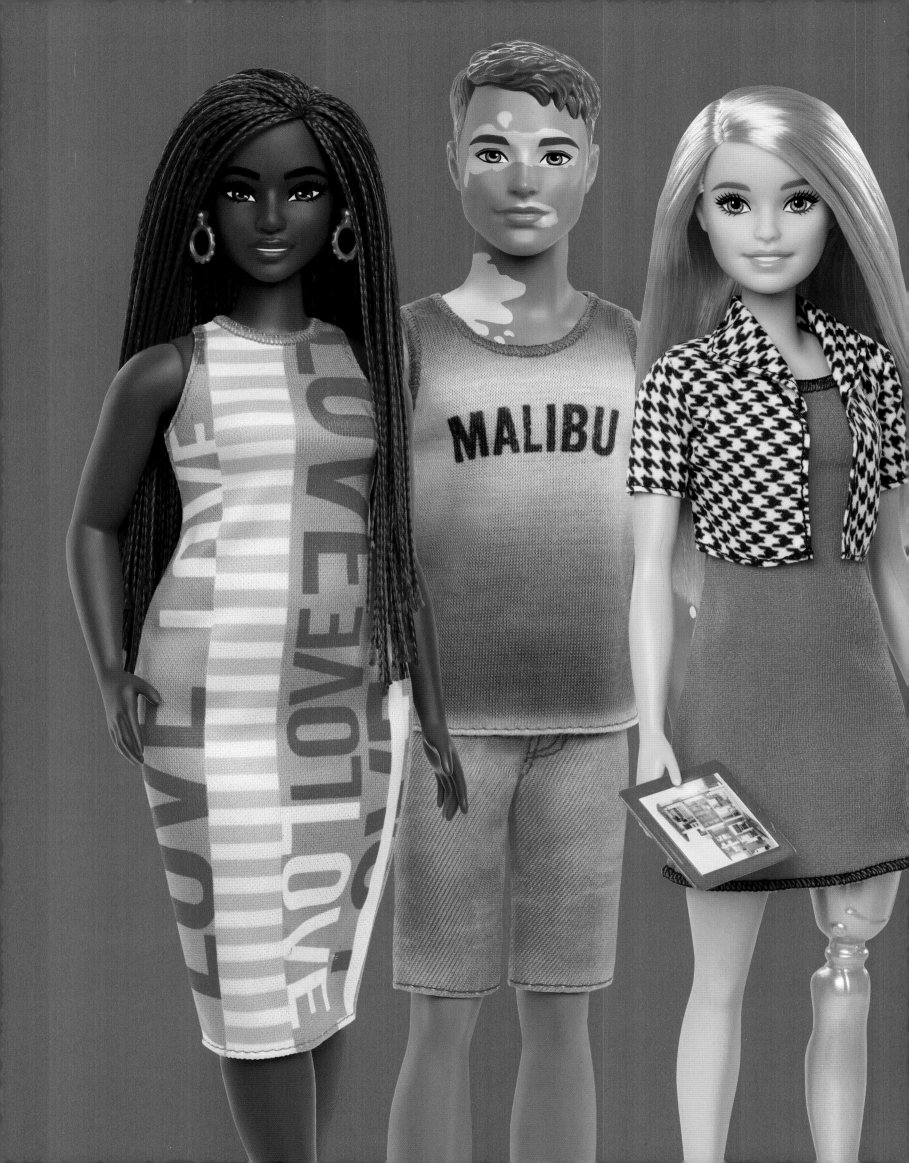

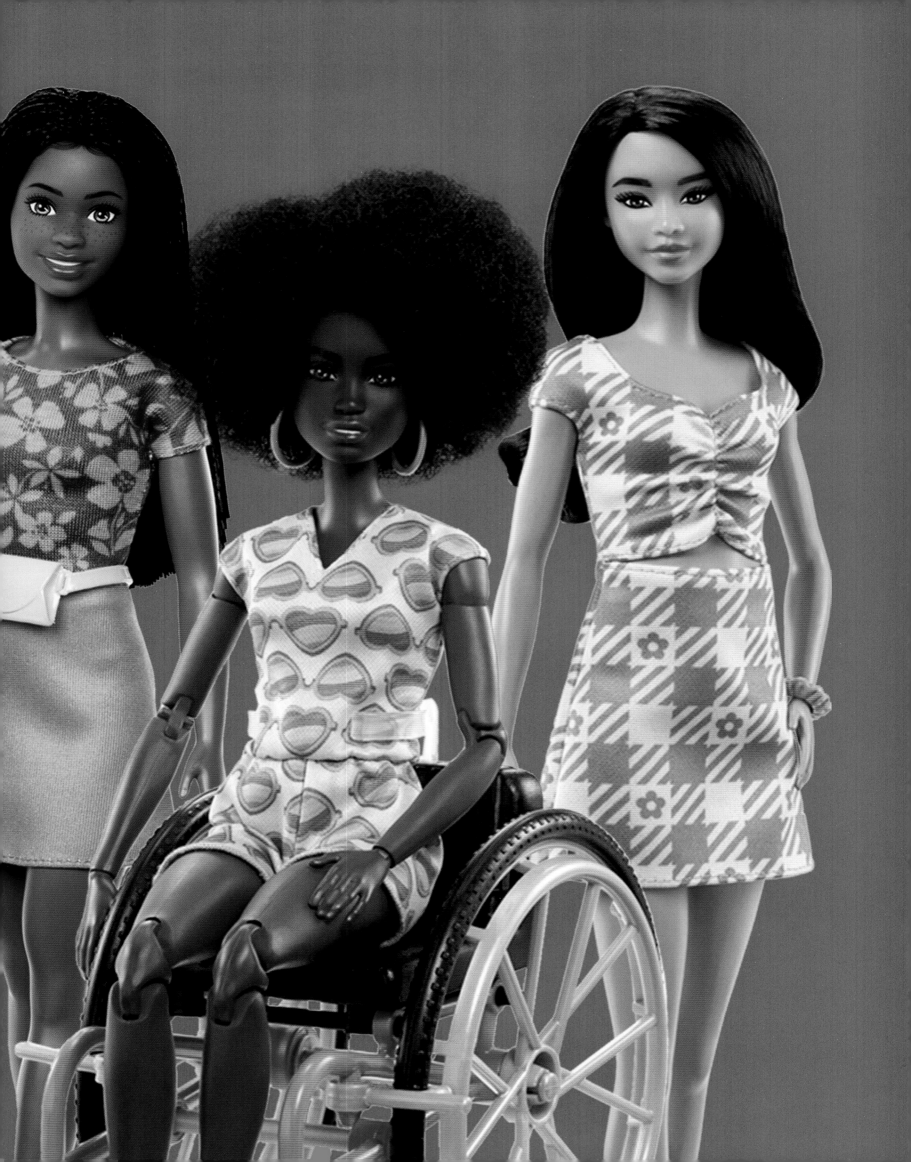

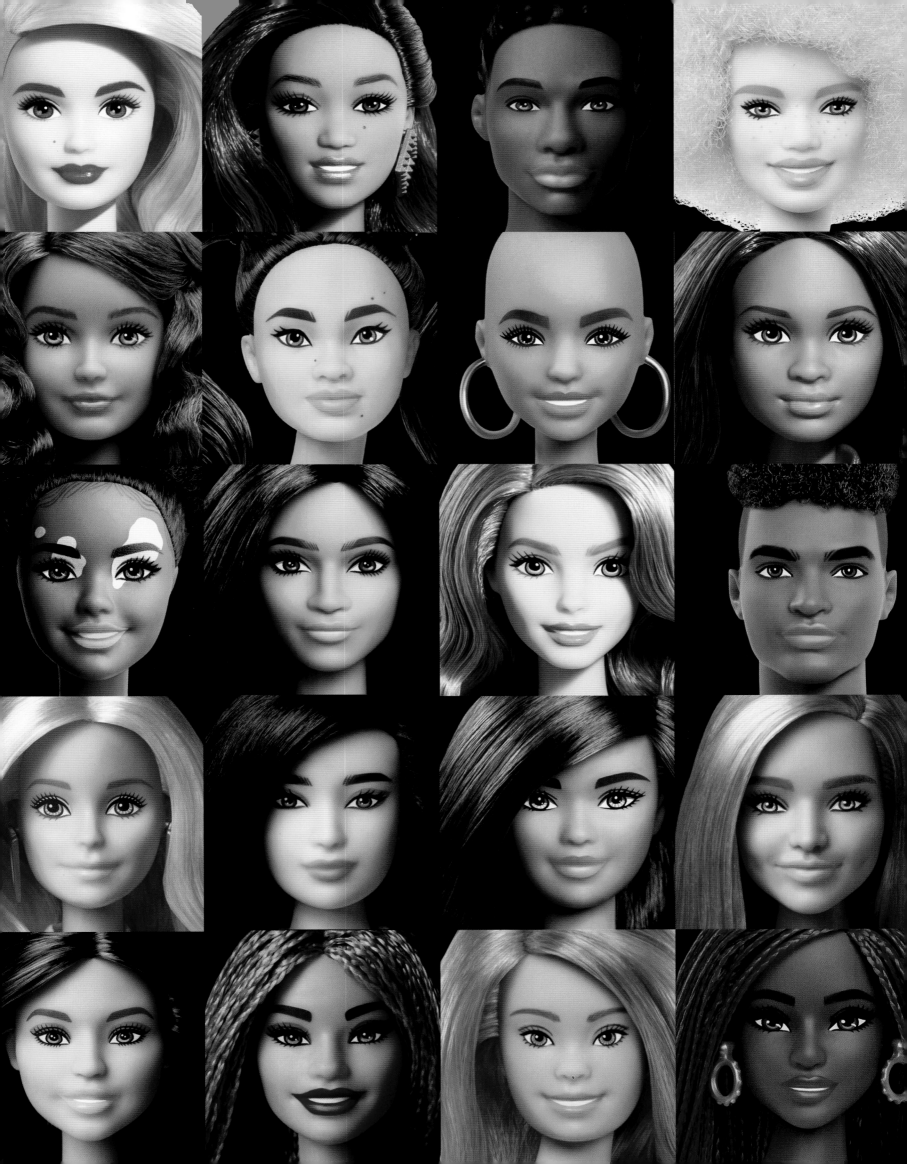

Preceding pages
Just a few of Barbie's numerous transformations
from the seventies to the present day, through
which Barbie has continued to evolve with the
times, increasingly inclusive and attentive to
issues of social awareness.

Facing page
Barbie, in a new version to celebrate her
sixty-fifth birthday (2024).

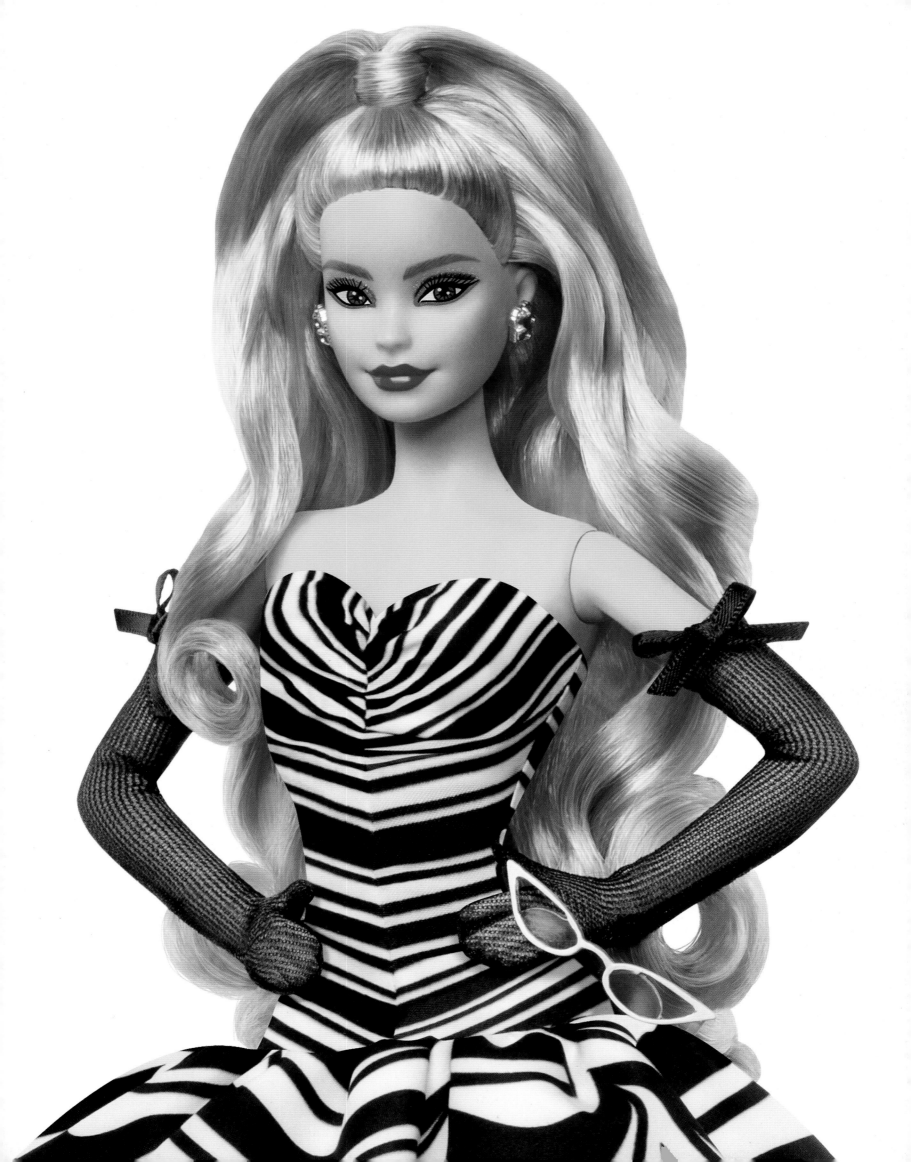

Introduction

Blonde Barbie. Barbie the doll. Quick-change Barbie. Barbie the icon . . .

In the year she turns sixty-five (2024), Barbie continues her transformations and evolutions, progressing with the times, ever faithful to her intrinsic nature as a fashion icon, but increasingly inclusive, keenly attentive to social and global themes and issues, such as diversity and gender equality, true to her longtime motto, timelier than ever: "You can be anything." In Greta Gerwig's 2023 Hollywood movie *Barbie*, she appears for the first time in the flesh, bearing the semblance of Margot Robbie, a full-fledged contemporary trans-position of the *Teen-Age Fashion Model* first pre-sented at the New York Toy Fair on March 9, 1959. Her sinuous figure and face were inspired by the sophisticated style of such stars as Marilyn Monroe, Elizabeth Taylor, and Sandra Dee. One constant in Barbie's world is a predilection for the aesthetics and culture of the fifties and sixties. That motif was confirmed once again at the film's London and Los Angeles premieres, where Margot Robbie wore two iconic gowns on the red carpet: created in 1959 and 1960, those dresses were masterfully reinterpreted by the creative genius of two fashion houses: Mai-son Schiaparelli and Vivienne Westwood: *Solo in the Spotlight* and *Enchanted Evening*.

Hollywood and the world at large have just cel-ebrated Barbie and her evergreen allure, endlessly transmogrifying and yet, at the same time, unfail-ingly recognizable. A full-fledged icon who has always offered a panoply of interpretations, of both herself and the surrounding world. Indeed, she has become a lens through which we can review and rethink so many of the social and aesthetic phe-nomena that have unfolded throughout the second half of the twentieth century and on into this first quarter of the twenty-first, whether in the realms of art, history, society, lifestyle, world cultures, or, first and foremost, fashion.

Barbie's incessant relationship with fashion lies at the roots of her very nature: she was a fashion model at her inception in 1959, and later, starting the following year, a career fashion editor. That bond, between dolls and fashion, is age old, sinking its roots as far back as the sixteenth century, when the French king François I, in November 1515, wrote to the Marchioness Isabella d'Este for news of the fashion on display at the court of Mantua. Isabella responded with a doll dressed in the style favored by Mantuan woman, thereby promoting the new Italian fashion in the French court. That historical episode shows us how dolls, along with reports from ambassadors and scenes depicted in paintings, were already the chief instruments for the promotion and spread of fashion, as early as the Renaissance: to put it in the terminology of the time, fashion was a way to *delectare*, or delight, but

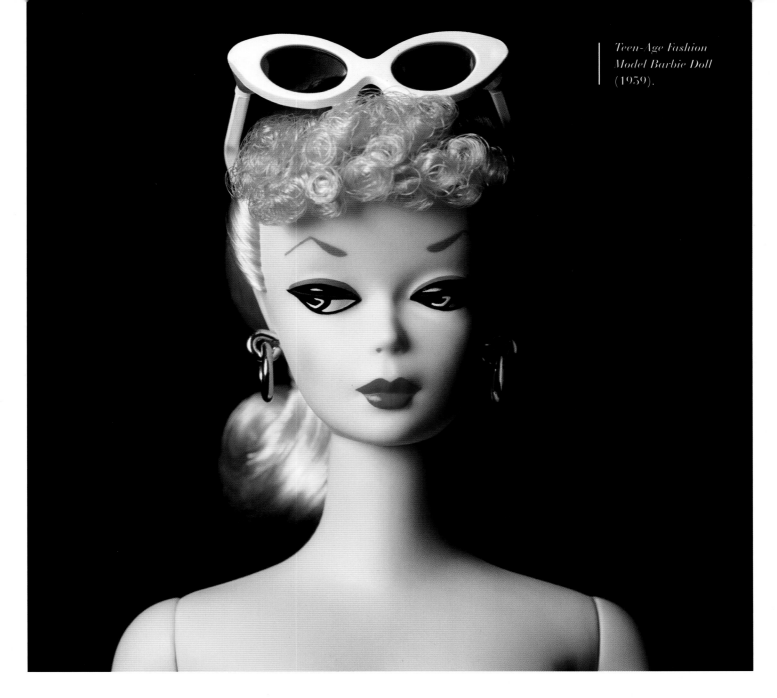

also and especially to *docere*, or teach. Over the centuries, the popularizing of fashions and styles throughout Europe took place in part through the publication of the *Almanach Royal*, or Royal Almanac, at the court of Louis XIV (from 1683 on). Later, starting in January 1786, the *Cabinet Des Modes* began publishing in Paris: the first specialty fashion periodical. Unlike engravings, paintings, and photographs, however, dolls would show off actual articles of apparel, albeit miniature ones. Those dolls could model the cut, style, and quality of fabric, all the tailoring and couture of real clothing. That is why it was dolls that played central role in the rediscovery of the new French *môde* after World War II. In fact, it was on March 28,

1945, that a traveling show called *Le Théâtre de la Mode* was inaugurated at the Musée du Louvre in Paris. Organized by the Chambre Syndicale de la Couture Parisienne, it featured seventy *maisons* presenting more than a hundred metal-wire dolls displaying miniature dresses from the new 1945–1946 collection, and they were intended as a way to prime the economic pump of fashion. Indeed, they spread an informed understanding of the quality of fashion creations being produced by France's most renowned fashion houses.

Barbie's story and, especially, her origins as a fashion doll, fit into this age-old tradition, whereby a doll becomes the vehicle of styles and trends, embodied in a three-dimensional form that made

it possible to show off authentic dresses and gown, albeit on a reduced scale.

From her very debut, Barbie was in fact a physical model for the spread of international styles and trends. Indeed, she came with what developed as her own miniature line of samples, an array of apparel narrating the development and flourishing of fashion over the years. Barbie sported everything from the unstoppable French haute couture to the international popularity of the Italian look and the development of American and British ready-to-wear, with intervals along the way of the hippie look, the disco style in the seventies, the highly structured fashion of the eighties, and the more recent, contemporary Street Style.

The appearance of *Superstar Barbie*, her face reshaped by the sculptor Joyce Clark with facial features inspired by the American actress Farrah Fawcett, then starring in the TV series *Charlie's Angels*, captured the world's attention.

Superstar Barbie was a captivating presence, with her eyes made larger by an application of light blue eyeliner, a smiling mouth brightened by coral lipstick, and a posture made even more shapely by a close-fitting, glittering shocking pink satin gown, with a lamé boa. And how could we forget the star-shaped pedestal that held her erect, reminding us that *Superstar Barbie* was ready to get out on the dance floor and boogie down to some disco, on the strength of the Bee Gees in *Saturday Night Fever*. That Barbie design remained popular throughout the eighties, with only an occasional tweak in makeup and hairstyle. In fact, it was *Superstar Barbie* who caught Andy Warhol's eye. In fact, he presented, on February 10, 1986, his renowned portrait of BillyBoy* as Barbie. The painting, created as a tribute to the love of the fashion designer BillyBoy* for Barbie, was the result of the Pop Art maestro's determination to paint a portrait of BillyBoy*. The designer famously replied, "If you want to do my portrait, do Barbie, because Barbie, *c'est moi*" (BillyBoy*, 1985). This response with its literary aura (Gustave Flaubert in fact is quoted as saying, "Madame Bovary, *c'est moi*") led Warhol to create a double portrait of Barbie. The first version had a brilliant blue background, inspired by BillyBoy*'s Surreal Couture jacket. Warhol gave it to BillyBoy* as a gift. The second portrait had a reddish-orange background and was purchased by Mattel. The face that Warhol immortalized was that of *Superstar Barbie*, transformed by his creativity from a mass-market children's toy into a global icon and timeless artwork, the last American icon painted by Warhol before his death, which came just a year later in New York.

Now Barbie devotes a special focus to the theme of diversity, celebrating with the Role Models line influential contemporary women. She remains a pop cultural phenomenon, a source of inspiration for children, grown ups, and artists who transformed her into an icon of herself. An icon for everyone!

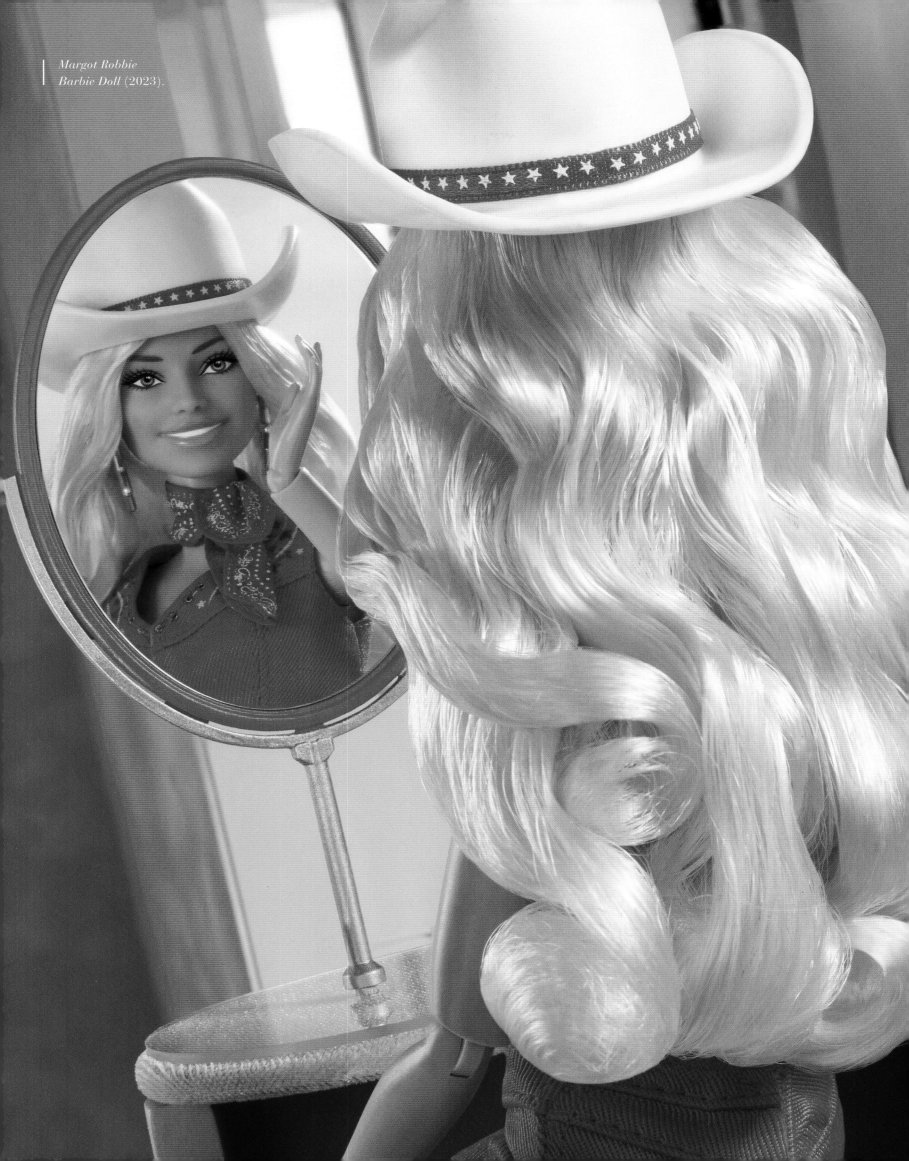

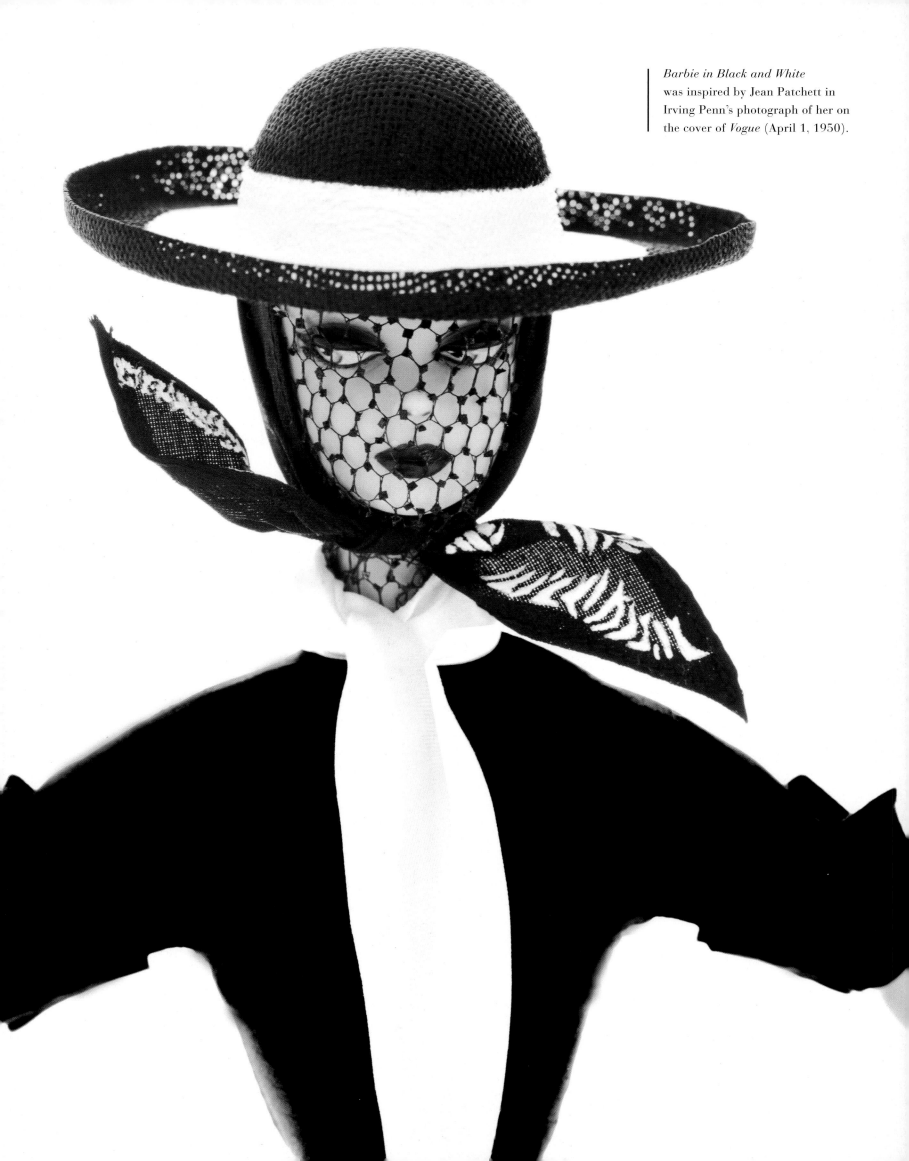

contents

Barbie evolution

1959
TEEN-AGE FASHION MODEL BARBIE DOLL

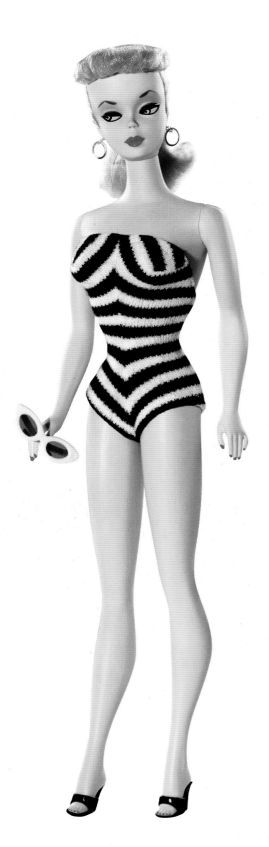

1962
BRUNETTE BUBBLECUT BARBIE DOLL

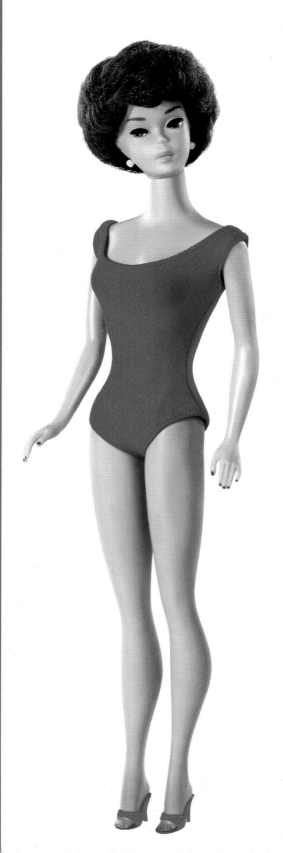

1964
MISS BARBIE DOLL

1967

**TWIST 'N TURN
BARBIE DOLL**

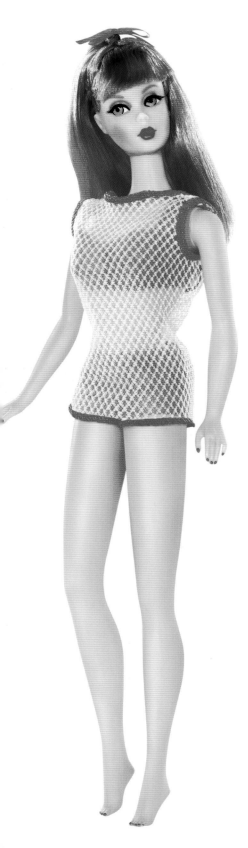

1971

MALIBU BARBIE DOLL

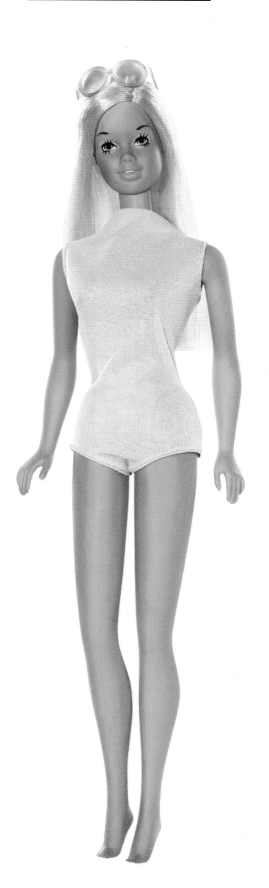

1977

SUPERSTAR BARBIE DOLL

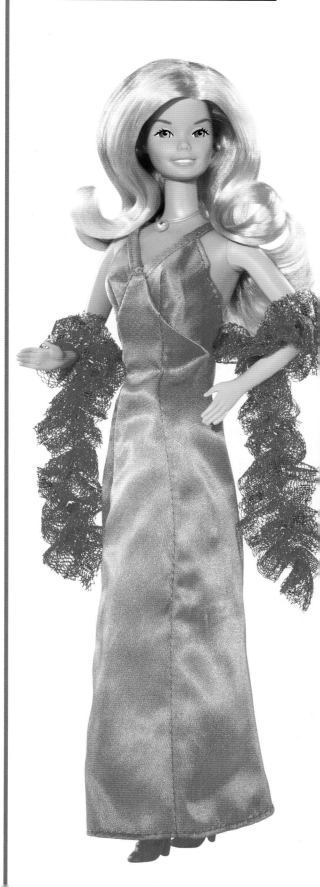

1980

BLACK BARBIE

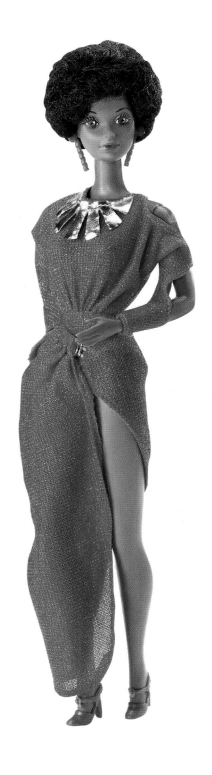

1986

ROCKER BARBIE DOLL

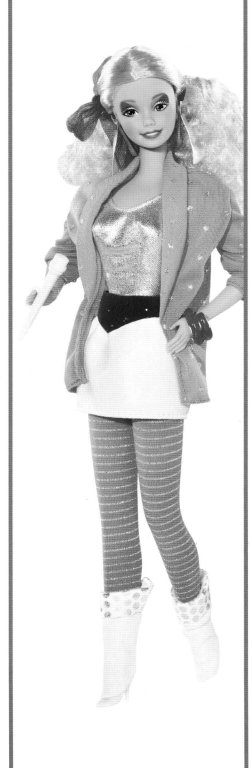

1992

TOTALLY HAIR BARBIE DOLL

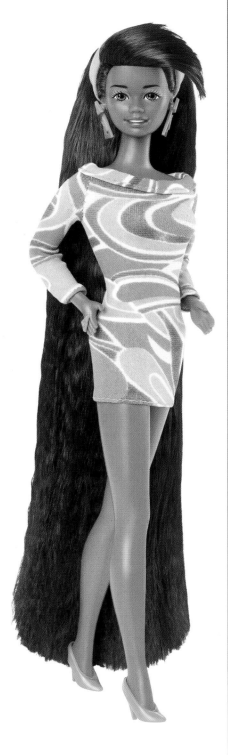

1999

GENERATION GIRL BARBIE DOLL

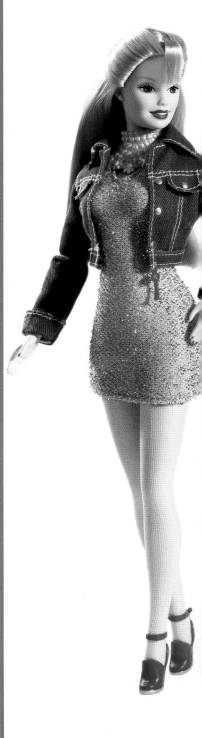

2000

JEWEL GIRL
BARBIE DOLL

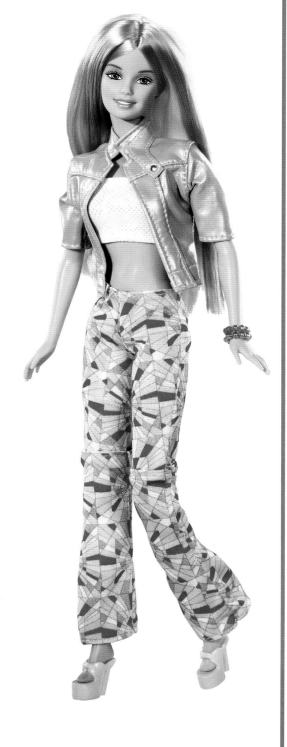

2016

FASHIONISTAS CURVY
BARBIE DOLL

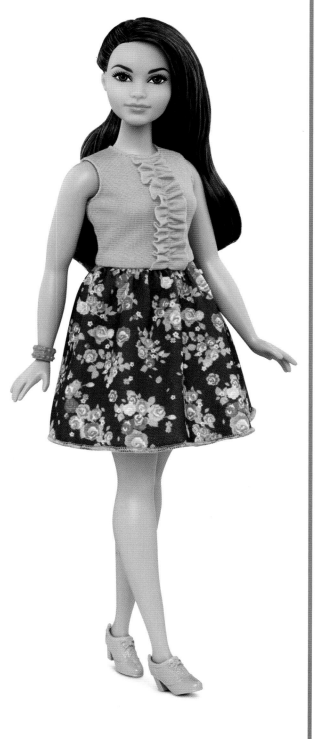

2022

DIVERSITY DOLLS

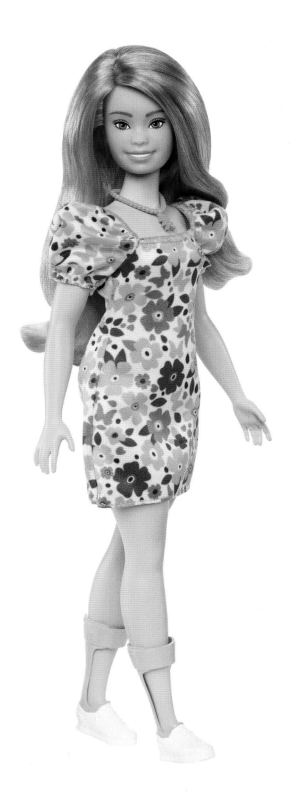

Barbie's Body Evolution

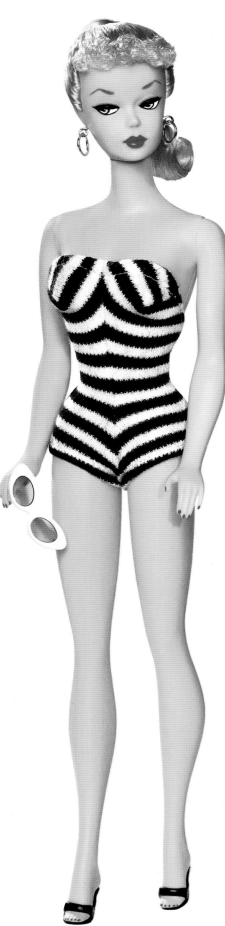

1960 1961

Teen-Age Fashion Model Doll

The first transformation in her proportions and the evolution of her Mod style.

1967

Twist 'N Turn

The body is now partially bendable, with the same proportions as previous models.

1970

Living

The body is entirely bendable with an even larger bust. The waist joint is now round, the hips are broader, and her feet click from tiptoe to flat.

1977

Superstar

Newly styled facial features, with a broader smile and a new articulation and shaping of the body.

1992

Shani Soul Train

She has the same body as *Superstar Barbie*, but her arms are straight.

1999

Barbie Chic

This model is characterized by a new configuration of the shoulders and hips, now more slender.

2000

Barbie Jewel (Belly Button body)

A decidedly innovative model featuring a belly button.

2003

Versace and Versus Barbie Dolls (Model Muse body)

The torso is slightly shorter, legs and arms are longer and more tapered. We now see the sculpting of neck and collarbone, and there is a clear distinction between left and right feet.

2015

Fashionistas

The foot lies flat to wear slippers, sandals, or sneakers.

2016

Fashionistas Evolution

A change in aesthetics. The Regular model is now accompanied by three new types: Tall, Petite, and Curvy.

Made to Move

The body is now entirely bendable with over 100 poses.

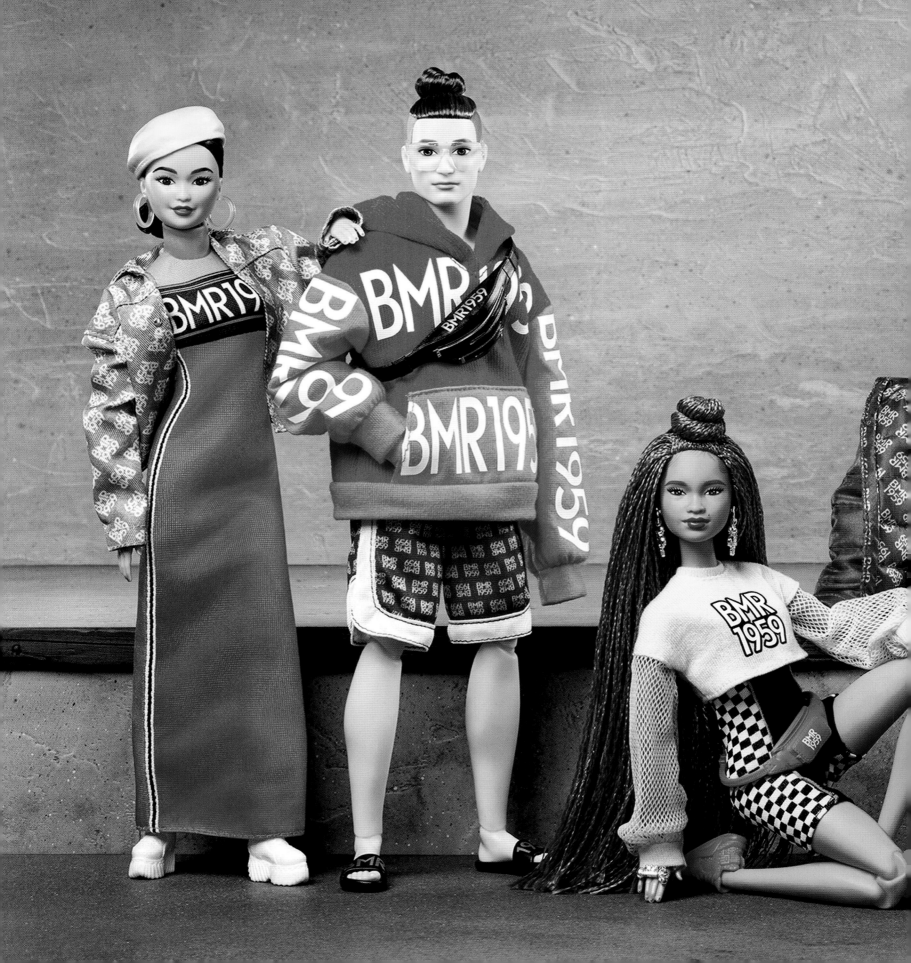

BMR1959 celebrates in 2019
Barbie's sixtieth year as a style icon
with a collection distinguished
by a decidedly contemporary mood.

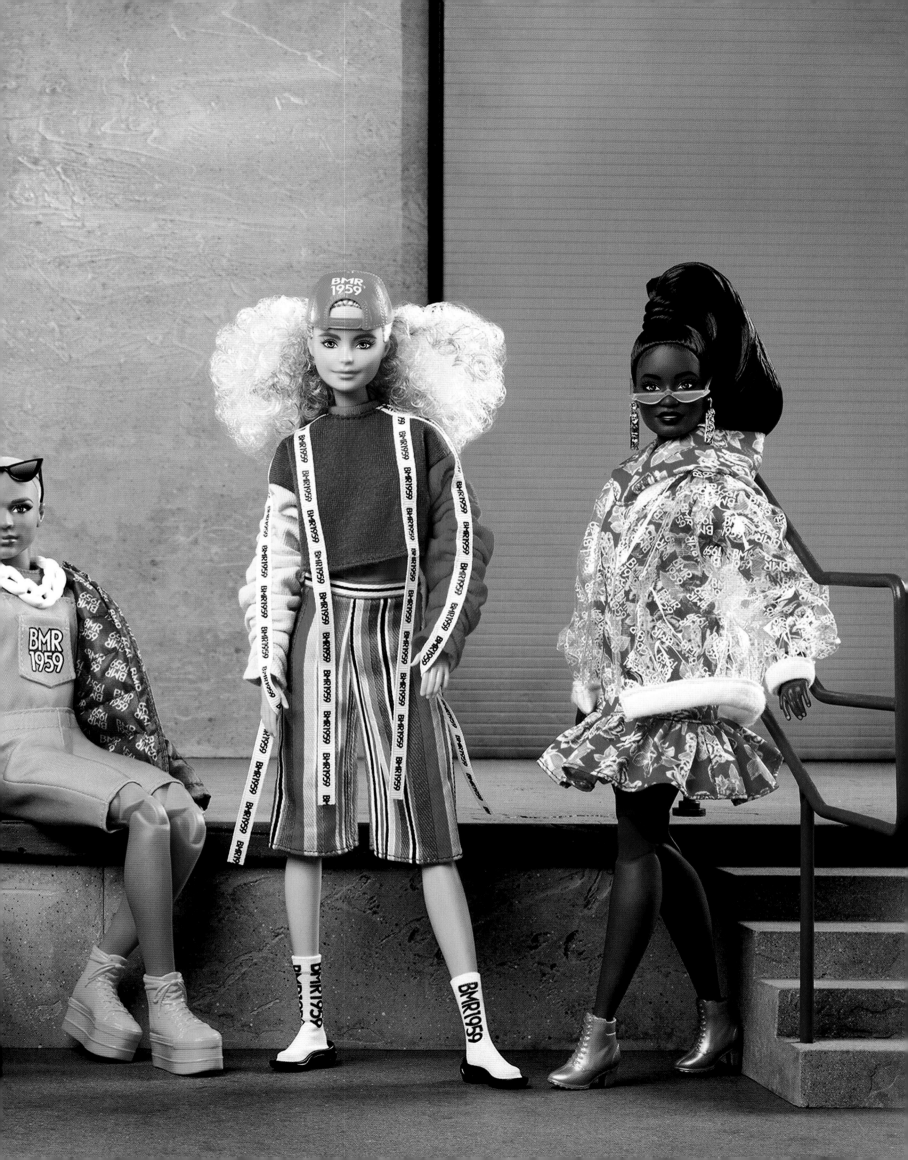

Barbie Barbie Barbie Barbie B
Barbie Barbie Barbie Barbie B
Barbie Barbie Barbie Barbie B
Barbie Barbie Barbie Barbie B
Barbie Barbie Barbie Barbie B
Barbie Barbie Barbie Barbie B
Barbie Barbie Barbie Barbie B

19/1969
59

THE SIXTIES

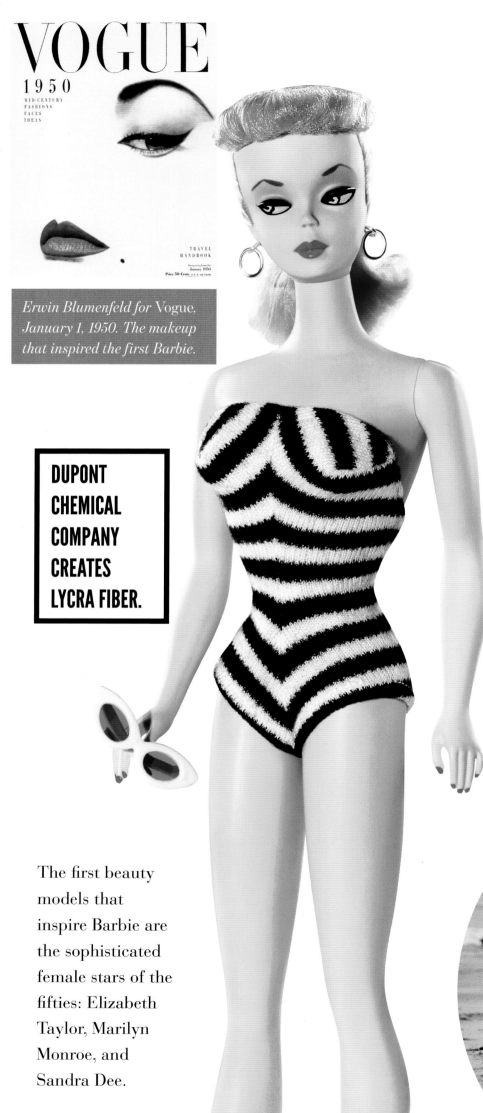

Erwin Blumenfeld for Vogue, *January 1, 1950. The makeup that inspired the first Barbie.*

DUPONT CHEMICAL COMPANY CREATES LYCRA FIBER.

The first beauty models that inspire Barbie are the sophisticated female stars of the fifties: Elizabeth Taylor, Marilyn Monroe, and Sandra Dee.

1959

TEEN-AGE FASHION MODEL BARBIE DOLL

Barbara Millicent Roberts of Willows (Wisconsin) debuts at the Toy Fair in New York. Her look mimics that of the sophisticated female stars of the fifties.

SOME FIGURES

The price of a gallon of gas is 25 cents on the dollar.

The average yearly salary in America is $5,000.

The price of a *#1 Teen-Age Fashion Doll Ponytail* is $3.

The price of each of her outfits ranges from $1 to $5.

The number of Barbies sold in the first year is 351,000.

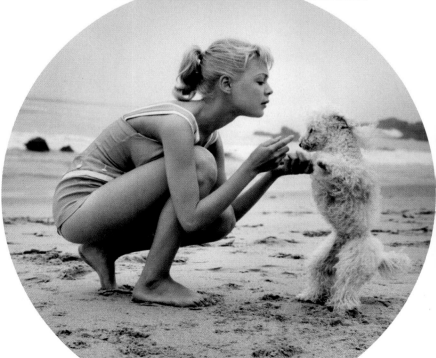

American actress Sandra Dee wearing a swimsuit on the beach (1959)

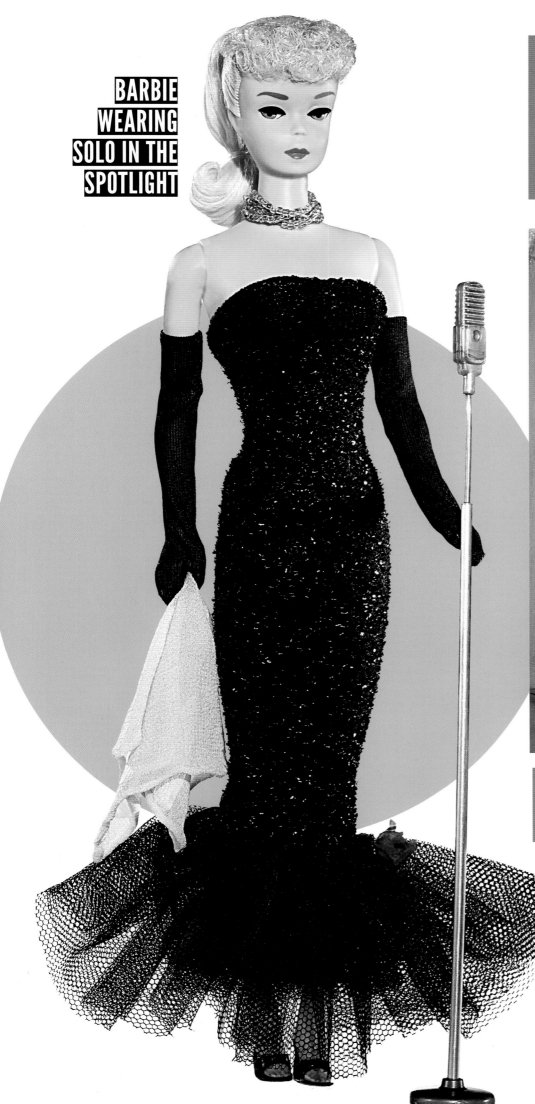

BARBIE WEARING SOLO IN THE SPOTLIGHT

1960

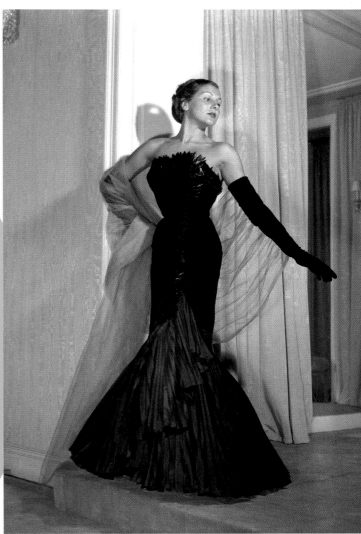

A dress by Marcel Rochas for the autumn/ winter collection 1950–1951 inspired Solo in the Spotlight.

IN 1959 THE OSCAR FOR BEST COSTUME DESIGN IS AWARDED TO CECIL BEATON FOR *GIGI*.

1962

Marilyn and Maria Callas show off their teased hairdos for President Kennedy's 45th birthday party.

BUBBLECUT BARBIE IN HER RED FLARE OUTFIT

Barbie wears her Jackie-inspired *Red Flare & Pillbox* outfit.

Maria Callas

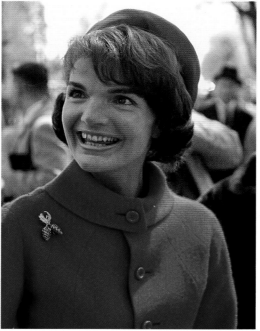

Jackie Kennedy

In New York, Andy Warhol introduces *The Souper Dress*, a paper dress printed with the famous Campbell's soup cans.

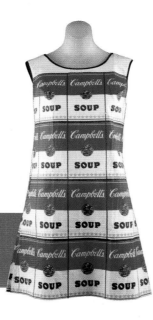

Andy Warhol, The Souper Dress. *New York, Metropolitan Museum of Art.*

THE OSCAR FOR BEST COSTUME DESIGN IS AWARDED TO PIERO GHERARDI FOR FELLINI'S *LA DOLCE VITA*.

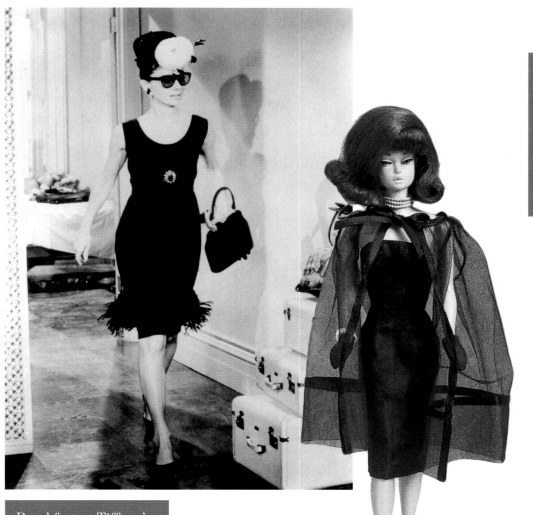

Breakfast at Tiffany's, *Audrey Hepburn (1961)*.

Between 1961 and 1963 *Breakfast at Tiffany's* is shown in movie theaters around the world. The "little black dress" is all the rage.

BARBIE WEARING BLACK MAGIC ENSEMBLE

1963 IS THE YEAR OF MARTIN LUTHER KING'S LEGENDARY "I HAVE A DREAM" SPEECH AND THE YEAR JFK IS ASSASSINATED IN DALLAS, AND ON JUNE 16, THE FIRST WOMAN ASTRONAUT, RUSSIAN VALENTINA TERESHKOVA, FLIES INTO SPACE. BARBIE WILL BE INSPIRED BY HER IN 1965, CELEBRATING THE IMPORTANCE OF THE SPACE PROGRAM, AND AT THE SAME TIME SHOWING HER YOUNG FANS THAT THERE ARE NO BARRIERS TO ACHIEVING YOUR AMBITIONS.

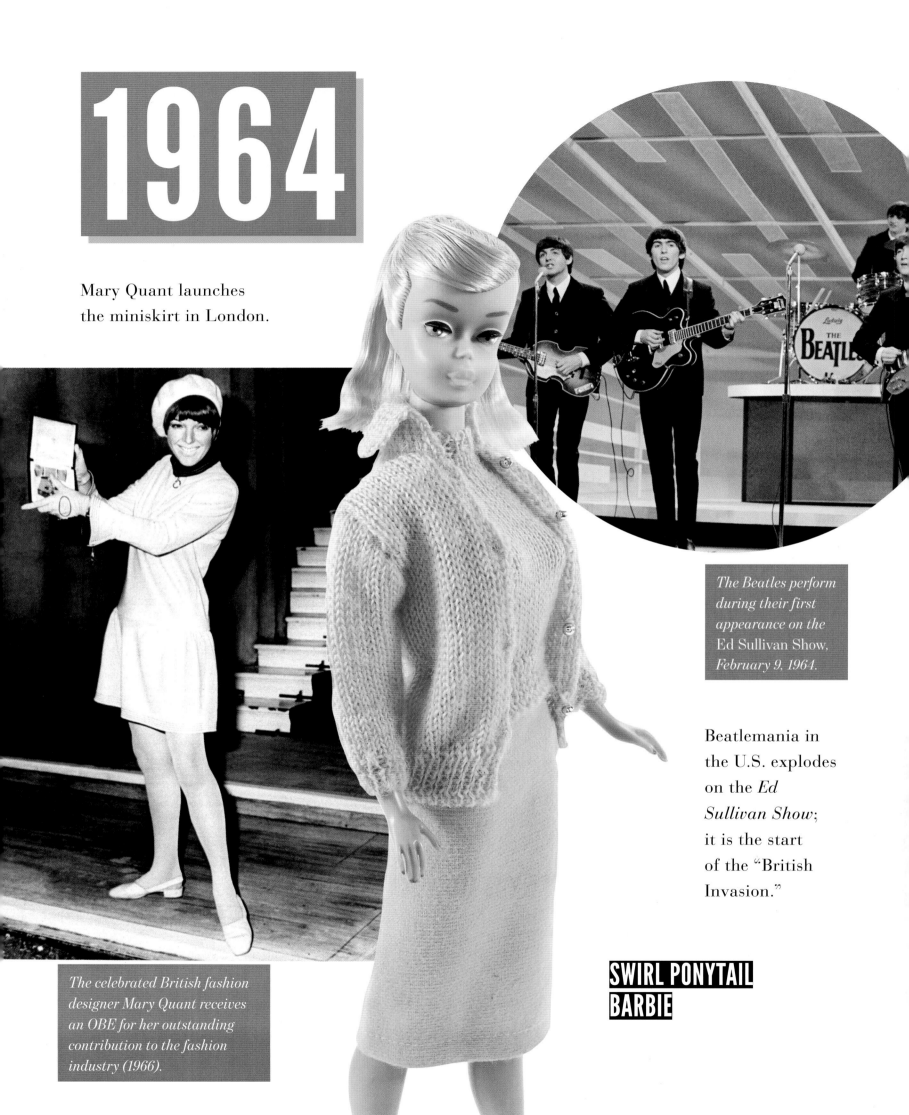

1964

Mary Quant launches the miniskirt in London.

The Beatles perform during their first appearance on the Ed Sullivan Show, February 9, 1964.

Beatlemania in the U.S. explodes on the *Ed Sullivan Show*; it is the start of the "British Invasion."

SWIRL PONYTAIL BARBIE

1965

CAREER GIRL BARBIE

In 1965 Mattel starts producing work clothes: women can have a career too.

Yves Saint Laurent introduces his innovative Mondrian collection.

Young lines, modern materials, and fabrics, contrasting colors, bright prints. The coordinates of the fifties/sixties— shoes, handbag, gloves, and hat—have lost their quaint bourgeois appeal.

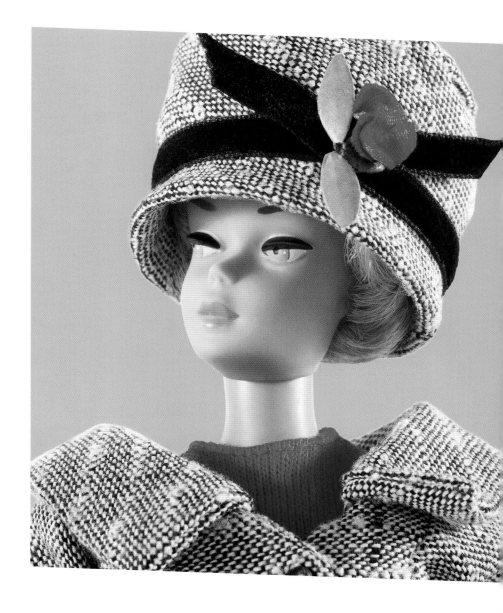

The Mondrian Dress by Yves Saint Laurent, designed in 1965, shown here at the haute couture show, Centre Pompidou, Paris (2002).

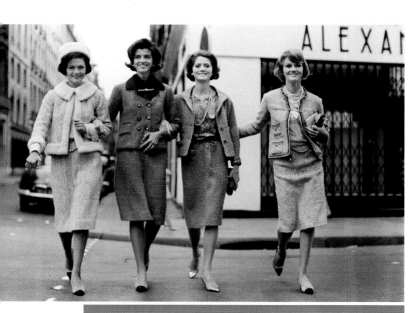

Paris fashions: tweed suit with tailored figure-fitting shape, small shoulders, and narrow set-in sleeves, designed by Coco Chanel.

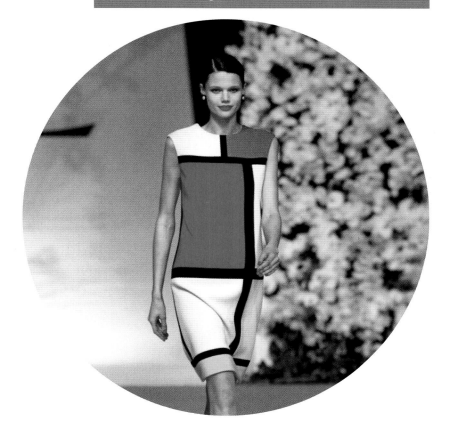

1966

Pierre Cardin introduces
the futuristic, space-age style,
and is joined by André Courrèges.

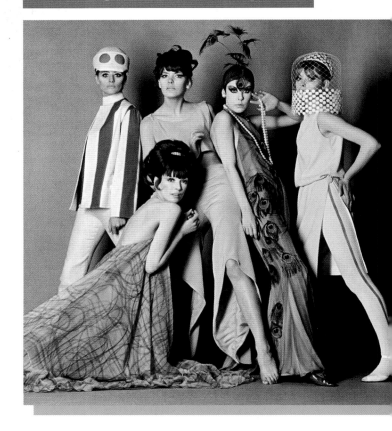

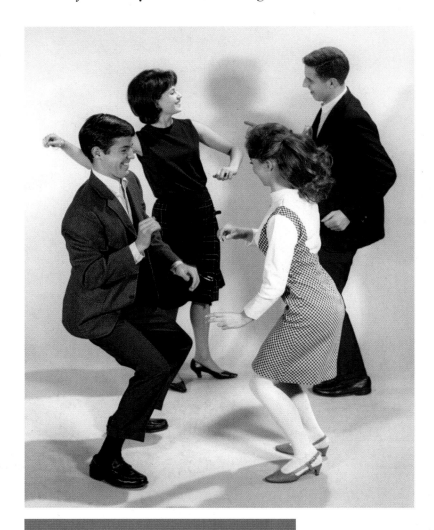

Young teenage couples dancing the Twist.

Michelangelo Antonioni makes the
movie *Blow-Up* (1966), and London
is seen 'round the world. Space-age
costumes are designed for the movie.
Stanley Kubrick's famous film *2001:
A Space Odyssey* (1968) is another
example of this new interest in space.

On the dance floors everybody's doing the twist. *Twist 'N Turn
Barbie*, with a bendable waist, and her British cousin Stacey, with
her charming accent, conquer the scene. *Twist 'N Turn Barbie* has
a new facial expression, lighter makeup, "real" eyelashes, and long
shiny hair, inspired by the British model Jean Shrimpton.

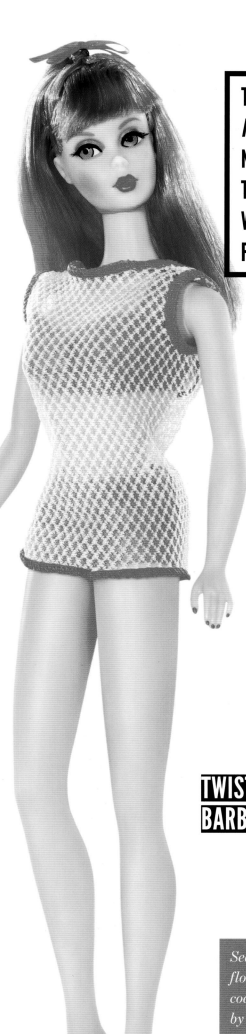

1967

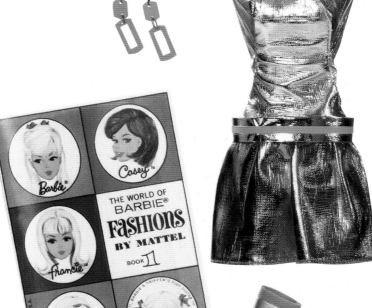

1968 Space-age model: *Zokko!* *#1820*

TWIST 'N TURN BARBIE

Sea-blue tile patterned floating chiffon voile coat over matching leotard by Emilio Pucci (1967).

33

1967

In 1966 Paco Rabanne makes his high-fashion debut and amazes everyone by using chainmail for dresses that dazzle and contrast sharply with the wearer's skin.

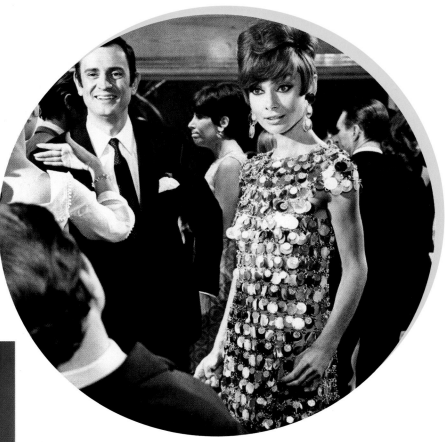

BARBIE IN HER INTRIGUE OUTFIT

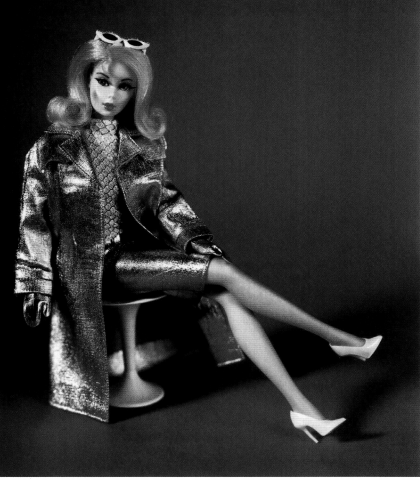

In Two for the Road, *Audrey Hepburn wears a Paco Rabanne dress made of chainmail.*

Andy Warhol describes Emilio Pucci as the inventor of the hippie/Pakistani look for the international jet set.

In the wake of the success of *Doctor Zhivago*, in 1967 the maxi coat is launched, to be worn with a warm fur ushanka hat. Mini and maxi are worn together, and lead to the invention of the midi, bringing the sixties to a close.

A scene from David Lean's Doctor Zhivago. *based on the novel by Boris Pasternak (1965).*

1968

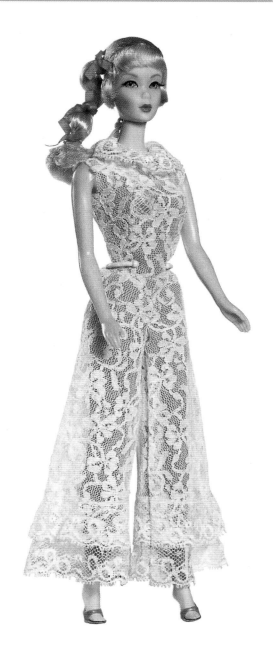

BARBIE IN HER JUMP INTO LACE OUTFIT

New magazines for the young are launched, and the first issue of *Petticoat* is published.

The sartorial cut of Barbie's *Jump Into Lace* outfit clearly recalls Irene Galitzine's original "Palazzo Pajamas," first introduced in 1960 at Palazzo Pitti, and destined to become a point of reference for the fashion of these years.

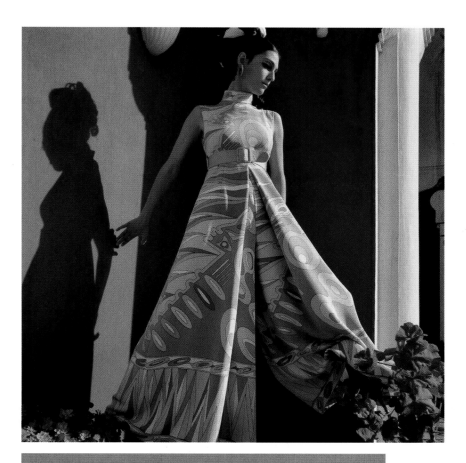

Model wearing Emilio Pucci pajamas with a high bodice, a belt, and palazzo pants in heavy silk crepe (1968).

IN 1969 *EASY RIDER* IS RELEASED STARRING DENNIS HOPPER. DANILO DONATI WINS AN OSCAR FOR BEST COSTUME DESIGN FOR FRANCO ZEFFIRELLI'S *ROMEO AND JULIET*.

"Barbie represents a confident and independent woman with an amazing ability to have fun while remaining glamorous."

DIANE VON FÜRSTENBERG

FASHION DESIGNER

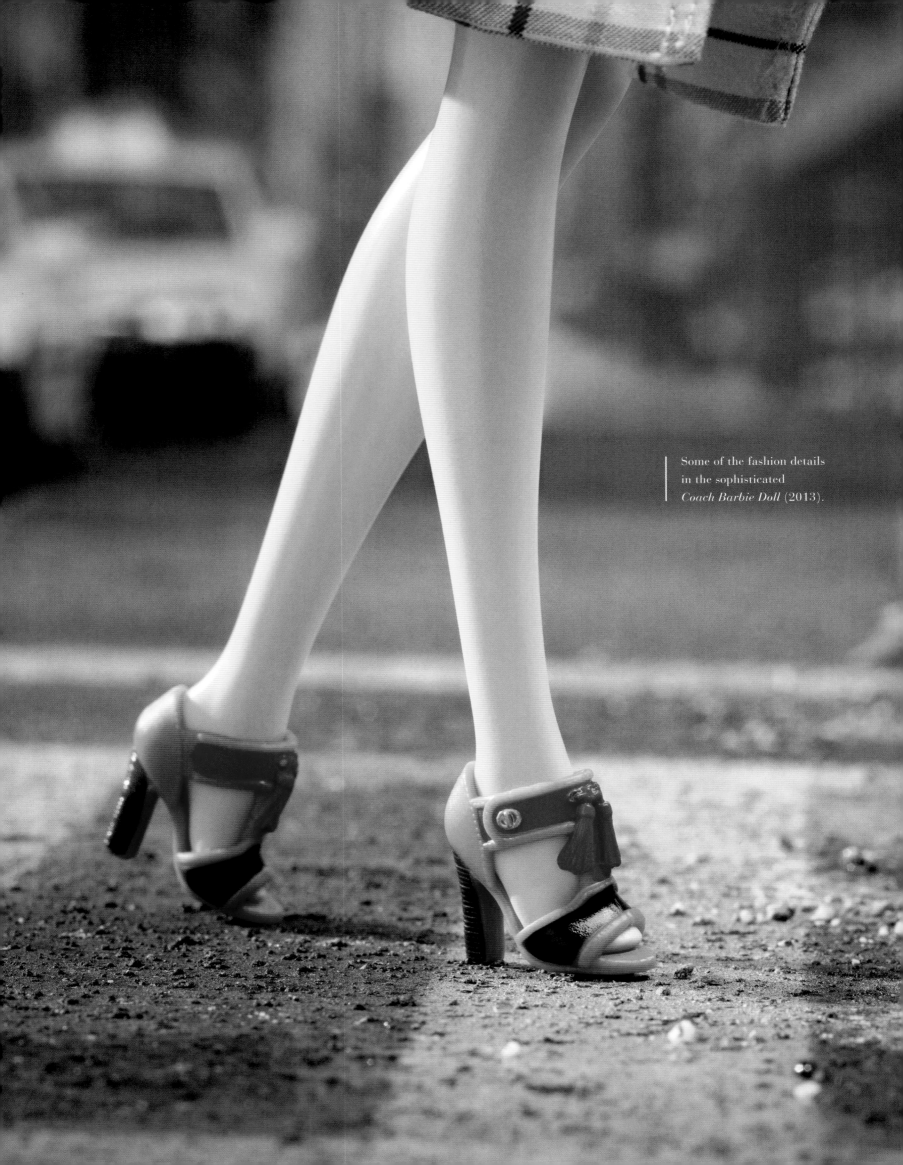

Some of the fashion details in the sophisticated *Coach Barbie Doll* (2013).

Barbie Barbie Barbie Barbie B
Barbie Barbie Barbie Barbie B
Barbie Barbie Barbie Barbie B
Barbie Barbie Barbie Barbie B
Barbie Barbie Barbie Barbie B
Barbie Barbie Barbie Barbie B
Barbie Barbie Barbie Barbie B
Barbie Barbie Barbie Barbie B

1970/1979

THE SEVENTIES

1971

ANDY WARHOL DESIGNS THE ALBUM COVER FOR THE ROLLING STONES' *STICKY FINGERS*.

Twiggy shows up at the opening night of Ken Russell's *The Boy Friend* wearing a peasant-style outfit by Bill Gibb. Mix&Match is an instant hit.

British model Twiggy wearing a peasant-style dress by Bill Gibb, with a full skirt and a knitted cap (1970).

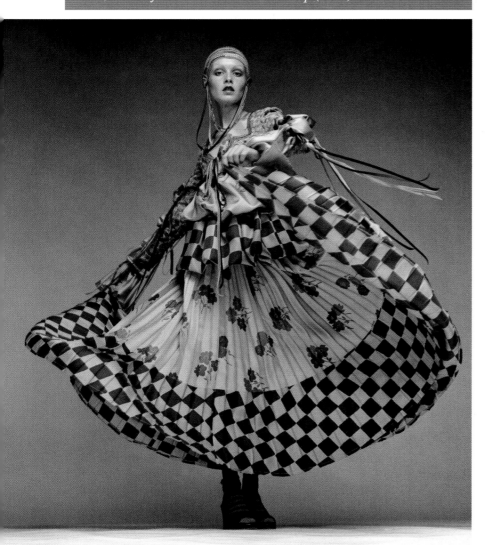

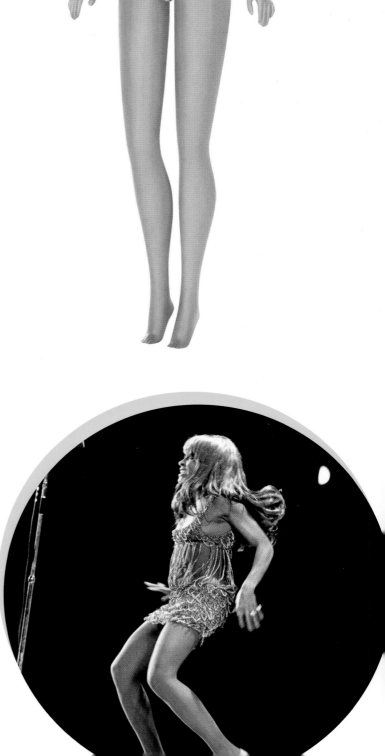

Tina Turner performing in Los Angeles (1971).

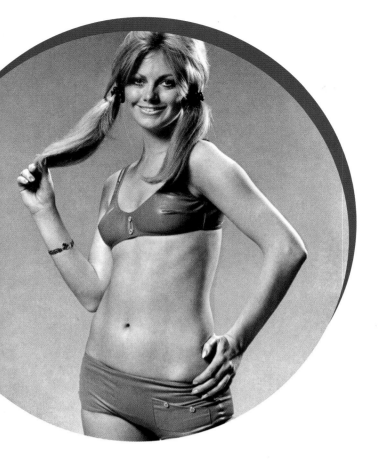

Swimwear (1971).

IN 1972 RICHARD NIXON ANNOUNCES THE DEVELOPMENT OF THE SPACE SHUTTLE PROGRAM, HE VISITS CHINA, AND THE WATERGATE SCANDAL BREAKS OUT.

LIVE ACTION BARBIE AND CHRISTIE

Just two years after the major concert event of Woodstock, Barbie and Christie wear flower children–style bell-bottoms.

MALIBU BARBIE

From the outset Barbie is an expert at going on holiday, but her swimsuit is still rather prudish and unrevealing. This same year, Rudi Gernreich is in the limelight with his new bathing suit styles. The monokini and the thong bathing suit are all the rage.

RALPH LAUREN INTRODUCES HIS FIRST LINE OF TAILORED WOMENSWEAR.

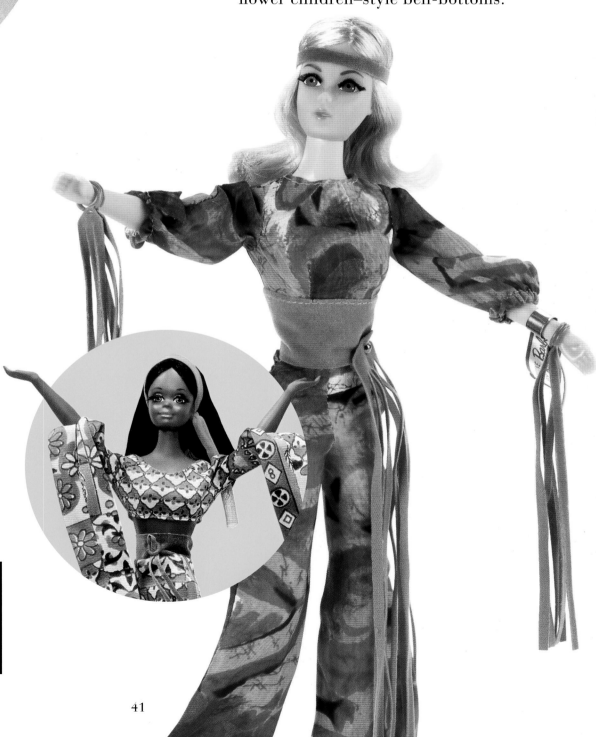

1973

Elvis Presley performs his first concert via satellite: *Aloha from Hawaii*, live from Honolulu.

Elvis Presley during a live performance at Honolulu International Center in Honolulu, Hawaii, on January 14, 1973.

Elvis's great love for Cadillacs is no secret, and true to the California car culture, in 1977 Barbie gets behind the steering wheel of a pink convertible *Star 'Vette.*

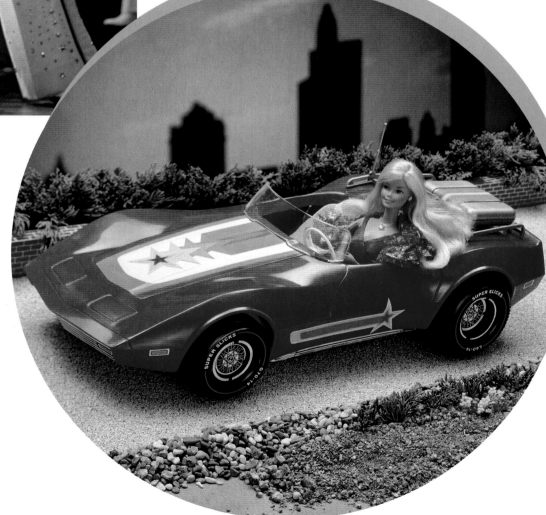

The international jet set spends its winter holidays in the famous Swiss resort of St. Moritz. Barbie, a lover of the high life, certainly can't miss out on this opportunity. In the mid-sixties Emilio Pucci designs and introduces women's ski wear: his women should make a great impression even on the ski slopes.

1974

ST. MORITZ BARBIE

is produced.

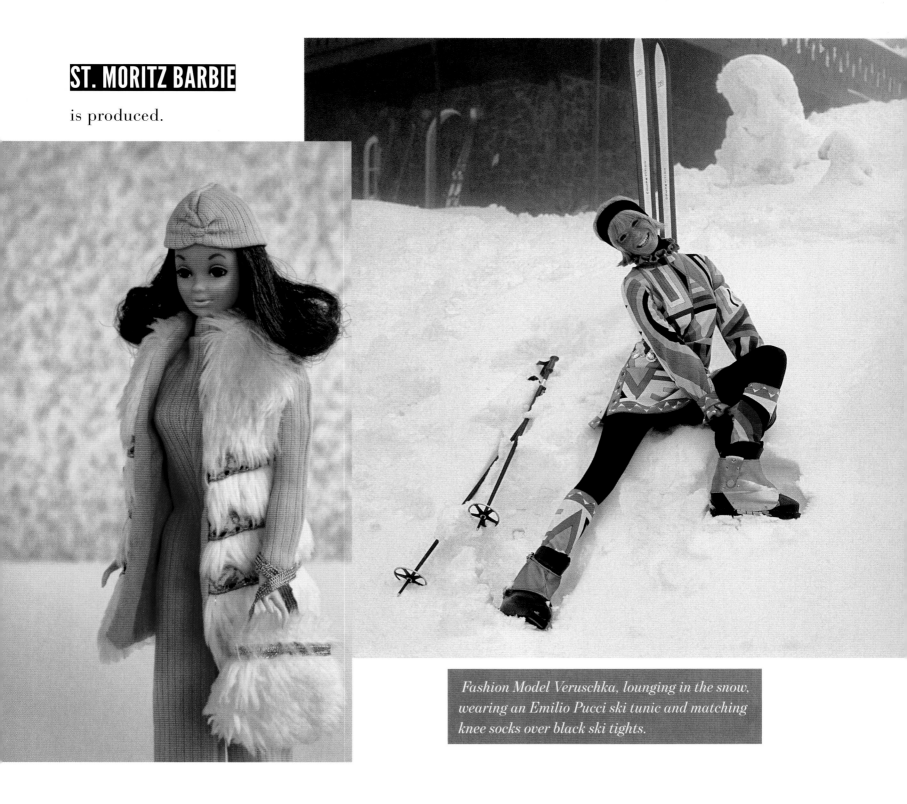

Fashion Model Veruschka, lounging in the snow, wearing an Emilio Pucci ski tunic and matching knee socks over black ski tights.

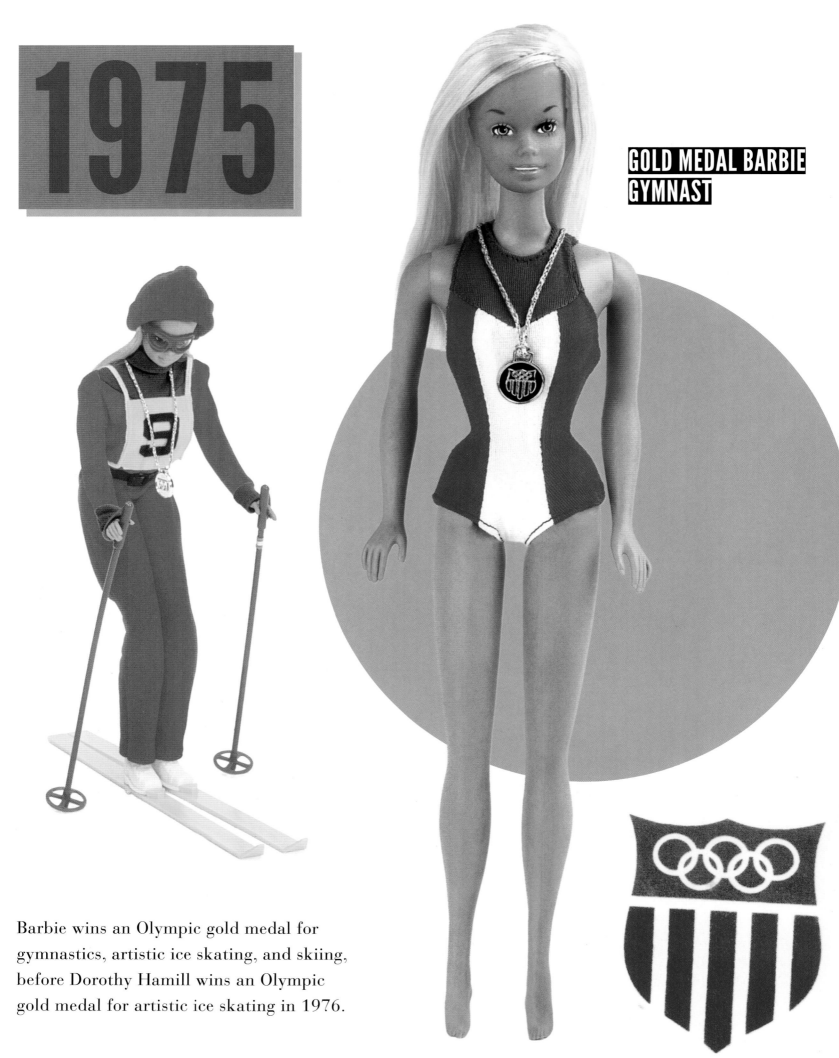

1975

GOLD MEDAL BARBIE GYMNAST

Barbie wins an Olympic gold medal for gymnastics, artistic ice skating, and skiing, before Dorothy Hamill wins an Olympic gold medal for artistic ice skating in 1976.

44

1977

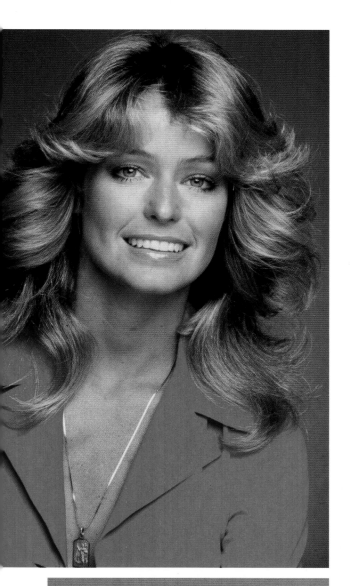

Actress Farrah Fawcett, original star of the hit 1970s TV series Charlie's Angels.

SUPERSTAR BARBIE

One of the most important changes ever made to Barbie's facial expression was inspired by Farrah Fawcett, star of the popular TV series *Charlie's Angels*.

IN 1977 TWO MUSICAL LEGENDS PASS AWAY: MARIA CALLAS AND ELVIS PRESLEY. *SUPERSTAR BARBIE* IS PRODUCED.

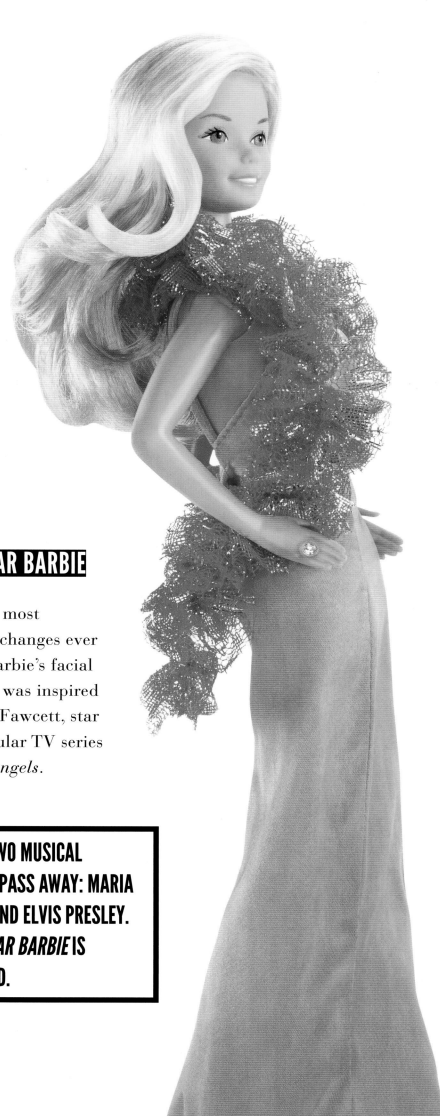

The musical-movie *Grease* is released, starring Olivia Newton-John and John Travolta. The high school queens are the brash Pink Ladies, and the first thing they say when they meet innocent Sandy is "She looks too pure to be Pink."

1978

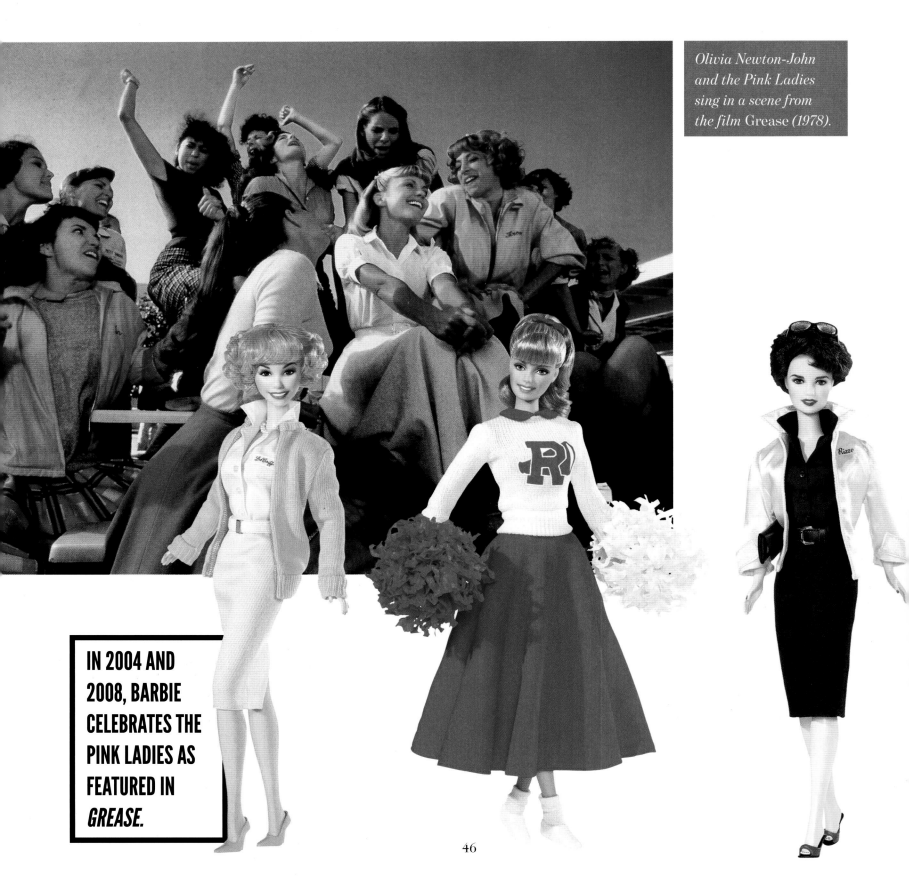

Olivia Newton-John and the Pink Ladies sing in a scene from the film Grease (1978).

IN 2004 AND 2008, BARBIE CELEBRATES THE PINK LADIES AS FEATURED IN *GREASE.*

In the seventies Barbie is packaged in her famous "Pink Box": pink is a fun, flirtatious color that befits her perfectly, and certainly does not pass unnoticed.

Choosing a color and identifying with it, or "chromatic monomania." In 1979 Margaret Thatcher is elected British prime minister: she'll never be seen without her dark/light blue outfits.

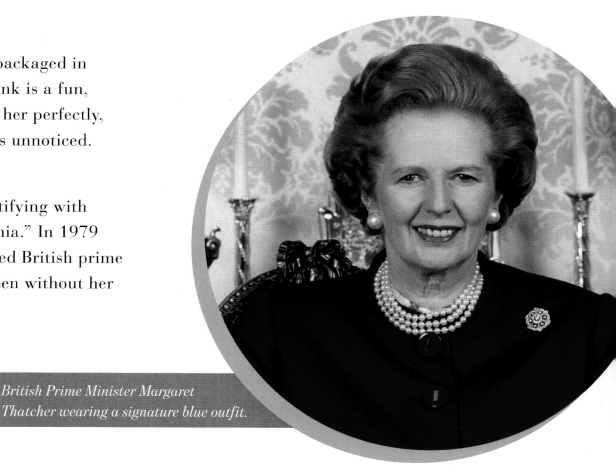

British Prime Minister Margaret Thatcher wearing a signature blue outfit.

IN MILAN GIANNI VERSACE INTRODUCES THE FIRST COLLECTION IN HIS NAME.

IN 1979 YVES SAINT LAURENT LAUNCHES HIS *TRIBUTE TO PABLO PICASSO* COLLECTION.

Barbie Barbie Barbie Barbie B
Barbie Barbie Barbie Barbie B
Barbie Barbie Barbie Barbie B
Barbie Barbie Barbie Barbie B
Barbie Barbie Barbie Barbie B
Barbie Barbie Barbie Barbie B
Barbie Barbie Barbie Barbie B
Barbie Barbie Barbie Barbie B

19/1989 80

THE EIGHTIES

MTV FUELS A NEW YOUTH MOVEMENT BY TRANSMITTING THE DECADE'S TRENDS AND FADS ALL AROUND THE WORLD. LIKE EVERYTHING ELSE IN THE EIGHTIES, BARBIE IS BLONDE, OUTRAGEOUS, AND SHE ROCKS.

BLACK BARBIE

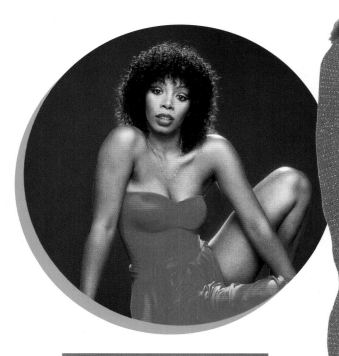

Donna Summer poses in 1980 for a photo shoot in Los Angeles.

Mattel launches *Black Barbie* and *Hispanic Barbie*.

1980

The very popular TV series *Dallas*, airing in America from 1978, is the first soap opera in television history to be televised around the world from the early eighties: in the everyday imagination it represents Texan-style country life.

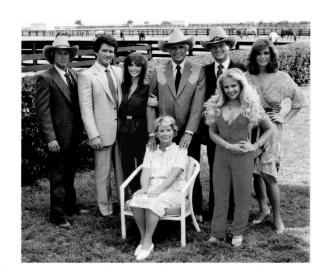

The cast of the legendary American TV series Dallas *(1979).*

IN THE UNITED STATES REPUBLICAN CANDIDATE RONALD REAGAN IS ELECTED PRESIDENT, AND JOHN LENNON IS SHOT AND KILLED IN NEW YORK.

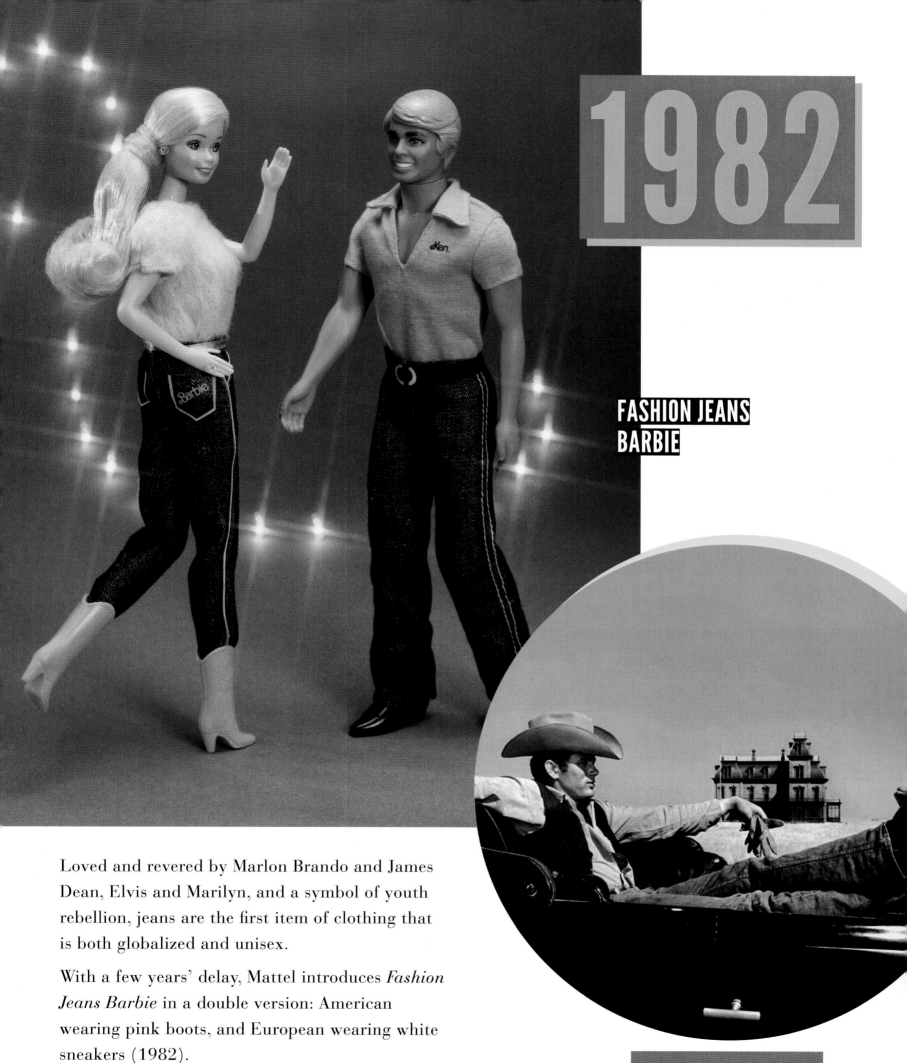

1982

FASHION JEANS BARBIE

Loved and revered by Marlon Brando and James Dean, Elvis and Marilyn, and a symbol of youth rebellion, jeans are the first item of clothing that is both globalized and unisex.

With a few years' delay, Mattel introduces *Fashion Jeans Barbie* in a double version: American wearing pink boots, and European wearing white sneakers (1982).

James Dean in Giant *(1956).*

1984

Aerobics is the latest craze, and its godmother, the adrenaline-pumping Jane Fonda, encourages women all around the world to wear colorful leg warmers and work out to the beat of disco music.

American actress Jane Fonda during a workout session, photographed by Harry Langdon (1985).

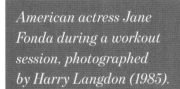

GREAT SHAPE BARBIE

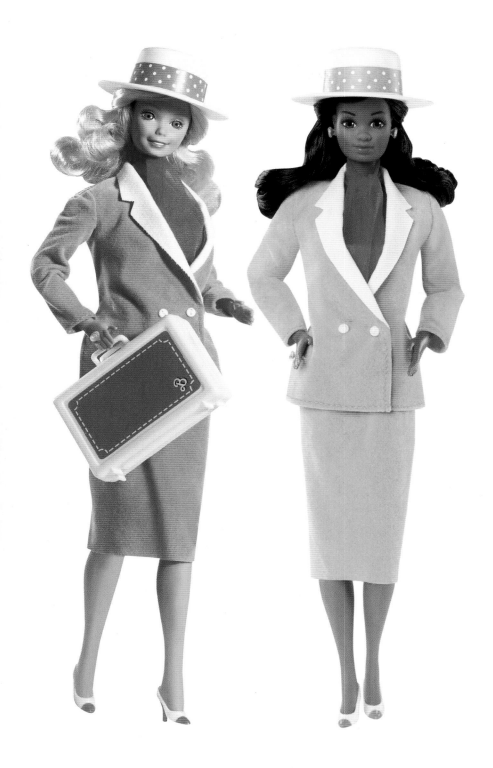

1985

This is the era of the go-getting yuppies, young and bold Americans just out of college striving for money and success. They work in the skyscrapers of Manhattan, wear Giorgio Armani and Versace, and collect artwork by Jean-Michel Basquiat. In the evening they go to exclusive restaurants and discos, such as Manhattan's famous Studio 54.

DAY-TO-NIGHT BARBIE

1985 perfectly embodies this dynamic lifestyle, and comes with one outfit for the day and the other for the night.

Oscar de la Renta is the first designer to create a collection of high-fashion outfits for Barbie.

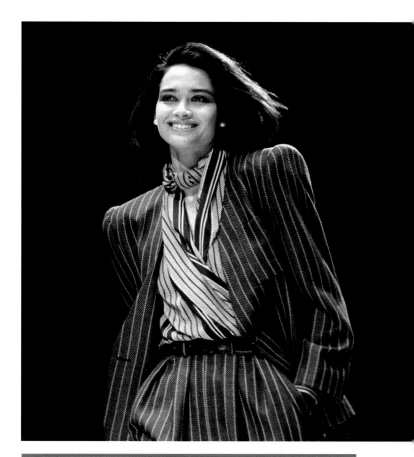

Armani model presented in fall 1985 with a pinstripe business suit, featuring the unmistakable eighties line with oversized shoulder pads.

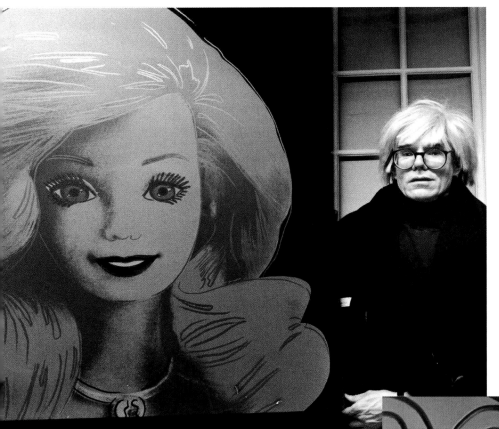

1986

BillyBoy* designs the sophisticated

FEELIN' GROOVY BARBIE

(produced in 1987) for Mattel.

Andy Warhol displaying his portrait of a Barbie doll in New York.

Andy Warhol pays tribute to his friend BillyBoy* by painting a portrait of Barbie, in response to his words: "If you want to do my portrait, do Barbie, because Barbie, *c'est moi.*" Barbie is elevated to the status of a work of art.

Noisy, outlandish rock bands are all the rage: Depeche Mode, Spandau Ballet, Duran Duran, Guns N' Roses. Young people around the world learn the lyrics of their songs by heart, and imitate their wild hairstyles. Twistbands, wide belts, and leggings are here to stay. The era of Madonna has just begun.

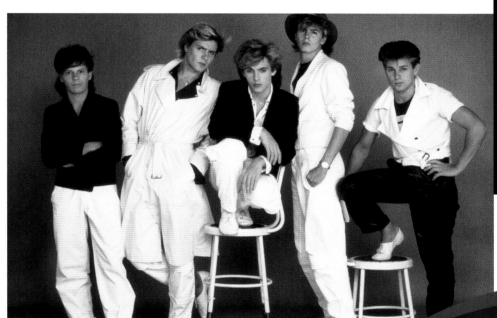

Duran Duran (1985).

Madonna performing onstage (1985).

Mattel launches

BARBIE & THE ROCKERS

a full-fledged glitter band in perfect eighties style. Barbie converts to fluorescent hues and padded shoulders.

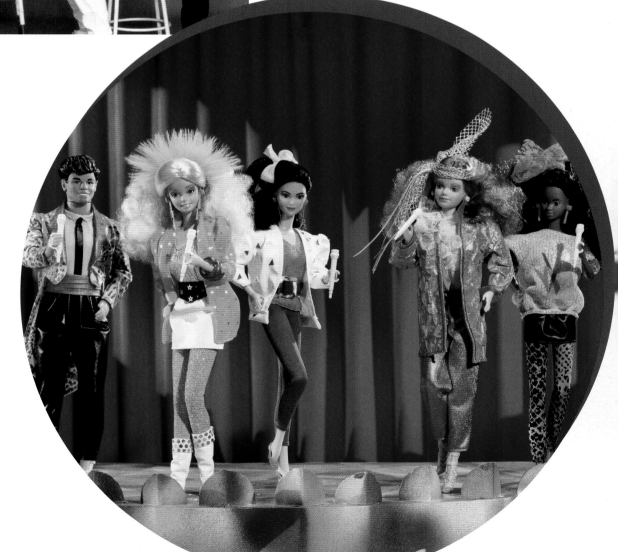

1989

Barbie is named
UNICEF AMBASSADOR

ON NOVEMBER 9 THE BERLIN WALL, THE SYMBOL OF THE COLD WAR, IS KNOCKED DOWN.

Barbie enlists in the armed forces one year before the start of the Gulf War. The Pentagon's approval is required to guarantee the perfect reproduction of Barbie's military uniform.

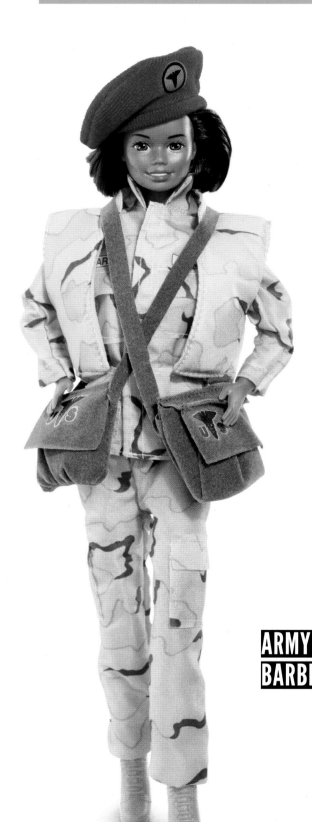

ARMY MEDIC BARBIE

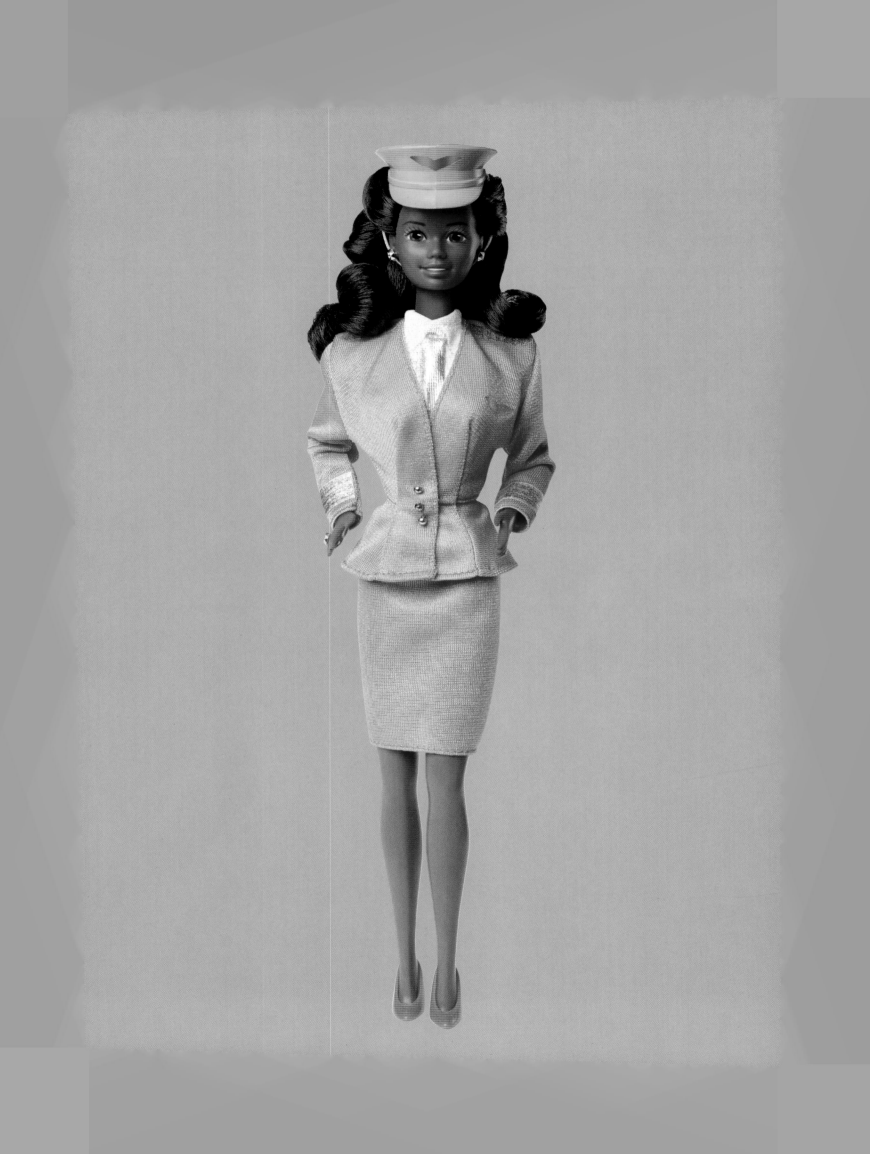

19 90

/1999

THE NINETIES

1991

Hollywood costume designer Bob Mackie creates a new line of collectible Barbie dolls, with a highly sophisticated wardrobe and a new face: the *Bob Mackie Golden Barbie*, a series that represents a high point in the Mattel catalogue, creatively, technically, and aesthetically, is produced.

It is the start of the collaboration between Mattel and Benetton, which will continue until the 2000s. Barbie and her friends wear colorful, fun winter outfits, in perfect United Colors of Benetton style.

BOB MACKIE GOLDEN BARBIE

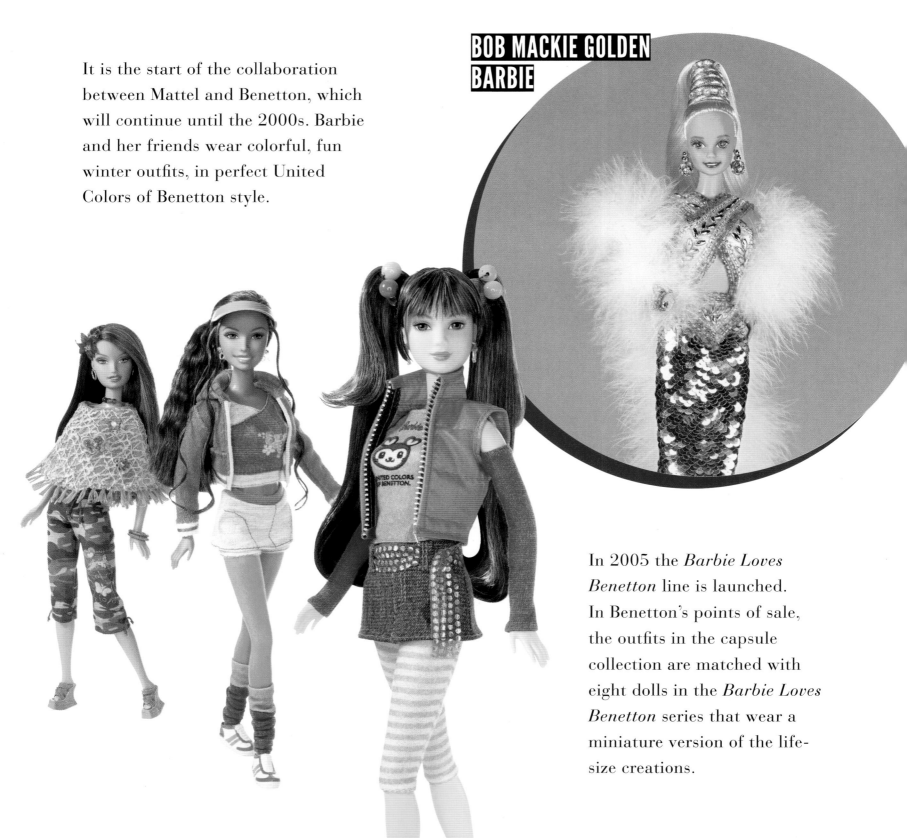

In 2005 the *Barbie Loves Benetton* line is launched. In Benetton's points of sale, the outfits in the capsule collection are matched with eight dolls in the *Barbie Loves Benetton* series that wear a miniature version of the life-size creations.

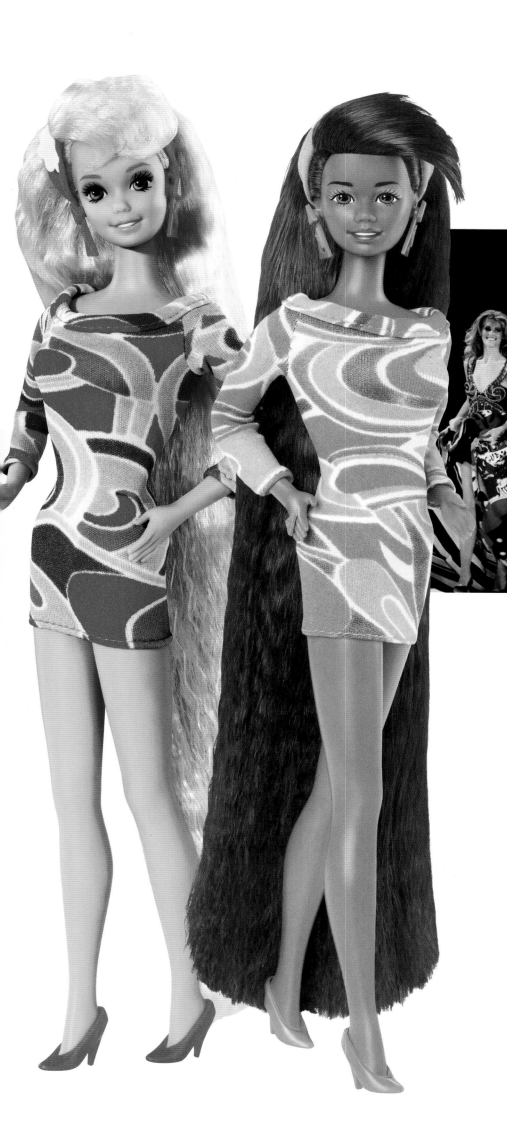

The "Fab Five" are on the catwalk for Gianni Versace's new and colorful *Pop Collection*, whose must-have outfit is a tribute to Andy Warhol.

Gianni Versace takes a bow at a fashion show in Los Angeles (1991).

TOTALLY HAIR BARBIE

Totally Hair Barbie (1992) is the top-selling doll ever, and it celebrates the showy hairdos and garish outfits of that period.

ON AUGUST 6 THE WORLD WIDE WEB IS CREATED.

THE FOLLOWING YEAR BILL CLINTON WINS THE ELECTION, BECOMING THE 42ND PRESIDENT OF THE UNITED STATES OF AMERICA, HOLDING OFFICE UNTIL 2001.

1992

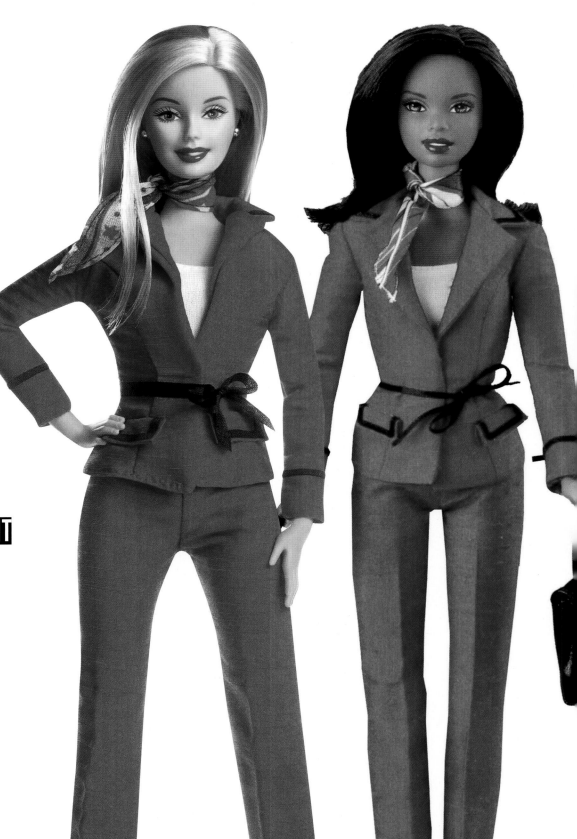

BARBIE I CAN BE... PRESIDENT

For the first time ever, Barbie runs for president of the United States of America, inspired by Geraldine Ferraro's pioneering attempt in 1984. She will again run for president in 2000, 2004, 2008, 2012, and 2020.

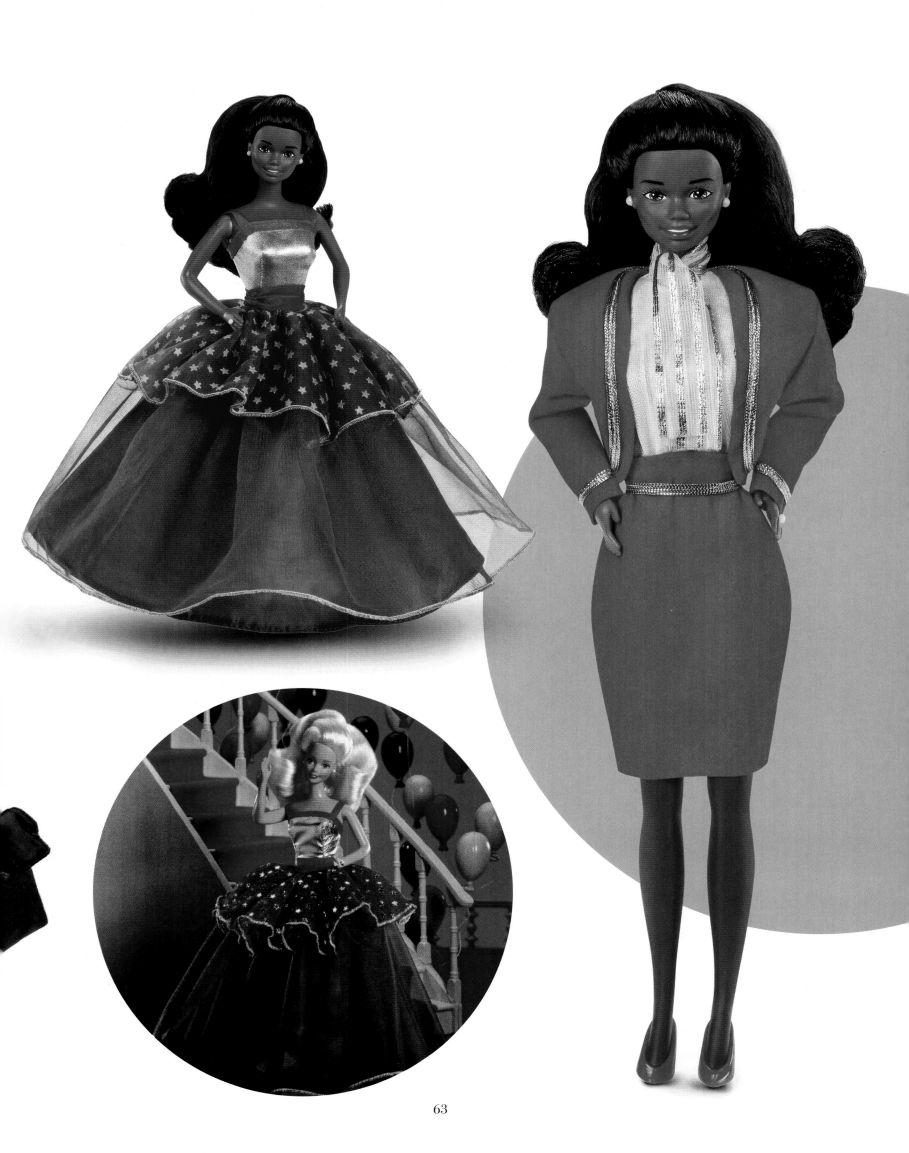

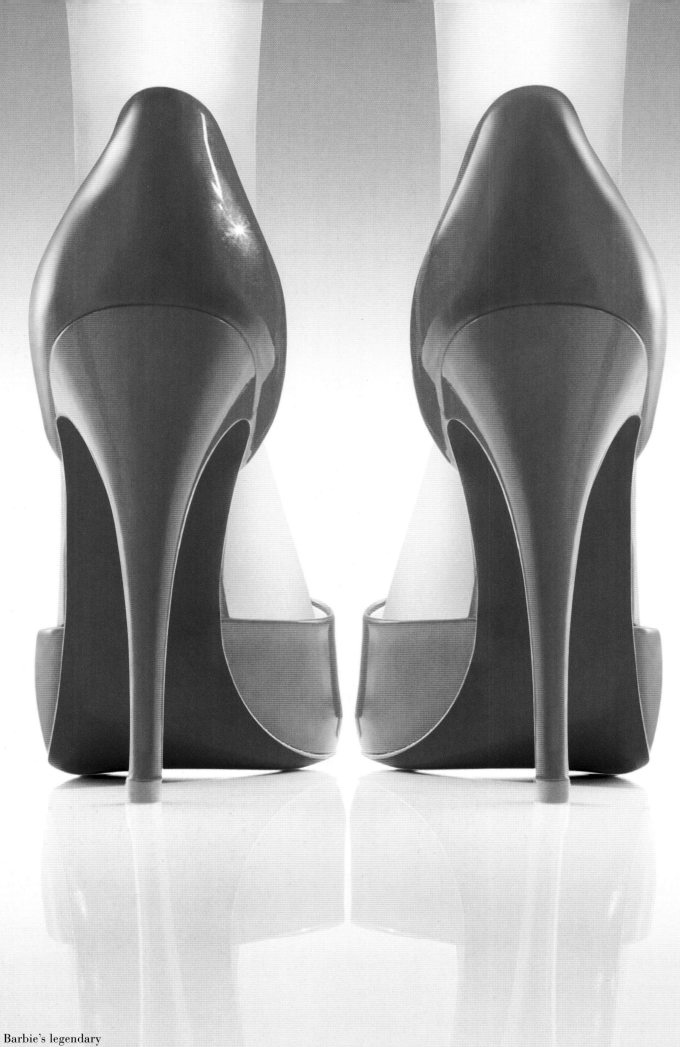

Barbie's legendary
spiked high-heel shoes,
strictly pink.

"R"

I remember seeing that first Barbie in her black-and-white striped bathing suit. She made it look perfectly natural to pair a stiletto heel with a bathing suit.

———

ROBERT BEST,
FASHION DESIGNER

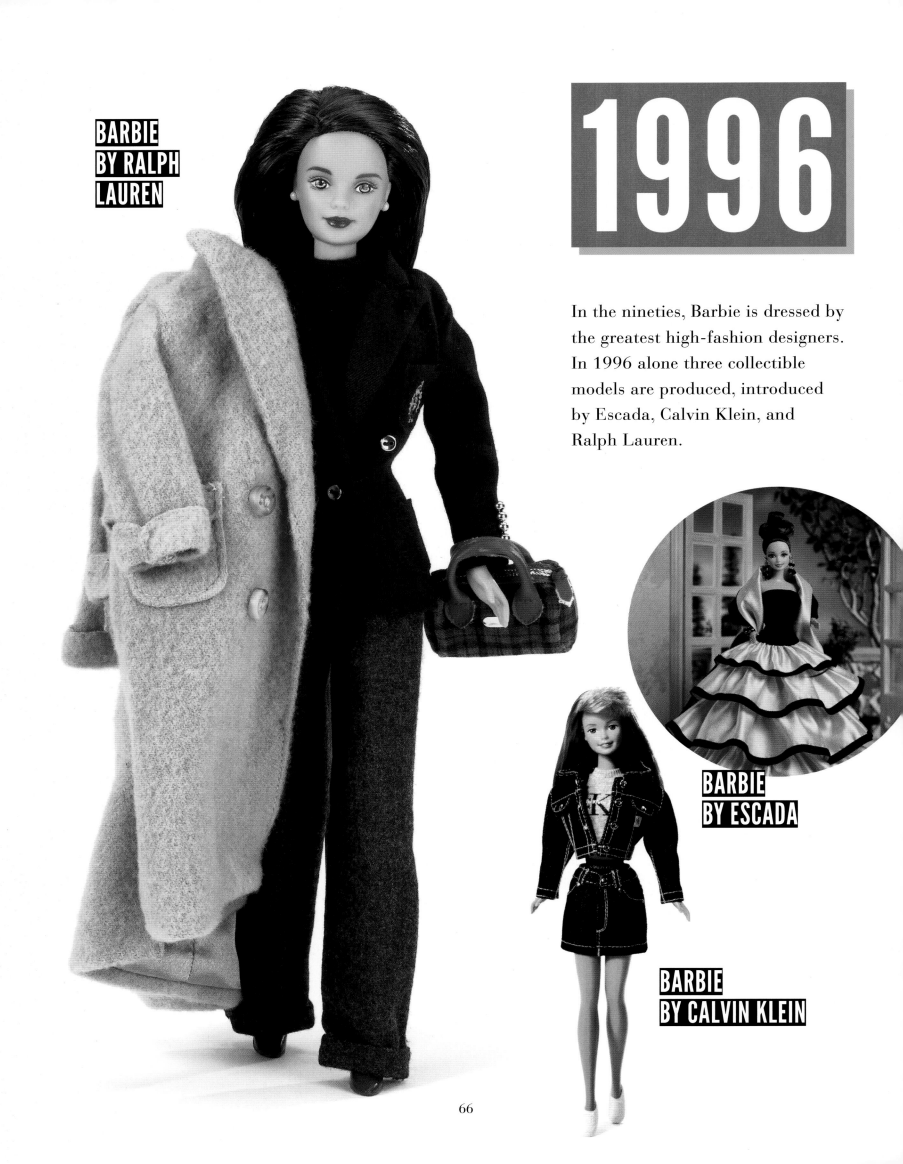

BARBIE BY RALPH LAUREN

1996

In the nineties, Barbie is dressed by the greatest high-fashion designers. In 1996 alone three collectible models are produced, introduced by Escada, Calvin Klein, and Ralph Lauren.

BARBIE BY ESCADA

BARBIE BY CALVIN KLEIN

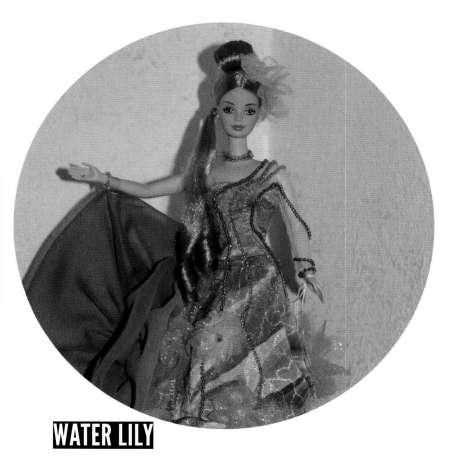

WATER LILY

is inspired by Monet's paintings.

1997

Among the many collectible Barbies, the *Artist Doll* series debuts, paying tribute to the greatest names in art: the dolls in the series wear outfits that reproduce some of the most famous paintings in history. The popular series will continue to be made until the 2000s.

IN JAPAN 159 COUNTRIES SIGN THE KYOTO PROTOCOL TO TRY TO CURB THE GREENHOUSE EFFECT.

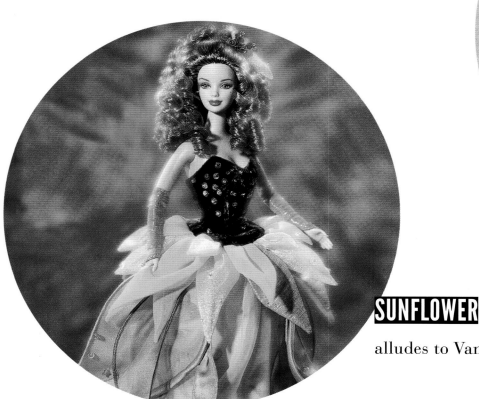

SUNFLOWER

alludes to Van Gogh's paintings.

REFLECTIONS OF LIGHT

inspired by Renoir's use of light effects.

1997

A BARBIE TODAY TO SAVE THE WOMAN OF TOMORROW

Eighty-one very special Barbie dolls are auctioned off, thirty-one of which come from Mattel's own private collection, while fifty are one-off pieces exclusively dressed by both Italian and foreign designers (Armani, Coveri, Versace, Ferré, Krizia, Gaultier, and many others). Organized by Mattel and *Vogue*, together with Christie's, the auction is a charity event.

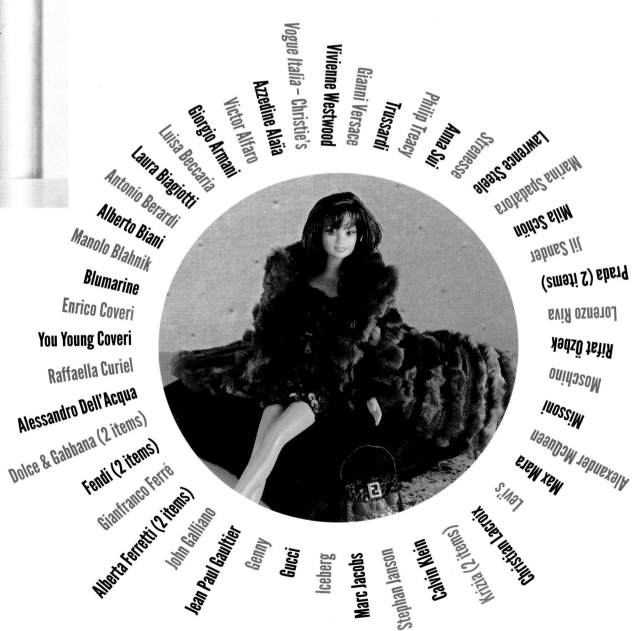

Vogue Italia – Christie's
Azzedine Alaïa
Victor Alfaro
Giorgio Armani
Luisa Beccaria
Laura Biagiotti
Antonio Berardi
Alberto Biani
Manolo Blahnik
Blumarine
Enrico Coveri
You Young Coveri
Raffaella Curiel
Alessandro Dell'Acqua
Dolce & Gabbana (2 items)
Fendi (2 items)
Gianfranco Ferré
Alberta Ferretti (2 items)
John Galliano
Jean Paul Gaultier
Genny
Gucci
Iceberg
Marc Jacobs
Stephan Janson
Calvin Klein
Krizia (2 items)
Christian Lacroix
Levi's
Max Mara
Alexander McQueen
Missoni
Moschino
Rifat Özbek
Lorenzo Riva
Prada (2 items)
Jil Sander
Mila Schön
Marina Spadafora
Lawrence Steele
Stranesse
Anna Sui
Philip Treacy
Trussardi
Gianni Versace
Vivienne Westwood

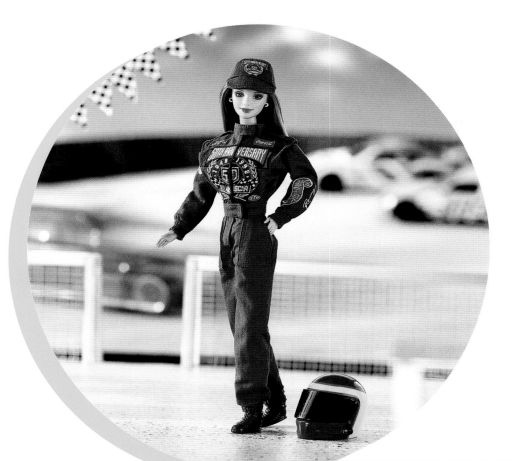

1998

Barbie tries her hand at NASCAR auto racing, ten years before Danica Patrick's historic victory at Motegi in 2008.

GOOGLE IS FOUNDED ON SEPTEMBER 27.

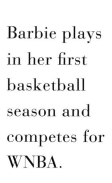

Barbie plays in her first basketball season and competes for WNBA.

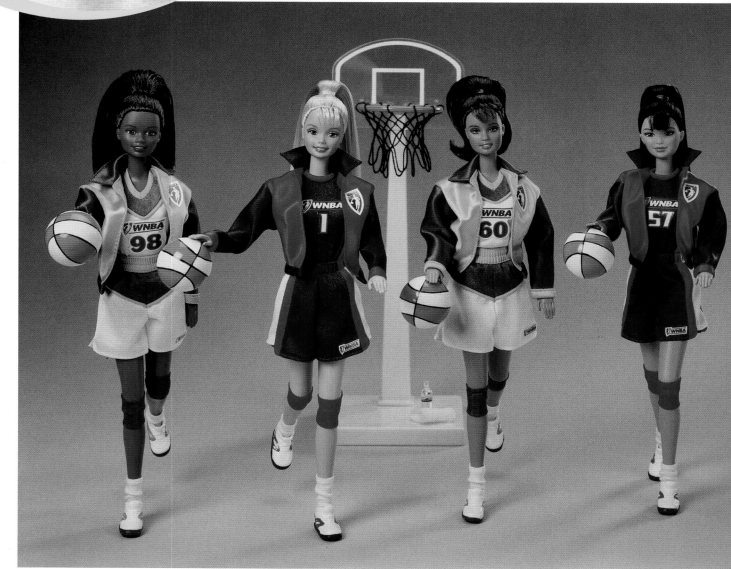

20

/2024

00

NEW MILLENNIUM

2000

The *Silkstone Barbie Dolls* line is launched, the epitome of haute couture elegance of the fifties and the sixties, designed by fashion designer Robert Best. These Barbie dolls are made of silkstone, a soft plastic resembling porcelain, while their face, makeup, and sophisticated taste are the same as those of the *Teen-Age Fashion Model Barbie Doll* (1959). The true essence of Barbie is back!

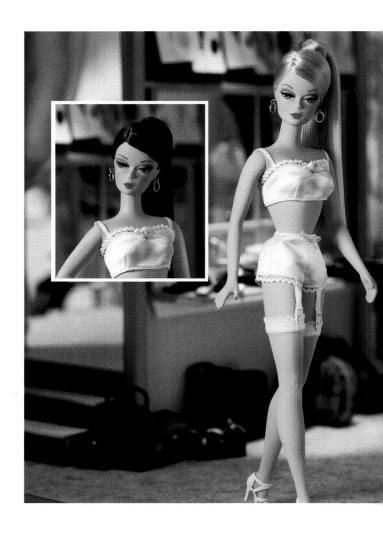

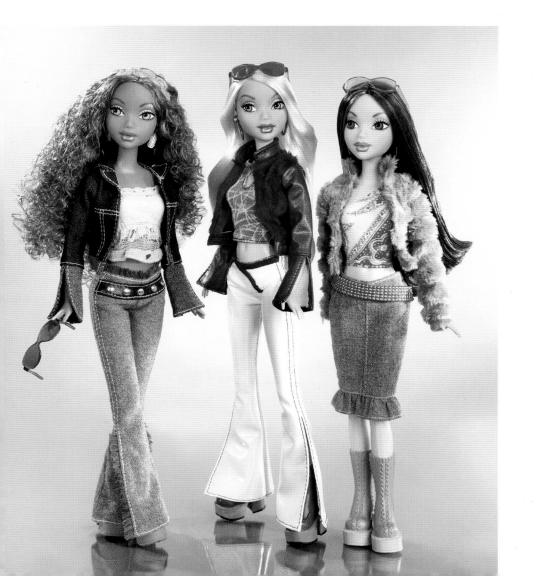

2002

In response to the new trends that prefer street style even for dolls, *My Scene Barbie* is created, clearly inspired by the urban and underground styles.

ON SEPTEMBER 11, 2001, THE TWIN TOWERS IN NEW YORK COLLAPSE FOLLOWING A TERRORIST ATTACK. AMERICA AND THE WHOLE WORLD ARE SHELL-SHOCKED.

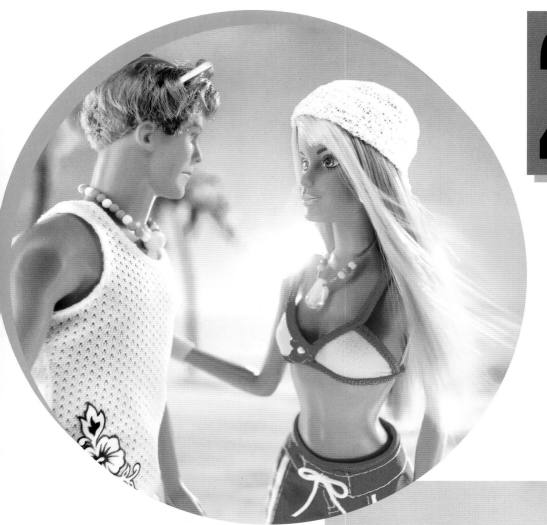

2004

Barbie and Ken break up after a relationship lasting forty-three years. Barbie meets the Australian surfer Blaine, whose model is inspired by the new idols of the youth boy bands, like Nick Carter of the Backstreet Boys.

Barbie is increasingly in line with fashion, and the Fashion Fever series is launched.

THE SOCIAL NETWORKING SITE FACEBOOK IS LAUNCHED. THE WORLD OF COMMUNICATION IS NOW GLOBAL.

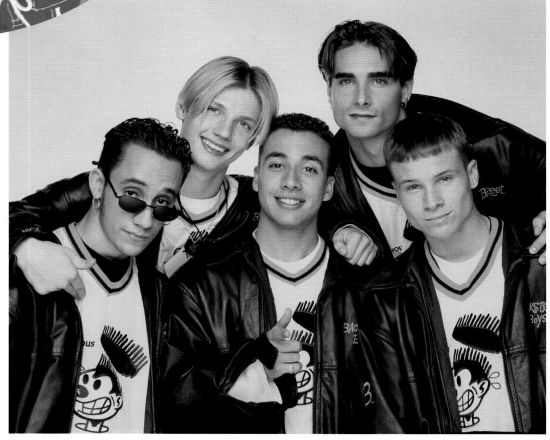

American pop group the Backstreet Boys (1995).

2006

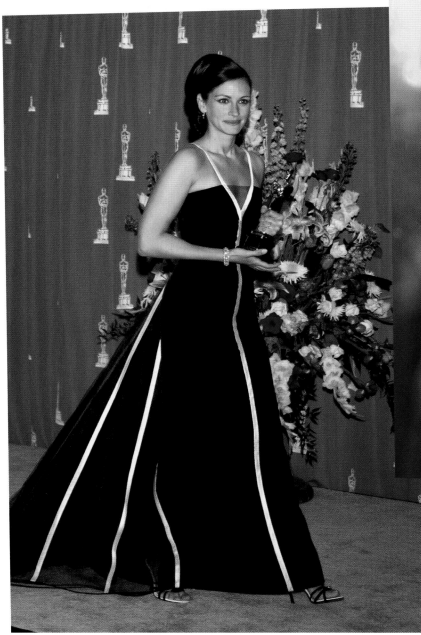

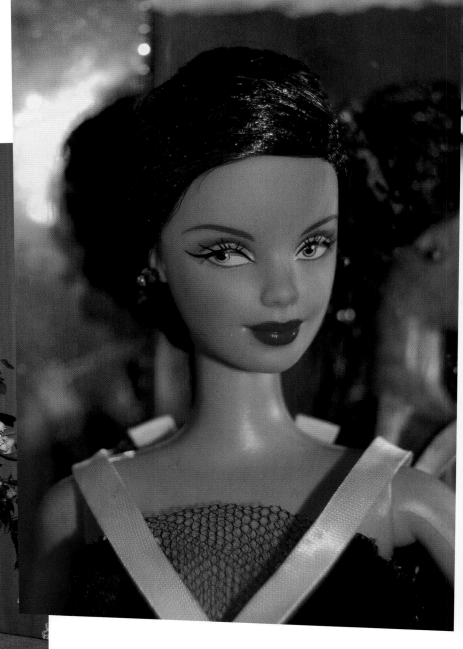

Barbie is the star of the Life Ball in Vienna, organized to raise money in the fight against AIDS. For the occasion, she wears a dress designed by Valentino, the same one worn by Julia Roberts on Oscar Night 2001.

2009

Barbie celebrates her first half century with events and worldwide collaborations. *Vogue Italia* dedicates a special "Black Barbie" issue to her.

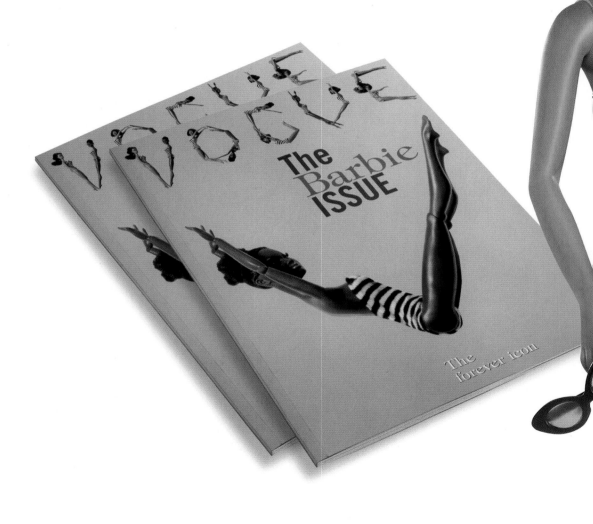

ON NOVEMBER 4, 2008, BARACK OBAMA BECOMES THE 44TH PRESIDENT OF THE UNITED STATES OF AMERICA.

2010

Barbie goes back to a "black code," the distinctive sign of her renewed minimal elegance.

AFTER REVOLUTIONIZING THE WORLD OF COMPUTERS, STEVE JOBS, FOUNDER OF APPLE, PASSES AWAY ON OCTOBER 5, 2011.

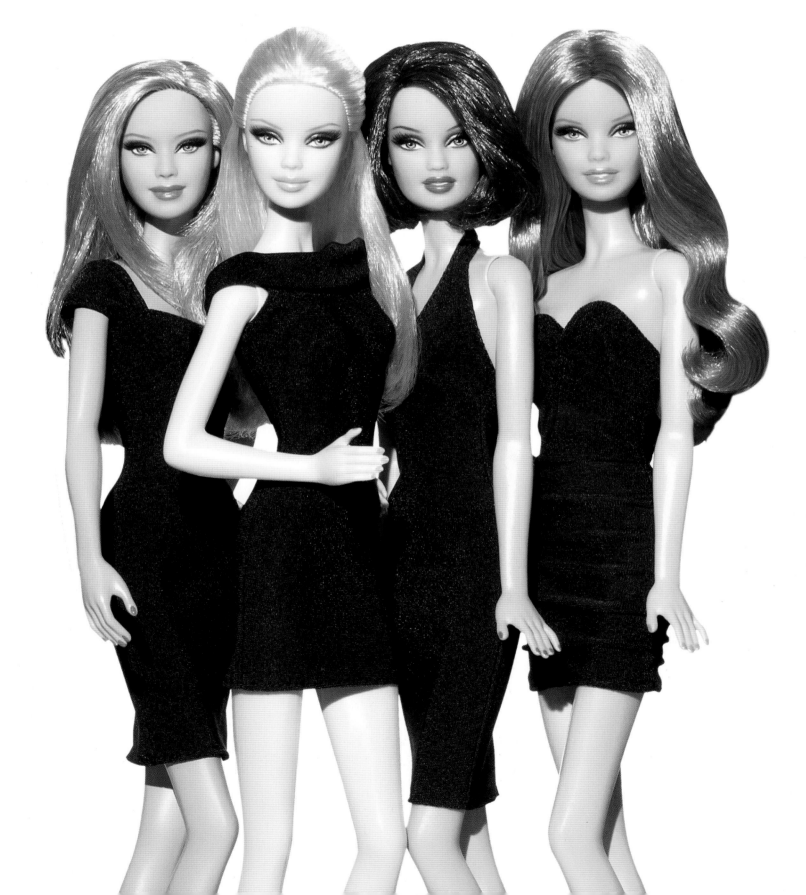

Barbie celebrates Italy's national airline Alitalia. For the occasion, she appears wearing fifteen different official flight attendant uniforms, designed by some of the most famous fashion designers, among them Sorelle Fontana, Delia Biagiotti, Mila Schön, Renato Balestra, and Giorgio Armani.

2011

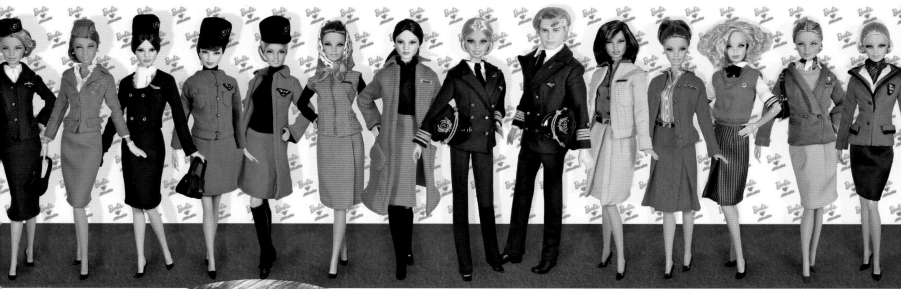

After acting together with Barbie on the set of *Toy Story 3*, Ken is the protagonist in 2011 of an advertising campaign in Times Square in New York to win his historic fiancée back. On February 14, 2011, Valentine's Day, Barbie and Ken get back together.

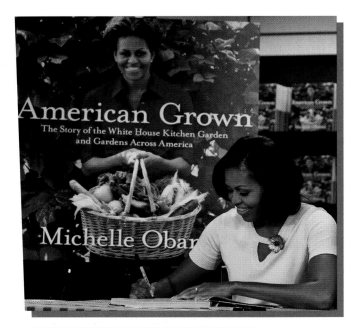

2011

FIRST LADY MICHELLE OBAMA IS A CHAMPION OF ECO-FRIENDLY, BIO-SUSTAINABLE POLICIES.

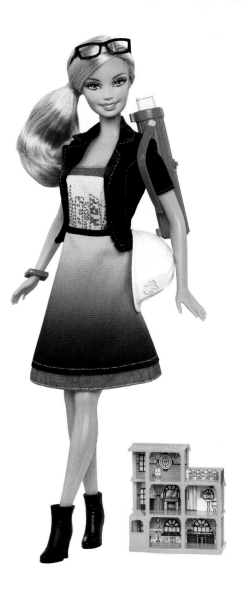

In the wake of a renewed sensitivity towards the environment, after presenting a collection of ecological accessories for little girls (2008), Mattel and the American Institute of Architects hold a contest for an eco-friendly *Barbie Dream House*. Barbie as architect is launched.

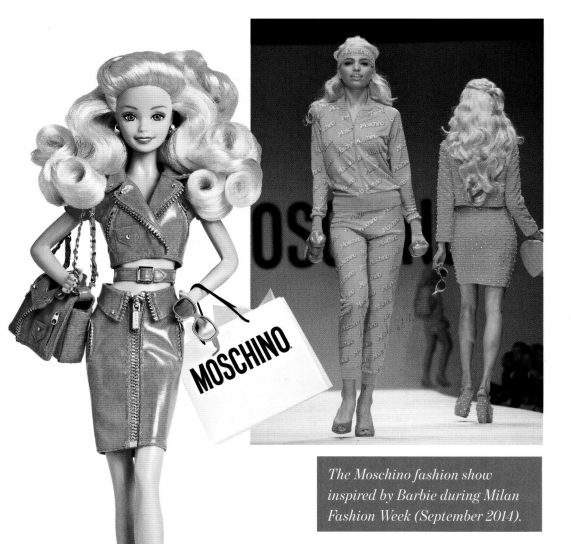

2015

Barbie invades the catwalks of Milan's Fashion Week S/S collections modeling clothes for Moschino.

The Moschino fashion show inspired by Barbie during Milan Fashion Week (September 2014).

EXPO MILAN 2015 IS INAUGURATED ON MAY 1. IT IS A UNIVERSAL EXPOSITION DEDICATED TO THE THEME OF "FEEDING THE PLANET, ENERGY FOR LIFE."

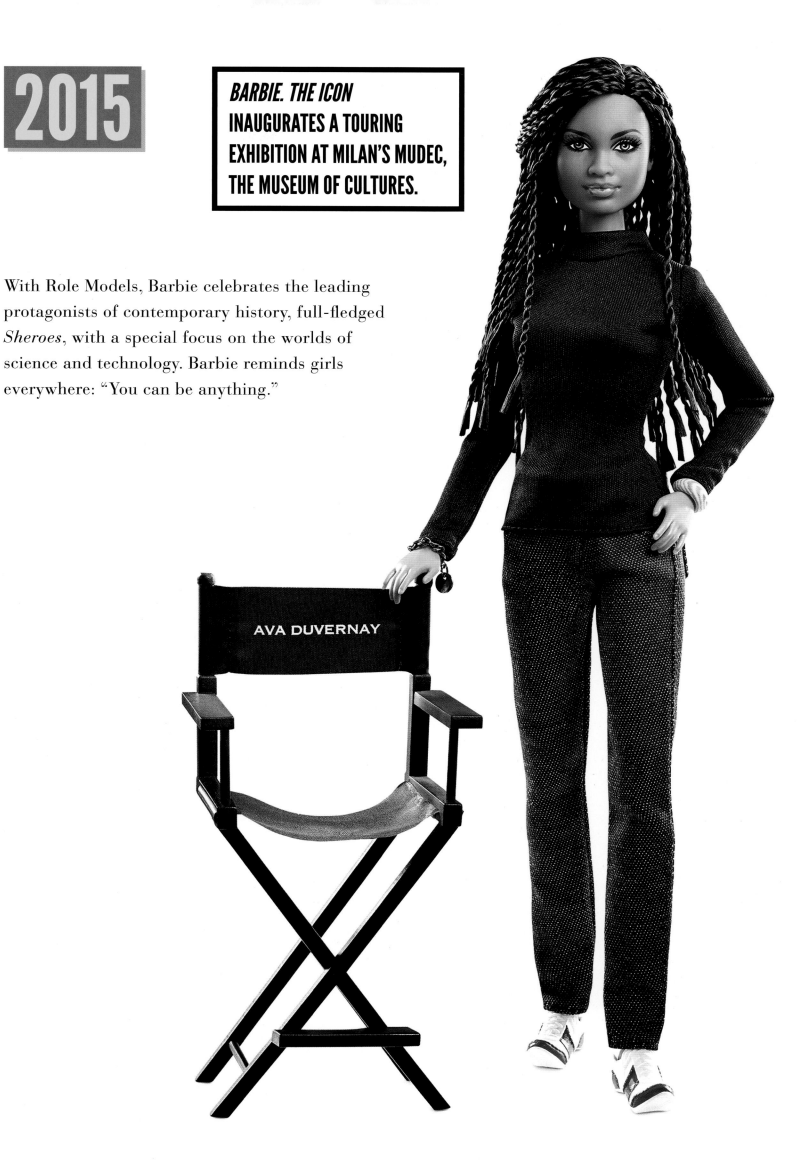

2015

BARBIE. THE ICON INAUGURATES A TOURING EXHIBITION AT MILAN'S MUDEC, THE MUSEUM OF CULTURES.

With Role Models, Barbie celebrates the leading protagonists of contemporary history, full-fledged *Sheroes*, with a special focus on the worlds of science and technology. Barbie reminds girls everywhere: "You can be anything."

AVA DUVERNAY

2016

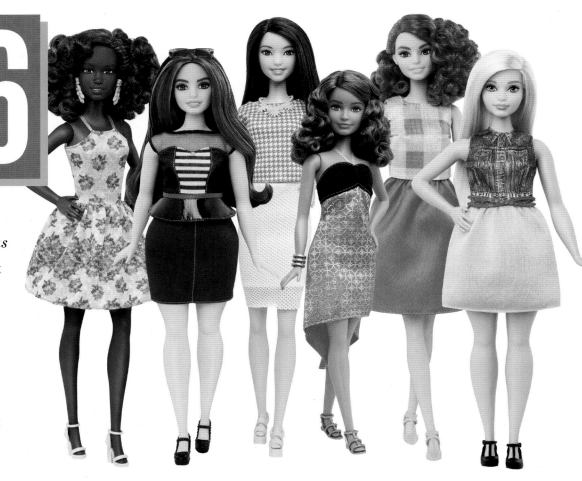

In 2016 the *Barbie Fashionistas* implement the most significant and revolutionary evolution in the history of Barbie, with THREE new body types, SEVEN skin tones, TWENTY-TWO eye colors, and TWENTY-FOUR different hairstyles.

HILLARY CLINTON BECOMES A CANDIDATE FOR THE AMERICAN PRESIDENTIAL CAMPAIGN.

On the occasion of Milan Fashion Week, ten Barbies are reinterpreted and dressed by ten fashion designers: Lorenzo Serafini of Philosophy; Tommaso Aquilano and Roberto Rimondi for Fay; Arthur Arbesser of Iceberg; Veronica Etro of Etro; Alessandra Facchinetti of Tod's; Peter Dundas, creative director of Roberto Cavalli; Massimo Giorgetti for Emilio Pucci; Sébastien Meyer and Arnaud Vaillant, creative directors of Courrèges; Alessandro Dell'Acqua for Rochas; and the Ferragamo creative team.

Barbie and Ken dressed by the fashion designer Moschino.

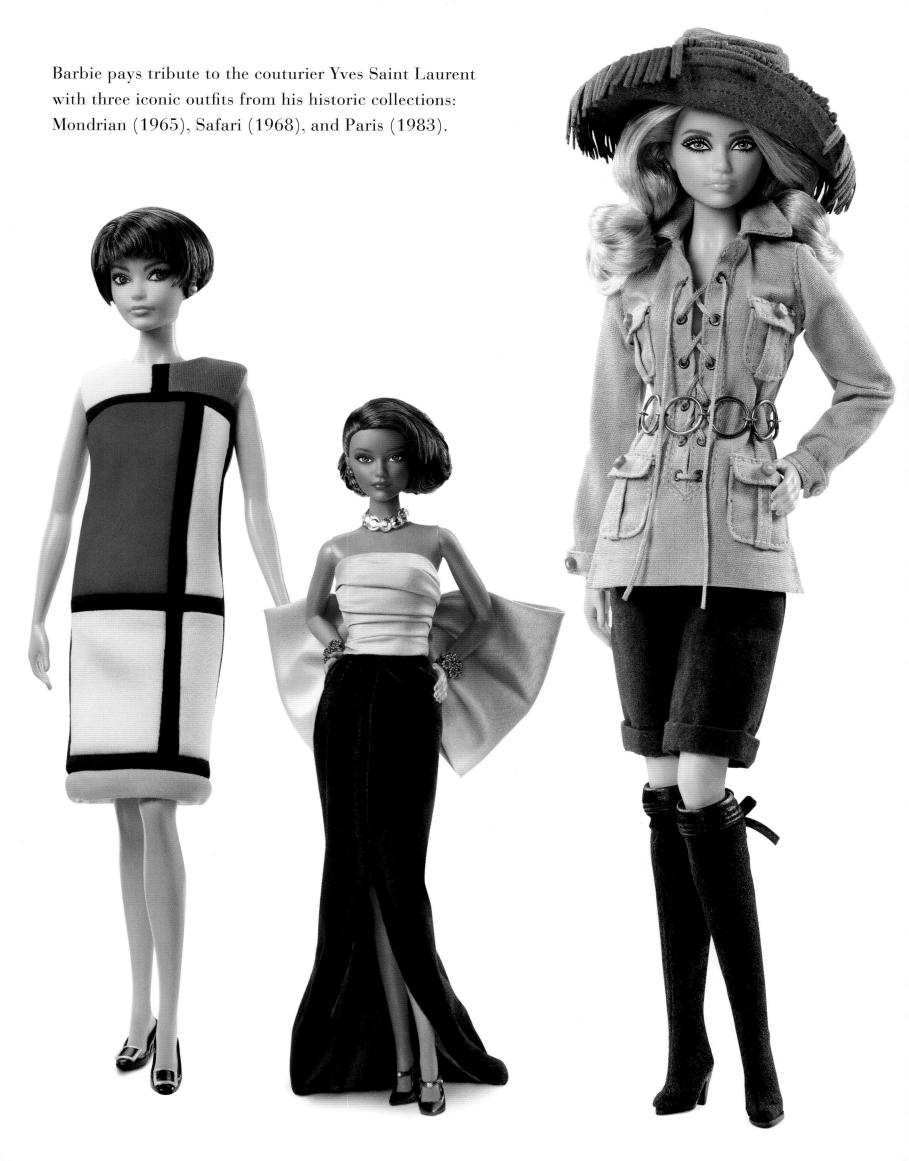

Barbie pays tribute to the couturier Yves Saint Laurent with three iconic outfits from his historic collections: Mondrian (1965), Safari (1968), and Paris (1983).

> BARBIE CONTINUES HER TOUR OF MUSEUMS WITH EXHIBITIONS DEVOTED TO HER IN PARIS, ROME, BOLOGNA, MADRID, AND HELSINKI, AS WELL AS A TOUR IN SOUTH KOREA.

Misty Copeland Barbie

Barbie interacts for the third time with the legendary Andy Warhol and dons a strapless gown with an illustration of the Barbie portrait done by Warhol in 1986.

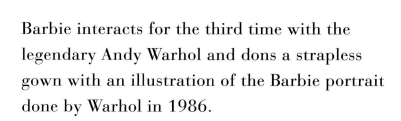

2016

82

2017

Ken has a brand-new look in the Fashionistas line: 15 new models with three different physiques (original, slender, and sturdy), seven skin tones, nine facial shapes, eight hair colors, and nine hairstyles. Barbie takes inspiration from the latest beauty and fashion trends with new hairstyles that range from "Afro curls" to the Cara Delevingne–style shaved head.

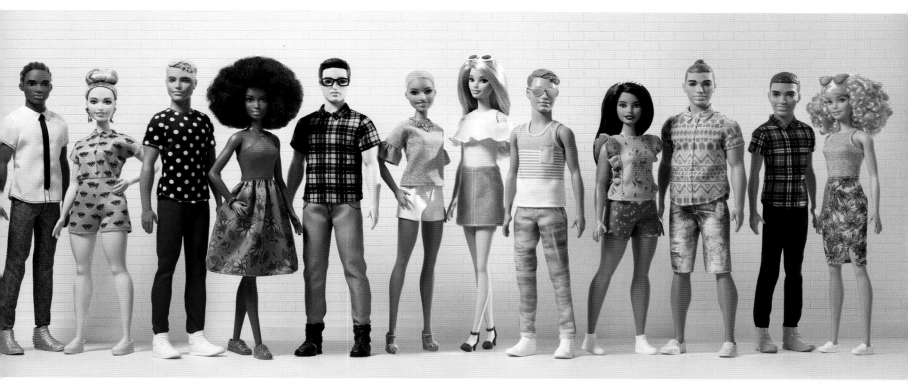

For the first time, Barbie wears a hijab in celebration of the champion fencer Ibtihaj Muhammad, winner of the bronze medal at the 2016 Rio Olympics, the first American fencer to cover her head during the meets.

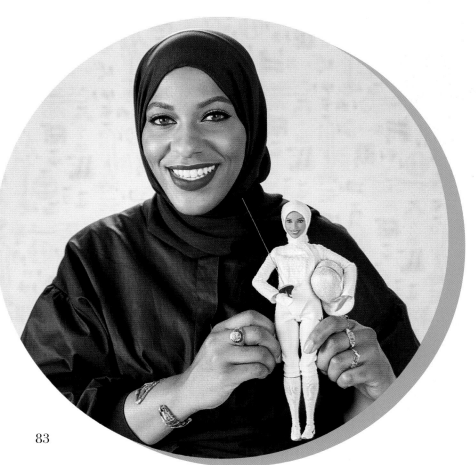

2018

With *Inspiring Women*, Barbie celebrates women from history who went well beyond the boundaries traditionally imposed by society, opening doors for the generations that followed: Frida Kahlo, Amelia Earhart, Katherine Johnson, Iris Apfel, as well as Rosa Parks, Sally Ride, and Eleanor Roosevelt.

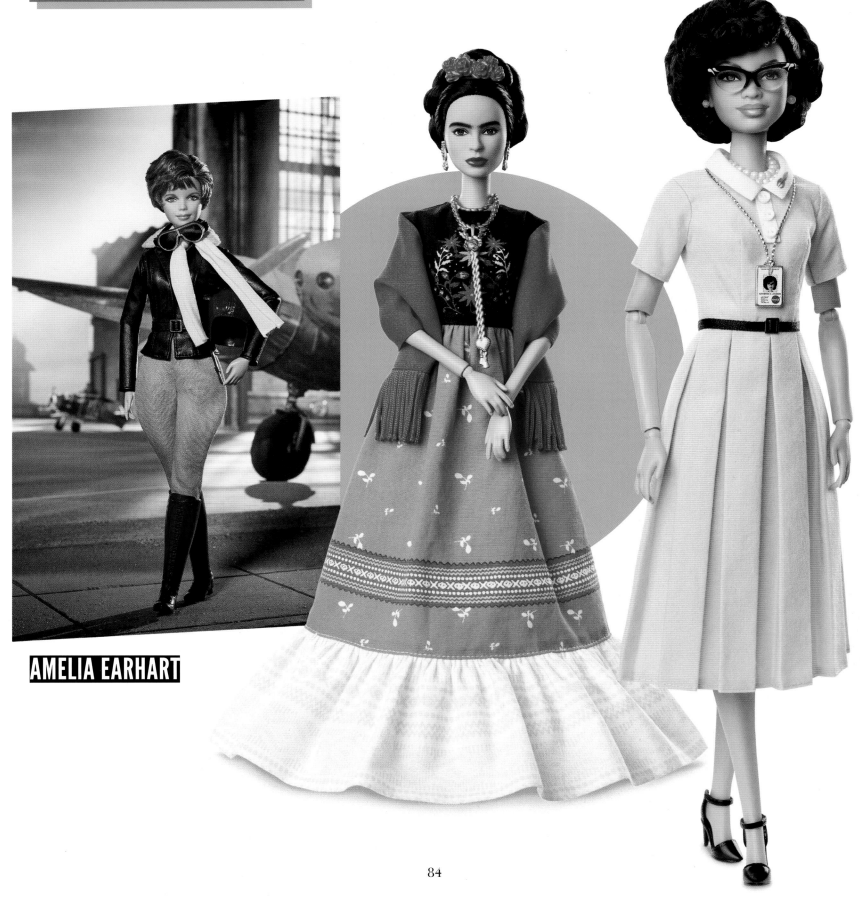

AMELIA EARHART

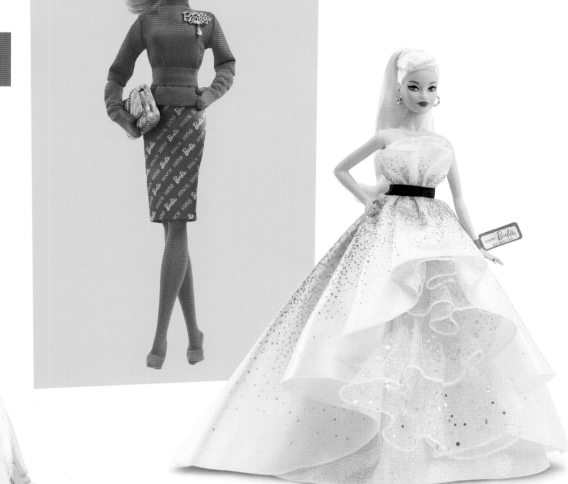

BARBIE TURNS SIXTY.

Collector Barbie for the 60th anniversary used for the cover of Toy Store.

BARBIE'S 60TH ANNIVERSARY

The *Barbie Fashionistas* are crusaders for diversity and inclusion, now more than ever before.

2019

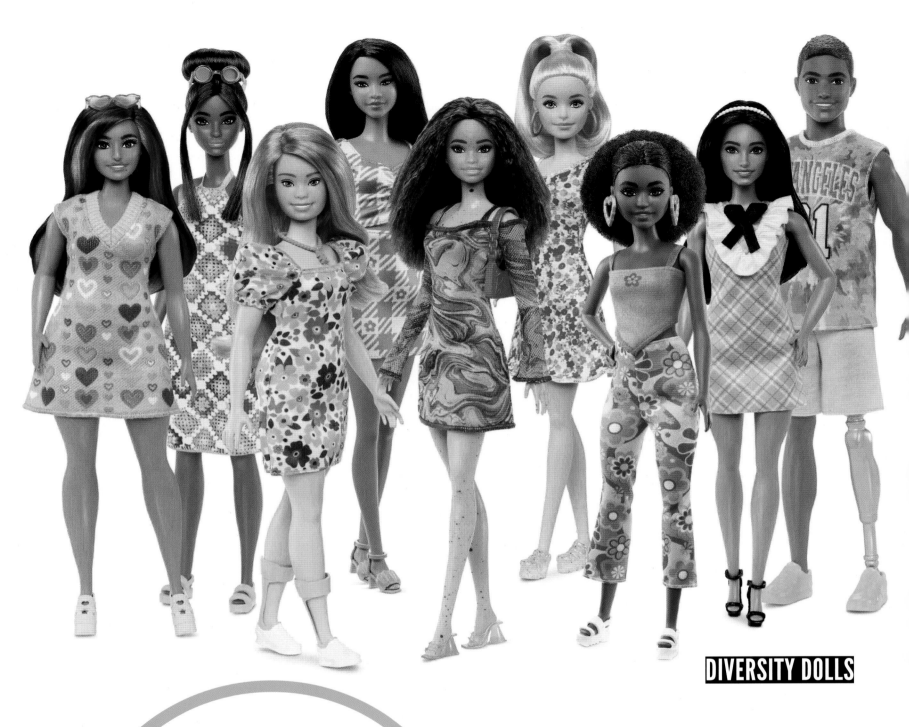

DIVERSITY DOLLS

Barbie becomes the
most diverse line of
dolls on earth.

THE WHO, OR WORLD HEALTH ORGANIZATION,
AFTER EVALUATING THE SEVERITY AND
GLOBAL SPREAD OF THE SARS-COV-2
INFECTION, DECLARES THE COVID-19 EPIDEMIC
TO BE CONSIDERED A PANDEMIC.

JOE BIDEN WINS THE PRESIDENTIAL ELECTION IN THE UNITED STATES OF AMERICA.

2020

2021

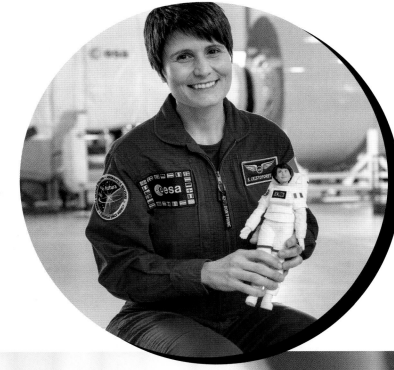

The *Samantha Cristoforetti Barbie* doll is launched.

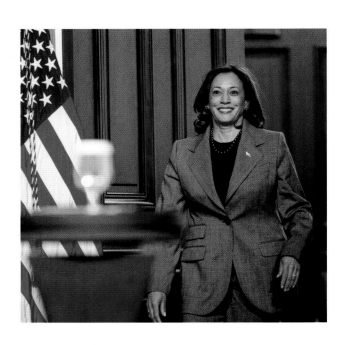

On January 20, Kamala Devi Harris is sworn in as the 49th Vice President of the United States of America.

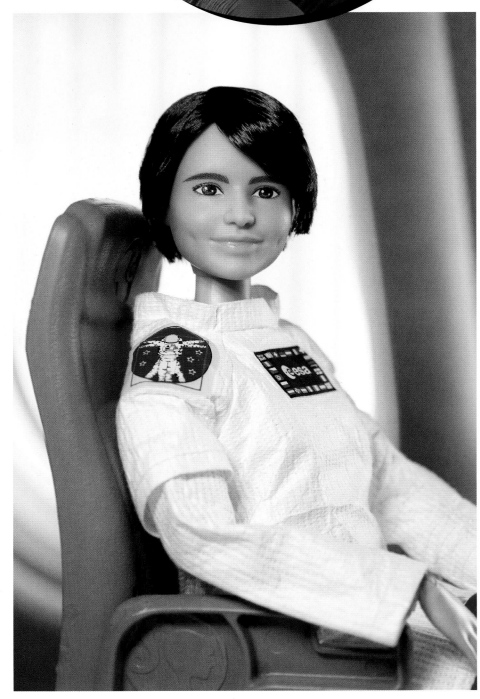

Barbie Loves the Ocean is the first line
of fashion dolls in recycled plastic.

2022

Barbie Signature Queen Elizabeth II celebrates the Platinum Jubilee in observance of the 70th anniversary of the rise to the throne of the queen of the United Kingdom.

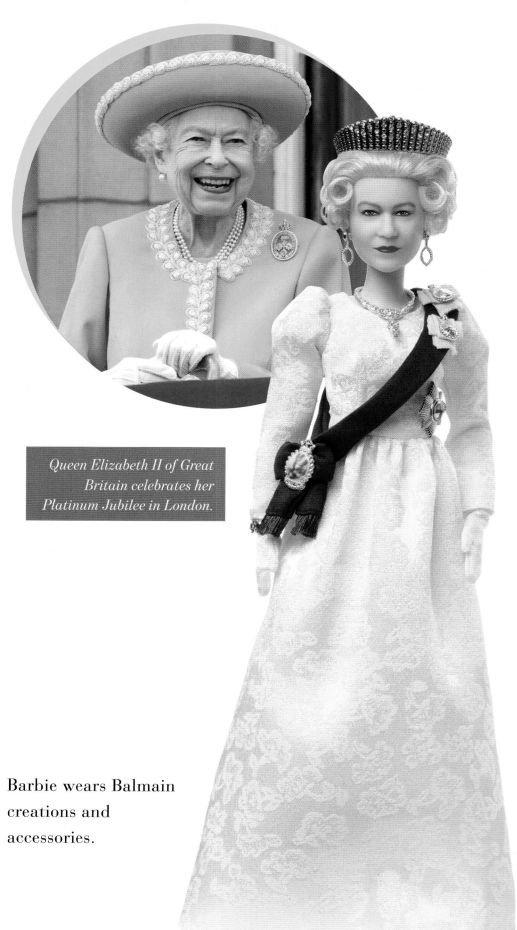

Queen Elizabeth II of Great Britain celebrates her Platinum Jubilee in London.

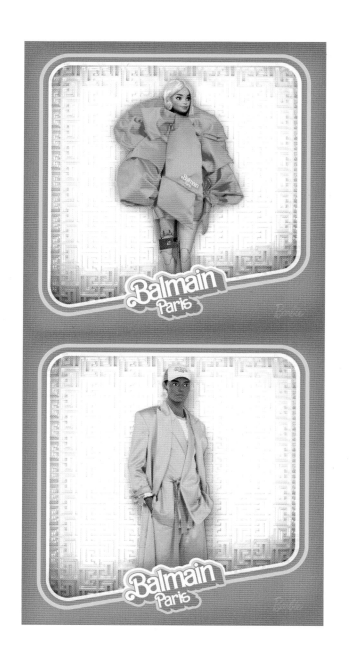

Barbie wears Balmain creations and accessories.

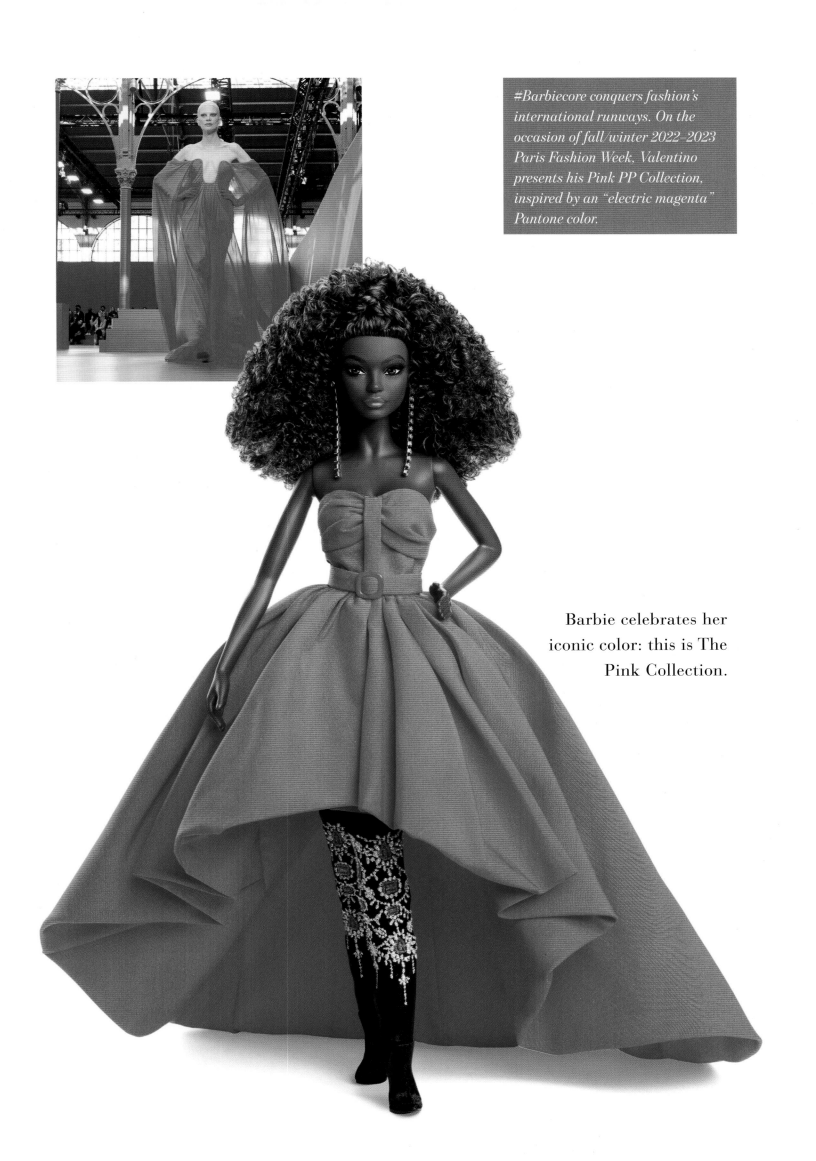

Barbie celebrates her iconic color: this is The Pink Collection.

2023

Barbie appears in the flesh in the film directed by Greta Gerwig, played by Margot Robbie.

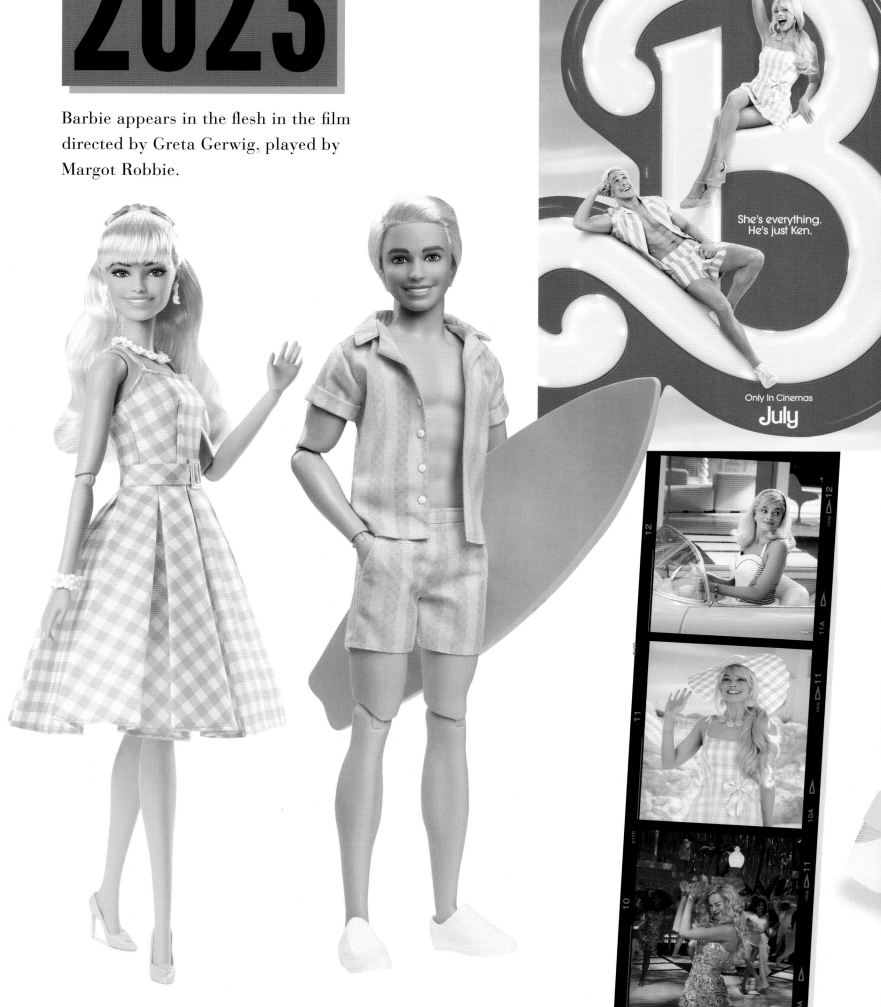

Margot **Robbie**

Rya **Gosli**

She's everything.
He's just Ken.

Only In Cinemas
July

On March 9, Barbie
turns 65.

2024

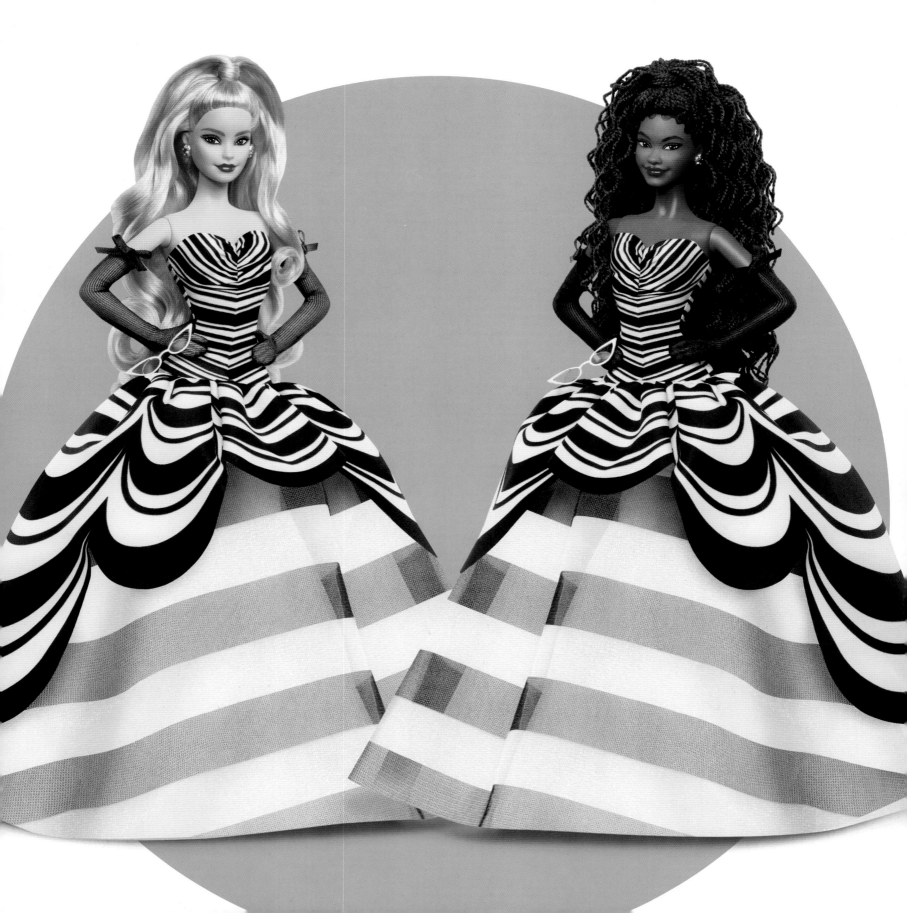

Barba

Millic

Rober

> ## "Barbie is an American Icon."

FRANCISCO COSTA
CALVIN KLEIN
fashion designer

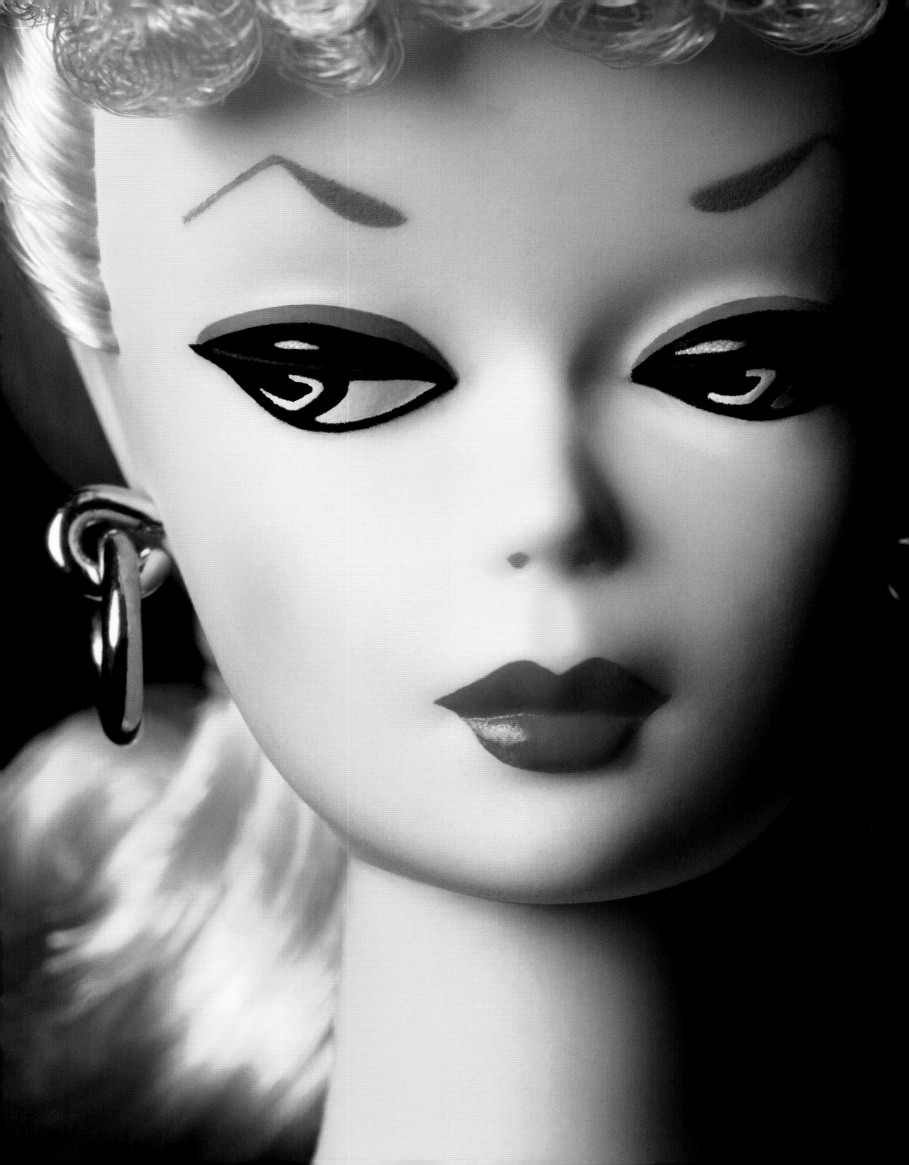

 "B"

Barbie, like a diamond, is forever.

PHILIPPE & DAVID BLOND, THE BLONDS,
FASHION DESIGNERS

Los Angeles—Hollywood. In the forties, the mecca of cinema successfully introduced the image of the star, poised halfway between the *femme fatale* and the dark lady, from Dolores del Rio to Lana Turner and, above all, Rita Hayworth, who, for her starring role in *Gilda* (1946), sang *Put the Blame on Mame* wrapped in a black satin strapless dress designed by Jean Louis.

Yet the charm of these new heroines of the silver screen was not limited to an adult audience; thanks to the images spread by newspapers and advertising, it also conquered the dreams of the younger generation. Barbara Handler (b. Los Angeles, 1941) much preferred to play with the paper-doll images of these actresses, which she would cut out of magazines, rather than with her baby and toddler dolls. Her mother, Ruth, would watch her play, and she eventually got the idea that there might just be a new kind of best friend for all the young girls in the world. Thus was born Barbie, from the pure and simple insight of Ruth Handler (Ruth Marianna Mosko, b. Denver, 1916; d. Los Angeles, 2002), wife of Elliot Handler, founder of Mattel in 1945 together with his friend Harold Matson. From a two-car garage in Los Angeles to a toy manufacturing multinational, Mattel's brand name is a combination of part of the two founders' last name and first name, respectively: Harold Matson and Elliot Handler. At first, the company produced simple wooden objects, furniture and furnishings for dollhouses. Ruth started working for the new business from the outset. Stimulated by little Barbara, she guided Mattel towards a new production of toys and, more specifically, she developed the idea of a doll that resembled an adult. However, it took several years for the idea of a Barbie doll to actually come to life, and in the meantime, the stars of the forties paved the way for the new beauties of the fifties. Even Barbara Handler was no longer a child when, in 1956, while spending some time in Locarno, Switzerland, Ruth succeeded in shaping her vision of Barbie. This was thanks to her discovery of Lilli, a doll that had been produced in Germany from 1955 by the Hausser Elastolin company of Neustadt, designed by Max Weissbrodt and inspired by the main character in Reinhard Beuthin's comic strip, published in *Bild-Zeitung* from January 1952. Lilli was 29.5 centimeters tall, made of plastic, and sold together with her outfits, which could not be bought separately. She also looked rather like Brigitte Bardot. The Handlers bought the patent for the doll and the rights for the U.S. market. They took the three specimens they'd bought in Switzerland apart and studied them, analyzing every single technical and aesthetic detail, and they managed to perfect Ruth's original idea. It took more than two years of research by the engineer Jack Ryan, whose job at Mattel was to

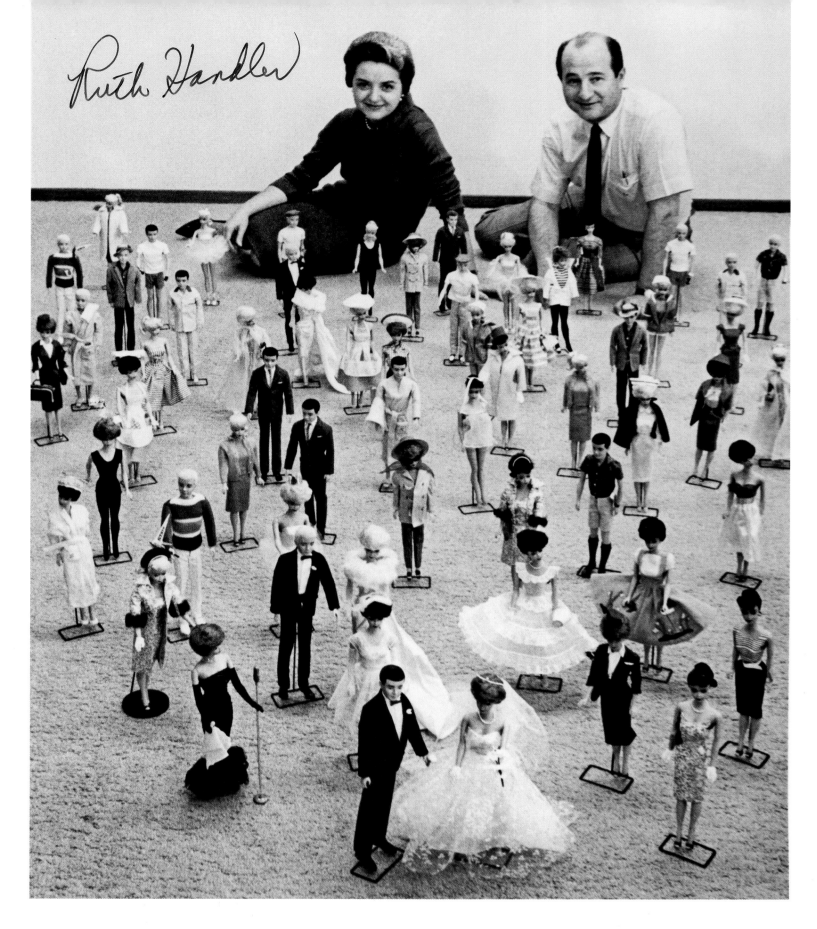

Ruth Handler

Above
Barbie's creator Ruth Handler and
her husband Elliot, co-founder
together with Harold Matson of
Mattel, and before them a collection
of historic Barbie dolls from the early
1970.

Opposite
Ruth and Elliot Handler with
a 1962 *Bubblecut* doll.
Ruth shows off her new hairstyle,
a teased bubblecut with bangs,
just like Barbie's.

On page 102
Barbara Millicent Roberts in the first
version of *Teen-Age Fashion Model*
(1959), this one with blonde hair,
a zebra-striped jersey swimsuit,
sunglasses, ponytail, and her
trademark high heels.

deal with the technical design, as well as to incorporate Ruth Handler's ideas. At long last Barbie was born! Barbara Millicent Roberts, named after the Handlers' daughter, was launched on the toy market on the occasion of the New York Annual Toy Fair on March 9, 1959, presented as a teenage fashion model. Barbie's debut was accompanied by an unprecedented TV advertising campaign, and in just a few months' time more than 351,000 dolls had been sold at three dollars each. The gorgeous outfits created for her wardrobe, in line with what was in fashion in Paris, Florence, and New York, were sold separately at prices that ranged from one to five dollars. It was from that moment on that the rules for young girls' play were revolutionized, and the biggest marketing phenomenon of the twentieth century was on its way.

Modern, free, liberated. A zebra-striped jersey swimsuit, sunglasses, earrings, a ponytail (*Ponytail* model), brunette or blonde with curly bangs and—needless to say—high heels. Heart-shaped red lips, side-glancing eyes, and severely arched eyebrows. Thus was the *#1 Teen-Age Fashion Model Barbie Doll* on her debut, and the world instantly found her to be a new icon, the ultimate interpreter of fifties elegance and taste. Barbie in the guise of a "teenage model" perfectly reflected the sophisticated charm of the most famous stars of the day, such as Marilyn Monroe, Elizabeth Taylor, Sandra Dee, but also of the models Dovima and Bettina. By calling her a "fashion model" it was clear that the idea was to transform her into a symbol of beauty, elegance, and style, and offer young girls a doll that looked like an adult woman, a combination of femininity and beauty. And indeed, in sixty-five years of life, Barbie has gone from being the model of a liberated, successful, and eclectic woman to an icon of contemporaneity—imitated, idolized, criticized and analyzed, collected, and transformed into a timeless work of art by Andy Warhol in 1986, and yet, at the same time, loyal to her day and age.

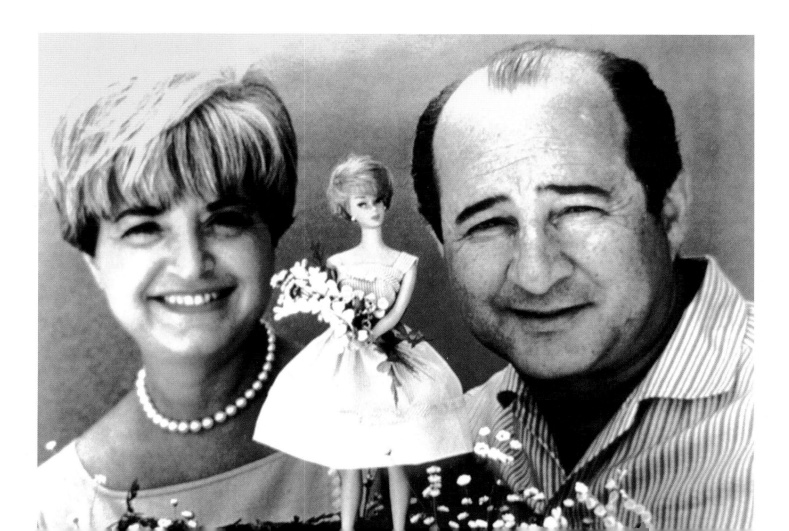

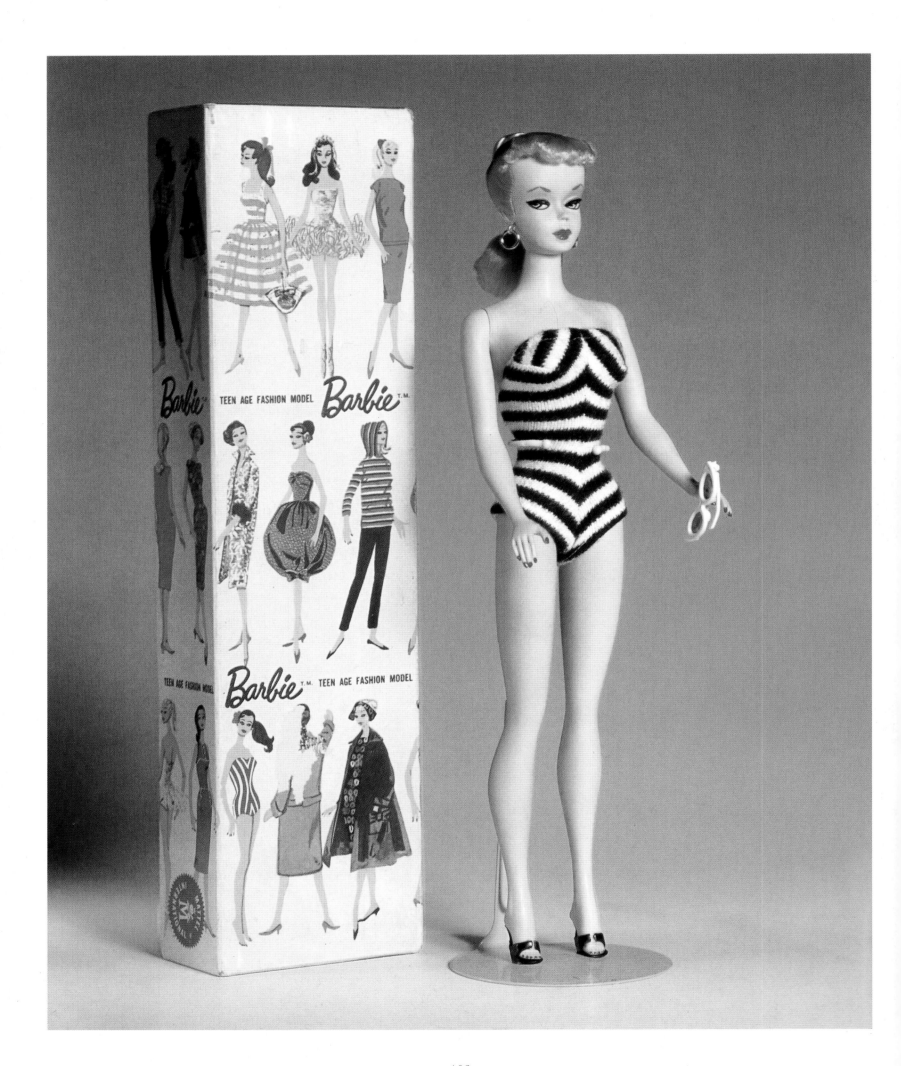

"

Barbie was never
just a doll;
above all she was
a mirror for our society,
evolving with it
continuously.

"

DONATELLA VERSACE
FASHION DESIGNER

Since 1959 Barbie has been renewed and transformed, and this is why she has continued to be the interpreter of taste and style in every historic period she has lived through as a leading figure. Barbie has become the interpreter of aesthetic and cultural transformations that have distinguished more than half a century of history, but unlike other myths of contemporaneity, crushed by time passing, she has had the privilege, as a doll, to be timeless as well, to cross distant eras and lands, thus reinforcing her status as a legend, and, above all, as a fashion icon and the voice of the people.

Barbie was born in March 9, 1959, in Willows, Wisconsin, where she attended Willows High School BARBIE'S REAL NAME IS BARBARA MILLICENT ROBERTS BARBIE IS 11.5 INCHES TALL The Barbie patent, registered in 1958, included the name *Barbie* written in italics and the words: Barbie TM Pats. Pend. © MCMLVIII By Mattel Inc. BARBIE MADE HER FIRST APPEARANCE WEARING HER FAMOUS BLACK-AND-WHITE ZEBRA-STRIPED SWIMSUIT AND PONYTAIL The first Barbie was sold for 3 dollars BARBIE HAS NEVER BEEN MARRIED BARBIE'S FIRST PET WAS A HORSE NAMED DANCER Barbie's first boyfriend, Ken, debuted two years after Barbie in 1961. Ken is two years and two days younger than Barbie *Some Barbie Collector dolls are made out of silkstone, a soft plastic that resembles porcelain* BARBIE IS THE ONLY DOLL TO HAVE A DEDICATED PANTONE COLOR: PMS 219 C In *The Simpsons* series the doll "Malibu Stacy" was inspired by Barbie BARBIE HAS BEEN A MUSE TO MANY ARTISTS OVER THE PAST 6 DECADES, INCLUDING ANDY WARHOL

fun facts

19₇6

dates

In 1976, on the occasion of the bicentennial of America's independence, Barbie is chosen, among other symbolic objects, for a TIME CAPSULE scheduled to be opened in 2076, so that our descendants will be able to see how their predecessors lived.

1989

Barbie enlists in the ARMED FORCES one year before the start of the Gulf War. The Pentagon's approval is required to guarantee the perfect reproduction of Barbie's military uniform. UNICEF is appointed official representative for children's rights, and Barbie is appointed UNICEF AMBASSADOR.

1992 2000 2004 2008 2012 2020

Barbie runs for PRESIDENT OF THE UNITED STATES.

2005

The GIRLSWEAR LINE *Barbie Loves Benetton* is created. Available in the Italian brand's points of sale are the items in the capsule collection that match eight dolls in the *Barbie Loves Benetton* series. Barbie wears outfits that are the miniature reproduction of the ones made for real girls.

2004

KEN AND BARBIE split up after 43 years. They get back together on February 14, 2011, and renew their relationship. They are still a couple today.

2001

Barbie.com is launched with an entirely female "Board of Administration." The website is literally catapulted into the universe of Internet celebrities.

20₀6

VALENTINO dresses 300 Barbie dolls on the occasion of the Life Ball of Vienna. For the occasion Barbie sports her iconic black-and-white dress designed by Valentino and worn by Julia Roberts on Oscar night 2001.

2009

In 2009, the year of Barbie's FIFTIETH BIRTHDAY, *Vogue Italia* dedicates its Black Barbie issue to her, now a rare edition and highly sought after by collectors. For her birthday Barbie meets three of the greatest names in design: Kartell, Bulgari, and FIAT 500.

VOGUE The Barbie ISSUE

2011

The *Barbie Loves Alitalia* collection pays tribute to the world's most famous fashion doll wearing the historic ALITALIA uniforms created by some of the greatest fashion designers (e.g., Sorelle Fontana, Delia Biagiotti, Tita Rossi, Mila Schön, Alberto Fabiani, Florence Marzotto, Renato Balestra, Giorgio Armani, Mondrian-Gruppo Nadini).

2008

Barbie launches a collection of ECO-FRIENDLY girls' accessories.

2015

Barbie becomes #BESUPER and invites her young fans to grow up to become superheroines, because for Barbie the sky's the limit.

2014

Barbie is chosen as GLAMOUR ICON by *Sports Illustrated* USA for its fiftieth anniversary campaign. Barbie is pictured wearing the historic striped swimsuit that made her famous from the day of her debut in 1959.

numbers

140 countries where Barbie is sold

More than

1 BILLION

THE NUMBER OF BARBIES SOLD

since 1959

27,450 dollars

the added value of the **original #1 Barbie made in 1959**, in mint condition and sold at a Sandi's Doll Attic auction in May 2006

different nationalities represented by Barbie

50

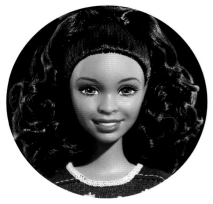

 31 top-selling DVD

movies in which Barbie played the lead character

1 BILLION the number of outfits produced since 1959 for Barbie and her friends

Millions of Barbie dolls **SOLD EACH YEAR** around the world

More than **100**
FASHION DESIGNERS
who have dressed Barbie

1,000
Barbie-inspired YouTube channels

⦿⦿ **5,000**
the number of GOLDEN HAND-SEWN SEQUINS for the 1991 *Bob Mackie Golden Barbie*

More than 150

COLLECTIONS
OF INTERNATIONAL BRANDS
INSPIRED BY BARBIE

1 billion
THE NUMBER OF PAIRS OF SHOES OWNED BY BARBIE

980 million meters

of fabric used to make outfits for Barbie and her friends, which makes Mattel one of the biggest clothing manufacturers in the world

 Barbie, the #1 girls' toy brand globally

 SEARCH RESULTS PRODUCED BY GOOGLING THE WORD "BARBIE"

 351,000 Barbie dolls sold in 1959 at the price of 3 dollars

100 people

designers, seamstresses, patternmakers, and fashion designers required to make a single outfit and look for Barbie

15 artists who work on a single Barbie using water-based acrylics and tiny sable-hair paintbrushes

12 average number of Barbie dolls owned by **girls between the ages of 3 and 6**

THE NUMBER 1

Totally Hair Barbie, created in 1992, is currently the highest-selling Barbie

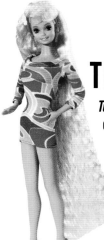

more than **300** different careers undertaken by Barbie

 BARBIE THE MOVIE (2023)

grossed **1 billion 418.4 million dollars** in the first two months of release, becoming the 14th highest-grossing film of all time

 99% percentage of young girls ages 3 to 10 who have owned at least one Barbie

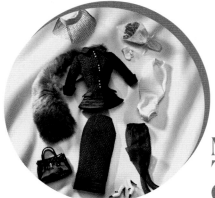

50 pets including dogs, horses, ponies, cats, and a parrot that Barbie has owned

MORE THAN 120 OUTFITS created each year for Barbie's wardrobe

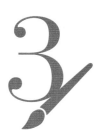 **3** facial restylings for Barbie since 1959: in 1967, 1977, and 1998

Style
Icon

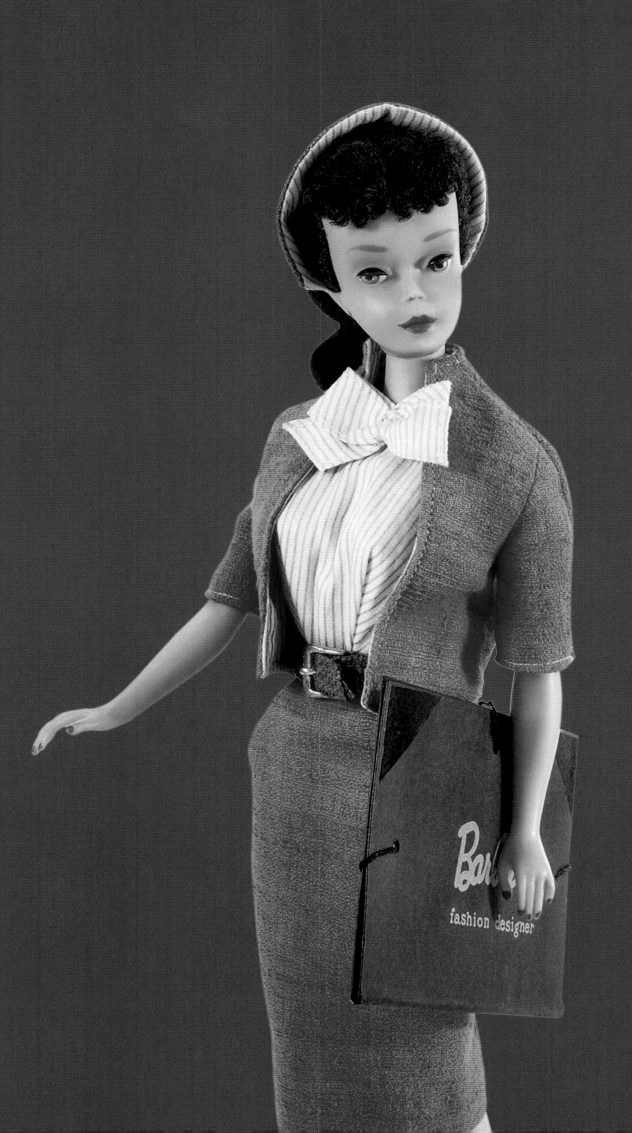

Barbie's legendary hair, made from synthetic fiber.

Previous page
Barbie pictured as *Fashion Editor* (1960).

" Barbie is
a glamour icon with
an endless wardrobe,
a dream house and lots
of cute friends.
What's not to love? "

PETER SOM
FASHION DESIGNER

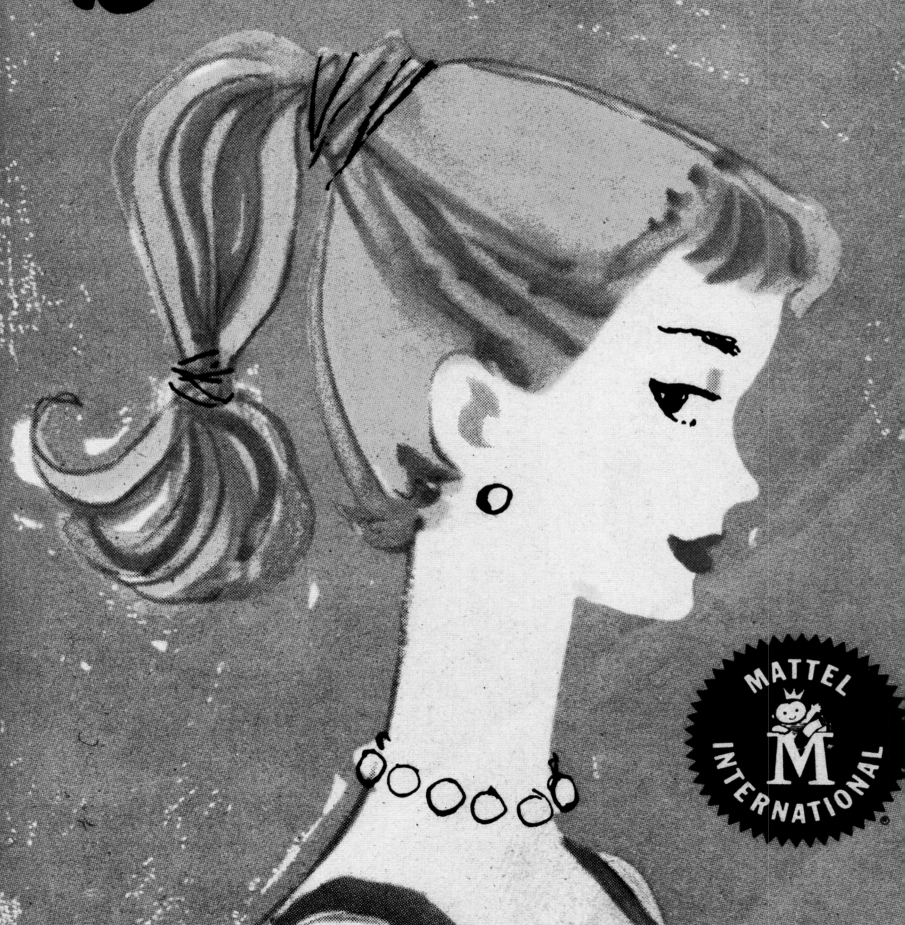

Barbie is above all else a style icon, and this was clear from the very first moment she appeared as a *Teen-Age Fashion Model* and, a year later, as *Fashion Editor* (1960).

Her huge success was instantly linked to the chance to separately buy the outfits that were sewn each year for her wardrobe, offering young girls the freedom to create new combinations and endless styles. Since 1959 some of the creations worn by Barbie have been so in line with the new international aesthetic trends that they have represented a full-fledged miniature taste of the evolution in fashion and style in the years that saw the predominance of French haute couture, the international affirmation of the Italian look, and the birth of American and British ready-to-wear fashion.

From the mid-sixties onwards, the style introduced by Barbie was the perfect combination of the fifties "economic miracle" represented in the fashion world by a sequence of trends and figures that marked the birth of a new aesthetic. It all started with Christian Dior, who, on February 12, 1947, launched his first collection, dubbed the *New Look* by Carmel Snow, the editor of *Harper's Bazaar*, owing to its outstanding elegance and the lavish fabrics that were used, the idea being to help people cast aside their war memories. The triumph of Dior—who was the first to understand the importance of the press and the media as an instrument that could

be used to promote high fashion—was followed by a new generation of talent that brought the center of international attention to Parisian haute couture, from Pierre Cardin to Hubert de Givenchy and Yves Saint Laurent. In the meantime, Maison Chanel reopened in 1954 after being closed for fifteen years. Italy had already responded to this wave of French creativity in 1951 when the historic fashion show organized by Giovanni Battista Giorgini was held at Villa Torrigiani, officially sanctioning the birth of Italian high fashion, as well as the talents of such designers as Fabiani, Marucelli, Schubert, Sorelle Fontana, Capucci, and, at the end of the decade, Valentino. In 1951 Bettina Ballard, fashion editor of *Vogue* America, had this to say: "I have some excellent news. Everybody seems interested in Italian fashion, alongside *Vogue*. I am sure we will be doing something together in the short term."

Three fashions worn by Barbie for her debut best sum up the cultural and aesthetic changes in the fifties: France's post-war reaffirmation of its place as the pinnacle of elegance (*Gay Parisienne*); Italy as it looks out at the rest of her world with new destructured models, modern in style, and using only the finest fabrics (*Roman Holiday*); American taste dominated by the bold use of color and decidedly sophisticated lines (*Evening Splendor*).

Gay Parisienne (1959) transformed Barbie into a Parisian woman with a bubble-skirt dress inspired

by the sartorial line that had been launched by Hubert de Givenchy in 1956; Barbie's two-piece suit in *Commuter Set* (1959) seemed like something right out of Madame Coco Chanel's atelier; while *Roman Holiday* (1959) immortalized Barbie in an outfit reminiscent of the ones designed by Emilio Schubert and Sorelle Fontana, the leading names in Italy's new *couture*.

Also in 1959 Yves Saint Laurent introduced his *Long Line Natural Figure* collection for Maison Dior in Paris, a success that followed hard on the heels of the designer's first revolutionary *Trapeze* collection in 1958, launched after Christian Dior passed away. In 1959 in Rome, Valentino opened his own atelier, while Irene Galitzine debuted with her first collection and, already the following year, became famous for her Palazzo Pajamas, worn and made famous in the rest of the world by Diana Vreeland.

Between 1959 and 1970 the outfits conceived for Barbie's wardrobe by the fashion designers at Mattel, Charlotte Johnson and Carol Spencer, were a direct tribute to the fashion created in Paris,

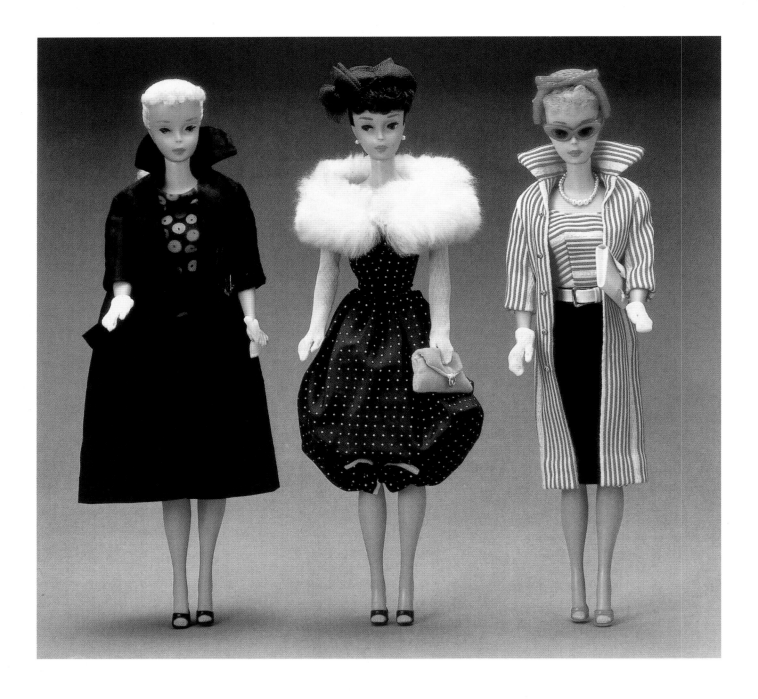

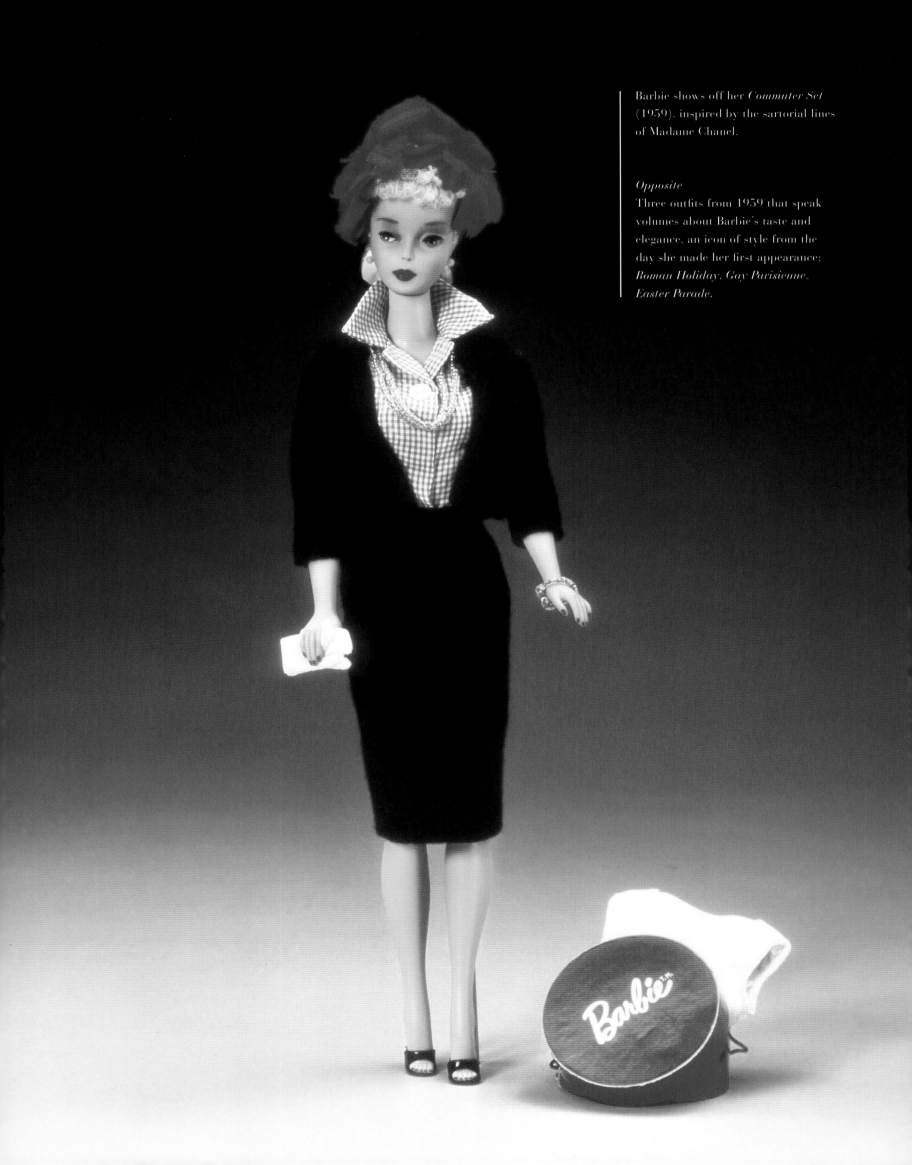

Barbie shows off her *Commuter Set* (1959), inspired by the sartorial lines of Madame Chanel.

Opposite
Three outfits from 1959 that speak volumes about Barbie's taste and elegance, an icon of style from the day she made her first appearance: *Roman Holiday, Gay Parisienne, Easter Parade.*

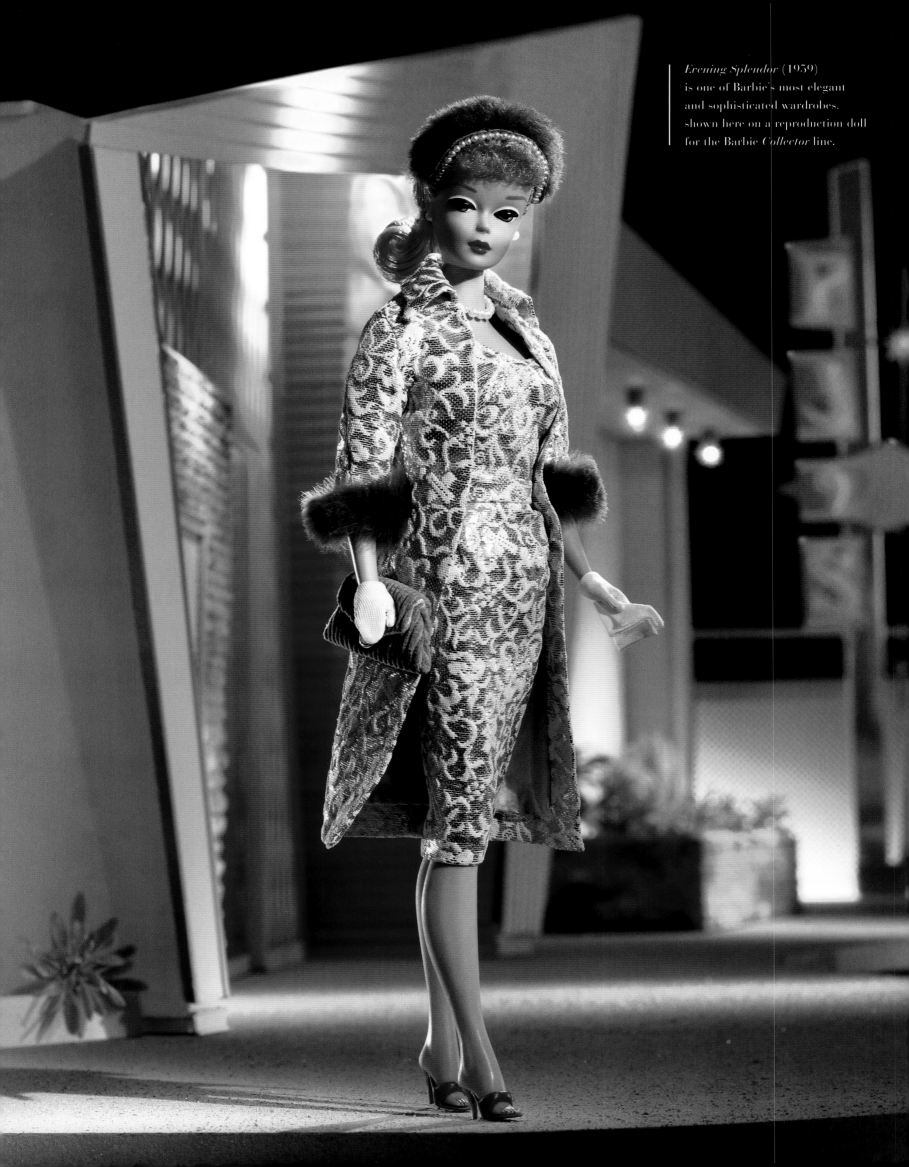

Rome, Florence, New York, and London, in some cases with an eye towards the fifties styles, which meant that there could be a difference of as much as five to ten years between the original model and the Barbie outfit. Points of reference for Mattel's designers were Dior, Givenchy, Chanel, Balenciaga, and, later, Pucci and Mary Quant. For Barbie's *Formal Evening Wear* inspiration also came from the spectacular creations of some of Hollywood's most famous costume designers, from Helen Rose to Edith Head to Irene, worn on the silver screen by Grace Kelly, Lana Turner, Audrey Hepburn, and Doris Day. *Plantation Belle* (1959) is clearly a tribute to the wardrobe designed by Helen Rose for Grace Kelly in *High Society* (1956): a zip-up garden party dress with a three-tiered skirt decorated with nylon flowers, a tasteful flat lace hat, white gloves, earrings, graduated pearl necklace, and sandals. Grace Kelly's elegance, immortalized in *Life* magazine on January 16, 1956, is again a model for Barbie's *Enchanted Evening* (1960) outfit: a figure-hugging evening gown in pink satin with a train, a fur stole, triple-strand pearl choker, and pearl drop earrings. For *Sweater Girl* (1959), in which Barbie wears a woolen sweater and a tweed skirt, the inspiration seems to come from the American movie style best represented by Doris Day and Lana Turner, also a model for the famous *Evening Splendor* (1959) outfit, a gold brocade coat with fur trimming, turquoise satin lining, corduroy purse, short white gloves, a strand of pearls and matching stud earrings.

The year Barbie debuted she had sixteen outfits in her wardrobe, from formal cocktail wear to evening wear, from casual clothes that could even be worn in the kitchen to an outfit perfect for excursions and picnics, and, lastly, a bridal gown. And Barbie's fashion collection continued to grow each year, with the addition of six new models in 1960, eight in 1961, and eight more in 1962.

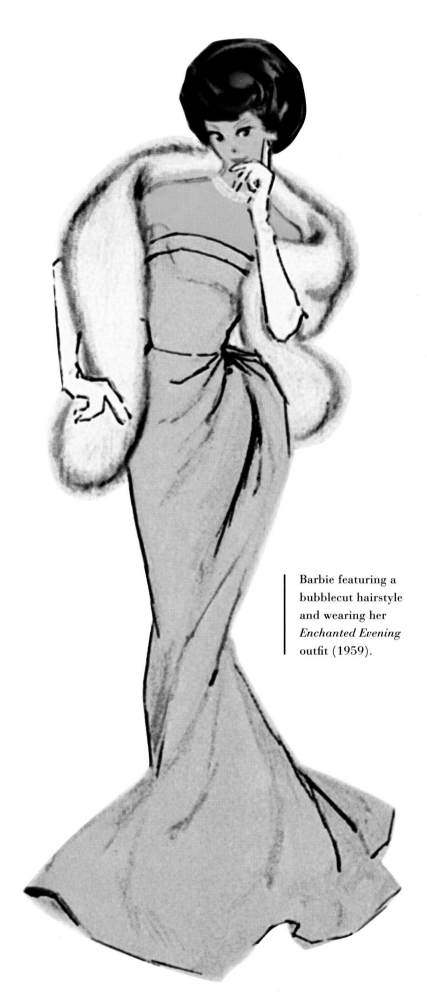

Barbie featuring a bubblecut hairstyle and wearing her *Enchanted Evening* outfit (1959).

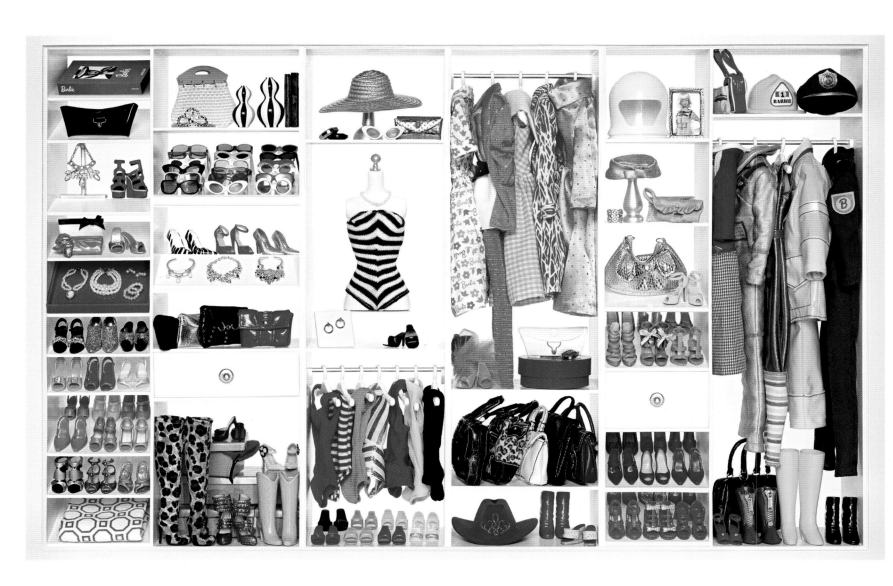
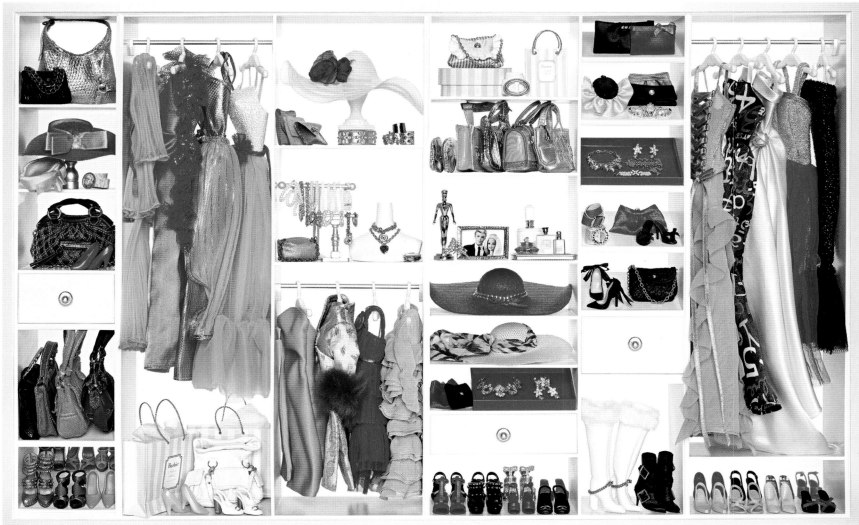

fashion

Barbie's vast wardrobe, consisting of outfits, accessories, shoes, and a countless number of uniforms, has characterized the 300 careers she has had since 1959.

Creating very detailed outfits for Barbie fully reflects the creative process and the packaging typical of the most prestigious *maisons* in the world, especially between 1959 and 1970. Just like their colleagues in Paris, Milan, and New York, Barbie's fashion designers created models of new clothing concepts, which were basted together using muslin and rubber mannequins the same size as Barbie. After several "tests" carried out by the patternmakers, the prototypes for the definitive model were born. Each outfit could be submitted to different variations before the final version was created, after which it was handed over to the hundreds of seamstresses. Not even the tiniest mistake was allowed! A seam that was just a millimeter off would be calamitous in an outfit worn by Barbie. And no look was complete without just the right accessories. Everything, from earrings to shoes, was designed by hand and carved in wax to create 3-D models.

Once the head designer had given his or her seal of approval, the accessories were produced and then worn by Barbie. Each outfit created for Barbie is signed with a fabric label that reads Barbie ® / © by Mattel, thereby guaranteeing the very detailed finishings, hems, linings, zippers, and buttons. To solve the problem of the difficulty sourcing miniature zippers and buttons, Mattel founded a company in Japan called YKK (managed by Yoshida Kogyo), which specialized in the production of small-scale accessories.

collection

1959

#OUTFITS

CRUISE STRIPE DRESS #918

Scoop neck top of novelty rib cotton stripe, contrasting sheath skirt. Plastic patent belt. Back zipper closing. Open-toe pumps.

ROMAN HOLIDAY SEPARATES #968

Smart ensemble of dress (same style as #918) and matching cotton rib-stripe travel coat. Complete with straw half-hat, pearl necklace, white gloves, shoes, white purse with glasses and case.

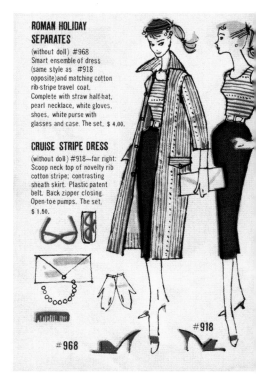

ROMAN HOLIDAY SEPARATES
(without doll) #968
Smart ensemble of dress (same style as #918 opposite) and matching cotton rib-stripe travel coat. Complete with straw half-hat, pearl necklace, white gloves, shoes, white purse with glasses and case. The set, $ 4.00.

CRUISE STRIPE DRESS
(without doll) #918—far right: Scoop neck top of novelty rib cotton stripe; contrasting sheath skirt. Plastic patent belt. Back zipper closing. Open-toe pumps. The set, $ 1.50.

#968 #918

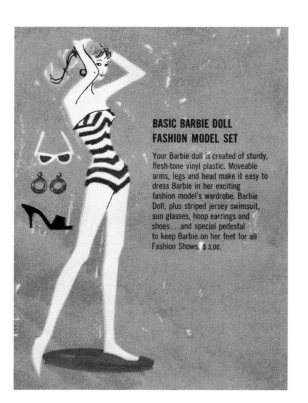

BASIC BARBIE DOLL FASHION MODEL SET

Your Barbie doll is created of sturdy, flesh-tone vinyl plastic. Moveable arms, legs and head make it easy to dress Barbie in her exciting fashion model's wardrobe. Barbie Doll, plus striped jersey swimsuit, sun glasses, hoop earrings and shoes... and special pedestal to keep Barbie on her feet for all Fashion Shows. $ 3.00.

BASIC BARBIE DOLL FASHION MODEL SET

Your Barbie doll is created of sturdy flesh-tone vinyl plastic. Moveable arms, legs and head make it easy to dress Barbie in her exciting fashion model's wardrobe. Barbie Doll, plus striped jersey swimsuit, sunglasses, hoop earrings and shoes... and special pedestal to keep Barbie on her feet for all Fashion Shows.

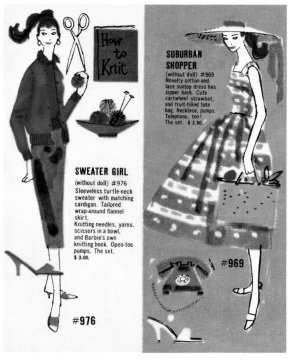

SWEATER GIRL
(without doll) #976
Sleeveless turtle-neck sweater with matching cardigan. Tailored wrap-around flannel skirt. Knitting needles, yarns, scissors in a bowl, and Barbie's own knitting book. Open-toe pumps. The set, $ 3.00.

SUBURBAN SHOPPER
(without doll) #969
Novelty cotton-and-lace suntop dress has zipper back. Cute cartwheel strawhat, and fruit-filled tote bag. Necklace, pumps. Telephone, too! The set, $ 2.50.

#969 #976

SWEATER GIRL #976

Sleeveless turtleneck sweater with matching cardigan. Tailored wrap-around flannel skirt. Knitting needles, yarn, scissors in a bowl, and Barbie's own knitting book. Open-toe pumps.

SUBURBAN SHOPPER #969

Novelty cotton-and-lace sundress has zipper back. Cute cartwheel straw hat and fruit-filled tote bag. Necklace, pumps. Telephone, too!

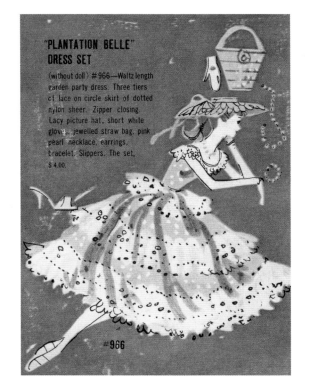

PLANTATION BELLE #966

Waltz-length garden party dress. Three tiers of lace on circle skirt of dotted nylon sheer. Zipper closing. Lacy picture hat, short white gloves, jewelled straw bag, pink pearl necklace, earrings, bracelet. Slippers.

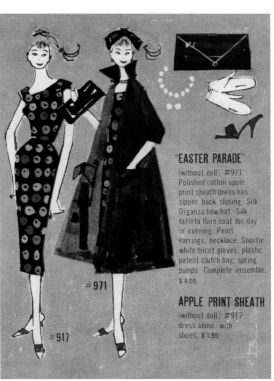

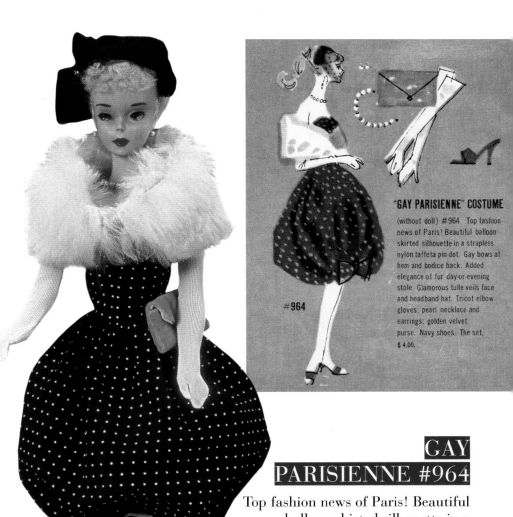

EASTER PARADE #971

Polished cotton apple print sheath dress has zipper back closing. Silk organza bow hat. Silk taffeta flare coat for day or evening. Pearl earrings, necklace. Short white tricot gloves, plastic patent clutch bag, spring pumps.

APPLE PRINT SHEATH #917

Dress alone, with shoes.

GAY PARISIENNE #964

Top fashion news of Paris! Beautiful balloon skirted silhouette in a strapless nylon taffeta pin-dot. Gay bows at hem and bodice back. Added elegance of fur day-or-evening stole. Glamorous tulle veils face and headband hat. Tricot elbow gloves, pearl necklace and earrings, golden velvet purse. Navy shoes.

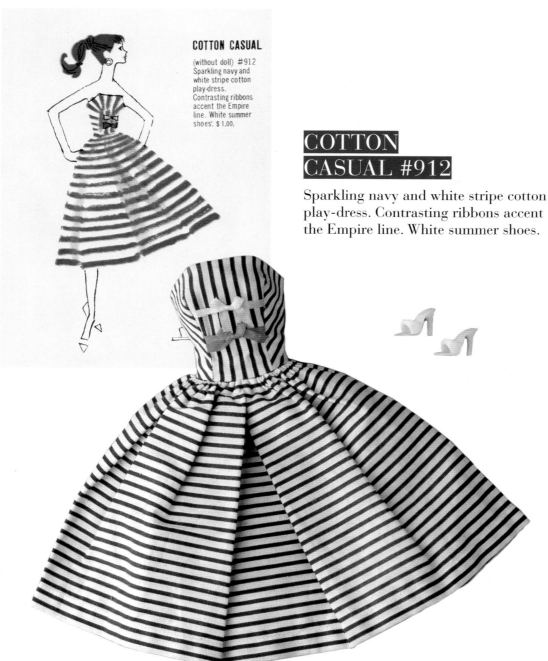

COTTON CASUAL #912

Sparkling navy and white stripe cotton play-dress. Contrasting ribbons accent the Empire line. White summer shoes.

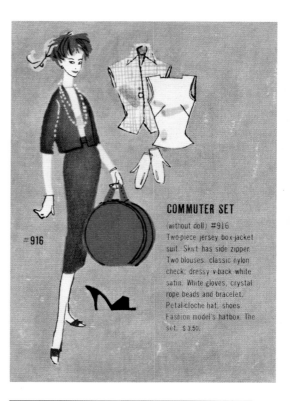

COMMUTER SET #916

Two-piece jersey box-jacket suit. Skirt has side zipper. Two blouses: classic nylon check, dressy v-back white satin. White gloves, crystal rope beads and bracelet. Petal-cloche hat, shoes. Fashion model's hatbox.

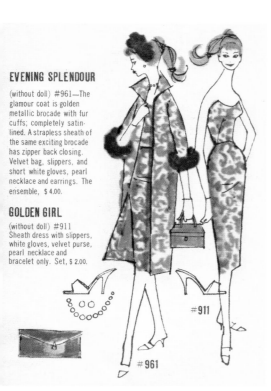

EVENING SPLENDOR #961

The glamour coat is golden metallic brocade with fur cuffs, completely satin-lined. A strapless sheath of the same exciting brocade has zipper back closing. Velvet bag, slippers, and short white gloves, pearl necklace and earrings.

GOLDEN GIRL #911

Sheath dress with slippers, white gloves, velvet purse, pearl necklace and bracelet only.

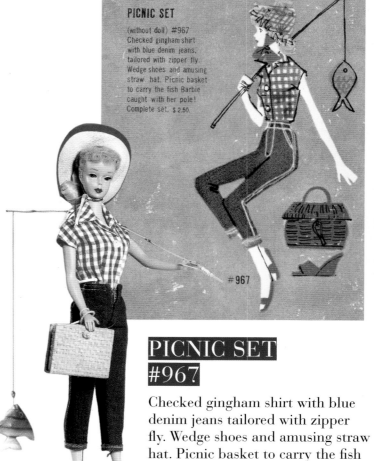

PICNIC SET #967

Checked gingham shirt with blue denim jeans tailored with zipper fly. Wedge shoes and amusing straw hat. Picnic basket to carry the fish Barbie caught with her pole!

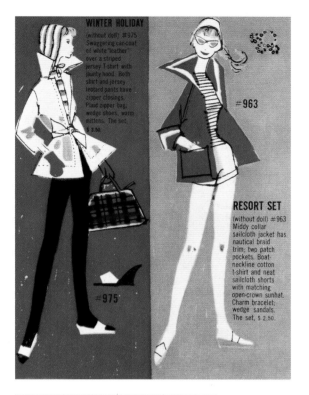

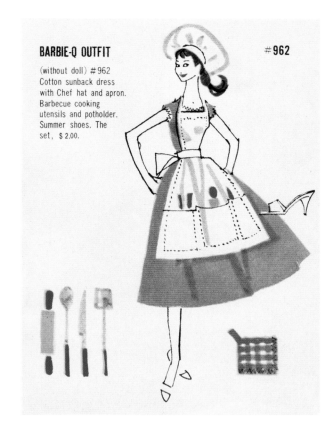

BARBIE-Q OUTFIT #962

Cotton sunback dress with Chef hat and apron. Barbecue cooking utensils and potholder. Summer shoes.

RESORT SET #963

Middy collar sailcloth jacket has nautical braid trim; two patch pockets. Boat-neckline cotton t-shirt and neat sailcloth shorts with matching open-crown sunhat. Charm bracelet, wedge sandals.

WINTER HOLIDAY #975

Swaggering car-coat of white "leather" over a striped jersey t-shirt with jaunty hood. Both shirt and jersey leotard pants have zipper closings. Plaid zipper bag; wedge shoes, warm mittens.

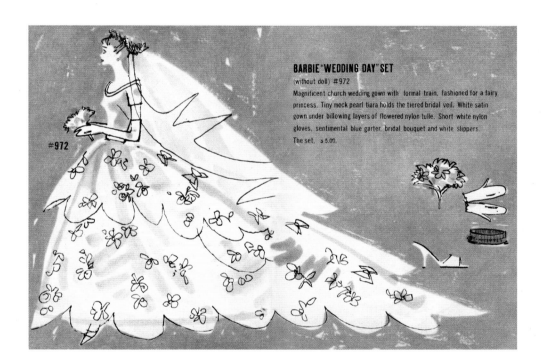

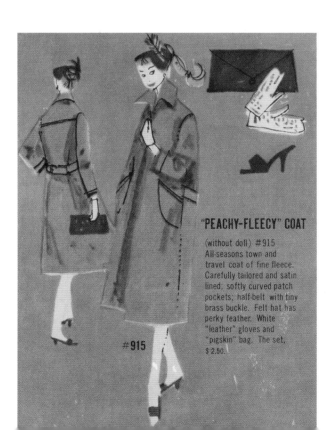

WEDDING DAY SET #972

Magnificent church wedding gown with formal train, fashioned for a fairy princess. Tiny mock pearl tiara holds the tiered bridal veil. White satin gown under billowing layers of flowered nylon tulle. Short white nylon gloves, sentimental blue garter, bridal bouquet and white slippers.

"PEACHY-FLEECY" COAT #915

All-seasons town and travel coat of fine fleece. Carefully tailored and satin lined; softly curved patch pockets, half-belt with tiny brass buckle. Felt hat has perky feather. White "leather" gloves and "pigskin" bag.

#LINGERIE SETS

FLORAL PETTICOAT #921

Crisp nylon sheer petticoat, all-over embroidered with pastel floral design and matching panties. Strapless bra, vanity mirror, comb, brush set.

FLORAL PETTICOAT

(without doll) #921 Crisp nylon sheer petticoat, all-over embroidered with pastel floral design and matching panties. Strapless bra, vanity mirror, comb, brush set. Complete. $1.25.

FASHION UNDERGARMENTS

(without doll) #919 Tricot half-slip has fluted flounce to match panties. Embroidered tricot girdle and strapless bra. The set, $1.00.

"SWEET DREAMS"

(without doll) #973 Novelty tricot Baby Doll gown and panties trimmed with embroidery and satin bows. Hair bow to match. Pastel bedroom scuffs. Plus Barbie's "Dear Diary" book, her apple-a-day, and alarm clock to wake her in the morn! Complete set. $1.25.

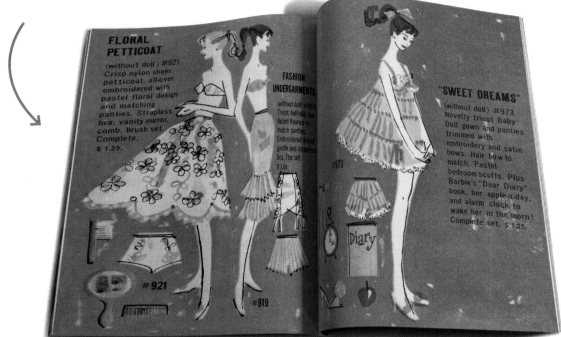

SWEET DREAMS #973

Novelty tricot Baby Doll gown and panties trimmed with embroidery and satin bows. Hair bow to match. Pastel bedroom scuffs. Plus Barbie's "Dear Diary" book, her apple-a-day, and alarm clock to wake her in the morn!

FASHION UNDERGARMENTS #919

Tricot half-slip has fluted flounce to match panties. Embroidered tricot girdle and strapless bra.

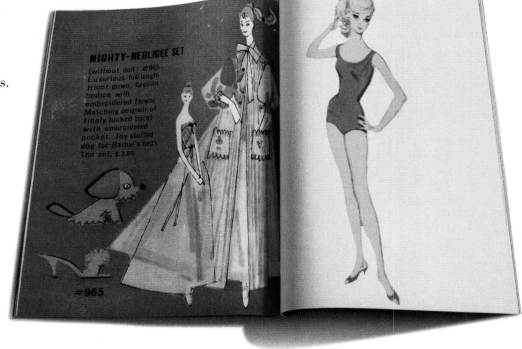

NIGHTY-NEGLIGEE SET

(without doll) #965 Luxurious full-length tricot gown. Grecian bodice with embroidered flower. Matching peignoir of finely tucked tricot with embroidered pocket. Toy stuffed dog for Barbie's bed! The set, $3.00.

NIGHTY-NEGLIGEE SET #965

Luxurious full-length tricot gown. Grecian bodice with embroidered flower. Matching peignoir of finely tucked tricot with embroidered pocket. Toy stuffed dog for Barbie's bed.

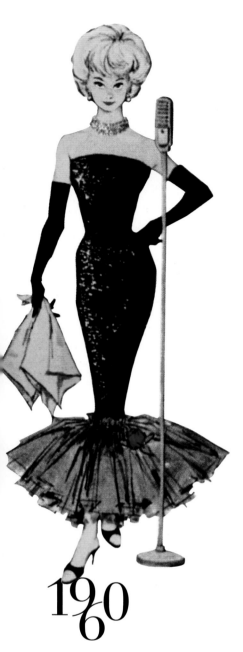

FRIDAY NITE DATE #979

Powder blue corduroy jumper with colorful felt appliqués. White blouse and bouffant pettiskirt. Black plastic shoes. Two plastic Coke tumblers with serving tray and drinking straws.

ENCHANTED EVENING #983

Formal floor-length gown with flowing train in the elegance of pink satin. Triple-strand pearl choker and drop earrings. Pink dancing pumps with silver glitter. White tricot elbow-length gloves. White fur stole.

1961

SHEATH SENSATION #986

Fashionable sheath dress in fireman-red cotton has 4 gold buttons and 2 deep pockets. Crisp white straw hat, gloves, and white shoes make dazzling accessories.

1962

AFTER FIVE #934

Princess-style dress made of black faille with white organdy portrait collar, button accent on bodice. Organdy picture hat with black velvet ribbon and black shoes.

RED FLARE #939

Luscious red velvet ensemble. Flared coat with bell sleeves and white satin lining. Matching pillbox hat, purse, long white gloves, and red shoes.

1963

SOPHISTICATED LADY #993

Romantic rose taffeta ball gown with silver filigree lace trim on bodice and drape of skirt. Silver tiara, long white gloves, pink pearls, and evening slippers. Fitted American Beauty dark rose velveteen evening coat, lined to match gown has dainty silver buttons.

CAREER GIRL #954

Classic two-piece tweed suit with red sleeveless shell. Hat matches suit, sparked with red rose. Black elbow-length gloves and black open-toe heels.

1964

BLACK MAGIC ENSEMBLE #1609

Magic for after-dark in the city! Black sheath dress with tulle evening cape. Accessories include black gloves, black shoes, and gold purse.

1967

INTRIGUE #1470

Turtleneck knit with zipper plus "Gold-Fingered" trench coat!

STRIPES AWAY #1775

Hot stripes stretch from top to bottom on this chic sheath with matching scarf. Ring bracelets.

1968

JUMP INTO LACE #1823

Taffeta-lined hostess party pajamas with lace all over.

1971

LIVE ACTION P. J. #1156

Buttoned vest with floor-length fringe covers up delightful mini-dress and high boots.

1960

SOLO IN THE SPOTLIGHT #982

Dramatic black glitter-gown with bare shoulders and rose corsage on nylon net flounce. Long black nylon tricot gloves. Pink chiffon scarf and bead necklace. Black plastic open-toe heels. Plastic microphone.

iconic outfits
1960-1971

1957

CHARLOTTE JOHNSON

1959

DOROTHY SHUE

1960

AILENE ZUBLIN
ELLA BROWN
KAY CARTER

1963

CAROL SPENCER

1969

JUDITH CURTIS

1972

KEITH HODGES

1974

JANET GOLDBLATT

1976

KITTY BLACK PERKINS

1980

ABBY LITTLETON

1989

CYNTHIA YOUNG

1990

NORA HARRI-TREZONA
ANN DRISKILL
SHARON ZUCKERMAN
ANNE BRAY

1993

HEATHER FONSECA

1994

PAT CHAN
CAROLINE DEMERSSEMAN

1995

ROBERT BEST

1996

KATIANA JIMENEZ
STACEY MCBRIDE-IRBY

1997

BILL MARTINEZ

1998

ERIKA KANE
LILY MARTINEZ

1999

BILL GREENING

2003

LINDA KYAW

2007

CARLYLE NUERA
JUDY CHOI

2010

CARLYE NUERA
SUIM NOH

2012

JAVI MEABE

2017

ANGEL KENT

MATTEL
fashion
designers

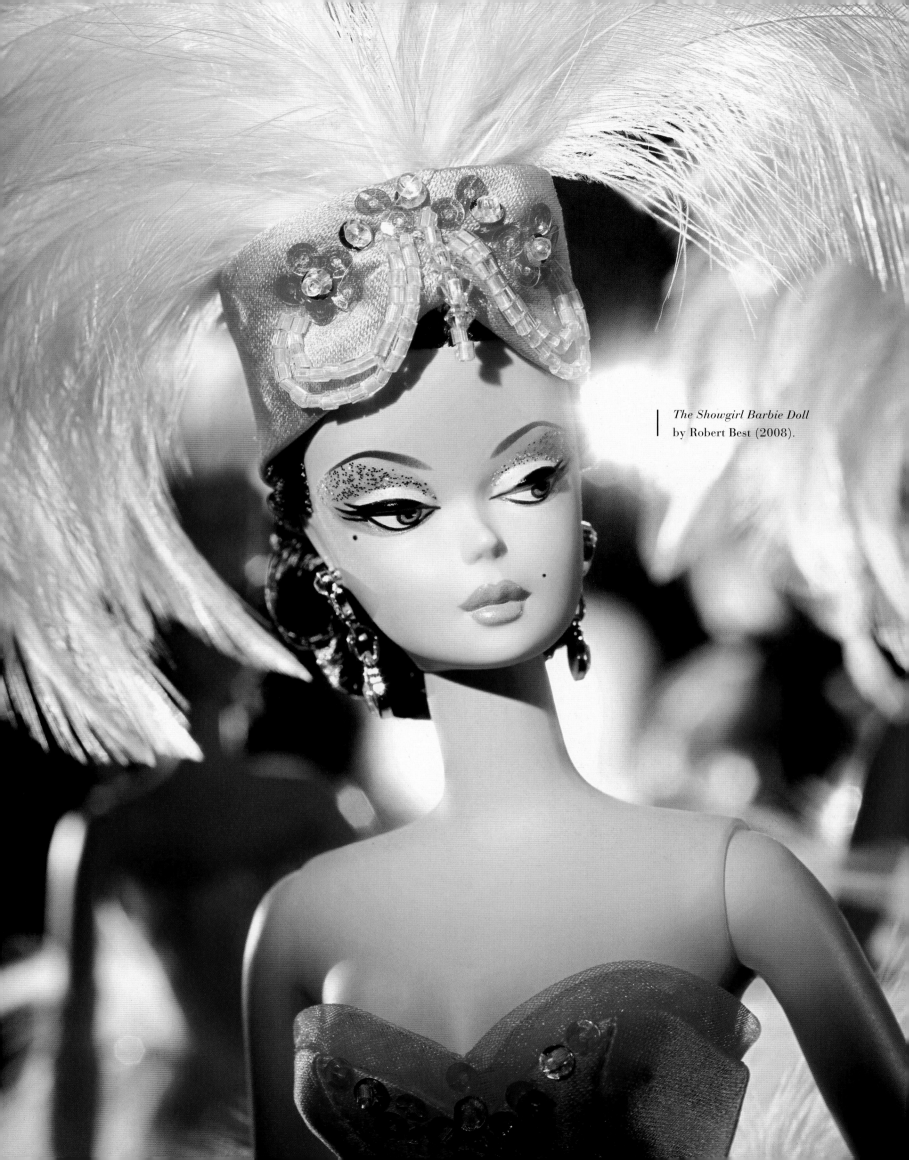

The Showgirl Barbie Doll
by Robert Best (2008).

INTERNATIONAL
fashion designers

1995
DONNA KARAN

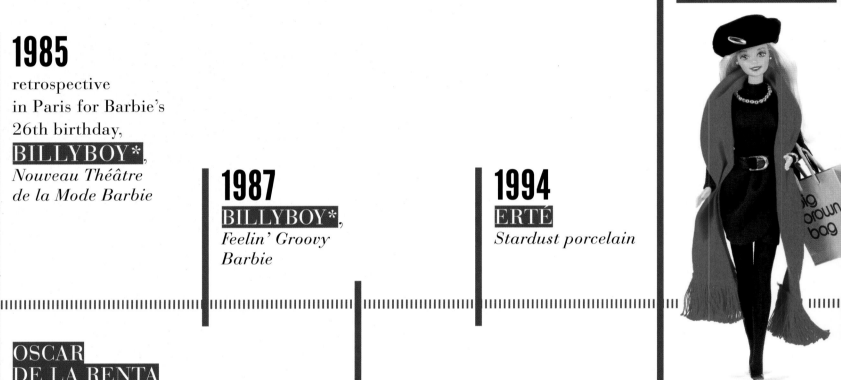

1985
retrospective
in Paris for Barbie's
26th birthday,
BILLYBOY*,
*Nouveau Théâtre
de la Mode Barbie*

1987
BILLYBOY*,
*Feelin' Groovy
Barbie*

1994
ERTÉ
Stardust porcelain

OSCAR
DE LA RENTA
four outfits

1991
BENETTON

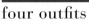

1995, 1997
DIOR

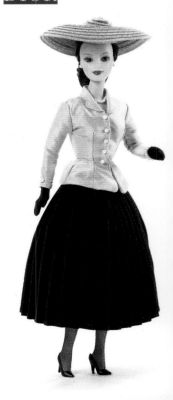

1996

ERTÉ
unnamed silver model and black porcelain

RALPH LAUREN

1997

BILL BLASS

NOLAN MILLER
Sheer Illusion Barbie Doll

1998, 1999, 2008, 2011

VERA WANG

1998

VIVIENNE WESTWOOD
Life Ball Limited Edition

OSCAR DE LA RENTA

CALVIN KLEIN

ESCADA

1999

YUMI MATSUTOYA

INTERNATIONAL
fashion designers

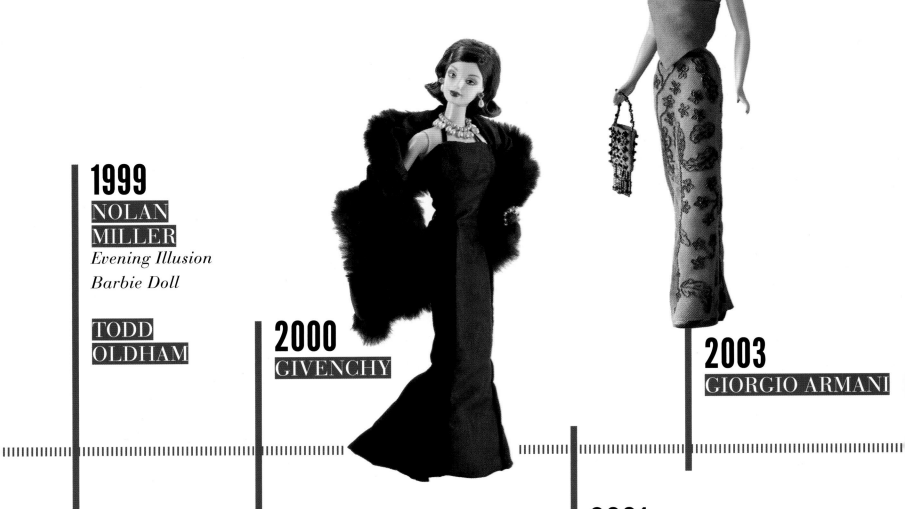

1999

NOLAN
MILLER

*Evening Illusion
Barbie Doll*

TODD
OLDHAM

2000
GIVENCHY

2003

GIORGIO ARMANI

CHRISTIAN
LACROIX

*Life Ball
Limited Edition*

NOLAN MILLER

Evening Illusion Barbie Doll

BELLY BUTTON

2001

KATE SPADE

two outfits

BURBERRY

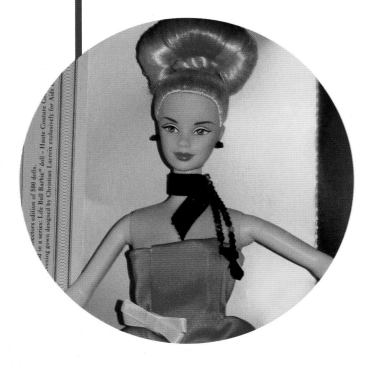

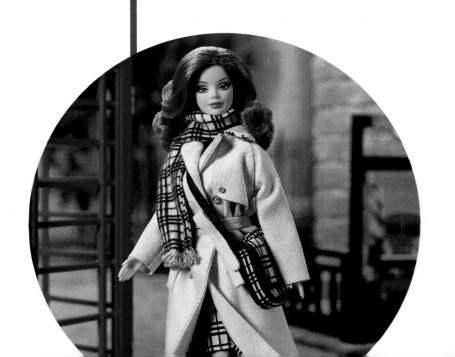

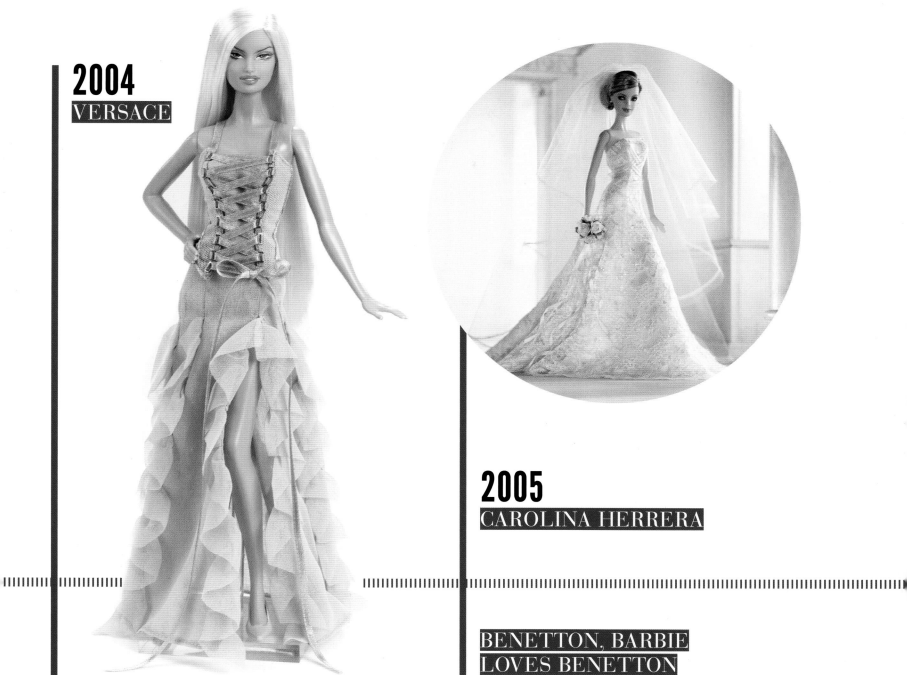

2004
VERSACE

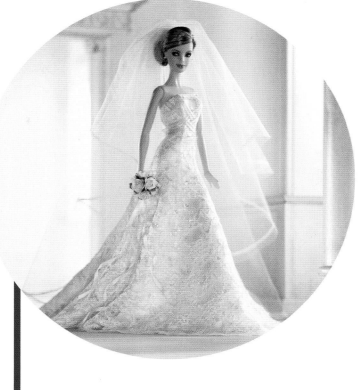

2005
CAROLINA HERRERA

VERSACE VERSUS

BENETTON, BARBIE LOVES BENETTON
eight dolls: Paris, London, New York, Beijing, Osaka, Stockholm, Melbourne, St. Tropez

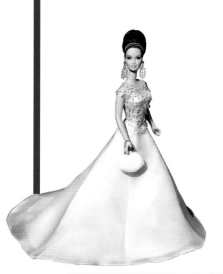

BADGLEY MISCHKA
Bride Barbie Doll

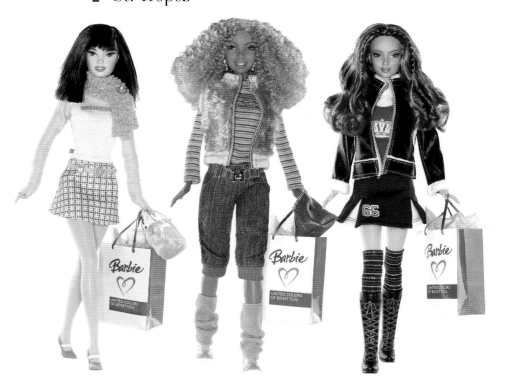

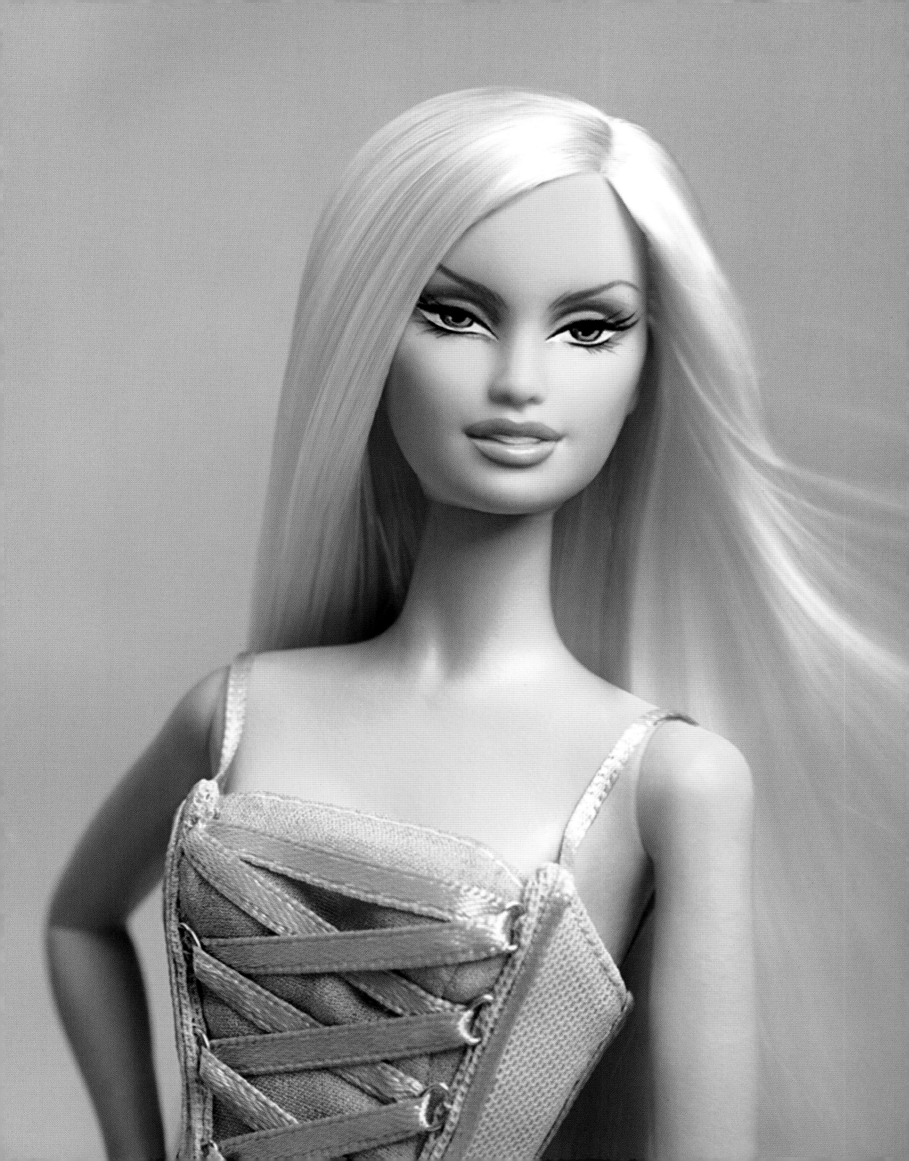

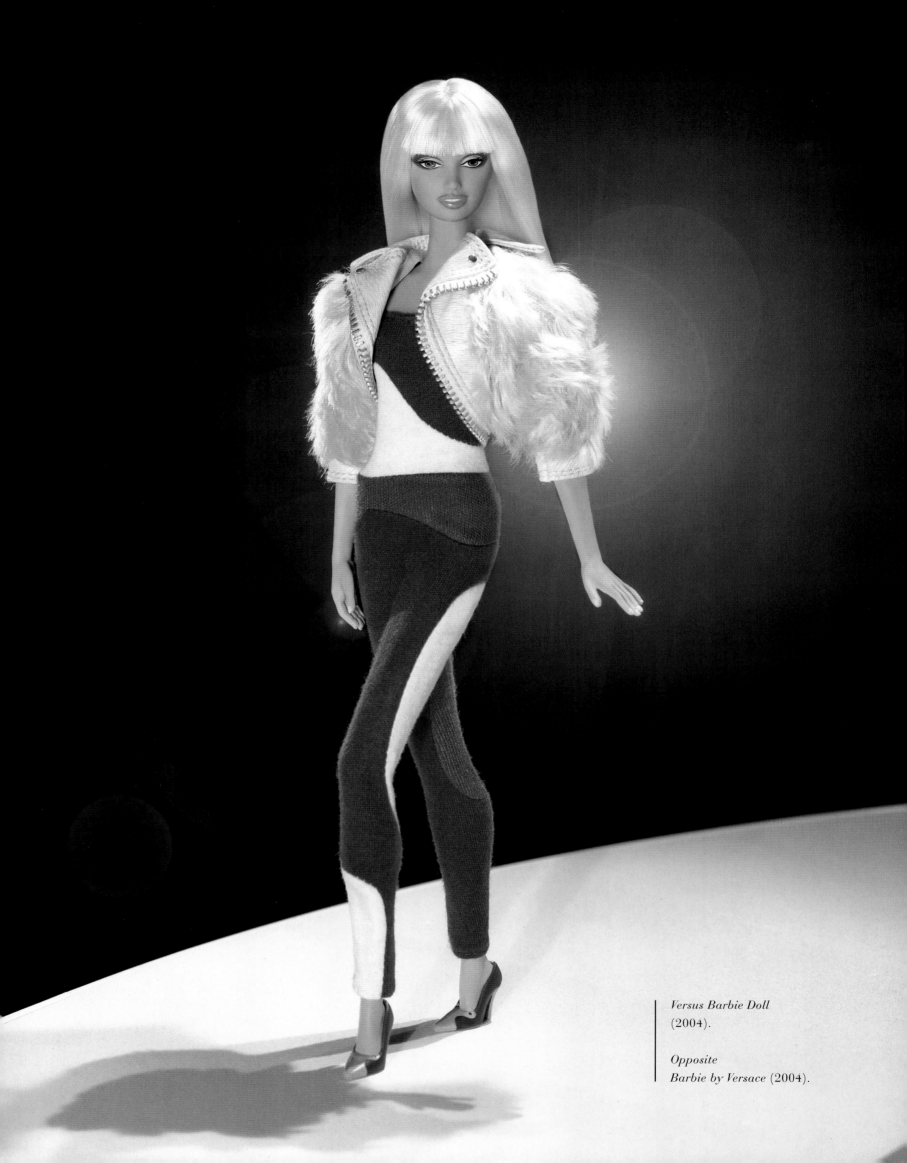

INTERNATIONAL
fashion designers

> " I started dressing
> Barbie dolls with my own
> designs at an early age. "

ANNA SUI,
fashion designer

2007
REEM ACRA

2006
ANNA SUI

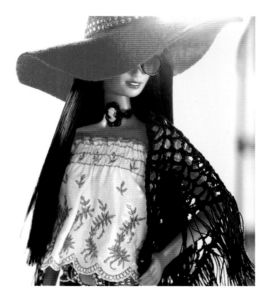

DIANE VON FÜRSTENBERG

VALENTINO
Life Ball Barbie
Limited Edition

2008
BADGLEY MISCHKA
Red Carpet

KIMORA LEE SIMMONS

JUICY COUTURE

TARINA TARANTINO

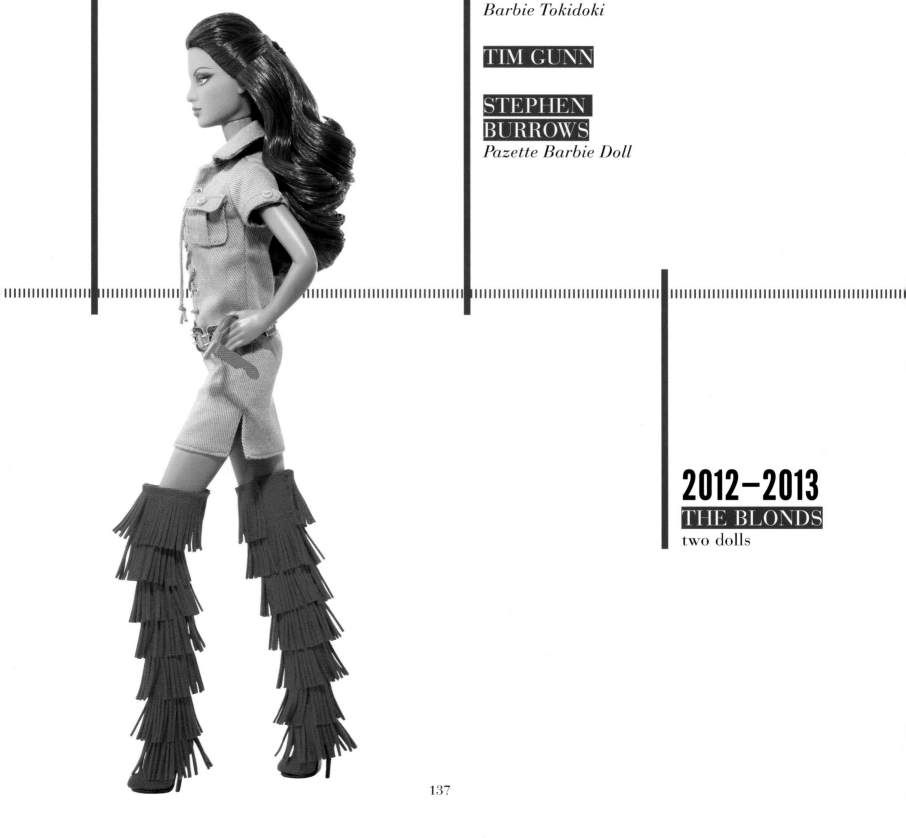

2009–2010
CHRISTIAN LOUBOUTIN
three dolls

2012
Barbie Tokidoki

TIM GUNN

STEPHEN BURROWS
Pazette Barbie Doll

2012–2013
THE BLONDS
two dolls

2014
ZUHAIR MURAD

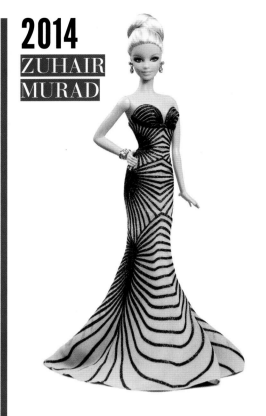

2013
STEPHEN BURROWS
Alazne Barbie Doll

BRITTO
Barbie Doll

STEPHEN BURROWS
Nisha Barbie Doll

2015

Tokidoki Barbie Doll

MOSCHINO

TRINA TURK
Malibu Barbie Doll

KARL LAGERFELD

HERVÉ LÉGER

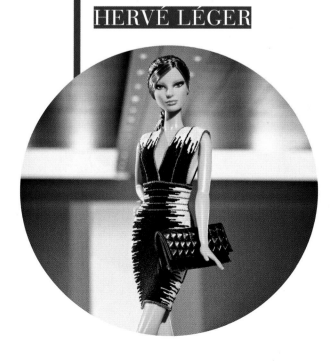

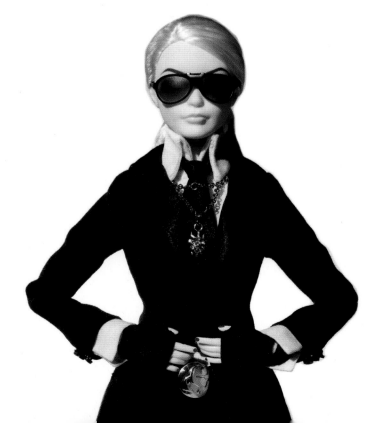

2018
YVES SAINT LAURENT
Barbie Doll

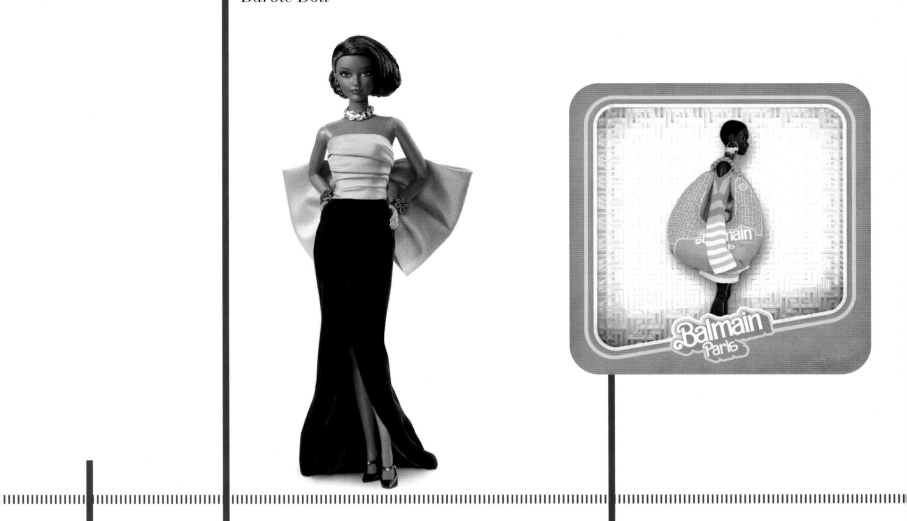

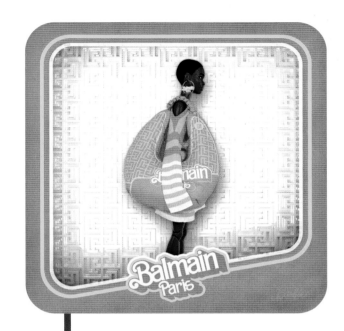

2022
BALMAIN X BARBIE

VERA WANG
Barbie Doll

2016
OSCAR DE LA RENTA
Barbie Doll

MOSCHINO
Barbie and Ken

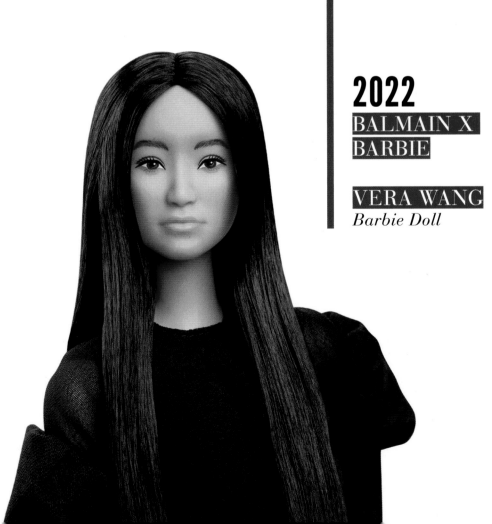

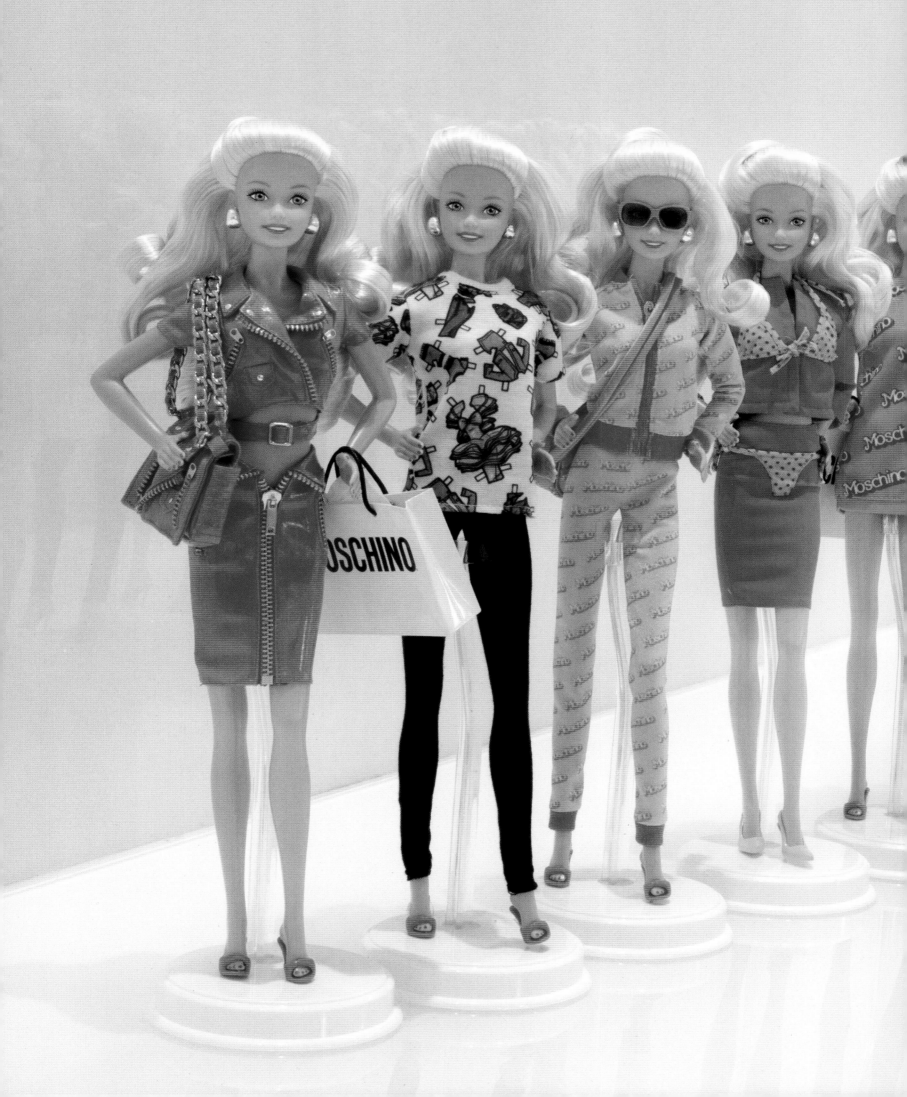

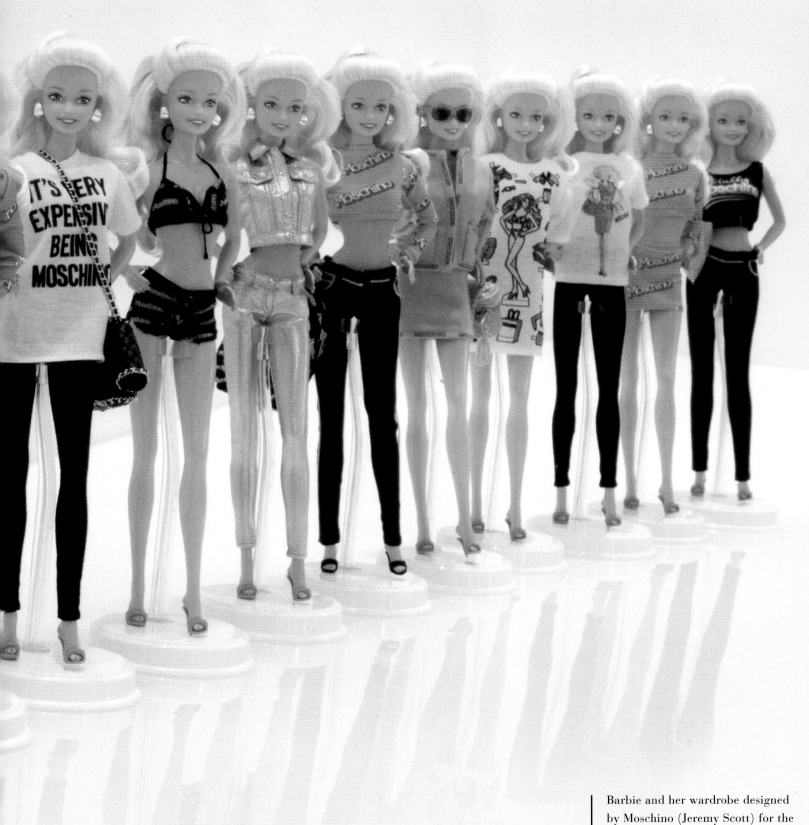

Barbie and her wardrobe designed
by Moschino (Jeremy Scott) for the
Spring/Summer 2015 collection.

Bob Mackie
Collection 1991–2023

1990

Bob Mackie Barbie Gold

1991

Bob Mackie Designer Black Barbie
Bob Mackie Designer Platinum
Bob Mackie Starlight Splendor Barbie Doll

1992

Bob Mackie Empress Bride Barbie Doll
Bob Mackie Neptune Fantasy Barbie

1993

Bob Mackie Masquerade Ball Barbie Doll

1994

Bob Mackie Queen of Hearts Barbie Doll

1995

Bob Mackie Goddess of the Sun Barbie Doll

1996

Bob Mackie Moon Goddess Barbie Doll
Bob Mackie Goddess Barbie Doll

1997

Bob Mackie Madame du Barbie Doll
Bob Mackie Emerald Embers Barbie Doll
Bob Mackie Diamond Dazzle Barbie Doll
Bob Mackie Ruby Radiance Barbie Doll
Bob Mackie Amethyst Aura
Bob Mackie Sapphire Splendor

1998

Bob Mackie Fantasy Goddess of Asia

1999

Bob Mackie Fantasy Goddess of Africa
Bob Mackie Le Papillon Barbie Doll
Bob Mackie The Tango Barbie

2000

Bob Mackie Fantasy Goddess of the Americas
Bob Mackie Lady Liberty

2001

Bob Mackie Fantasy Goddess of Arctic
Bob Mackie The Charleston Barbie
Bob Mackie Cher

2002

Bob Mackie Sterling Silver Rose
Bob Mackie Radiant Redhead Barbie

2003

Bob Mackie Brunette Brilliance Barbie Doll
Bob Mackie 45th Anniversary Barbie Doll
Diana Ross by Bob Mackie

2005

Holiday Barbie by Bob Mackie

2007

Bob Mackie Couture
Confection Bride Barbie Doll
'70s Cher Bob Mackie Doll
'80s Cher Bob Mackie Doll

2008

Lady of the Unicorns Doll by Bob Mackie

2009

Bob Mackie Golden Legacy Barbie Doll

2010

Bob Mackie Circus Barbie Doll

2011

Bob Mackie Countess Dracula Barbie Doll

2013

Bob Mackie Brazilian Banana
Bonanza Barbie Doll

2014

Bob Mackie Princess Stargazer Barbie Doll

2022

Bob Mackie Barbie Holiday Angel Doll

2023

Barbie x Bob Mackie Holiday Angel Doll

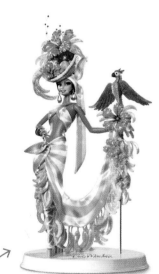

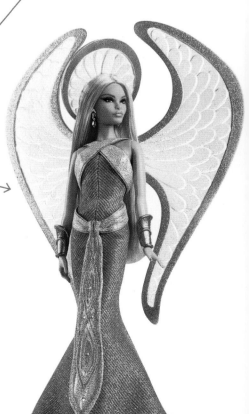

Byron Lars
Collection 1997–2011

1997
In the Limelight Barbie Doll

1998
Cinnabar Sensation Barbie

1999
Plum Royale Barbie Doll

2000
Indigo Obsession Barbie

2001
Moja Barbie

2002
Mbili Barbie Doll

2003
Tatu Barbie Doll

2004
Nne Barbie Doll

2005
Tano Barbie Doll

2006
Sugar Barbie Doll

2007
Coco Barbie Doll

2008
Pepper Barbie Doll

2009
Ayako Jones Barbie Doll

2010
Charmaine King Barbie Doll

2011
Fenella Layla Barbie Doll

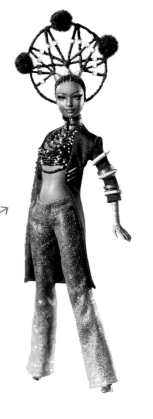

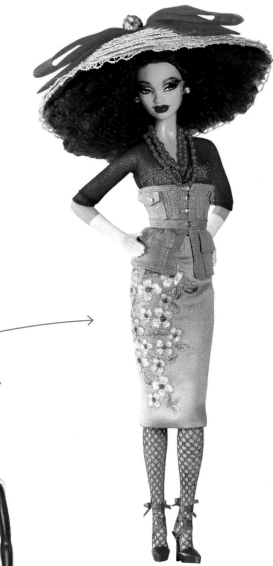

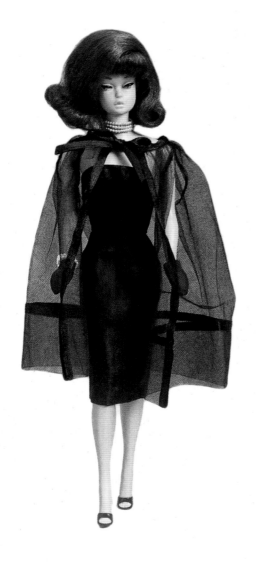

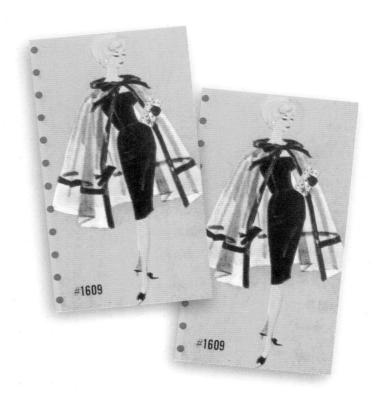

Barbie wearing one of the outfits that marked her transformation into a style icon: *Black Magic Ensemble* (1964), inspired by the "little black dress" that has by now become a classic in every woman's wardrobe.

For Barbie the sixties represented the height of elegance and ongoing transformation, from one style to another.

One of the most beautiful and iconic pieces in Barbie's wardrobe dates to 1960: it is *Solo in the Spotlight*, a figure-hugging, long black sleeveless dress with sequins, a black tulle flounce, and long black nylon gloves. The dress was a tribute to thirties fashion and to some of the dresses designed by Adrian and Travis Banton for Greta Garbo, Joan Crawford, and Marlene Dietrich, but still in vogue in the early fifties, as can be seen in the dress designed by Marcel Rochas and photographed by Irving Penn in 1950.

A tribute to Balenciaga's sartorial cut is clearly visible in the creations of *Career Girl* (1963), *On the Avenue* (1965), and *Sunday Visit* (1965), while *After Five* (1962) seems to stem directly from the atelier of Dior. Between 1961 and 1963, thanks to the international distribution of *Breakfast at Tiffany's*, which featured a wardrobe designed for Audrey Hepburn by Edith Head and Hubert de Givenchy, the "little black dress" was all the rage. This was the new favorite outfit of American fashion as well, which was just starting to introduce lines conceived for formal cocktails and openings at the New York galleries. On the scene was a new generation of fashion designers, including Claire McCardell (1905–1958), who best interpreted the need for high-quality clothing that was both elegant and practical, worn every day by the modern, emancipated woman. Barbie was once again a symbol. *Black Magic Ensemble* (1964), a strapless silk sheath dress and a tulle coat, gloves, and a clutch, represented the new trend in which the black sheath dress was worn during the day as well.

"

She is a miracle.
She is timeless
and she epitomizes fashion,
always 'surfing' in
the cutting edge of trends
and style, becoming not only
an icon but an inspiration too.
She represents energy.
So she represents life.

"

CHRISTIAN LACROIX
FASHION AND COSTUME DESIGNER

But besides the outfits that represented the changes underway in fashion, at least until the late sixties, it is also worthwhile examining the technical and aesthetic changes that were made to Barbie's body, from her posture, to her makeup, to her hairstyle, a reflection of the great cultural changes that took place from the fifties onwards. Barbie *#1 Teen-Age Fashion Model* (1959) was produced in both a blonde and brunette version; she had side-glancing eyes with black eyeliner, her hair was gathered in a ponytail (which was also the name of this first series of Barbie dolls), and she had a slender full-breasted body. Typical of this very first model were the white irises and the presence of two holes in the soles of the doll's feet so that she could be placed on the metal-pronged stand she was supplied with. The stand was improved for Barbie #2, produced in 1960, which supported the doll from underneath the arms. In 1960 Barbie #3 was produced, featuring blue irises and lighter makeup characterized

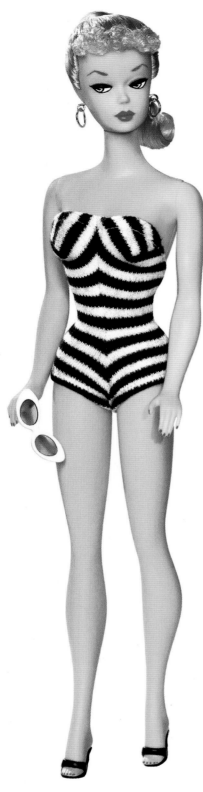

by brown eyeliner. The first four Barbie dolls had a full, heavy vinyl body, but with edition #5 the doll's body became hollow and light. Furthermore, for this model a new fiber was used for the doll's hair, which was available in different shades, from brunette to blonde to red, as well as others.

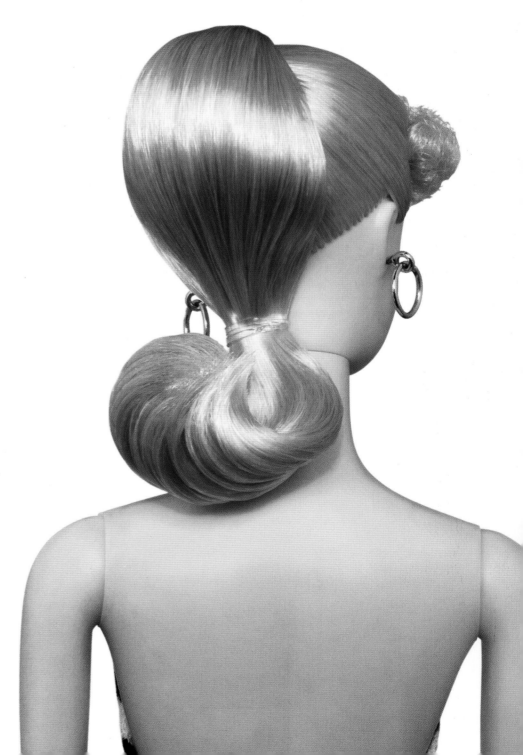

Barbie as *Teen-Age Fashion Model Barbie Doll* wearing her famous black-and-white zebra-striped swimsuit and ponytail (*Ponytail* version), created by Larry Germain of Universal Studios in Hollywood.

Opposite
Barbie as *Sweater Girl* (1959), wearing a woolen pullover and a tweed skirt, inspired by American movie stars Doris Day and Lana Turner.

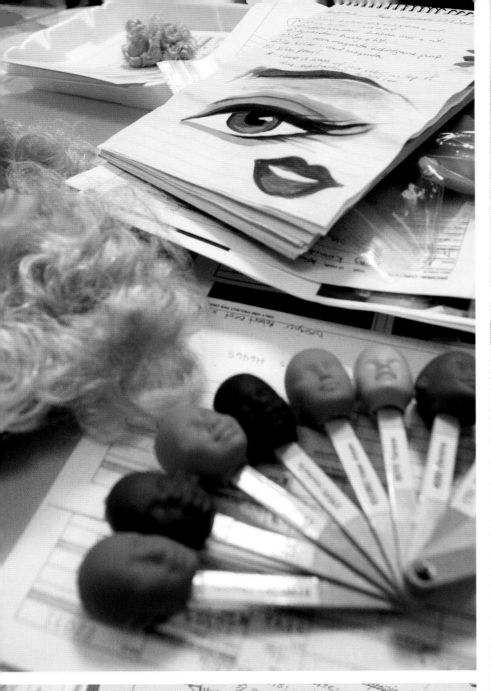

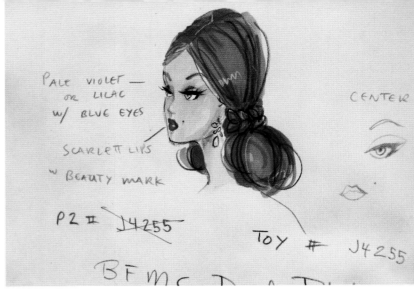

PALE VIOLET —
OR LILAC
w/ BLUE EYES

SCARLETT LIPS

w BEAUTY MARK

P2 ☰ J4255

CENTER

TOY # J4255

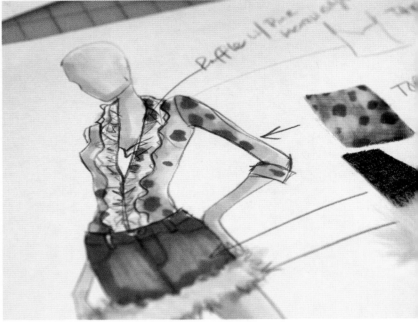

the making of Barbie

Barbie first appeared in 1959 as *Teen-Age Fashion Model Barbie Doll* made out of vinyl, manufactured by Pony Ltd. in Japan under the guidance of Mr. Yamasaki. For the Mattel company, Barbie's technical design was overseen by the engineer Jack Ryan, who, to solve the problem of molding the vinyl, traveled to Japan where the industries specialized in the treatment of this type of material guaranteed the finest quality at competitive prices.

Barbie's outfits were initially also made in Japan by Kokusai Boeki Kaisha Ltd., under the expert guidance of Fumiko Nakamura, who worked alongside Mattel's fashion designer Charlotte Johnson. Between 1957 and 1964 the manufacturing of the Barbie doll expanded from Hong Kong to Korea. In 1968 new countries were added to those where the doll was produced: Mexico, the Philippines, and Taiwan.

Filed July 24, 1959

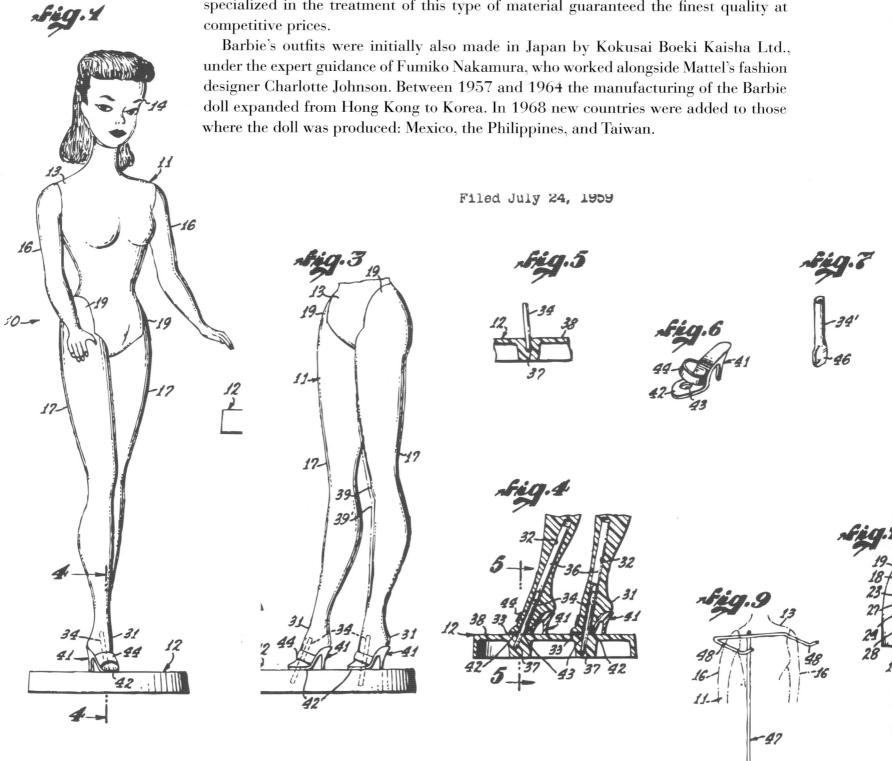

EVEN TODAY THE MAKING OF BARBIE IS BASED ON THE ORIGINAL PROCEDURES. THIS INCLUDES:

1

A preliminary phase to develop a model for Barbie's head.

2

Prototypes of the head are made from epoxy resin; these prototypes are either oversized or reduced.

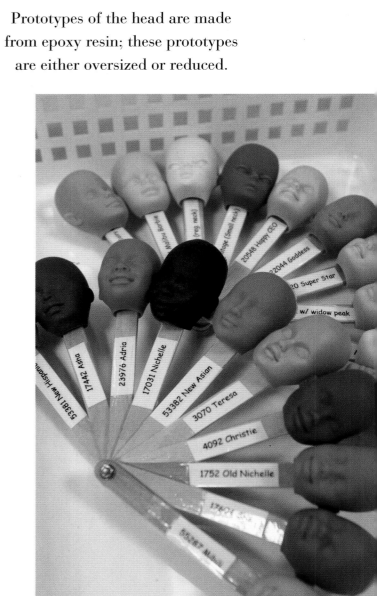

3

A mold is made from opaque and transparent resin for Barbie's oversized torso.

4

A metal Master Mold is created of the torso; its positive is made from wax.

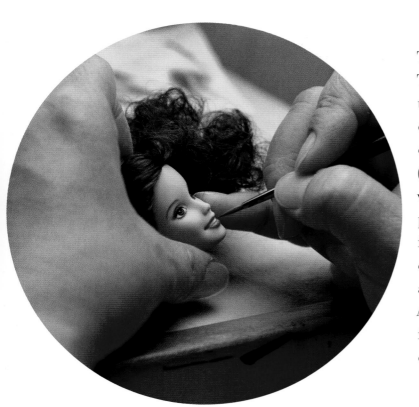

5

The makeup for the doll's face is identified for mass production. There are various phases in the manual decoration of the prototype for the face with makeup and the characterization of the doll's facial features; different nuances lead to the determination of the desired physical type. To create a new face for Barbie (a prototype that will then be produced), fifteen expert artists work on her face with water-based acrylics and tiny sable-hair paintbrushes. These artists are painting one of the most famous faces in the world. It's all about nuances: with sessions that can last up to three hours, each color used on Barbie's face is applied in thin "layers" so that the brushstrokes won't be visible. Although Barbie is famous for her lively, colorful makeup, her favorite eyeshadow is brown, and it's the color she wears most often. Barbie has more than 300 different shades of brown in her beauty kit!

6

Sampling of the heads with different skin colors, based on the most suitable makeup, representing different races and physical types.

7

Preparation of the supports with the prototype heads ready for the makeup chosen.

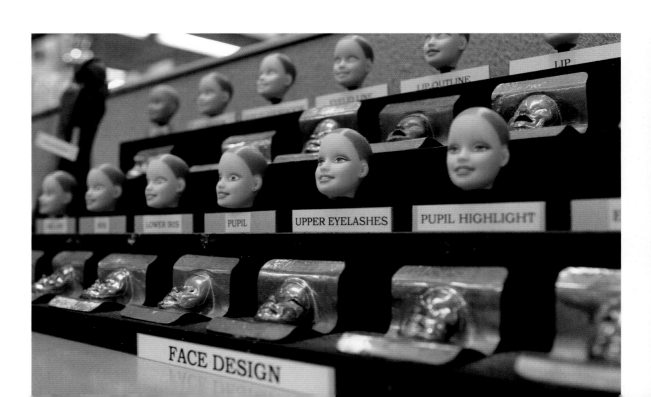

8

Creation of the Master Head, which is essential to determine the reference parameters required for the industrial production of the Barbie doll.

9

Determination of Barbie's hairstyle. Her hair comes in several different shades, with various combinations to get darker or lighter shades. A special sewing machine called "Dolly" featuring a rotating movement is used to sew Barbie's legendary curls. Barbie's synthetic fiber hair is then cut and combed by professionals, tress by tress, to create chic styles. Once her hair has been implanted, brushed, and styled, Barbie is placed inside a personalized heating machine that sets her hairdo: the machine is a lot like a salon-style dryer. The essential tools to make Barbie's hair shiny are a brush and water, ideal for avoiding frizziness.

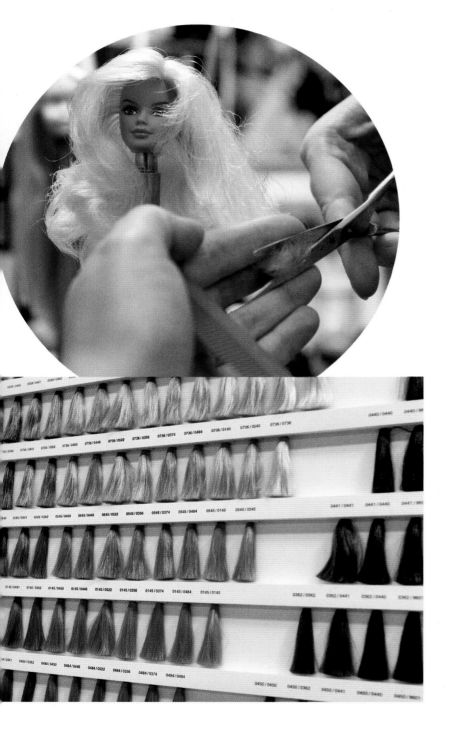

10

After she's dressed, Barbie is boxed and ready for distribution.

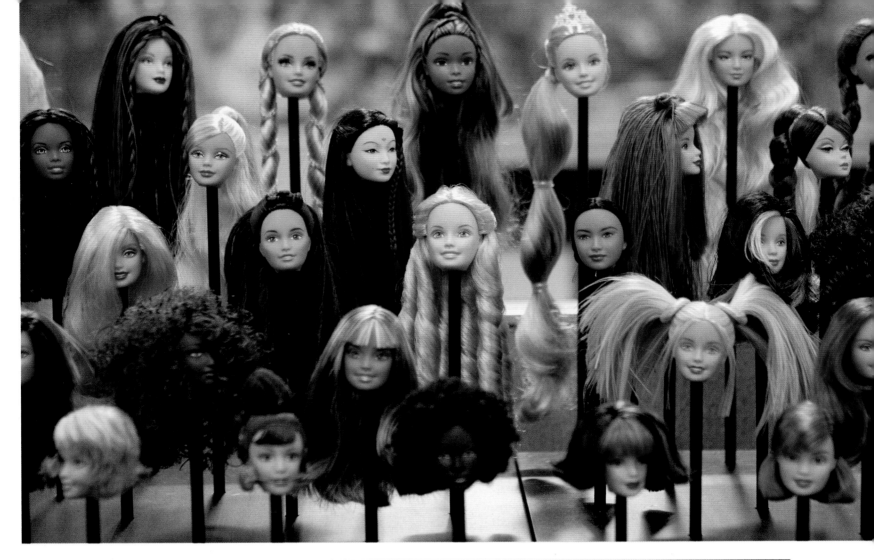

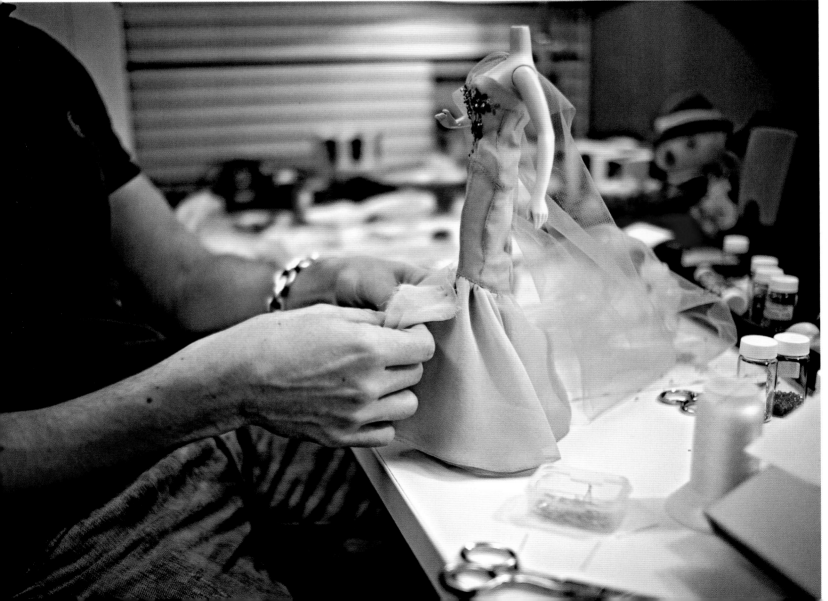

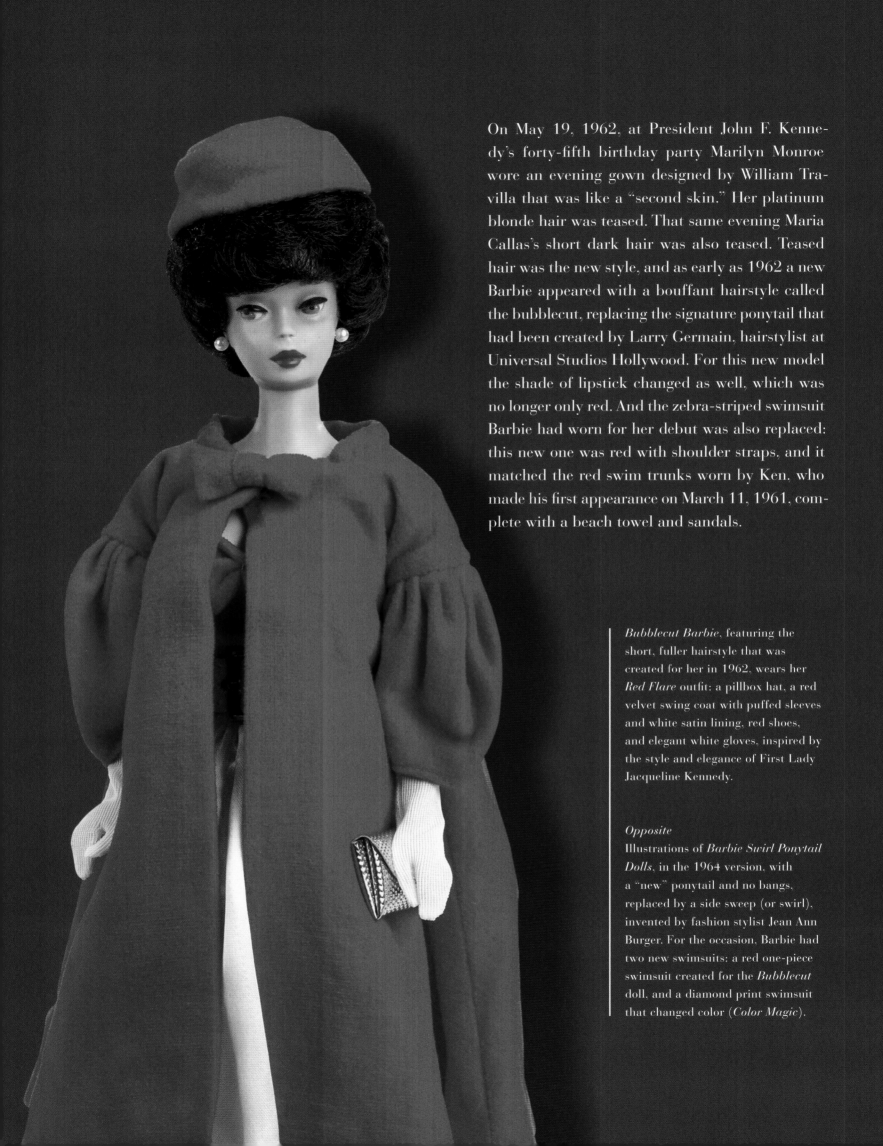

On May 19, 1962, at President John F. Kennedy's forty-fifth birthday party Marilyn Monroe wore an evening gown designed by William Travilla that was like a "second skin." Her platinum blonde hair was teased. That same evening Maria Callas's short dark hair was also teased. Teased hair was the new style, and as early as 1962 a new Barbie appeared with a bouffant hairstyle called the bubblecut, replacing the signature ponytail that had been created by Larry Germain, hairstylist at Universal Studios Hollywood. For this new model the shade of lipstick changed as well, which was no longer only red. And the zebra-striped swimsuit Barbie had worn for her debut was also replaced: this new one was red with shoulder straps, and it matched the red swim trunks worn by Ken, who made his first appearance on March 11, 1961, complete with a beach towel and sandals.

Bubblecut Barbie, featuring the short, fuller hairstyle that was created for her in 1962, wears her *Red Flare* outfit: a pillbox hat, a red velvet swing coat with puffed sleeves and white satin lining, red shoes, and elegant white gloves, inspired by the style and elegance of First Lady Jacqueline Kennedy.

Opposite
Illustrations of *Barbie Swirl Ponytail Dolls*, in the 1964 version, with a "new" ponytail and no bangs, replaced by a side sweep (or swirl), invented by fashion stylist Jean Ann Burger. For the occasion, Barbie had two new swimsuits: a red one-piece swimsuit created for the *Bubblecut* doll, and a diamond print swimsuit that changed color (*Color Magic*).

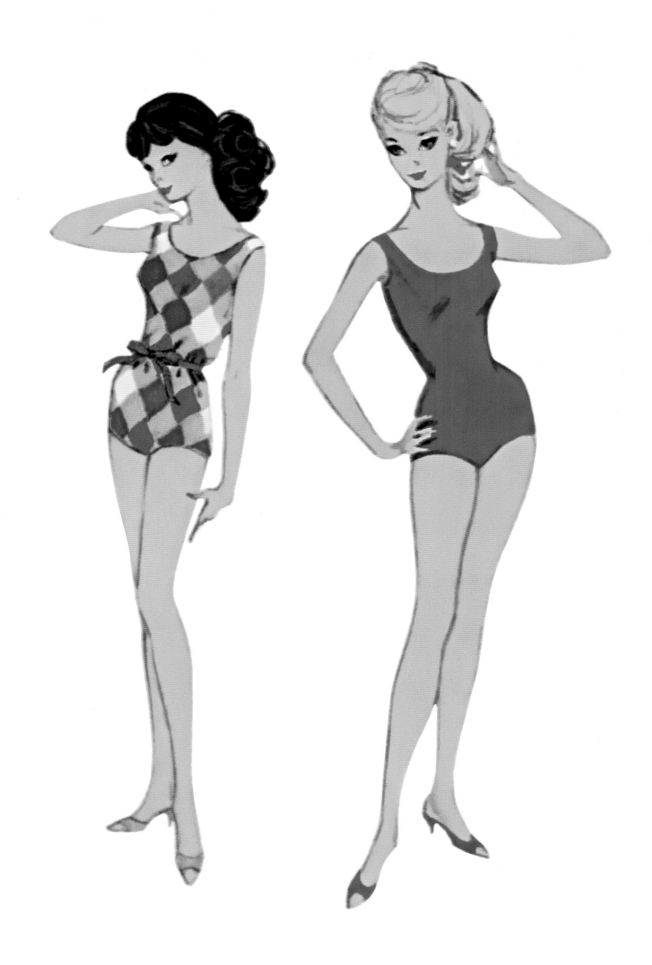

the family

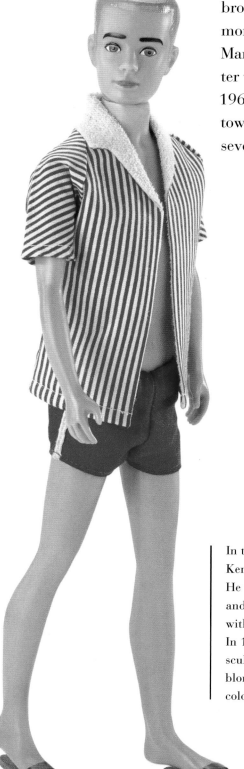

After Barbie debuted in America in 1959, she was introduced to Europe in 1961. (She arrived in Italy in 1964.) In the meantime, Mattel worked to bolster Barbie's legend by giving her an increasingly articulated biography. This was done by creating new characters that would make up Barbie's big family, which includes four younger sisters and a brother, friends, pets (six horses, an Arabian stallion, an Afghan hound, a poodle, three mongrels, and two cats), and her long-standing boyfriend, Ken. Ken first appeared on March 11, 1961, on the occasion of the American International Toy Fair, but his encounter with Barbie took place on the set when they made their first TV ad, also recorded in 1961. Ken debuted wearing a red swimsuit, cork sandals, and holding a yellow beach towel. The original Ken had either blond or brunette flocked hair, and a wardrobe with seven outfits. Over the years, Ken has been produced in more than forty versions.

In the original 1961 version Ken was a brunette (right). He wore red bathing trunks and cork sandals, and came with a yellow beach towel. In 1962, Ken featured a sculpted crew cut in both blond and brunette hair colors (left).

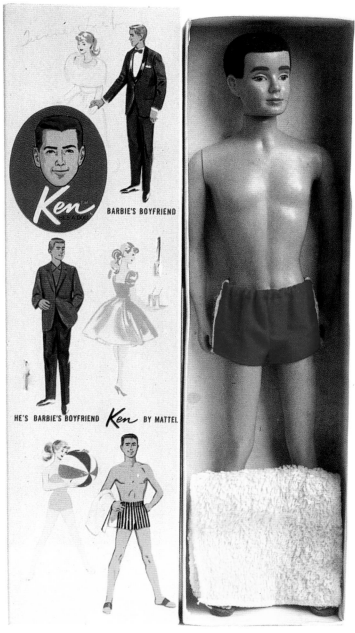

 Ken debuted on
11 MARCH 1961.

Ken is
2 YEARS AND 2 DAYS
younger than Barbie.

 Ken's full name is
Ken Carson.
Ken got his name from
KENNETH, Barbara's
brother and Ruth and Elliott
Handler's son.

 In the summer of 2010,
Ken debuted on the
silver screen
in *Toy Story 3*.
For the occasion Ken changed
more than 50 costumes.

 Ken is
12 inches tall,
slightly taller
than Barbie.

$ The first Ken
sold for $3.50
in **1961**.

In 1961 two versions of Ken
were produced, with either
blond or ***brunette***
flocked hair.

 In 1973 Ken was given a more
natural style of hair, either straight
or curly, with a MUSTACHE,
BEARD and SIDEBURNS.

Ken has a
***younger
brother***,
named Tommy (1997).

★ In 1977 the ***Superstar***
version of Ken was produced.

Ken was given a
MAKEOVER
by famous stylist
Phillip Bloch.

 Ken's **BEST FRIEND**
is Allan.

In 1982 *Sunsational Malibu Ken*
appeared; it was the first
African American version with a
new **AFRO HAIRCUT**.

After Ken and Barbie broke up in 2004,
he played the leading role in 2011 in a sensational
marketing campaign
in Times Square in New York to win back his historic girlfriend.
New York was lit up with slogans by Ken, such as
Barbie, you're the only doll for me!

ken
in a Nutshell

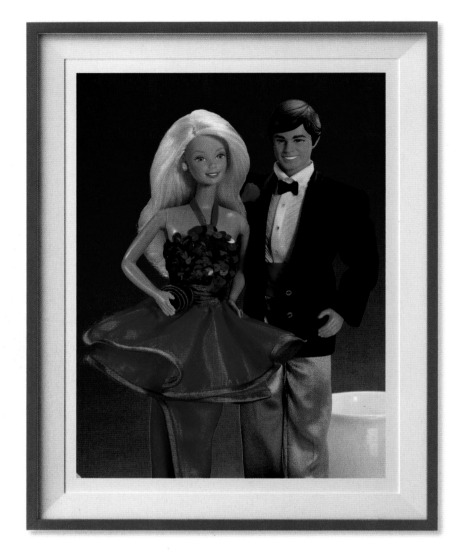

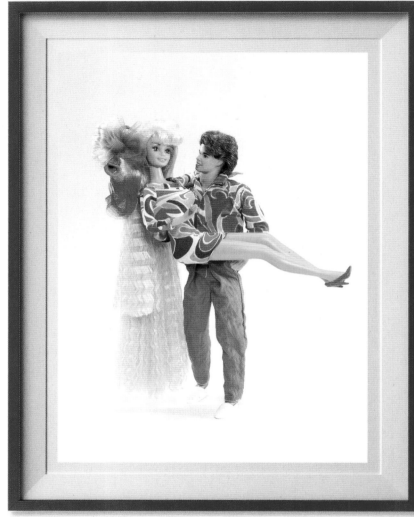

Barbie and Ken pictured during some of the happiest moments of their long love story.

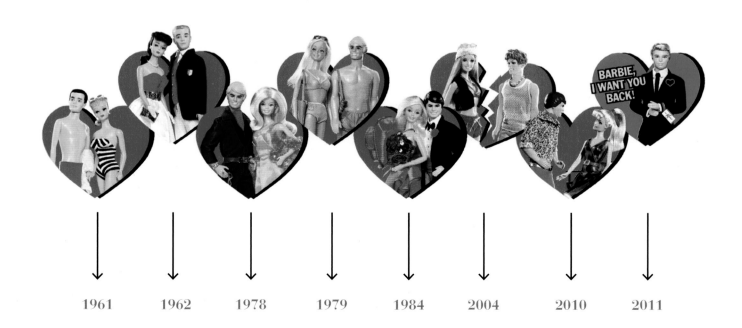

1961 1962 1978 1979 1984 2004 2010 2011

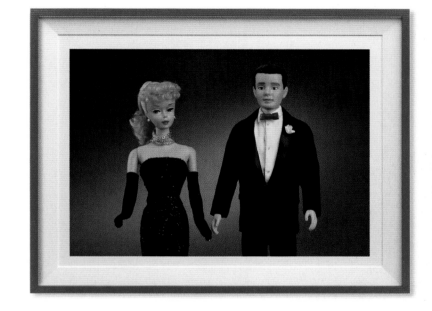

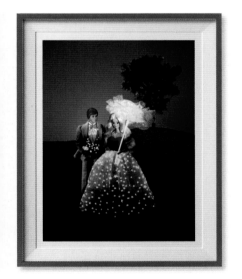

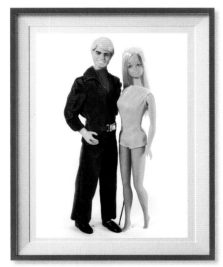

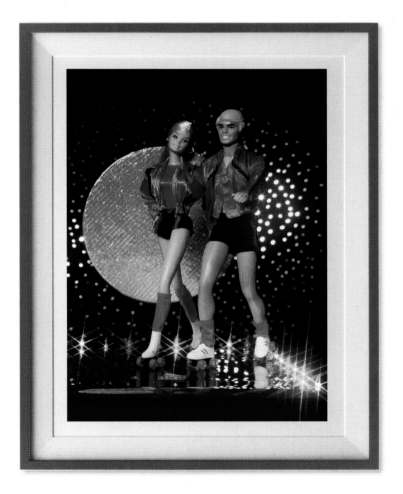

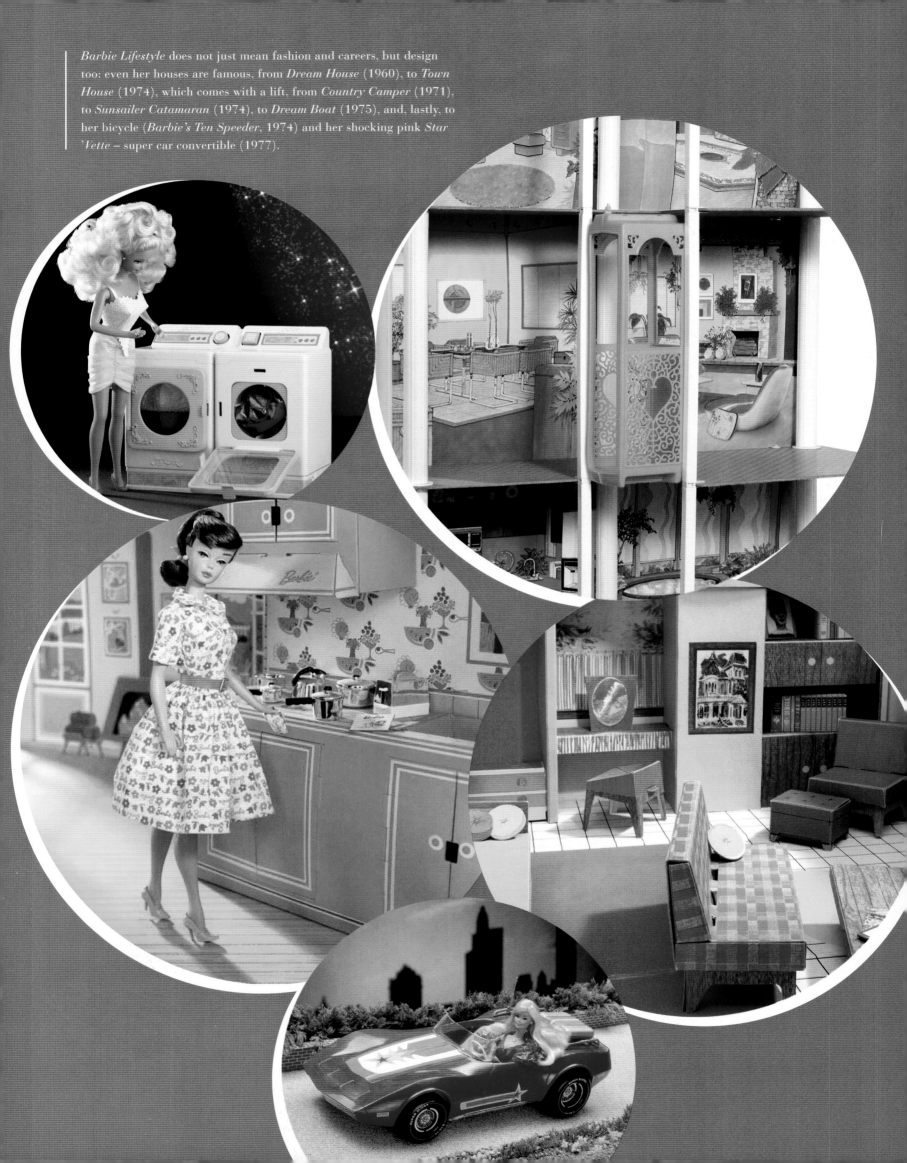

Barbie Lifestyle does not just mean fashion and careers, but design too: even her houses are famous, from *Dream House* (1960), to *Town House* (1974), which comes with a lift, from *Country Camper* (1971), to *Sunsailer Catamaran* (1974), to *Dream Boat* (1975), and, lastly, to her bicycle (*Barbie's Ten Speeder*, 1974) and her shocking pink *Star Vette* – super car convertible (1977).

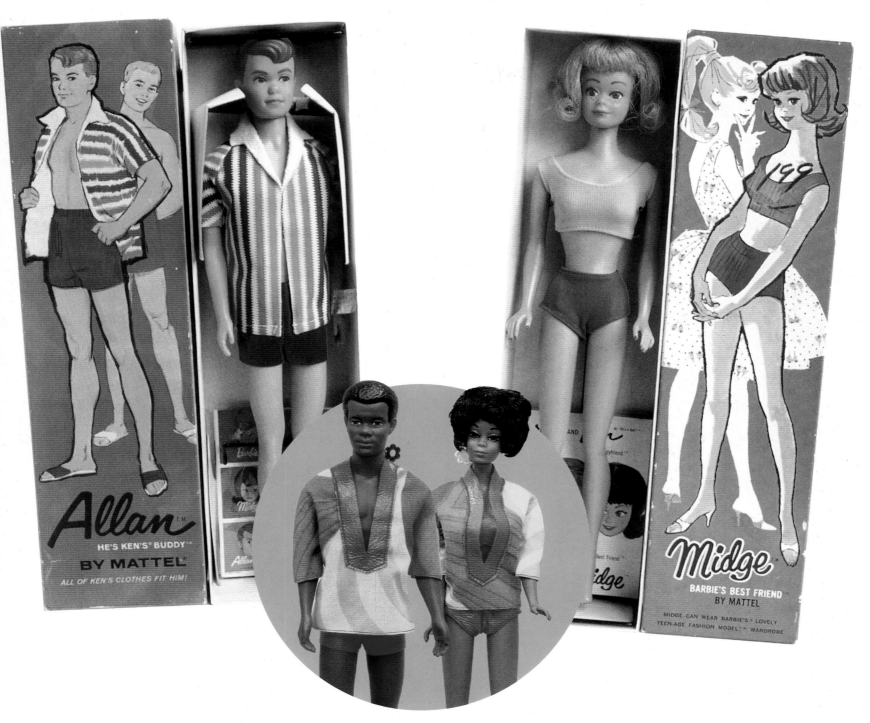

Midge and Allan, Barbie and Ken's best friends, in their original 1963 and 1964 versions, respectively.

Barbie's younger sisters include Skipper (1964), Tutti (1966), Stacie (1992), Kelly (known as Shelley in Europe, 1995, and renamed Chelsea in 2011), and little Krissy (1999). Barbie also has a brother named Todd (1966) and two famous cousins, MOD Francie (1966) and Jazzie (1989). Barbie's best friend Midge was created in 1963. Because her body is the same as Barbie's, Midge can wear anything from her friend's extraordinary wardrobe. Midge looks like the "girl next door," and she was her very best friend until 1966, when Mattel decided to stop producing her. Midge was reissued in 1988, almost thirty years later. The circle of friends closest to Barbie has always reflected the variety of the real world. In 1968 Barbie's African American friend Christie appeared, and over the years they have had lots of other Hispanic, Asian, and multiethnic friends, like Teresa, Kira, and Kayla. The Mattel company's sensitivity to social issues created Becky, Barbie's disabled friend, in 1997 for the American market, and other characters in the following years with a special focus on inclusion.

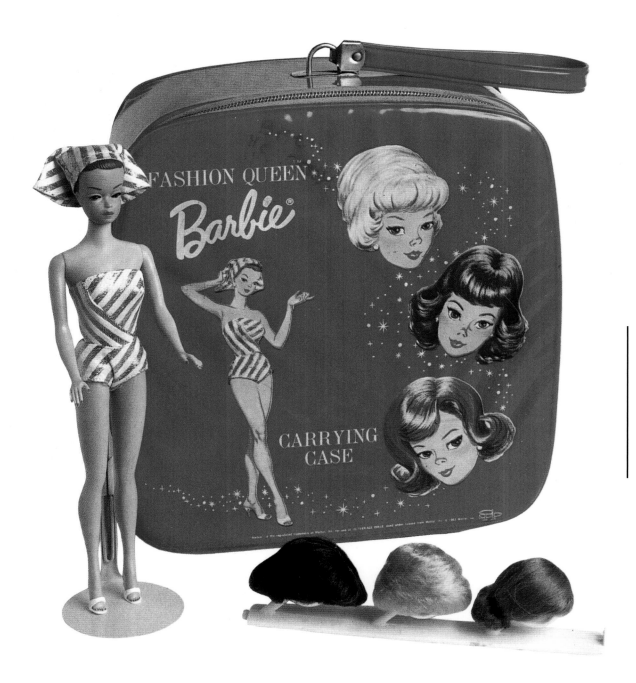

Barbie Fashion Queen with her famous glossy red carrying case, created in 1963 to also contain three different wigs: blonde, brunette, and red.

In the early sixties, Barbie, who always managed to keep up with fashion, couldn't possibly ignore the great style icons, like Jacqueline Kennedy: *Red Flare* (1962) included a pillbox hat and red velvet swing coat with puffy sleeves and white satin lining, red shoes, and very elegant white gloves, inspired by the elegance of the First Lady. In 1961 Jackie chose Oleg Cassini as her official fashion designer, and in 1962 he designed her entire wardrobe for a trip to India, which earned her the sobriquet "America's Queen" (Ameriki Rani). Those were years of great change in the fashion system: in Paris, in 1962, Marc Bohan replaced Saint Laurent as director of Dior when the latter designer opened his own atelier called Rive Gauche.

In 1963 Barbie also underwent a change: the Barbie *Fashion Queen* edition was produced, with flocked hair so that she could take turns wearing three different wigs. But Barbie still loved her pony-tail, and in 1964 *Swirl Ponytail* Barbie was created:

thanks to an idea by stylist Jean Ann Burger, her bangs were gone, and her hair was now parted on the side. This new model accompanied the one created in 1964 by Dick May, who patented the first Barbie with bendable legs: *Miss Barbie* had a hard plastic head, molded painted vinyl hair, "sleep" eyes, as well as blonde, brunette, and red wigs. As early as 1965 Barbie had a short straight bobbed hairstyle that gave her the name *American Girl*; her makeup was heavier and she came with a new diamond print swimsuit called *Color Magic*, which changed color when swabbed with a water-based solution. That same year Barbie celebrated a milestone for women when *Miss Astronaut* was created, inspired by the first Russian woman astronaut, Valentina Tereshkova. It was Barbie's way of celebrating the space program, at the same time showing her young fans that there was nothing they couldn't aspire to do or to become.

Barbie underwent some major changes in style in the early 1960s: *Miss Barbie* (1964), *Swirl Ponytail* (1964), *Color Magic* (1964), and *American Girl* (1965).

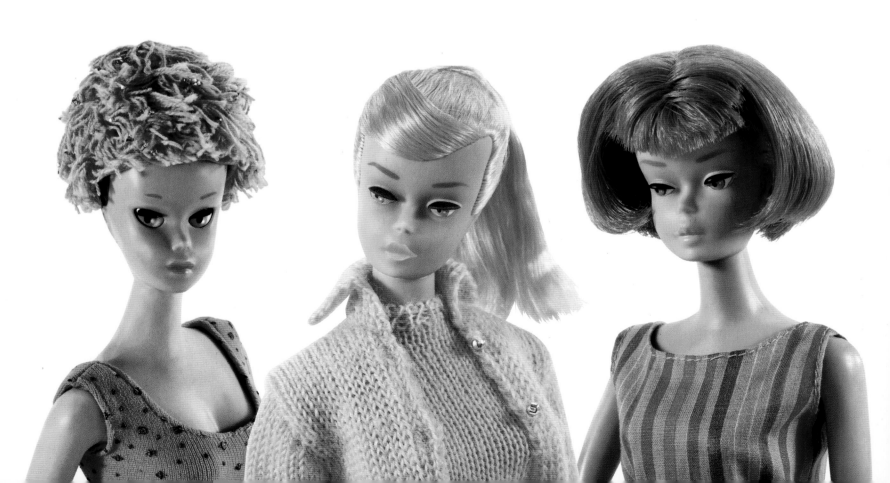

"D"

Barbie has always represented that a woman has choices. Even in her early years, Barbie did not have to settle for only being Ken's girlfriend or an inveterate shopper. She had the clothes, for example, to launch a career as a nurse, a stewardess, a nightclub singer. I believe the choices Barbie represents helped the doll catch on initially, not just with daughters—who would one day make up the first major wave of women in management and professionals—but also with mothers.

Ruth Handler,
INVENTOR OF BARBIE

Barbie Working Woman (1999).

careers

For more than half a century Barbie has been inspiring the dreams and aspirations of young girls.

In her sixty-five years Barbie has had more than 300 careers as proof of her enduring motto: *"You can be anything."* Thanks to the international career collection, Barbie has inspired and encouraged at least three generations of young girls to dream, discover, and explore a world where everything can come true. Barbie has been a volunteer nurse, a UNICEF ambassador, a member of the armed forces, and many other things. Furthermore, Barbie has supported many causes and important initiatives.

In 2008 Barbie used her signature color, pink, to turn fashion into an environmental cause, helping to disseminate the environmental protection movement among young girls with Barbie BCause, a collection of limited edition accessories made out of recycled materials and fabric from Barbie's outfits.

1959
Teen-Age Fashion Model

1960

Fashion Editor

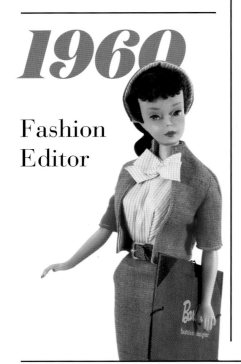

19 61
Ballerina
Flight Attendant
Registered Nurse

1962
Ice Skater
Tennis Player

1964
Candy Striper Volunteer

19 63 EXECUTIVE
(CAREER GIRL)

Student Teacher
Astronaut

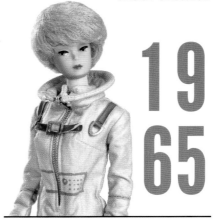

19 65

1966
Pan Am Flight Attendant

1967
Junior Designer

1973
United Airlines
Flight Attendant
Surgeon

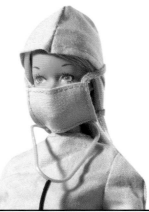

Miss America

1974

1979
MISS AMERICA

19 77 ACTRESS

1976 BALLERINA

VETERINARIAN
DRESS DESIGNER
TV NEWS REPORTER
BUSINESS EXECUTIVE
TEACHER

1985

1984
Aerobics Instructor

1975
Figure Skater
Olympic Athlete
Olympic Downhill Skier

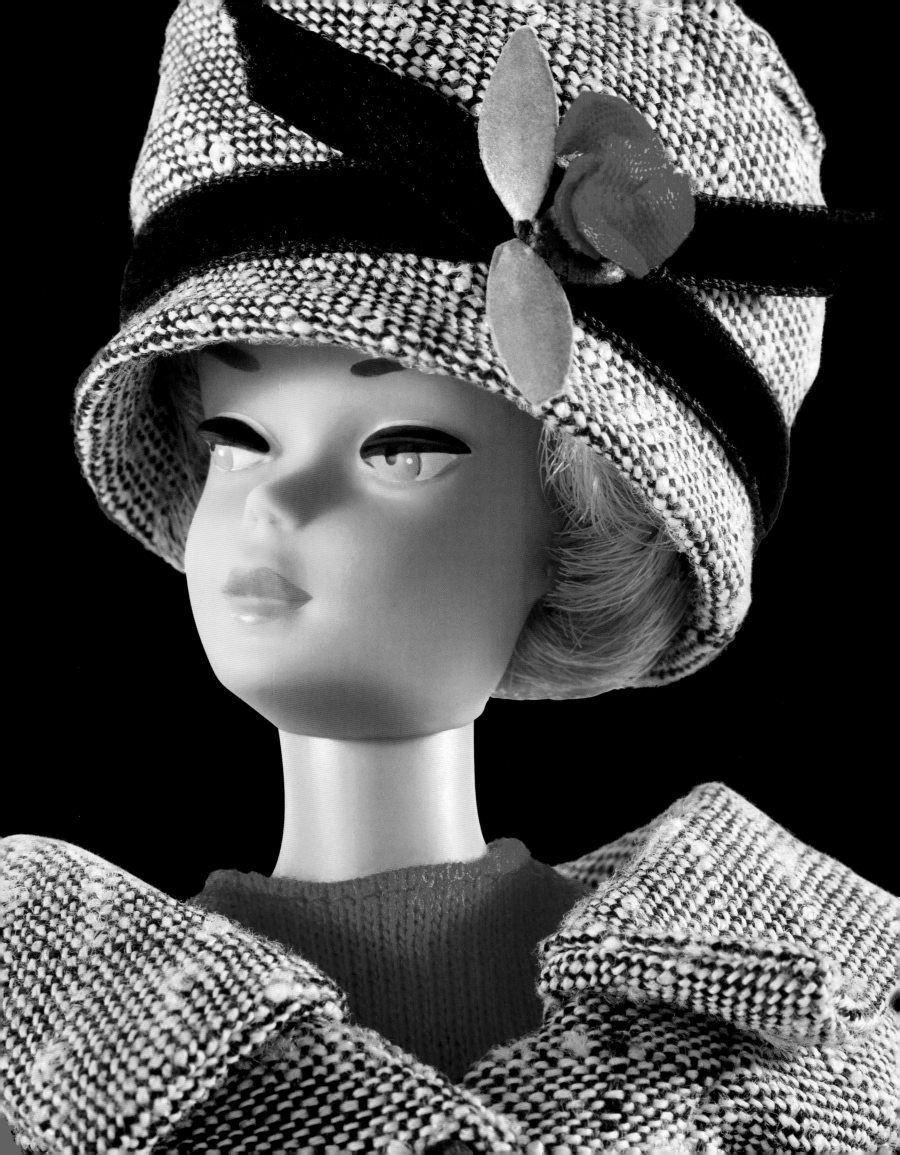

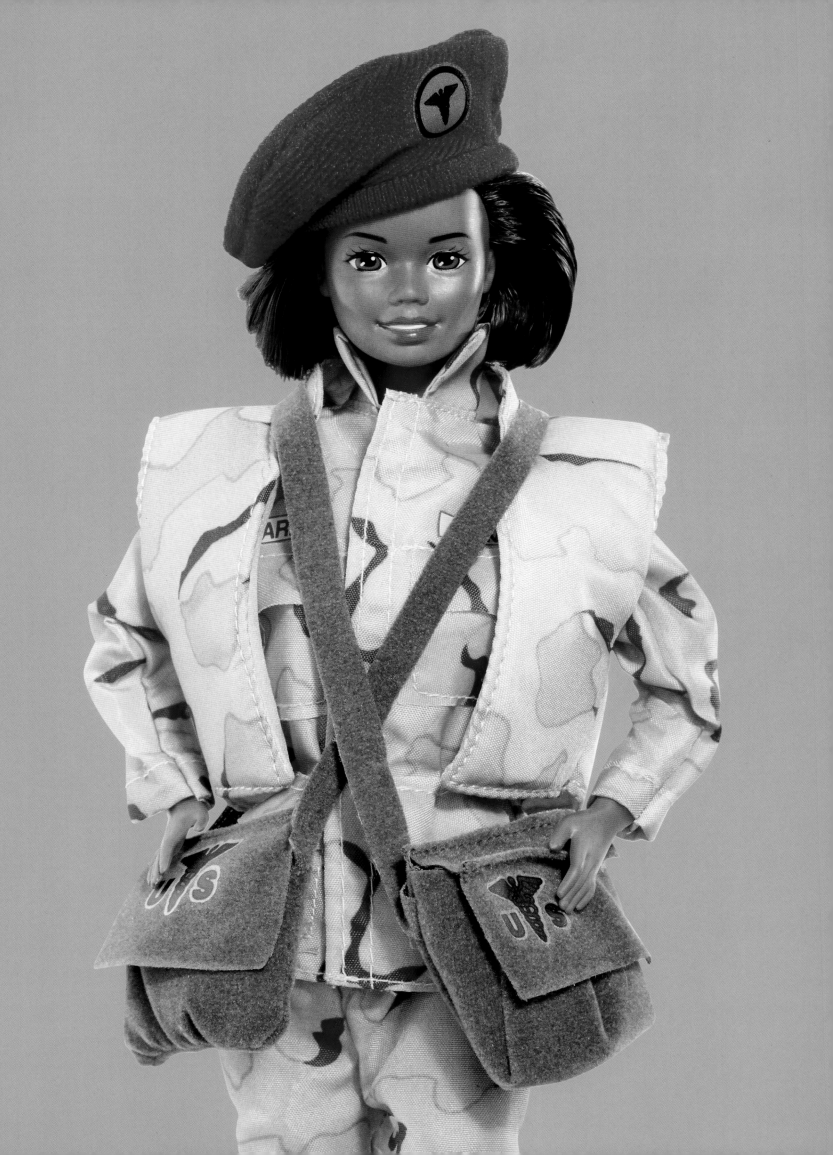

19
86

Rock Star
Astronaut

1987
BALLERINA

1993

RADIO CITY MUSIC
HALL ROCKETTE

BASEBALL PLAYER

POLICE OFFICER

ARMY MEDIC

1988 Doctor

1989

UNICEF
Ambassador
Doctor

U.S. Army
Officer

2001

Children's Doctor
Sign Language Teacher

20
02

Olympic Ice
Skater

Art Teacher

2003
Producer

NAVAL PETTY
OFFICER **1991**

19
94

Astronaut
Pediatrician
U.S. Air Force
Thunderbird
Squadron Leader
Scuba Diver

DENTIST 19
PALEONTOLOGIST 97

1998

ROCK STAR • NASCAR DRIVER
OLYMPIC SKATER • WNBA PLAYER
(DALLAS) • BOUTIQUE OWNER

RAP MUSICIAN • DOCTOR
PRESIDENTIAL CANDIDATE
BUSINESS EXECUTIVE • CHEF
T E A C H E R
MARINE CORPS SERGEANT

1992

1995

Lifeguard
Teacher
Firefighter

1996

Pet Doctor
Olympic Gymnast
Engineer

1999

NASCAR Driver
Women's World Cup
Soccer Player
Airline Pilot
Major League
Baseball Player
B U S I N E S S
EXECUTIVE

2000

FORMULA ONE DRIVER
Olympic Swimmer
P R E S I D E N T I A L
C A N D I D A T E

2004

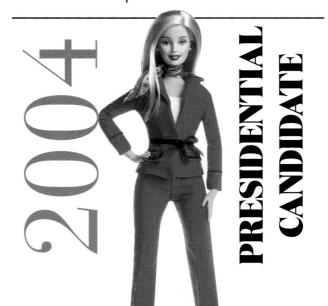

PRESIDENTIAL
CANDIDATE

Baby Doctor
Pet Doctor
TEACHER
American
Idol Winner
2005

TEACHER
BALLERINA
ZOOLOGIST
BABY DOCTOR
2006

Equestrian
Fashion Magazine
Intern
Pet Vet
Sea World
Trainer
Newborn Baby
Doctor
Gymnastics Coach
2009

2007

Ballet Teacher
Chef • Teacher
Pet Sitter • Baby
Photographer

2010

2011

Presidential
Candidate
ZOO DOCTOR
Space Camp
Instructor
TV CHEF
Swim
Instructor
Soccer Coach

2008

COMPUTER ENGINEER
NEWS ANCHOR
Dentist
ROCK STAR
RACECAR DRIVER

ARCHITECT
Skier
ART TEACHER
Movie Star
CHEF

2014
Nurse • Singer (with guitar)
PASTRY CHEF • ICE SKATER
FOOTBALL PLAYER • ENTREPRENEUR
DOCTOR • TEACHER
Veterinarian • Cake Chef
Zoo Veterinarian • Babysitter

Presidential Candidate
Fashion Designer
Zoo Doctor
Paleontologist
Arctic Rescuer

2012

Pet Stylist
Cupcake Chef
HOLLYWOOD STAR
POP STAR
PEDIATRICIAN

2013

CHEF
Asian Nurse
ICE
SKATER
PRESIDENT
AND VICE PRESIDENT
Game Developer

2016

2015
Tennis Player • Rock Star
Nurse • Lifeguard
Scientist • Eye Doctor
Geography Teacher

2017

Skater
Martial Artist
Soccer Player

MAGICIAN
Zookeeper
Pastry Chef
GYMNASTICS TEACHER

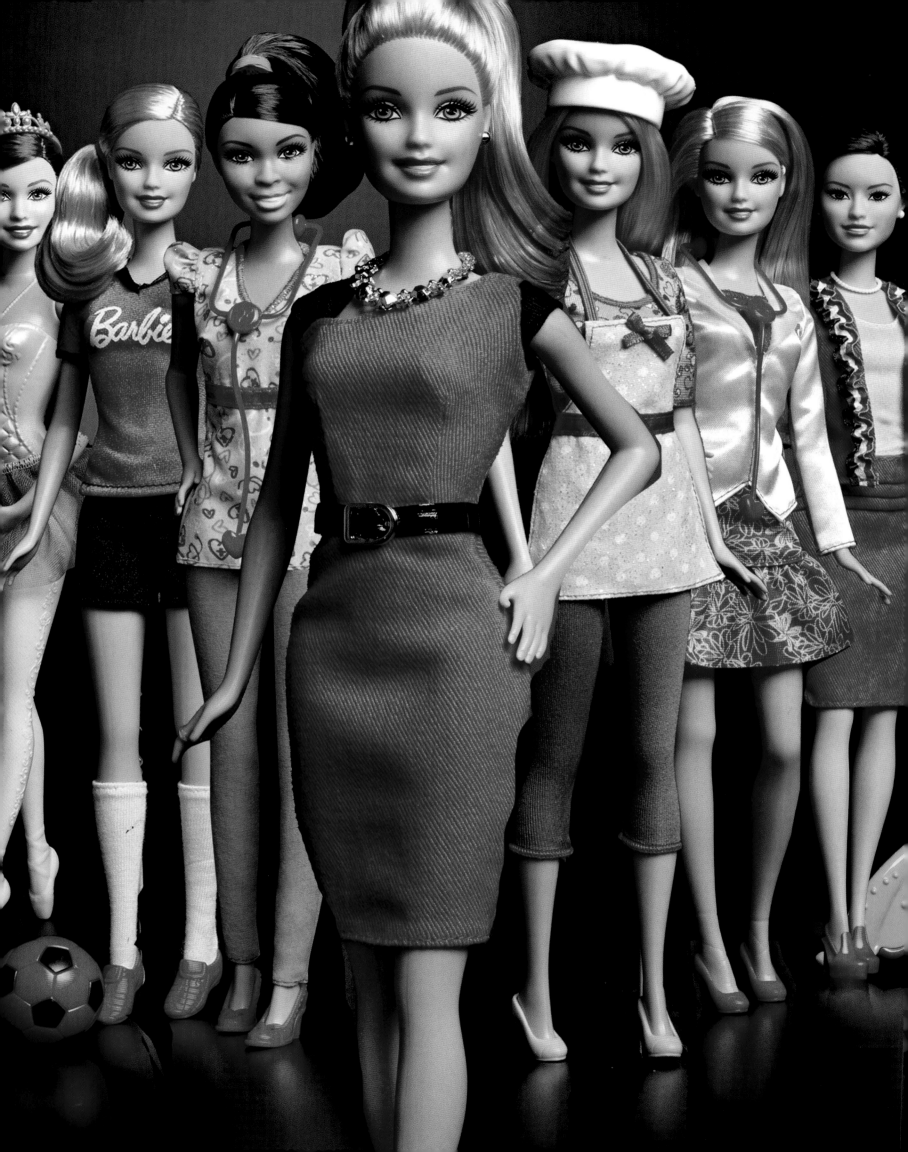

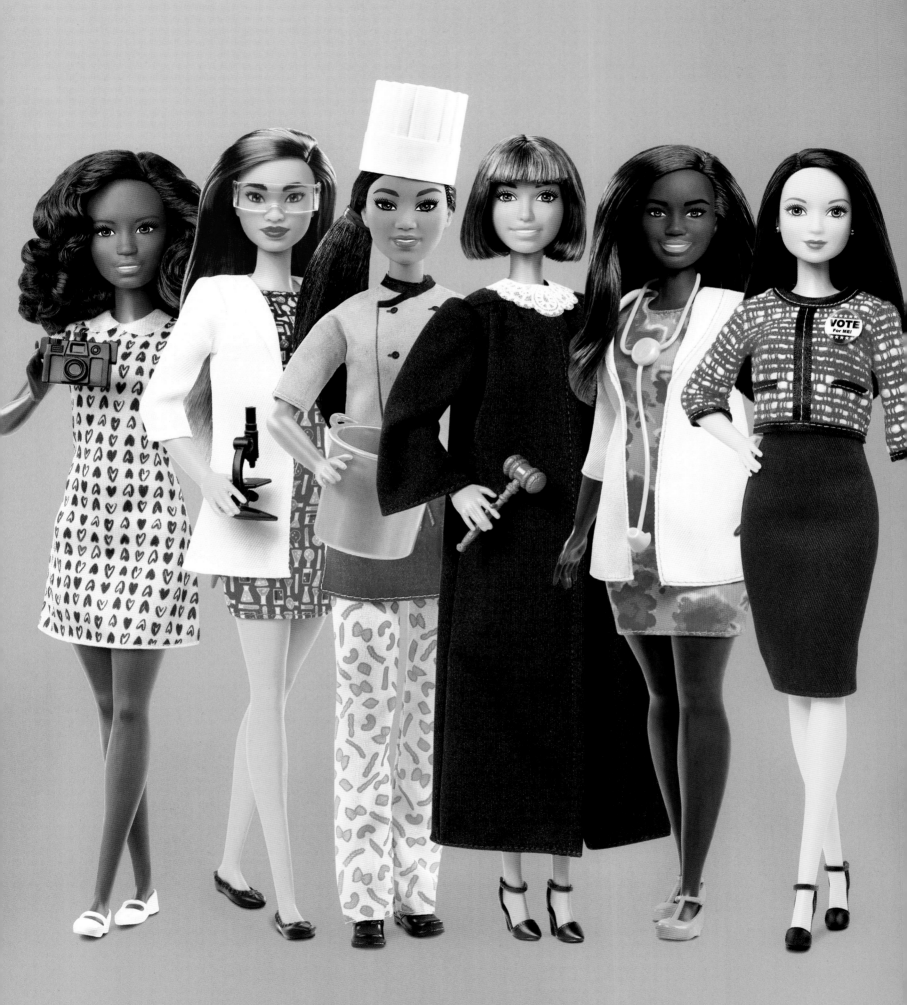

20 18

Baseball player
GOLFER
Saxophonist
ROBOTICS
ENGINEER

2021
• Firefighter •
• Violinist •
• Zoologist •
• Keyboardist •
• Lifeguard •

ASTROPHYSICIST
Entomologist
Judge
MARINE
BIOLOGIST
PoP
STAR
2019

2022

Soccer player
MAKEUP
ARTIST
Microbiologist

THE
PRESIDENT OF
UNITED STATES OF AMERICA
TRAINER
General Manager
Referee
Reporter
20 23

2020
BOXER
OLYMPIC
ATHLETE
Tennis Player
VOLLEYBALL PLAYER

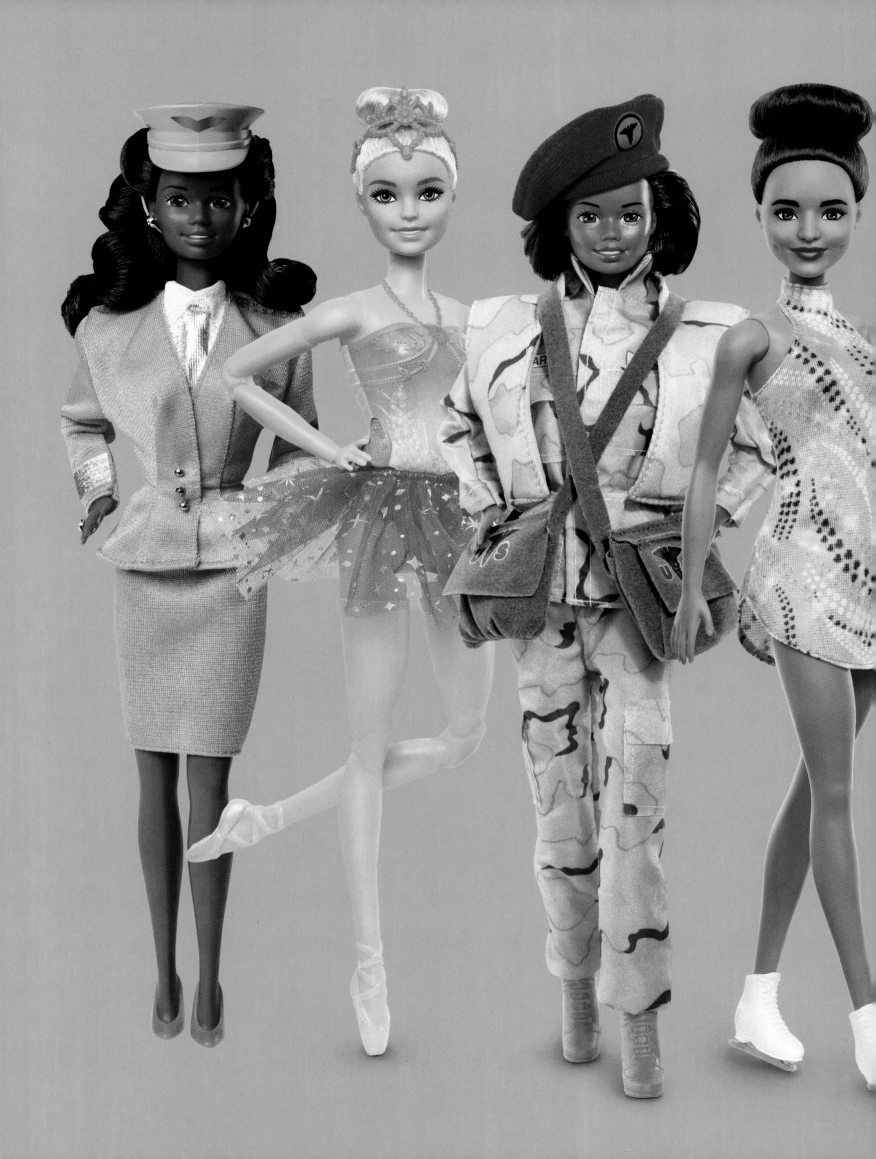

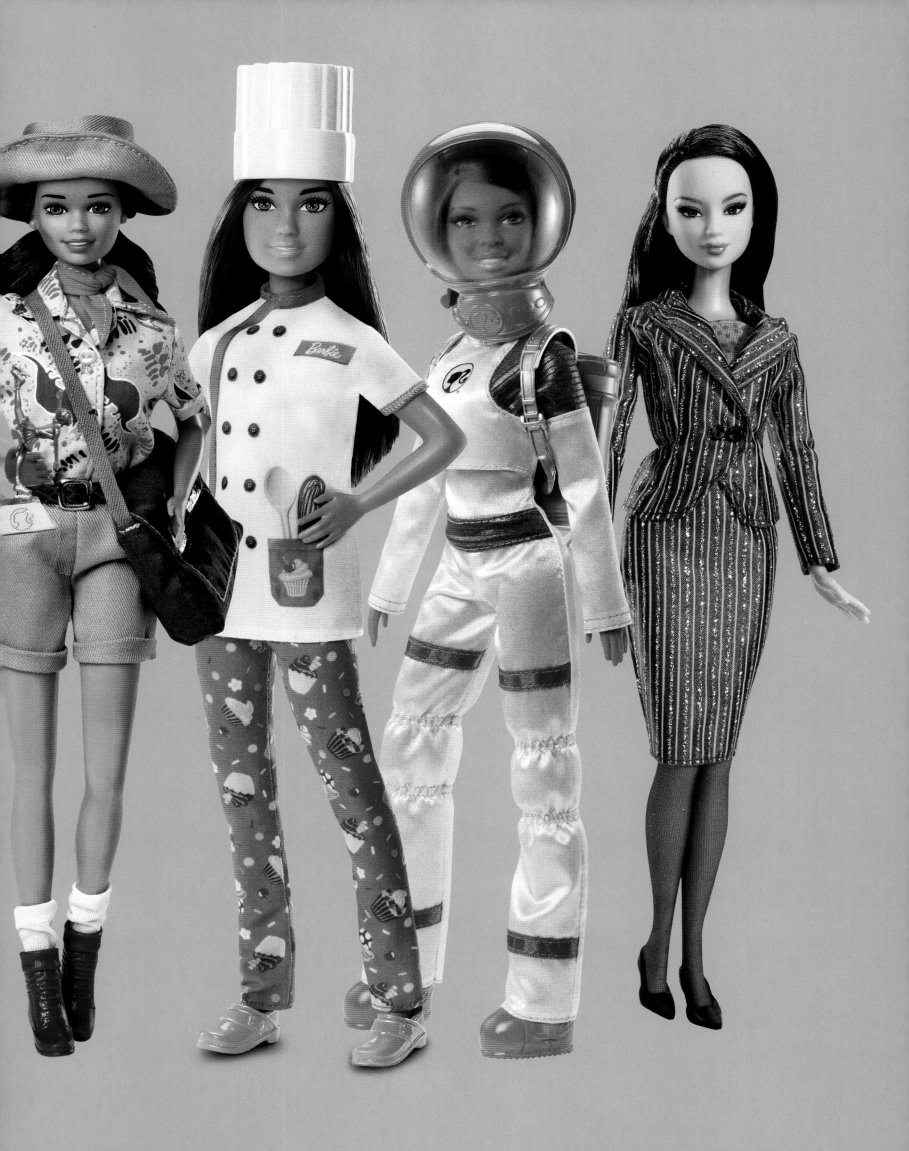

However, the sought-after elegance of the early sixties, of which Barbie is a reflection, soon became outmoded.

In 1964 Beatlemania exploded in the U.S. after the Beatles' appearance on the *Ed Sullivan Show*. It was the start of the "British Invasion"!

In London Mary Quant launched the miniskirt, while in 1965 in Paris, Yves Saint Laurent introduced his Mondrian collection, a high point in the symbiosis between art and fashion. In 1964 André Courrèges launched the *Space Age* collection inspired by the beauty of the moon and outer space, and in 1966 Paco Rabanne introduced the first line of body jewelry, outfits made from small plastic and metal pieces. In 1968 Cristóbal Balenciaga retired from the fashion world: he was openly against the new needs of a style that seemed to have waived the elegance and sartorial cut that this Spanish genius loved. That same year Valentino designed his first red outfit: Valentino Red would soon become a legend.

Mattel's fashion designers traveled to Europe twice a year to study all these changes in style, after which they would transfer them to Barbie's wardrobe. Inevitably, from the mid-sixties the technical and aesthetic changes made to the doll followed hard on the heels of what was new, especially in British fashion. London had become the capital of fashion and youth culture. In 1967 the Beatles opened their Apple Boutique on Baker Street, which sold hippie-gypsy-style outfits. The ostentation of luxury and haute couture elegance was beginning to make way for a more practical fashion, demanded by a generation of young people who, from the mid-sixties, were beginning to gain momentum. It was handcrafts versus industrial production, haute couture against prêt-à-porter. "The English are here!" exclaimed Diana Vreeland upon welcoming to her New York *Vogue* office the model Jean Shrimpton and the Swinging Sixties photographer David Bailey. The new model of beauty was represented by Twiggy, while in the United States the hippie look took over, midi and maxi skirts, bell-bottom trousers, for a sort of anti-fashion that was an expression of the youth movement that rejected consumerism and American politics.

In 1971 Twiggy showed up at the opening night of Ken Russell's movie *The Boy Friend* wearing an outfit designed by Bill Gibb. It was the triumph of the Mix&Match style, and Barbie, with *Live Action* (1971), was almost totally immersed in the hippie culture of those years.

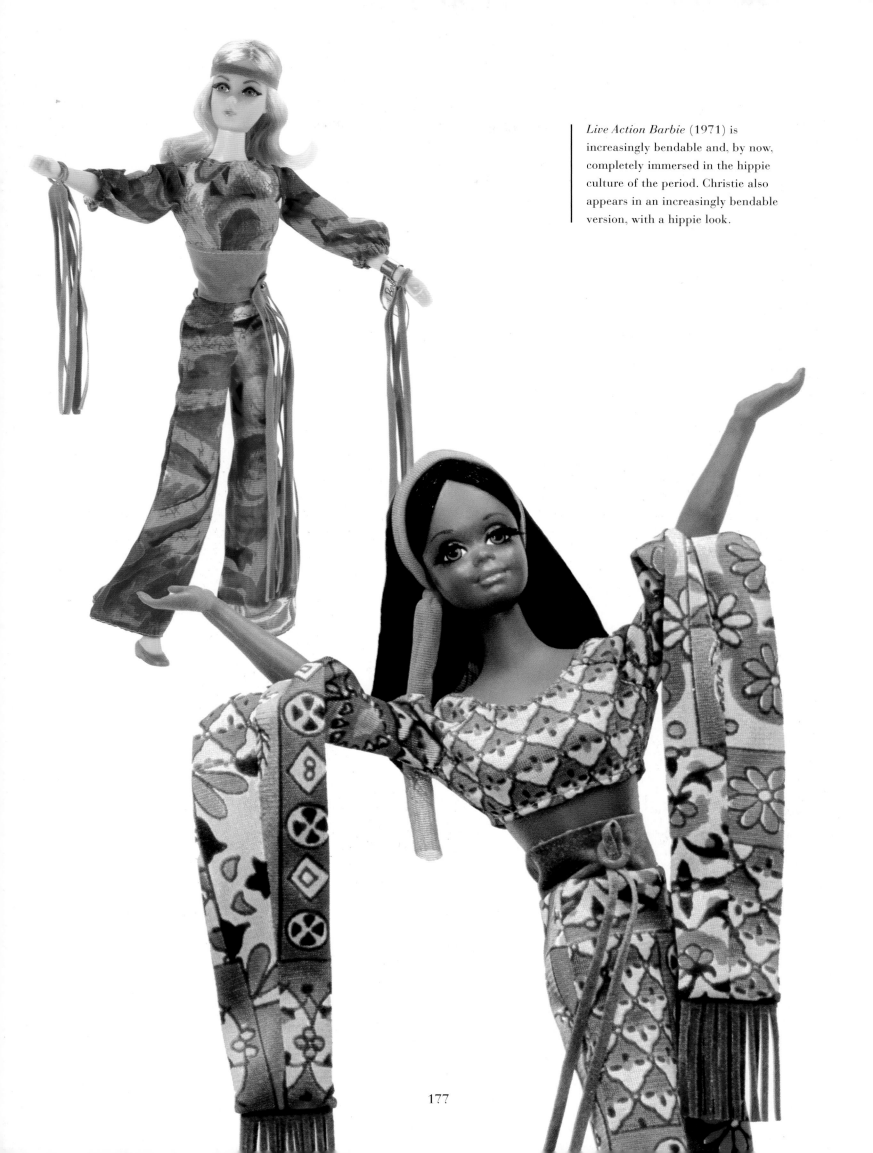

Live Action Barbie (1971) is increasingly bendable and, by now, completely immersed in the hippie culture of the period. Christie also appears in an increasingly bendable version, with a hippie look.

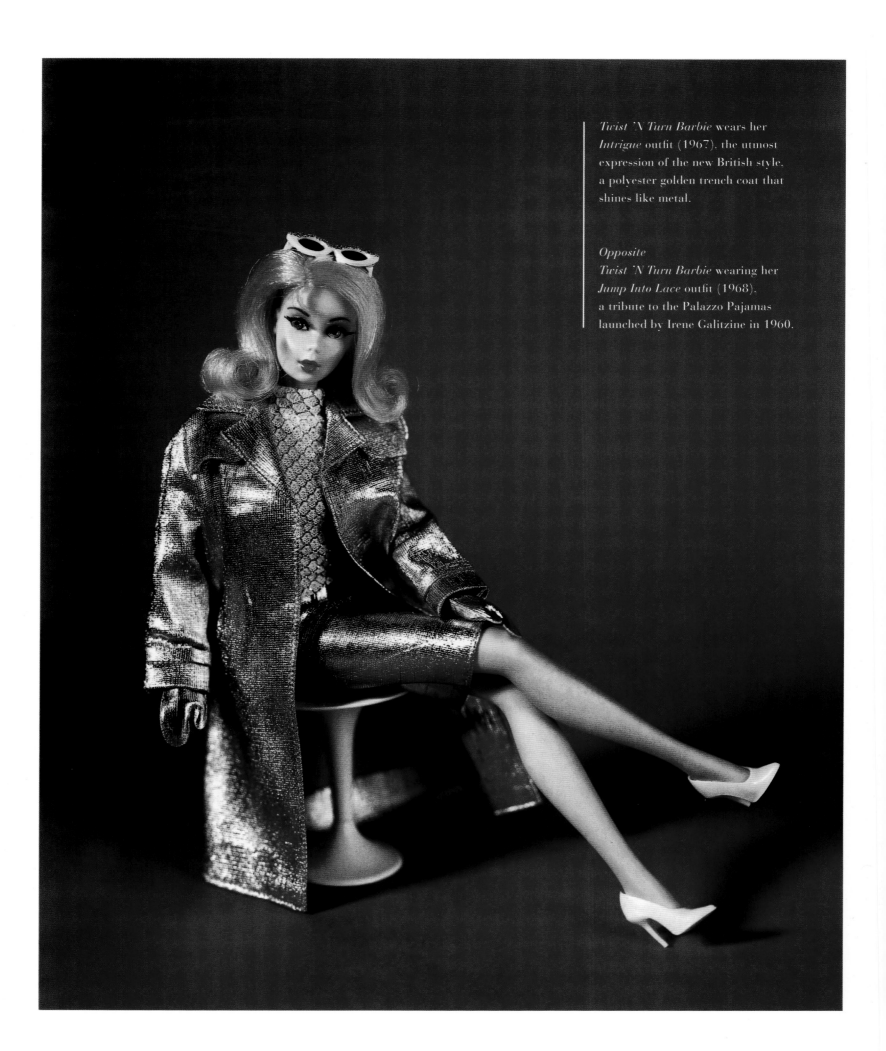

Twist 'N Turn Barbie wears her *Intrigue* outfit (1967), the utmost expression of the new British style, a polyester golden trench coat that shines like metal.

Opposite
Twist 'N Turn Barbie wearing her *Jump Into Lace* outfit (1968), a tribute to the Palazzo Pajamas launched by Irene Galitzine in 1960.

Barbie's style had changed radically: "The gorgeous outfits I wore in the early sixties, which I was so happy to wear and that needed lots of work done to them so that I'd look perfect, have made room for livelier, younger creations!" In 1967 Barbie sported *Intrigue*, the utmost expression of the new English style; this metallic gold trench coat was so new that it made Valerie Steele exclaim "*James Bond, move over!* Barbie now looked like Emma Peel in *The Avengers* or the *Girl from U.N.C.L.E.*"

Jump Into Lace (1968) was a reminder of the Palazzo Pajamas that Irene Galitzine had launched in 1960, while Emilio Pucci's multicolored graphics were the model for the new and very colorful 1967 collection, which included, among others, *Tropicana*, *Sunflower*, *Pajama Pow!*, and *Stripes Away*.

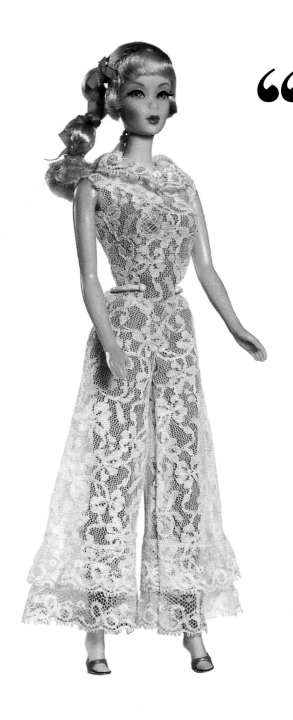

> **My whole philosophy of Barbie was that, through the doll, the little girl could be anything she wanted to be. Barbie always represented the fact that a woman has choices. Everything is possible.**

RUTH HANDLER
FOUNDER, ENTREPRENEUR, AND PIONEER

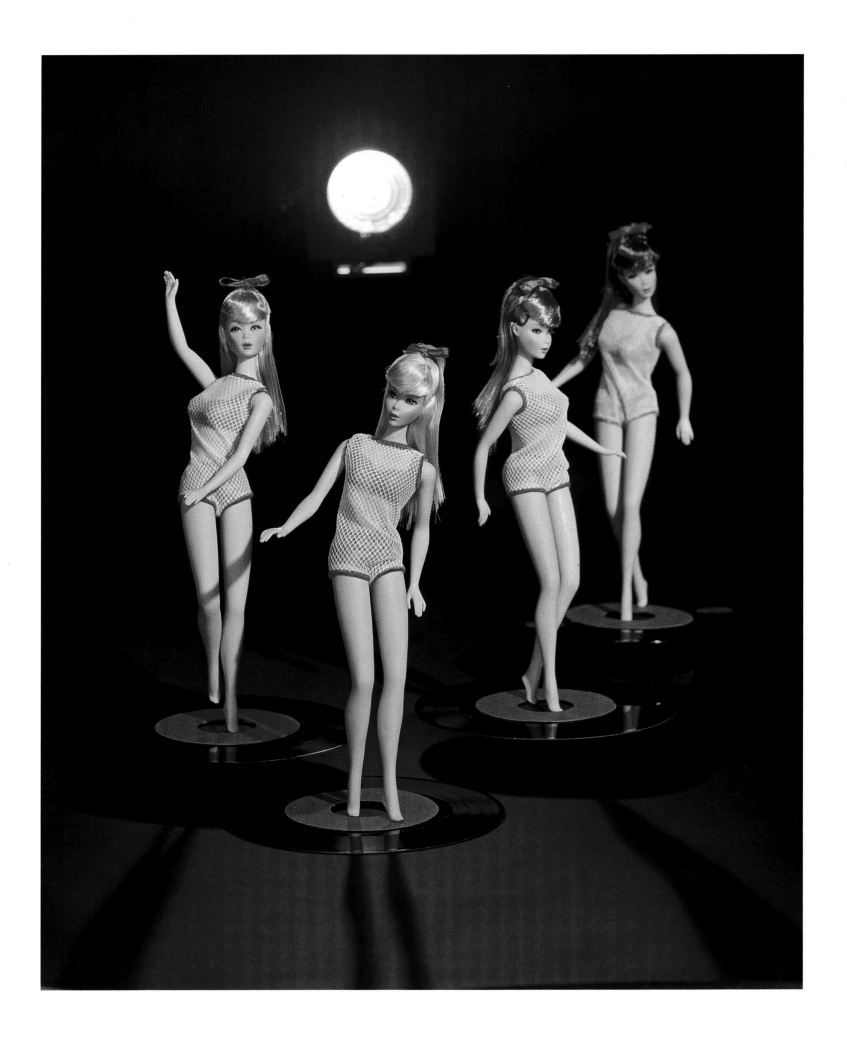

These radical changes in life-
style correspond to the first great
makeover in Barbie's physiog-
nomy, which took place in 1967
when the *Twist 'N Turn* model was
made: this featured a pivoting waist,
completely different makeup, rooted
lashes made of synthetic fiber, bigger
eyes, and hair that was tied at the top of
her head with a colored bow. Aesthetically
speaking, there had been a complete break-
through. Barbie was no longer identifiable with the
American pin-ups or the great fifties Hollywood stars; she
was now identified with the new British fashion icons, from
Jean Shrimpton to Twiggy: blonde, tall, with big eyes and long
eyelashes. In 1967, the new, pivoting *Twist 'N Turn Barbie
Doll* also wore a bright orange bikini in the latest style, rather
like the one worn by the actress Marilyn Tindall in the 1967
swimsuit edition of *Sports Illustrated*.

In 1968 Barbie could finally talk. To make *Talking Barbie*
talk all one had to do was pull the string on her back to acti-
vate a mechanism and hear her say any one of the following:
*What shall I wear to the prom?; I have a date tonight; Would
you like to go shopping?; Stacie and I are having tea; Let's
have a costume party; I love being a fashion model.*

Super
Foreve

star...
r

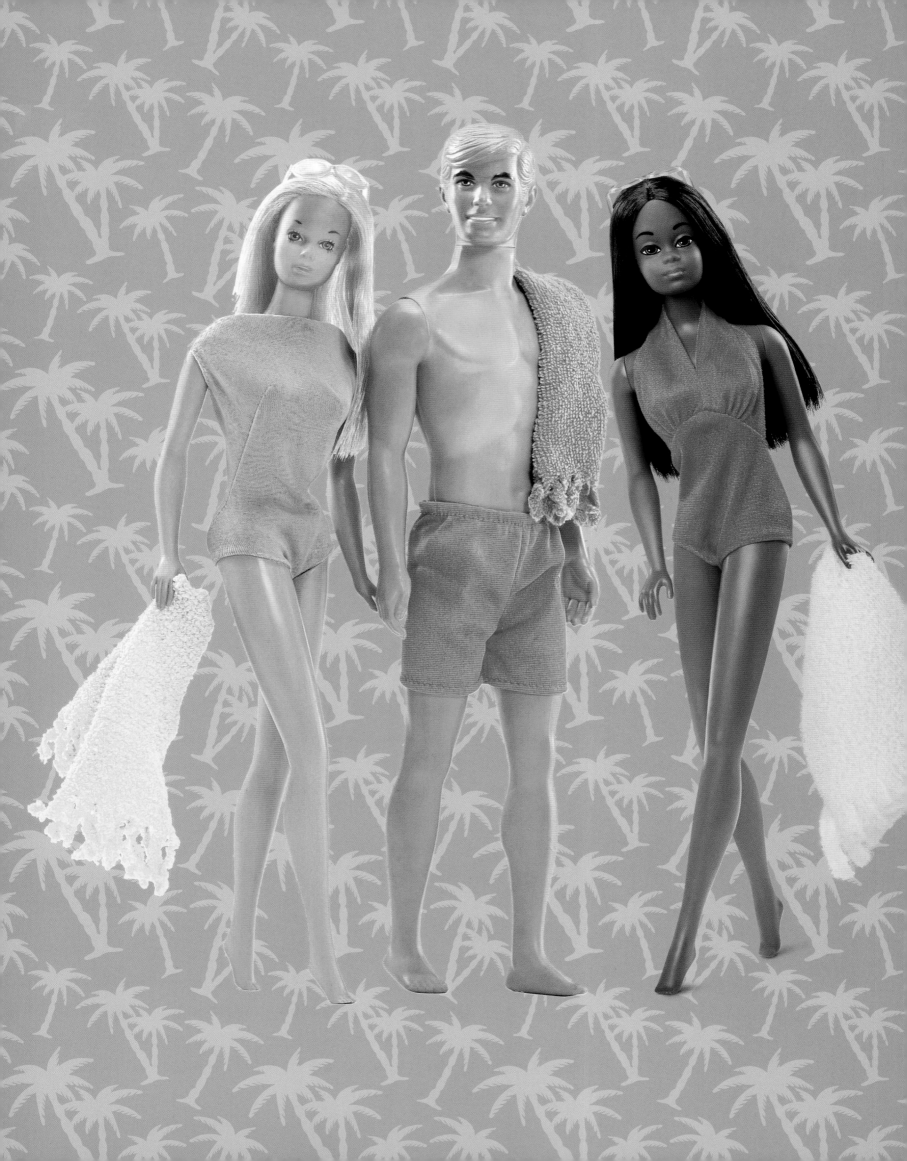

Barbie and Ken in *Malibu* version (1971), with tanned skin and gleaming blue eyes, the utmost expression of California style. Christie, too, appears in a *Malibu* version with a coral red swimsuit.

The focus in the early seventies was to make Barbie increasingly bendable. *Dramatic New Living Barbie* (1970), *Live Action Barbie* (1971), and *Busy Barbie* (1972) were manufactured, the latter of which had hands with thumbs and could grip her accessories.

Having cast aside the elegance of the finishings and the evocative names of the outfits from the early sixties, these were now characterized by the label "best buy" and a code. All the same, the packaging was renewed, with the introduction of a pink box that featured art nouveau lettering and would be used for more than a decade.

During those same years the manufacturing of Barbie spread to other countries besides Japan and Korea, ones that could guarantee both quality and low cost. On the bodies of Barbie and her family and friends, alongside the Mattel brand, the words Made in Mexico, Taiwan, or the Philippines appeared. Together with the new company strategies and the proposals of a prevalently technical nature, Barbie was ready for a new aesthetic turnaround: in 1971 *Malibu Barbie* arrived on the scene, one of the most successful models in terms of appeal and longevity. This tanned Barbie wore a basic aqua blue swimsuit, and her accessories included a yellow beach towel, typically pink sunglasses, and, for the first time ever, shiny blue eyes

that gazed straight ahead. *Malibu Barbie*'s hair was platinum blonde and from now on there would never again be any doubts about Barbie being a real blonde icon. In 1974 *St. Moritz Barbie* was born, an interpreter of the tastes of the most sophisticated ladies and members of the international jet set who loved to spend their winter holidays in this Swiss resort, from the slopes to the parlours, wrapped in colorful outfits designed by Emilio Pucci. By that time, Barbie had become the doll of the century, and wearing a blue top and red skirt printed with revolutionary soldiers and the stars and stripes, she was added to the 1976 Time Capsule, due to be opened in 2076 on the occasion of the tricentennial of American independence so that future generations can learn about twentieth-century customs and traditions. The real breakthrough for Barbie took place in 1977, however, when Mattel asked Joyce Clark to design some new facial features for the doll inspired by the American actress Farrah Fawcett, the star of the TV series *Charlie's Angels*. *Superstar Barbie* was created, wrapped in a dazzling shocking pink satin evening gown, a lamé boa, and supported by a star-shaped stand, ready to head down to the dance floor and dance to the rhythm of the disco music that had become all the rage that year thanks to the Bee Gees' soundtrack for the movie *Saturday Night Fever*.

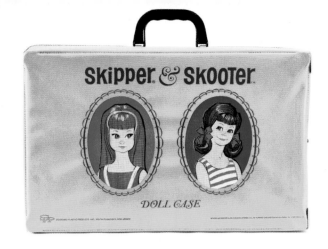

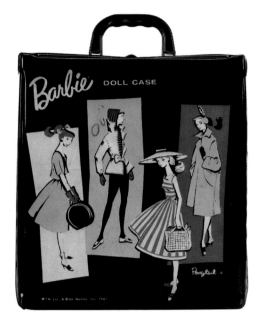

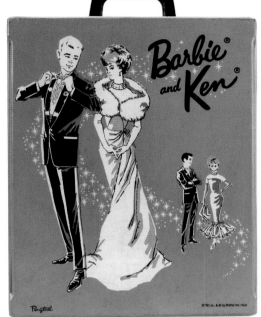

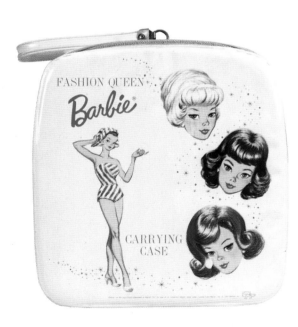

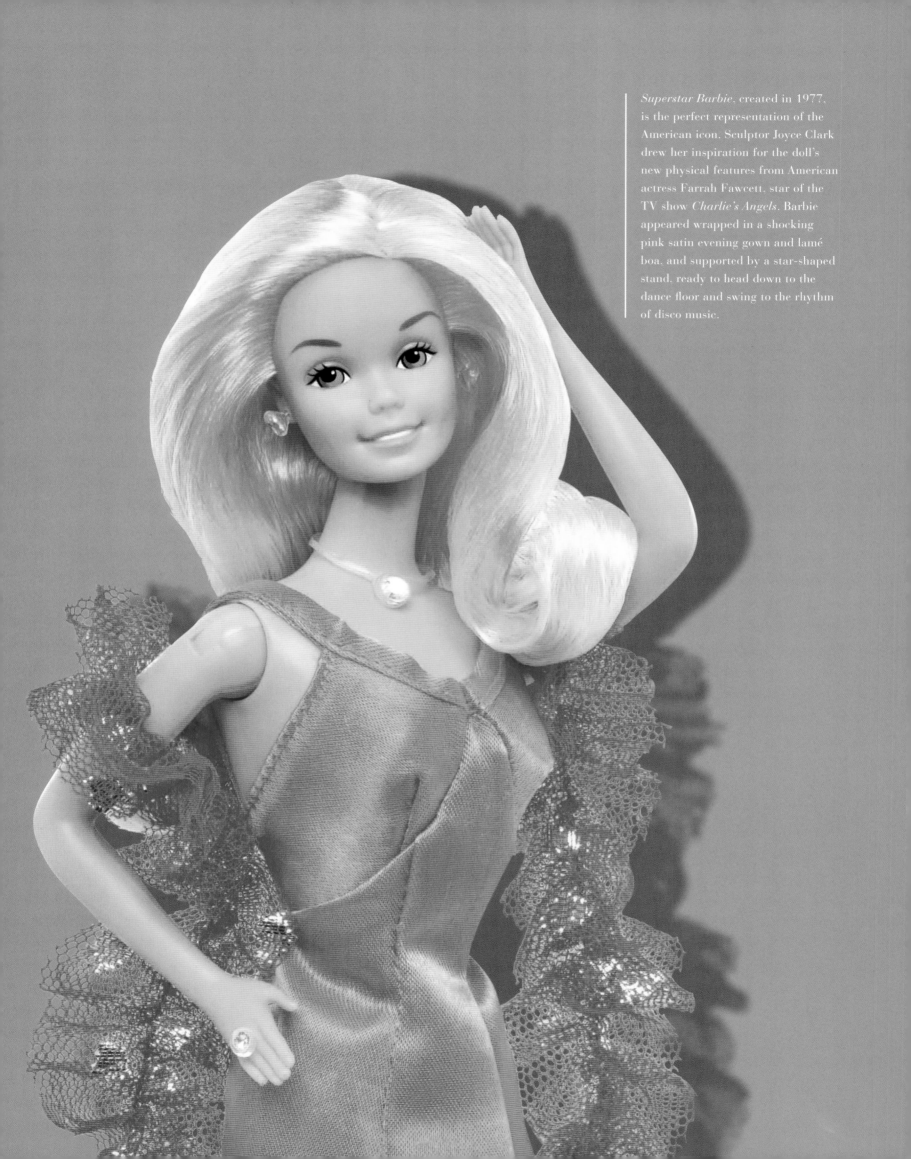

Superstar Barbie, created in 1977, is the perfect representation of the American icon. Sculptor Joyce Clark drew her inspiration for the doll's new physical features from American actress Farrah Fawcett, star of the TV show *Charlie's Angels*. Barbie appeared wrapped in a shocking pink satin evening gown and lamé boa, and supported by a star-shaped stand, ready to head down to the dance floor and swing to the rhythm of disco music.

As compared with the past, every single thing about Barbie had changed: the shape of her face was different, and she now had bright eyes with typically blue eyeshadow, an open-mouthed smile with coral lipstick, and the design of her body and her posture had been modified as well. This doll would be produced throughout the eighties, with some variations in makeup and hairstyle.

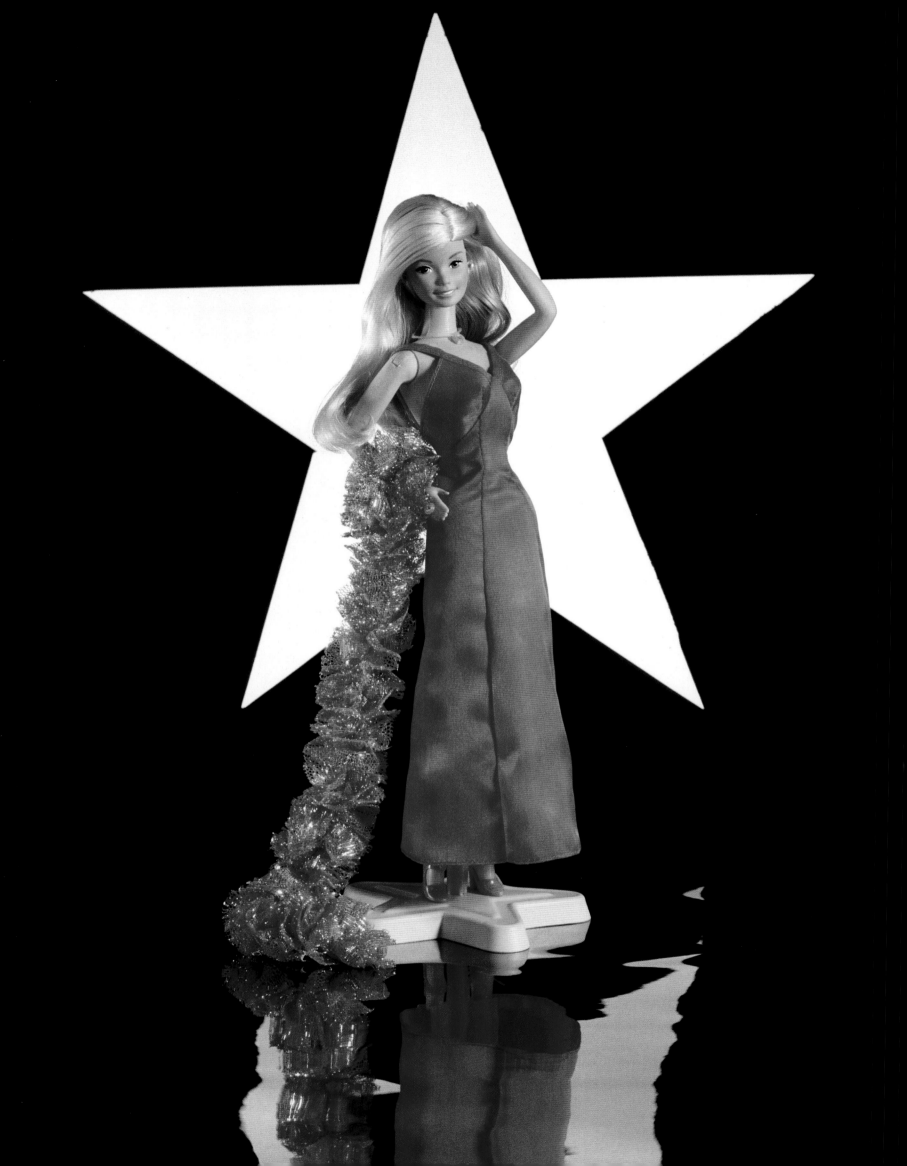

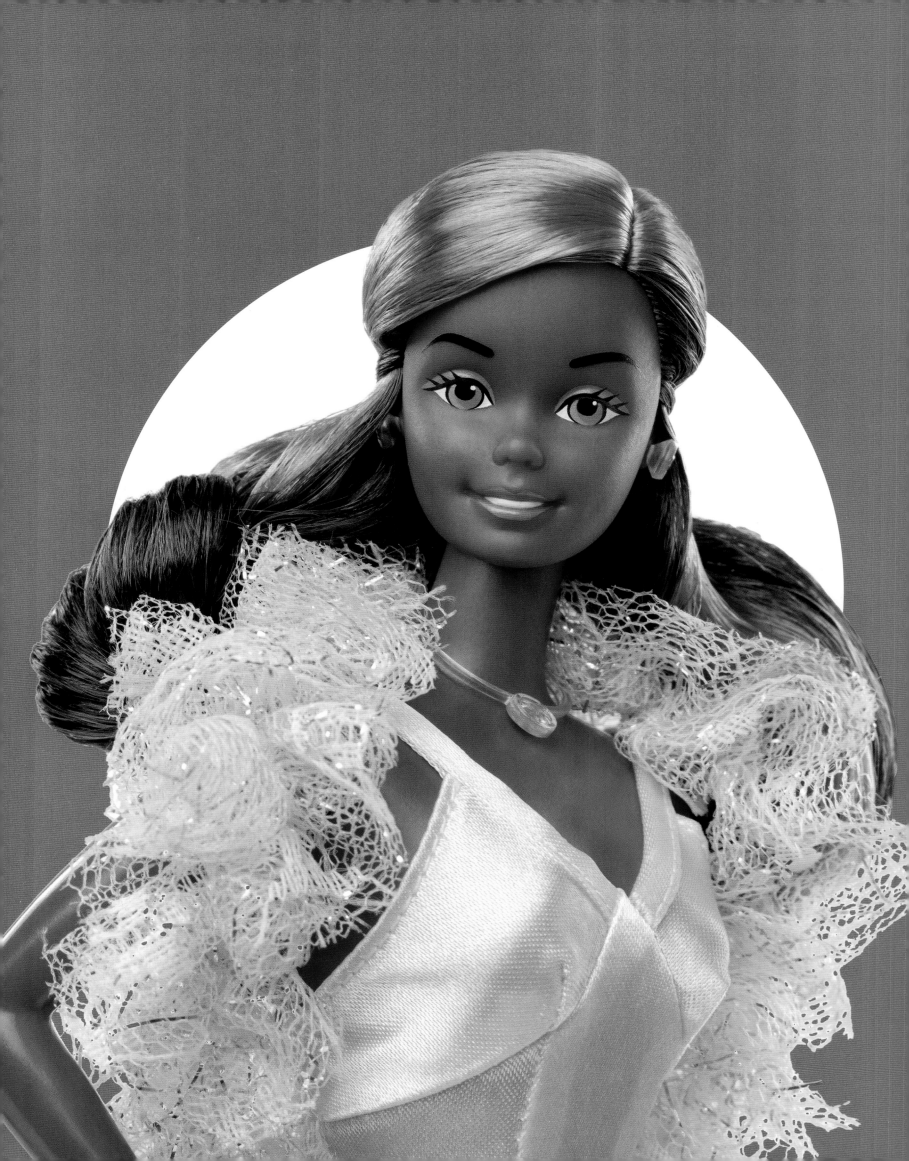

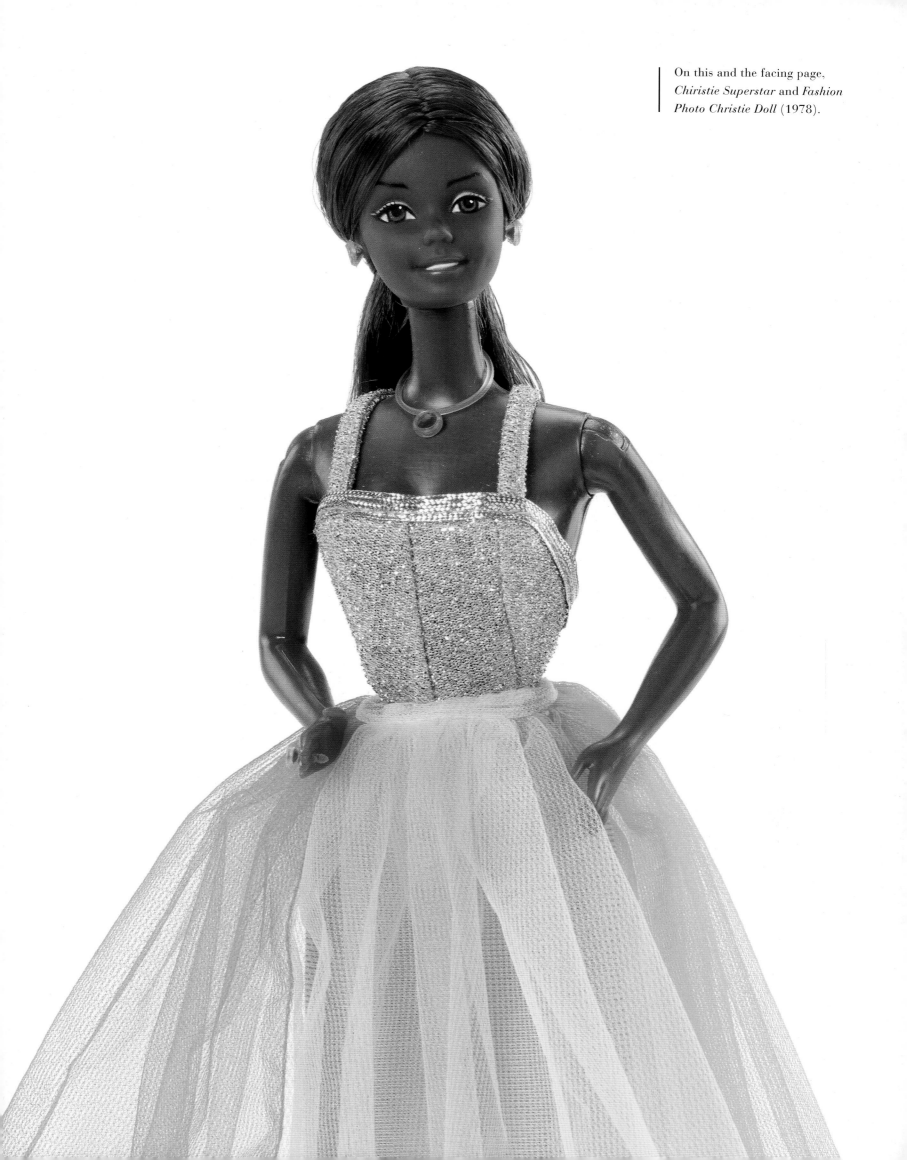

On this and the facing page, *Chiristie Superstar* and *Fashion Photo Christie Doll* (1978).

We are Barbie

One of the most modern and original aspects of the Barbie story is the search, dating back to 1964, for bonds among different cultures, a diversity understood as a fundamental contemporary value. Barbie manages to strike down all linguistic, cultural, social, and anthropological boundaries.

With Barbie young people around the world had an opportunity to understand new cultures. In order to strengthen this important message of brotherhood, after two chance episodes in 1964 and 1969, Mattel launched new models in which Barbie became the spokesdoll par excellence for the contemporary transformations of fashion and society into an increasingly inclusive and multiethnic vision.

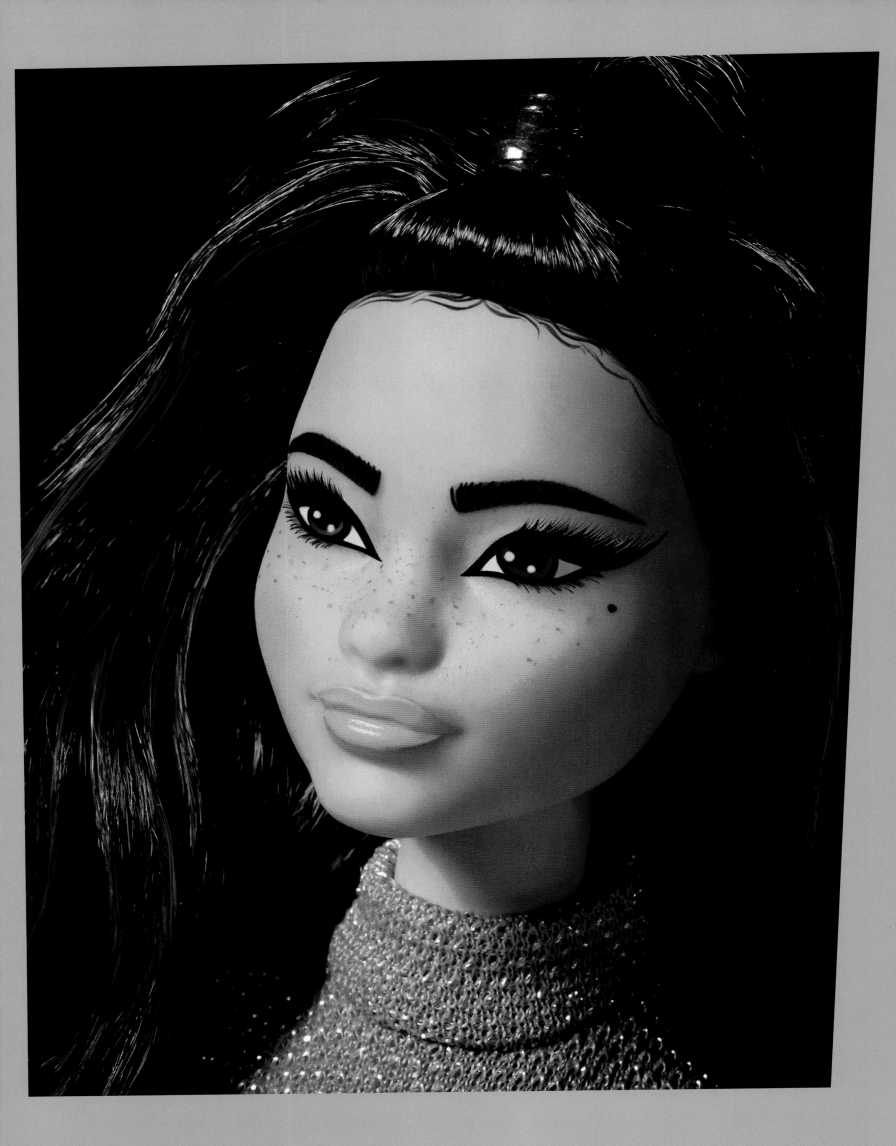

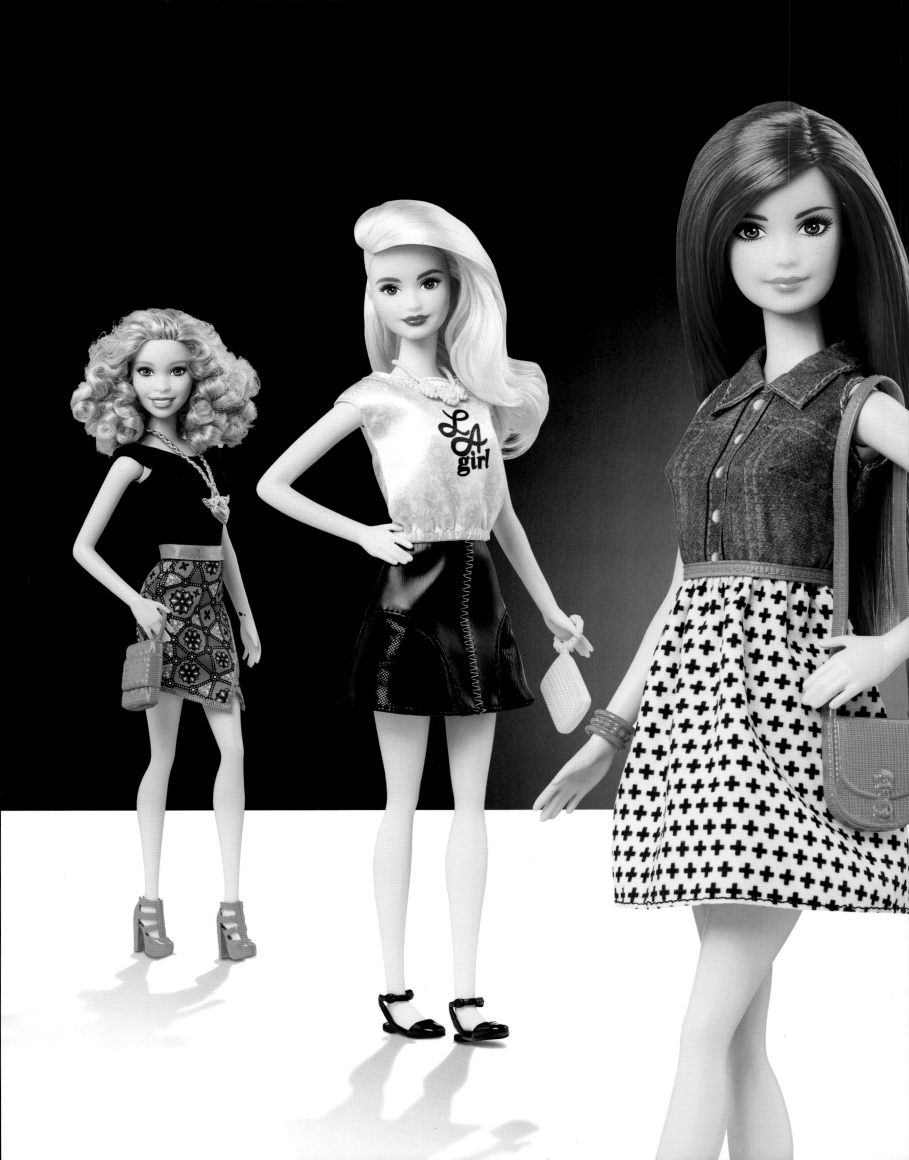

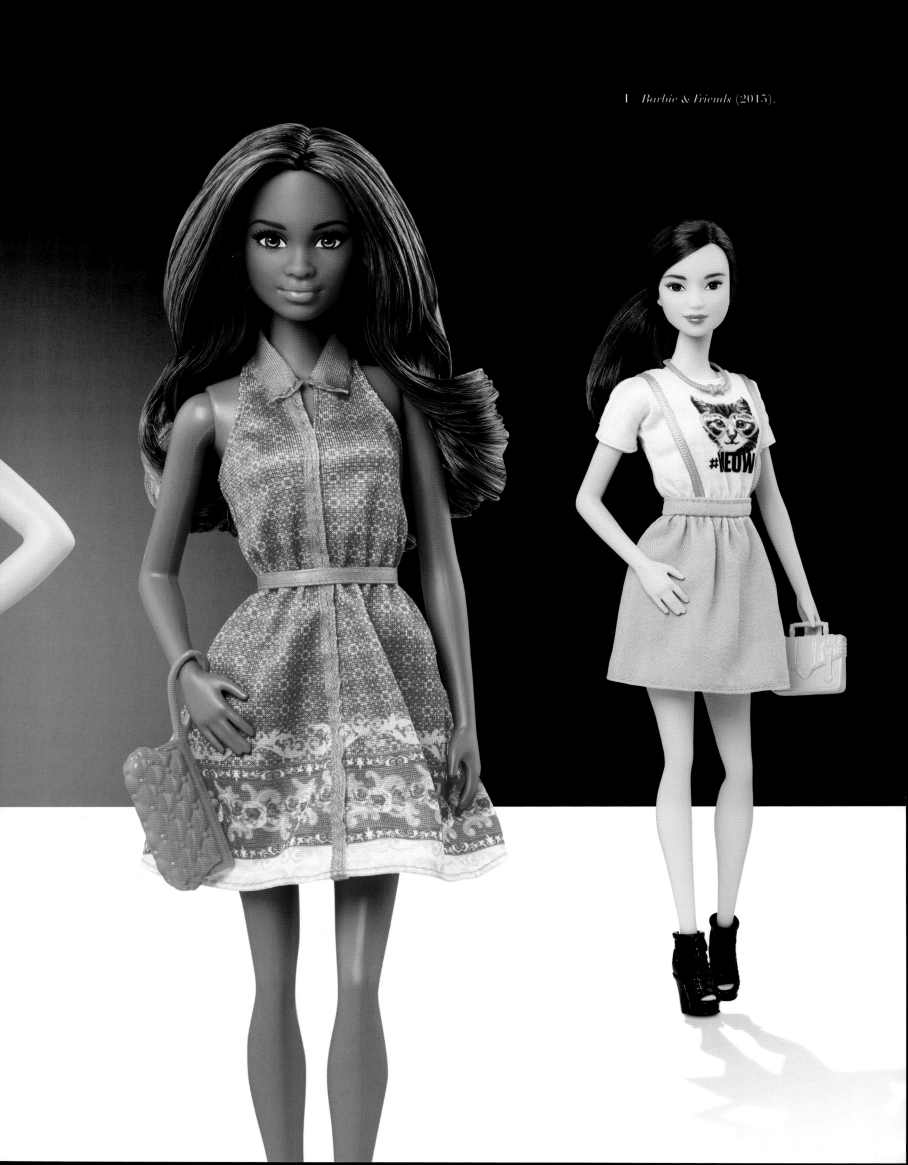

In 1980 for the first time ever Barbie was Black: called *Black Barbie*, she had sophisticated makeup, brown eyes, and curly hair. In those years, two molds were used to produce Barbie dolls: with her arms outstretched (*Palm to Rear* model, wearing a swimsuit), and with her arms in an L shape (*Bent Arms* model, wearing an outfit complete with accessories, earrings, and a ring). In the eighties fashion was not (just) what you saw on the catwalks. Anything new came directly from the TV and advertising. Those were the years of the "American Dream," a dream of beauty and well-being, affluence, and consumerism, which everyone aspired to. Barbie adapted to and crossed the eighties following all the major trends. In the wake of the success of the TV series *Dallas*, aired in America from 1978, *Western Barbie* (1981) riding her charger Dallas was created. *Great Shape Barbie* (1984) celebrated the new aerobic exercise fad made famous by an exceptional godmother, the adrenaline-pumping Jane Fonda, who encouraged women everywhere to put on their leg warmers and work out to the rhythm of disco music. Those were also the years of the go-getting yuppies, young and ambitious Americans just out of college striving for money and success. They worked in the skyscrapers of Manhattan, wore Giorgio Armani and Versace, and collected the artwork of Jean-Michel Basquiat. In the evenings they'd go to exclusive restaurants and discos, such as Manhattan's famous Studio 54. *Day-to-Night Barbie* (1985) embodied this dynamic lifestyle perfectly: she came with a strawberry double-breasted suit for the daytime career woman, as well as a chiffon and lamé evening gown that turned her into a femme fatale at night.

Black Barbie first appeared in 1980, featuring sophisticated makeup, brown eyes, and curly hair.

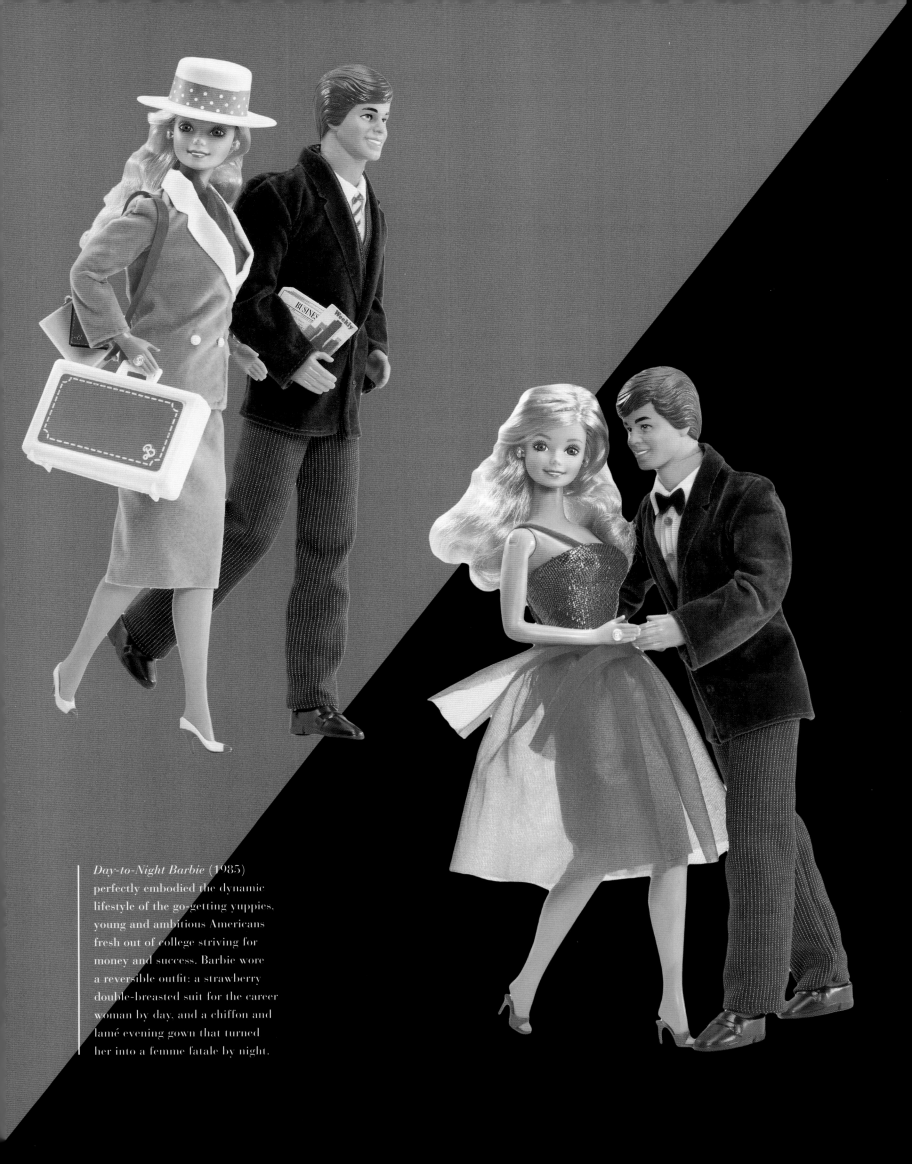

Day-to-Night Barbie (1985) perfectly embodied the dynamic lifestyle of the go-getting yuppies, young and ambitious Americans fresh out of college striving for money and success. Barbie wore a reversible outfit: a strawberry double-breasted suit for the career woman by day, and a chiffon and lamé evening gown that turned her into a femme fatale by night.

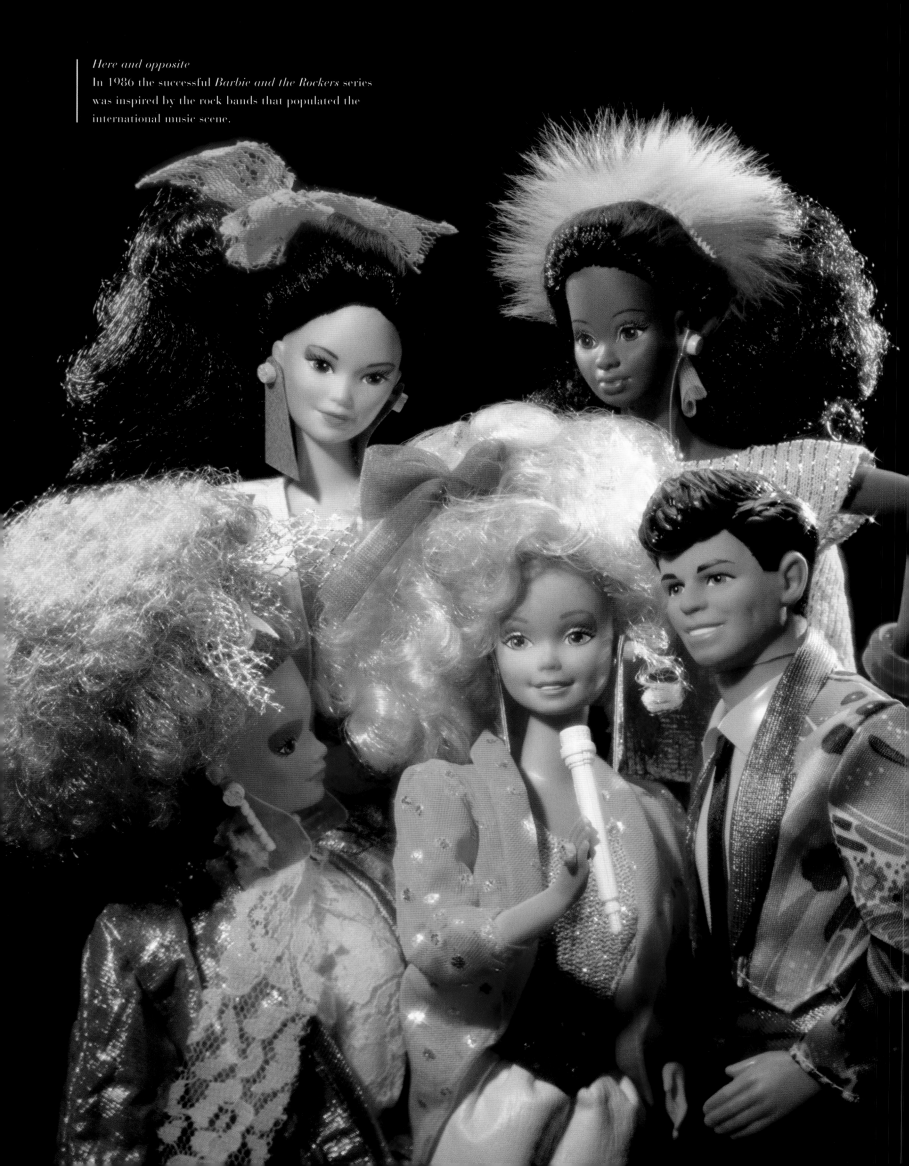

Here and opposite
In 1986 the successful *Barbie and the Rockers* series
was inspired by the rock bands that populated the
international music scene.

In 1986 the popular series called *Barbie and the Rockers* was made, inspired by the rock bands that populated the international music scene. Also produced that year was the first fine bisque porcelain Barbie called *Blue Rhapsody*, made for an adult market and representing a new frontier in collecting that in the decades to come would lead to the creation of several other precious lines and specimens. After embodying the fashion of her time, from the mid-eighties onwards Barbie became the source of inspiration for fashion itself. Collaborations with some of the most famous fashion designers began, new editions of rare vintage models were put on the market, and the relationship between Barbie and the great myths of cinema and fashion was reinforced. The first fashion designer to place his signature on the doll's packaging was

BillyBoy*, who, in 1984, made a series of models and prototypes (some of which were not realized until 1989) in which Barbie sported some very refined haute couture creations, presented in Paris along with a brand new doll called *Barbie BillyBoy*.* This was created on the occasion of the traveling exhibition *Nouveau Théâtre de la Mode* (1985), organized to celebrate Barbie's 26th birthday, as well as being a tribute to the historic exhibition *Le Petite Théâtre de la Mode* (April 1945, Musée des Arts Décoratifs), which had included over 150 wire dolls dressed by the most famous French *maisons*, and thanks to which Paris had been able to resume its place as fashion capital of the world after the war. In 1986 BillyBoy* again designed for Mattel the sophisticated *Feelin' Groovy Barbie* (produced in 1987), and that same year

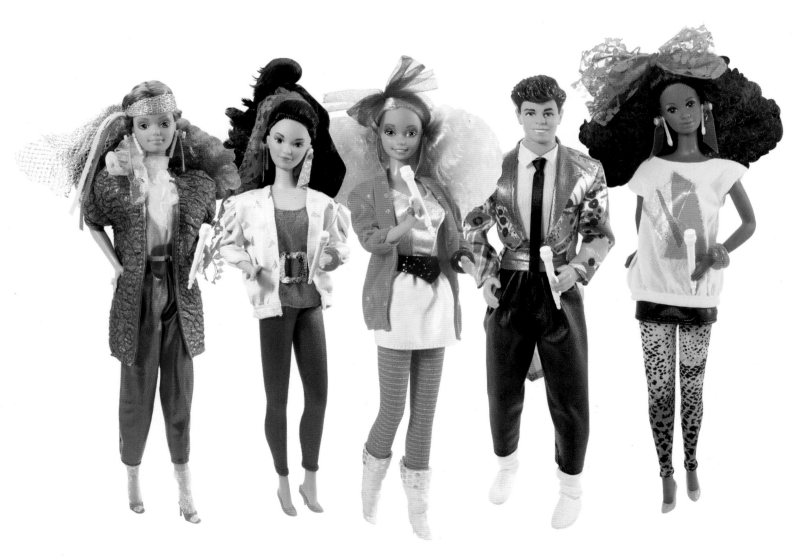

In 1986 BillyBoy* designs the sophisticated *Feelin' Groovy Barbie* (produced in 1987), after creating the 1985 Barbie for the *Nouveau Théâtre de la Mode*.

Opposite
Superstar Barbie wears an outfit by Oscar de la Renta designed in 1985 for a collection of four haute couture outfits that were created especially for Barbie, and could be purchased separately from the doll.

this particular model was immortalized in Andy Warhol's famous portrait *BillyBoy* as Barbie*. The work, unveiled in New York on February 10, 1986, is a tribute to BillyBoy*'s love for Barbie; indeed, when Warhol had insisted that he wanted to make a portrait of him, BillyBoy*'s reply had been: "If you want to do my portrait, do Barbie, because Barbie, *c'est moi*" (BillyBoy*, 1985). The designer's answer, an allusion to Gustave Flaubert's famous words "Emma Bovary, c'est moi," gave Warhol the idea of making a double portrait of Barbie, the first of which with a very bright blue background, inspired by the *Surreal Couture BillyBoy** jacket, donated to BillyBoy* himself, the second with a reddish-orange background, acquired by Mattel for 75,000 dollars. The face immortalized by Warhol is that of *Superstar Barbie* (1977), the most American of all the models produced, whose features were initially outlined by Warhol on a 1980 picture of Barbie from BillyBoy*'s private collection. As for the relationship between this portrait and the works Warhol is most famous for, Eric Shiner, director of the Andy Warhol Museum in Pittsburgh, has noted how Warhol's icons, such as the portraits of Marilyn or Liz Taylor, are as famous today as Leonardo da Vinci's *Mona Lisa*, and are equal in importance to other famous works by the artist, such as his *Campbell's Soup Cans*, *Flowers*, and *Coca-Cola Bottles*. On a par with these commercial legends Barbie was also famous around the world as a purely mass phenomenon, but when Warhol made his *Myths* series in 1981, which included Mickey Mouse, the Wicked Witch from the *Wizard of Oz*, and even Howdy Doody, oddly he did not make a portrait of her. And so it is thanks to the 1986 work inspired by BillyBoy* that Barbie was transformed from mass toy to global icon and timeless work of art, the last American icon portrayed by Warhol before he passed away a year later in New York.

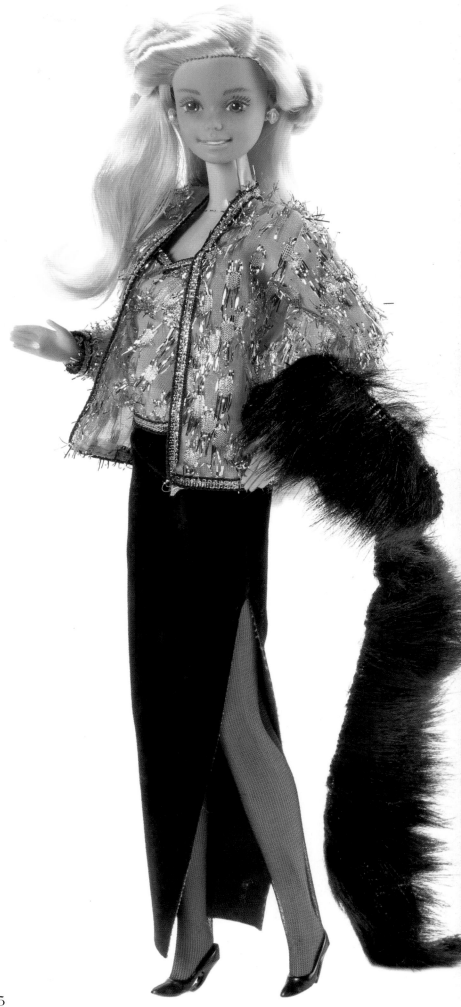

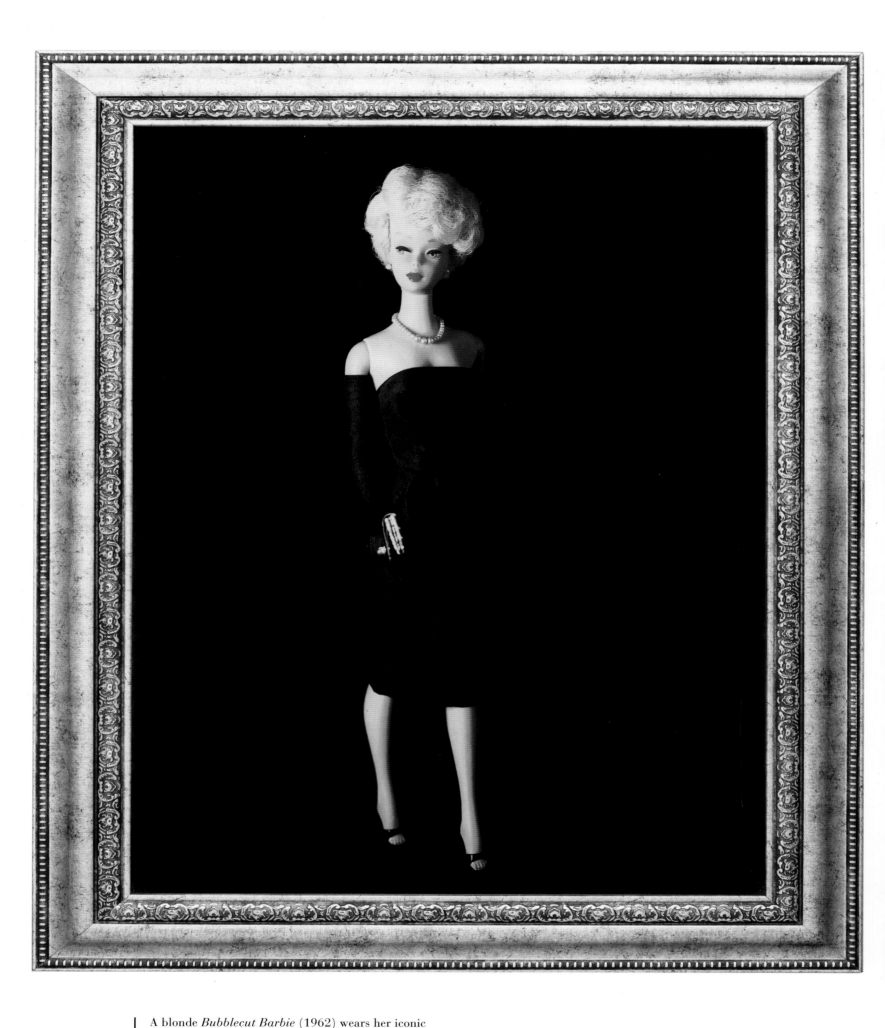

A blonde *Bubblecut Barbie* (1962) wears her iconic
1964 *Black Magic Ensemble* in this picture taken
by David Levinthal (1998).

art

Barbie *American Girl* (1965) shows off her *Modern Art* outfit (1964), a floral dress in silk tulle complete with an Impressionist painting and an invitation to a gallery.

Barbie inspires art and art inspires Barbie. Art has always been an inspiration for Barbie: ever since the early sixties she has shared a conversation with the world of painting, museums, and art galleries. Barbie's *Modern Art* outfit was created in 1964. This floral dress in silk tulle came complete with an Impressionist painting and an invitation to a gallery (Mattel / Art Gallery / PAINTINGS / by / Barbie® / © 1964 Mattel Inc. Japan). *Modern Art* was the prelude to the refined *Artist Series*, inaugurated in 1997 and 1998, which in turn paid tribute to the greatest names in the art world. The dolls in this series were dressed in outfits that reproduced some of the best-known paintings in art history: *Water Lily Barbie Doll*, inspired by Claude Monet's lilies, and *Reflections of Light Barbie Doll*, inspired by the light effects in the work of Pierre Auguste Renoir. In 2011, in the *Museum Collection* series, Barbie was the interpreter of some of the icons of painting, from Leonardo da Vinci to Klimt, from Van Gogh to Manet, and to Dalí.

Barbie herself has inspired many contemporary artists who, thanks to their multifarious interpretations, have been behind some of the greatest moments in her history. In 1986 Andy Warhol created *Portrait of BillyBoy* as Barbie* (a tribute to the fashion designer BillyBoy*), proof of Barbie's artistic and cultural relevance, and the confirmation of her place as the queen of pop culture, the same culture that has turned her into a full-fledged, timeless work of art. Photographer David Levinthal immortalized Barbie in a series of seventy-five Polaroids taken in 1998 that transformed Barbie into

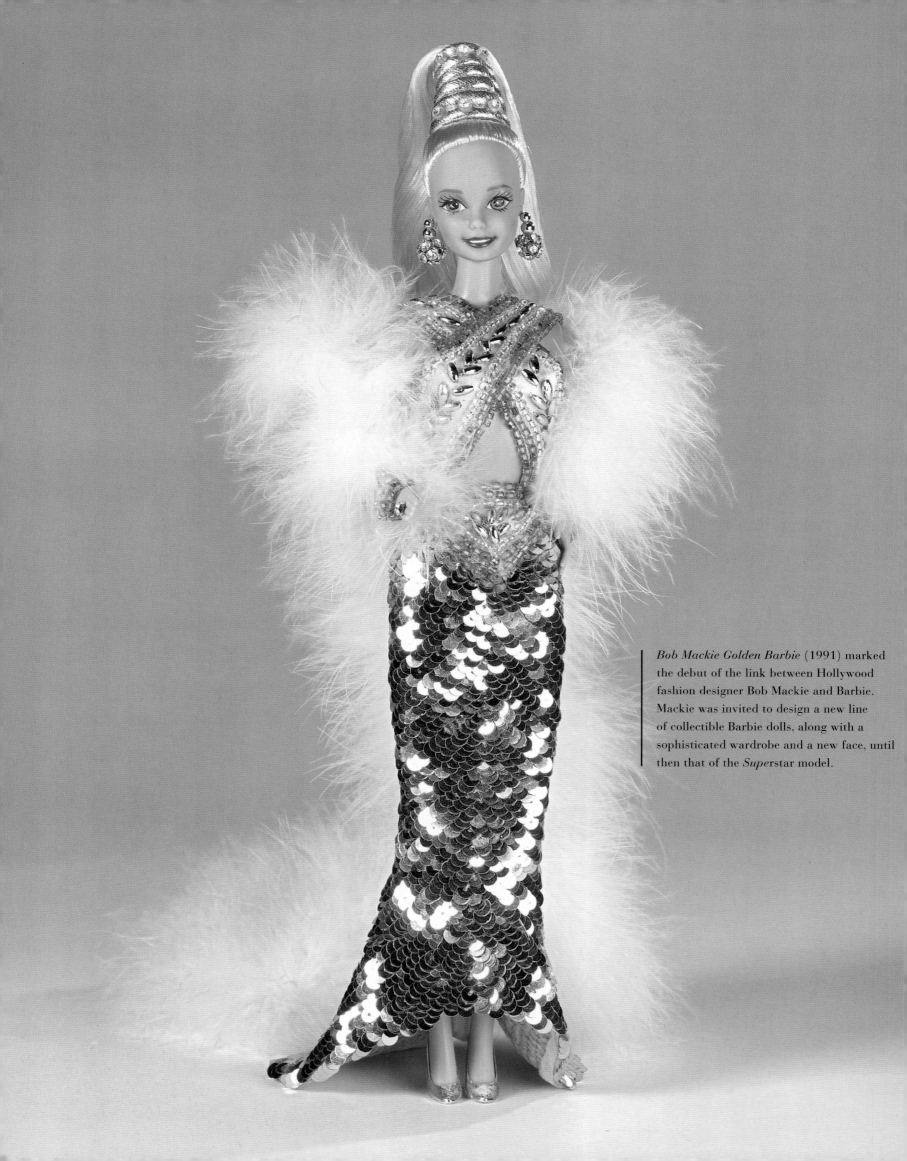

Bob Mackie Golden Barbie (1991) marked the debut of the link between Hollywood fashion designer Bob Mackie and Barbie. Mackie was invited to design a new line of collectible Barbie dolls, along with a sophisticated wardrobe and a new face, until then that of the *Superstar* model.

the undisputed protagonist of elegance within a context made of light and extreme clarity of image. Levinthal's work represents one of the high points of the Barbie-art connection.

Barbie's relationship with the fashion world over the years continues to provide the best insight into her restyling and new look. In 1989 Hollywood costume designer Bob Mackie was invited to design a new line of collectible Barbie dolls, with a very special wardrobe and a new face, until then the same as the one that had been used for the *Superstar* doll. Mackie worked in close collaboration with the whole Mattel team, from Stephen Tarmichael for the doll's hairstyle to Hiroe Okubo-Wolf for her makeup. Starting with *Bob Mackie Golden Barbie* (1991), he produced a series of models that over the past twenty years have represented a high point in the Barbie catalogue, creatively, technically, and aesthetically.

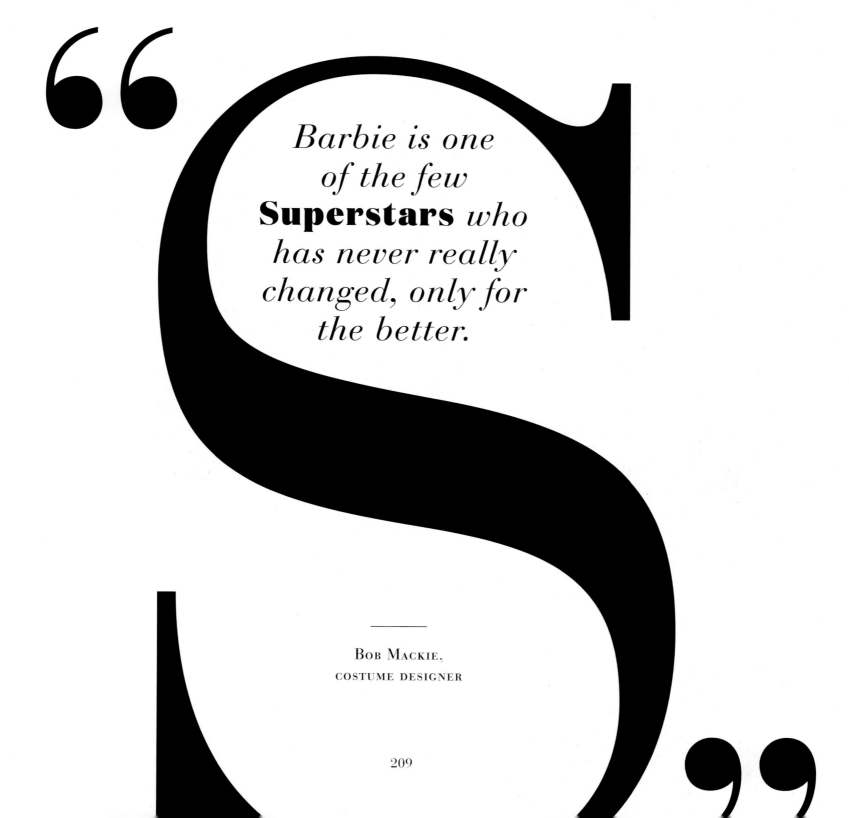

Barbie is one of the few **Superstars** *who has never really changed, only for the better.*

———

BOB MACKIE,
COSTUME DESIGNER

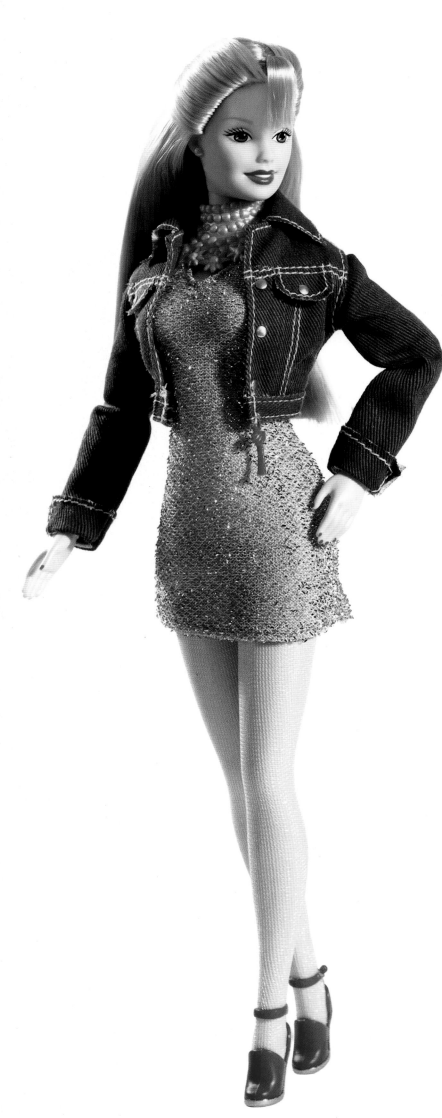

Barbie's new mouth, featuring closed, full lips conceived specially for the Mackie collection, was introduced in 1998 for the standard models as well. From *Generation Girl* (1999) onwards the doll had a more structured nose and a plumper oval face. With the new *Generation Girl* line, Barbie became more fashionable, she was a lover of the performing arts, she attended International High School, and she dreamed of being an actress. The *Hollywood Legends* series was first produced in 1994, the first of which was *Scarlett O'Hara/Vivien Leigh*. In the series Barbie identified with or interpreted many of the heroines of her day in a sort of celebration of aesthetics and the deeper essence of being a star.

In 2000, *Jewel Girl Barbie* (shown at right) underwent a millennial makeover featuring a new, more athletic physique, a bendable, flexible waist, and her first belly button. However, what was really new in 2000 was the *Barbie Fashion Model* line, designed by fashion designer Robert Best, who represented the quintessence of haute couture elegance in the fifties and sixties, and who seemed to bring back the splendor of the outfits worn by the original *Teen-Age Fashion Model Barbie Doll*.

"Like the Mona Lisa, whose image has been liberated from the Louvre to enter popular culture, the Barbie doll is a familiar cultural icon."

VALERIE STEELE
DIRECTOR OF THE MUSEUM AT THE
FASHION INSTITUTE OF TECHNOLOGY

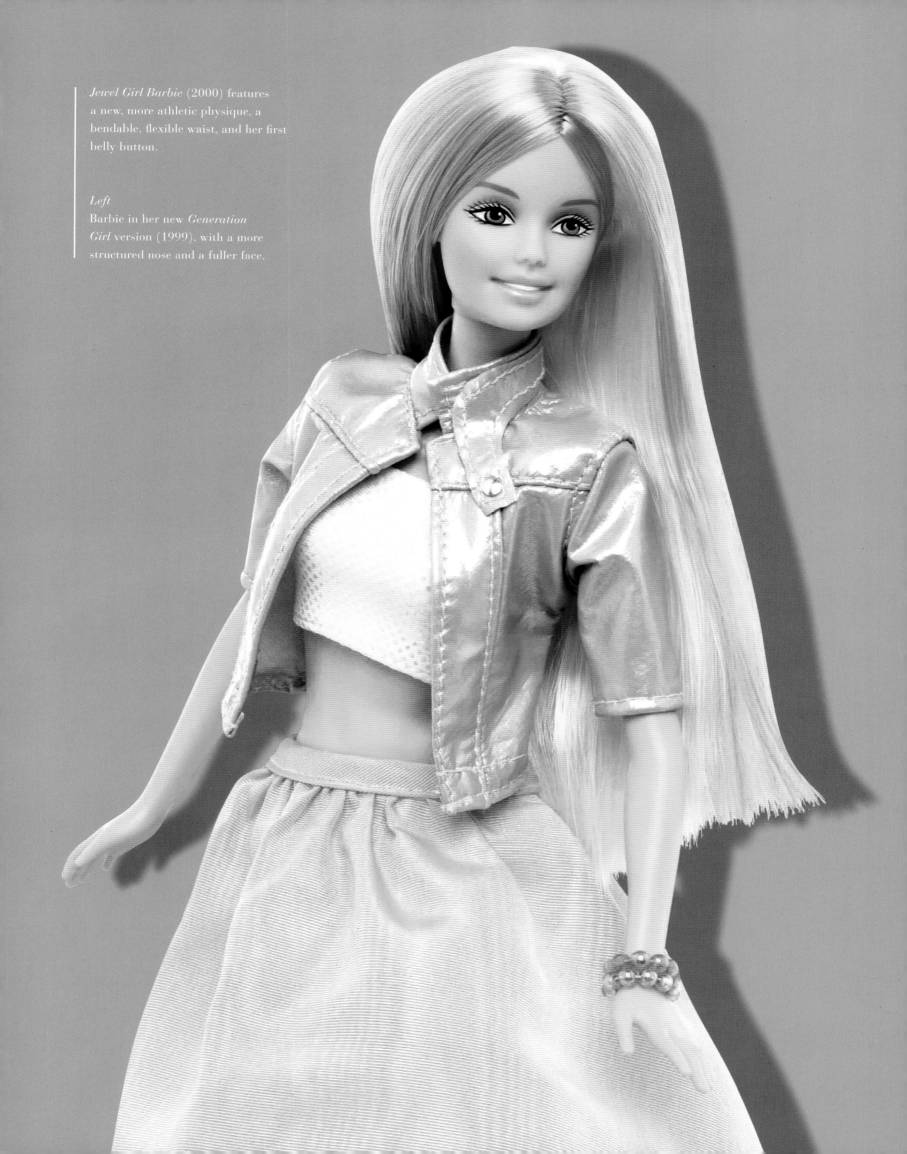

Jewel Girl Barbie (2000) features a new, more athletic physique, a bendable, flexible waist, and her first belly button.

Left
Barbie in her new *Generation Girl* version (1999), with a more structured nose and a fuller face.

'80s Cher Bob Mackie Doll (2007) features the legendary outfit the singer wore in 1989 in the video she made for the song *If I Could Turn Back Time*.

celebrities

Barbie is the modern star par excellence, close to all of us, but at the same time unreachable. This is why she has been identified with and measured up to many of the heroines of her day for a sort of celebration of aesthetics and the deepest essence of being a star. Before identifying with the stars of the contemporary age Barbie was also transformed into some of the most legendary women in history, women who, thanks to their personalities, have become true cultural icons: Cleopatra, Elizabeth I, Catherine de' Medici, Madame de Pompadour.

Twiggy was the first modern celebrity to join Barbie's "family" in 1967, and since then the list has grown with the names of many famous women, from Lucille Ball to Tina Turner, Elvis, Cher and Wonder Woman, Marilyn, Liz Taylor, Grace Kelly, Audrey Hepburn, Lady Diana, Heidi Klum, Barbra Streisand, and Jennifer Lopez.

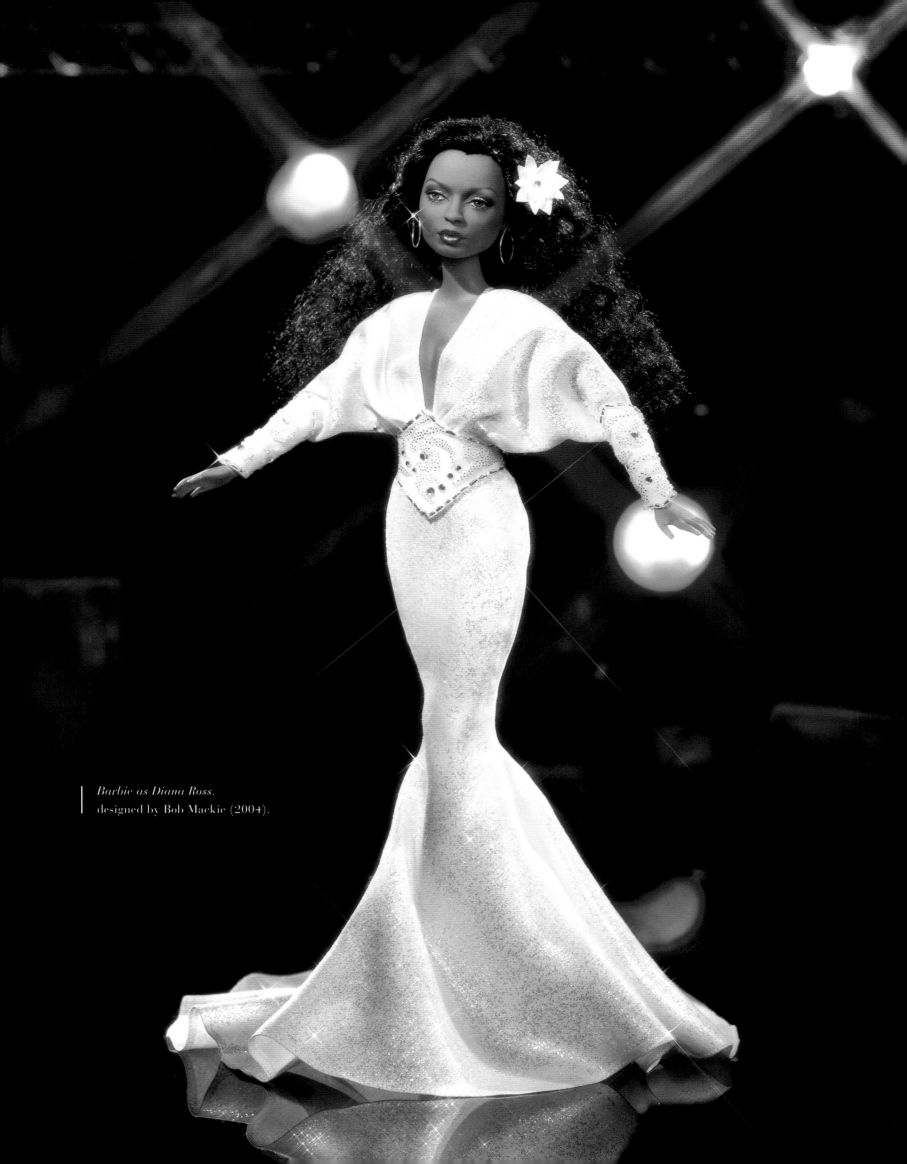

Barbie as Diana Ross.
designed by Bob Mackie (2004).

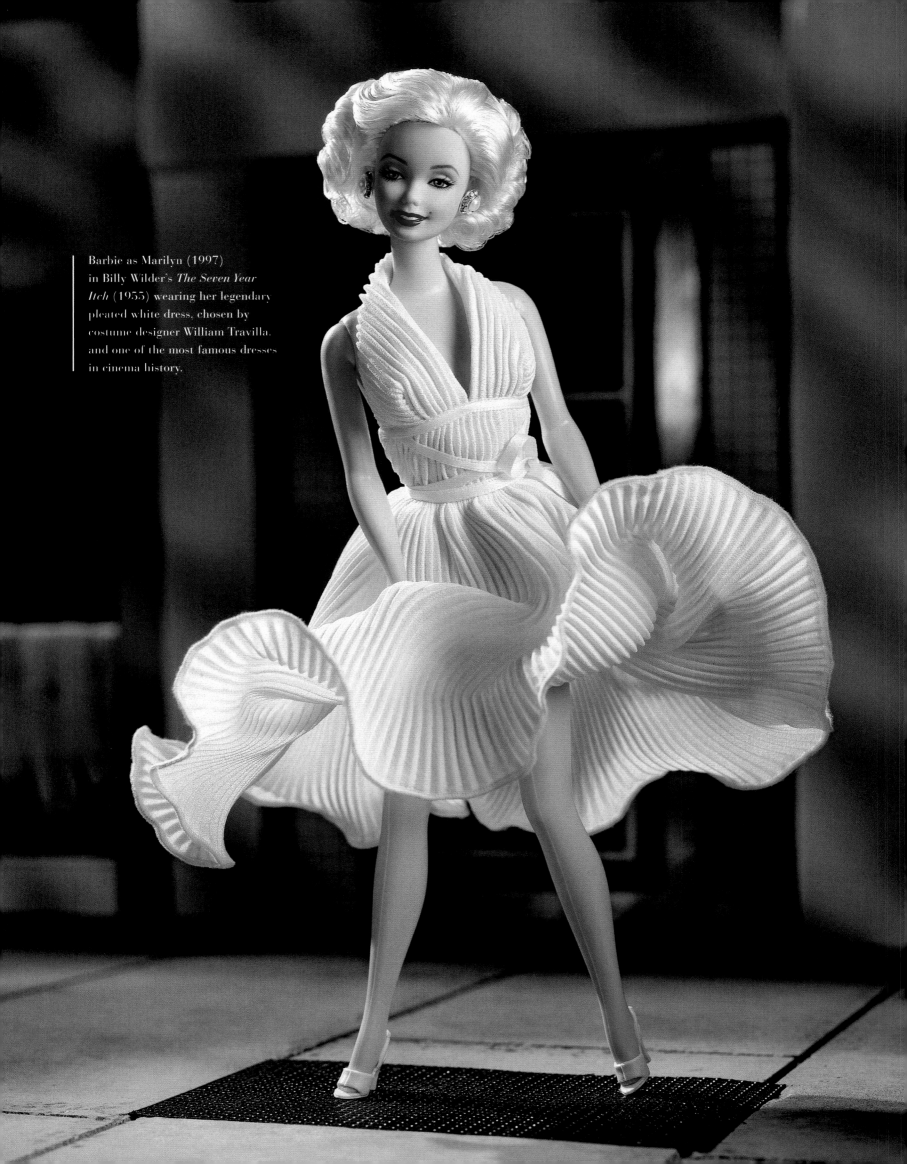

Barbie as Marilyn (1997) in Billy Wilder's *The Seven Year Itch* (1955) wearing her legendary pleated white dress, chosen by costume designer William Travilla, and one of the most famous dresses in cinema history.

Barbie and...

1967, TWIGGY • 1969, TALKING JULIA (DIAHANN CARROLL) • 1972, WALKING MISS AMERICA •

1978, Kitty O'Neil • 1978, Kate Jackson • 1978, Donny & Marie Osmond • 1978, Jimmy Osmond • 1978, Cheryl Ladd •

1979, Kristy McNichol as Buddy • 1979, Debby Boone • 1992, Beverly

Hills, 90210, *Brenda, Brandon, Kelly, Donna, Dylan • 1994, The Great*

Eras, Egyptian Queen • 1994, Gone with the Wind Barbie as Scarlett O'Hara #1 •

1995, Gone with the Wind Barbie and Ken as Scarlett and Rhett • 1995, Gone with the

Wind Barbie as Scarlett O'Hara #2 • 1995, Gone with the Wind Barbie as Scarlett O'Hara

#3 • 1995, Barbie as Dorothy • 1995, The Great Eras, Elizabethan Queen •

1995, The Great Eras, Southern Belle • 1995, The Great Eras, Medieval Lady • 1996, Empress

Sissy Barbie • 1996, My Fair Lady Barbie and Ken as Eliza Doolittle and Professor Henry Higgins •

1996, My Fair Lady Barbie Doll as Eliza Doolittle at Ascot • 1996,

My Fair Lady Barbie Doll as Eliza Doolittle at the Embassy Ball •

1996, My Fair Lady Barbie Doll as Eliza Doolittle final scene • 1996,

The Wizard of Oz Barbie and Ken as Dorothy and the Tin Woodsman •

1996, THE WIZARD OF OZ BARBIE AS GLINDA THE GOOD WITCH • 1996, THE GREAT ERAS, GRECIAN GODDESS •

1996, The Great Eras, Victorian Lady • 1997, The Great Eras, French

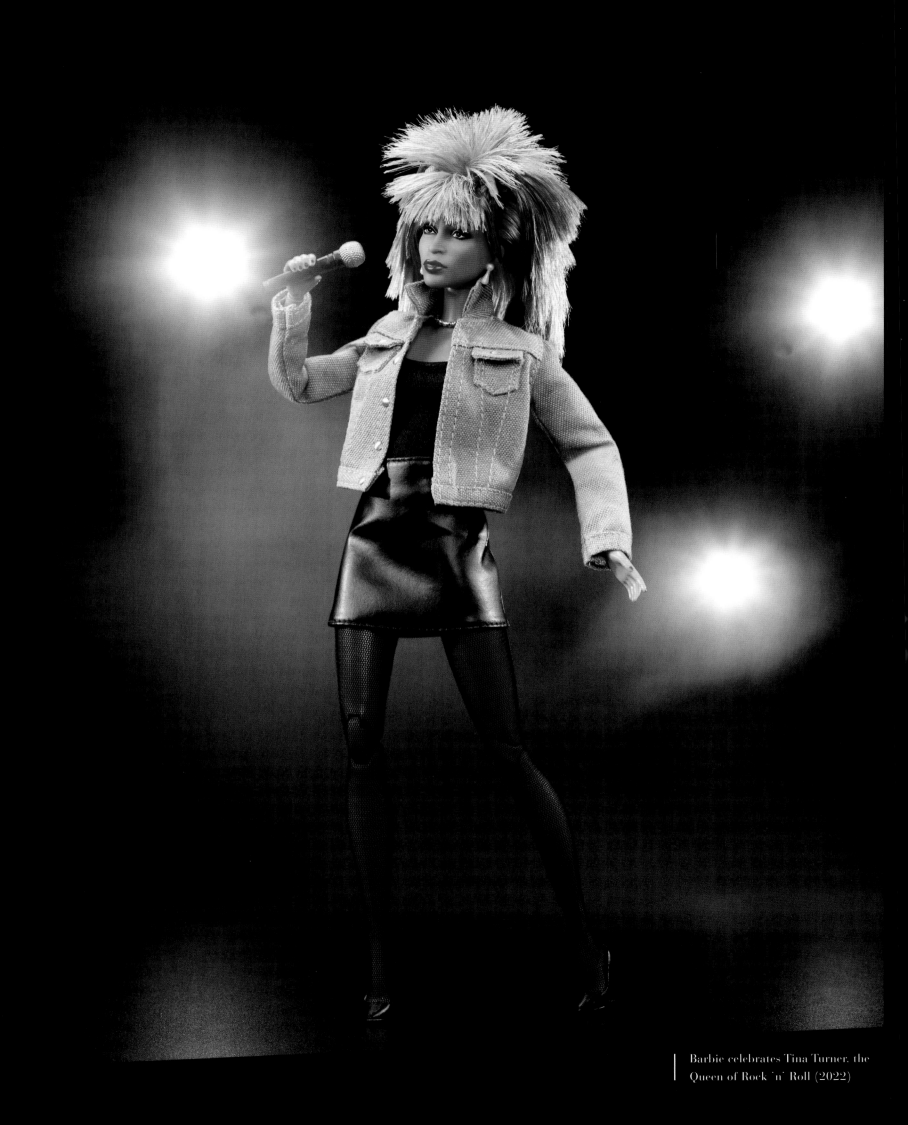

Barbie celebrates Tina Turner, the
Queen of Rock 'n' Roll (2022)

Barbie as a Hollywood movie legend with equally legendary outfits: Grace Kelly wearing the bridal gown designed for her wedding to Prince Rainier of Monaco in 1956 by Metro-Goldwyn-Mayer costume designer Helen Rose; Audrey Hepburn in a black evening gown designed for *Breakfast at Tiffany's* by Hubert de Givenchy (1961), and Elizabeth Taylor as Cleopatra, wearing a twenty-four-carat gold cloth cape designed to resemble the wings of a phoenix, part of a sixty-five-piece wardrobe designed for the star by Irene Sharaff and Renie Conley.

On page 218
In 2008 Barbie celebrates the wedding between Elvis Presley and Priscilla Beaulieu (Las Vegas, May 1, 1967).

On page 219
In 1996 Barbie celebrates Dorothy, the Tin Woodsman, and Glinda of *The Wizard of Oz* (1939), followed in 2007 by *Mary Poppins* (1964).

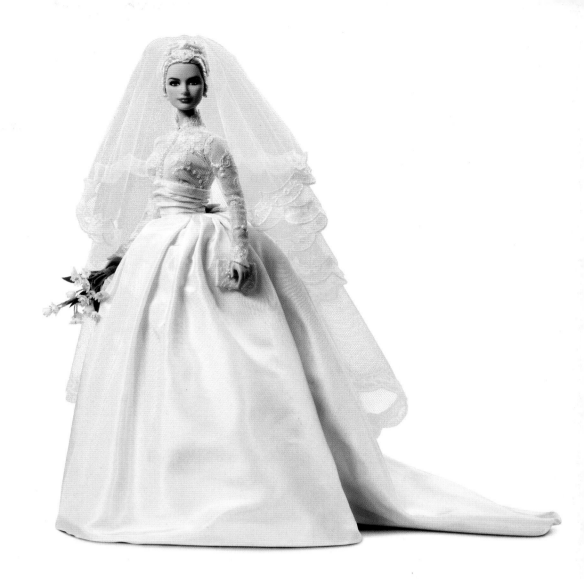

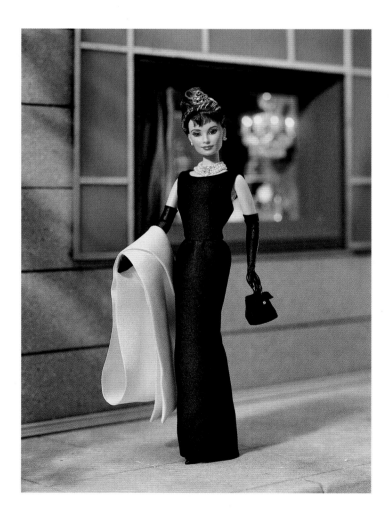

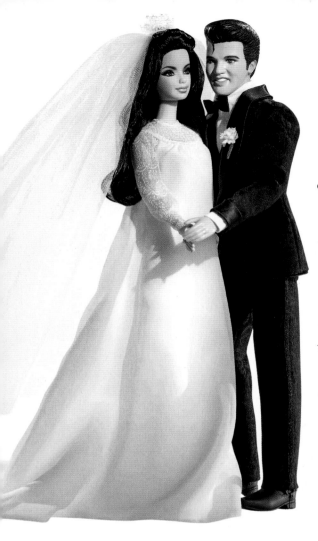

Lady • 1997, The Great Eras, Chinese Empress • 1997, The Seven Year Itch, Barbie as Marilyn Monroe • *1997, Gentlemen Prefer Blondes, Barbie as Marilyn Monroe* • *1997, Barbie Loves Elvis Giftset (Elvis and Barbie Elvis' fan)* • 1997, **The Wizard of Oz, Ken as the Scarecrow and Cowardly Lion** • 1997, **Clueless Barbie Doll (blonde, black, red)** • 1997, **Lady Diana (never produced)** • 1998, **Romeo and Juliet** • 1998, **The X-Files Giftset** • 1998, **The Elvis Presley Doll** • **1998, Lucille Ball as Lucy Ricardo Doll** • **1998, Breakfast at Tiffany's, Audrey Hepburn in Black daytime fashion** • **1998, Breakfast at Tiffany's, Audrey Hepburn in Black evening fashion** • 1998, **Breakfast at Tiffany's, Audrey Hepburn in Cat's mask fashion** • 1998, **Breakfast at Tiffany's, Audrey Hepburn as Pink Princess** • 1998, **Ken and Barbie as King Arthur and Guinevere** • 1998, **Barbie Loves Frankie (Frank Sinatra plus Barbie fan)** • 1998, ELVIS THE ARMY YEARS • 1998, I LOVE LUCY, JOB SWITCHING • 1998, DAYS OF OUR LIVES, MARLENA EVANS DOLL • 1998, ALL MY CHILDREN, ERICA KANE DOLL • 2000, BARBIE AS DOROTHY (WIZARD OF OZ) • 2000, **Barbie as Glinda (Wizard of Oz)** • 2000, **Barbie as Bella (Beauty and the Beast)** • 2000, **Barbie as Snowflake (The Nutcracker)** • 2000, **Mary-Kate & Ashley TV Series** • 2000, **Barbie as Wonder Woman**

• 2000, Ken and Barbie as Merlin and Morgan Le Fay •

2000, ELIZABETH TAYLOR AS CLEOPATRA • 2000, FATHER OF THE BRIDE, ELIZABETH TAYLOR AS THE BRIDE • 2000, ELVIS THE ARMY YEARS • 2000, LUCY'S ITALIAN MOVIE • 2000, THE WIZARD OF OZ, PORCELAIN DOROTHY WITH TOTO •

2000, The Wizard of Oz, The Wicked Witch • 2001, Barbie and Ken as The Munsters • 2001, I Love Lucy, 50th Anniversary • 2001, Cher • 2001, Elvis Eagle Jumpsuit • 2001, Frank Sinatra The Recording Years • **2001, James Dean American Legend • 2001, Scarlett O'Hara, Barbecue at Twelve Oaks • 2001, Scarlett O'Hara Doll on Peachtree Street • 2001, The Wizard of Oz Porcelain Wicked Witch with Monkey • 2001, THE WIZARD OF OZ PORCELAIN DOROTHY WITH TOTO • 2001, THE WIZARD OF OZ PORCELAIN SCARECROW •**

2001, The Wizard of Oz Porcelain Tin Woodsman • 2002, Barbie as Samantha in Bewitched • 2002, Gone with the Wind, Rhett Butler • 2002, How to Marry a Millionaire, Barbie as Marilyn Monroe (white dress) • 2002, How to Marry a Millionaire, Barbie as Marilyn Monroe (pink bodysuit) • 2002, HOW TO MARRY A MILLIONAIRE, BARBIE AS MARILYN MONROE (PINK GOWN)

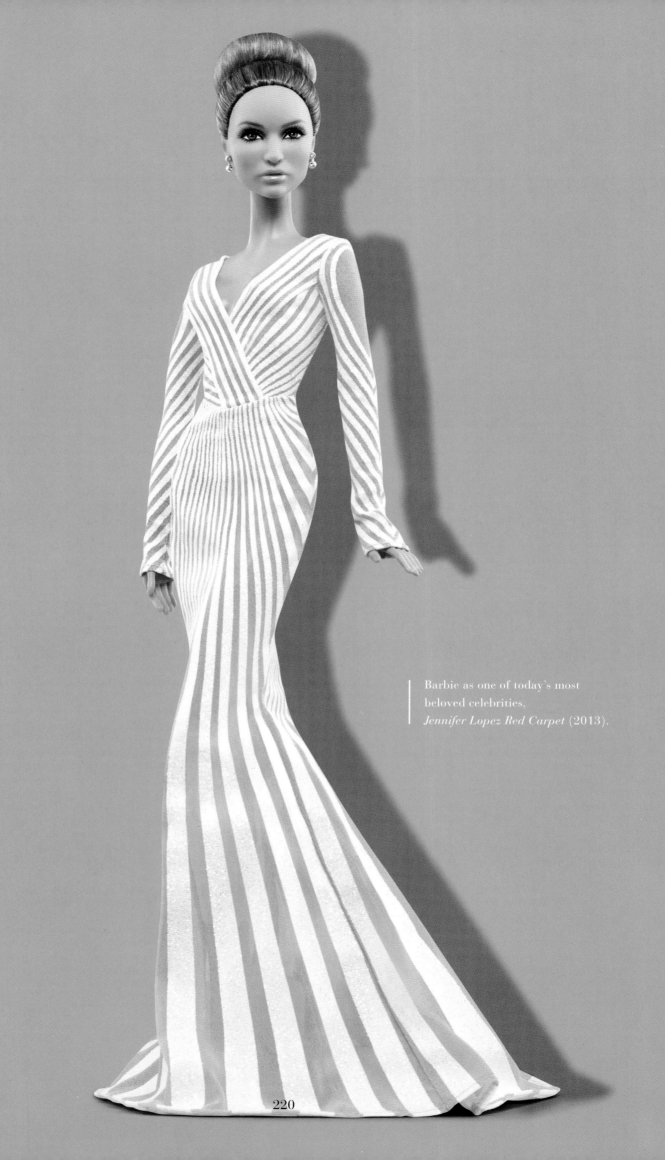

Barbie as one of today's most
beloved celebrities,
Jennifer Lopez Red Carpet (2013).

• **2002, ELVIS THE KING OF ROCK 'N ROLL** • 2002, I LOVE LUCY "BE A PAL" • **2002, THE WIZARD OF OZ PORCELAIN BERT LAHR AS THE COWARDLY LION** • 2004, Lord of the Rings, The Return of the King, Barbie and Ken as Arwen and Aragorn • 2004, Diana Ross by Bob Mackie • 2004, I Love Lucy, Sales Resistance • 2004, Barbie as Sandy in Grease • 2005, Destiny's Child Beyoncé Knowles • 2005, Destiny's Child Kelly Rowland • 2005, Destiny's Child Michelle Williams • 2005, That's So Raven Doll • **2005, WOMEN OF ROYALTY COLLECTION, EMPRESS JOSEPHINE • 2005, LORD OF THE RINGS, THE FELLOWSHIP OF THE RING, KEN AS LEGOLAS • 2005, WOMEN OF ROYALTY COLLECTION QUEEN ELIZABETH I •** *2005, Women of Royalty Collection Marie Antoinette • 2005, Lord of the Rings, The Fellowship of the Ring, Barbie as Galadriel • 2005, I Love Lucy, The Operetta • 2007, The Wizard of Oz Dorothy Doll • 2007, The Wizard of Oz Wicked Witch of the West Doll • 2007, The Wizard of Oz Glinda the Good Witch Doll •* 2007, The Wizard of Oz Cowardly Lion Doll • 2007, The Wizard of Oz Scarecrow Doll • 2007, The Wizard of Oz Tin Woodsman Doll • 2007, Titanic Barbie Doll • 2007, I Love Lucy, The Audition • **2007, '70s Cher Doll • 2007, '80s Cher Doll • 2007, Mary Poppins Doll (Julie Andrews) • 2008, Grease Rizzo Doll • 2008, Grease Frenchy Doll • 2008, Grease Sandy Doll** • 2008, Speed Racer Giftset • 2008, I Love Lucy Giftset • 2008, Grease Rizzo Doll, Prom Night • 2008, Grease Frenchy Doll, Prom Night • 2008, Grease Sandy Doll, Prom Night • 2008, Elvis and Priscilla Giftset • 2009, I Love Lucy, The Ballet • 2009, ELVIS

PRESLEY JAILHOUSE ROCK • 2009, BLONDE AMBITION GOLDIE HAWN DOLL • 2009, BLONDE AMBITION MARILYN MONROE DOLL • 2009, THE WIZARD OF OZ WICKED WITCH OF THE EAST DOLL • 2009, STAR TREK CAPTAIN KIRK DOLL • 2009, STAR TREK MR. SPOCK DOLL • 2009, STAR TREK LT. UHURA DOLL • 2009, Blonde Ambition Heidi Klum Doll • 2009, The Carol Burnett Show Went with the Wind! Barbie Doll • 2010, Barbie as Cleopatra Doll • 2010, Twilight Saga Bella Doll • 2010, Twilight Saga Edward Doll • 2010, Twilight Saga New Moon Jacob Doll • 2010, Twilight Saga Eclipse Alice Doll • 2010, Twilight Saga Eclipse Victoria Doll • **2010, ELVIS PRESLEY DOLL IN BLUE HAWAII • 2010, I LOVE LUCY, LUCY TELLS THE TRUTH • 2010, 007, OCTOPUSSY • 2010, 007, LIVE AND LET DIE • 2010, 007, DR. NO • 2010, 007, GOLDFINGER** • *2010, 007, Die Another Day • 2010, Mad Men Doll, Joan Holloway Doll • 2010, Mad Men Doll, Roger Sterling Doll • 2010, Mad Men Doll, Don Draper Doll • 2010, Mad Men Doll, Betty Draper Doll • 2010, The Wizard of Oz, Glinda Doll (vintage Barbie)* • 2010, The Wizard of Oz, Dorothy Doll (vintage Barbie) • 2010, The Wizard of Oz, Wicked Witch of the West Doll (vintage Barbie) • 2010, Ladies of the 80s, Debbie Harry Doll • 2010, Ladies of the 80s, Joan Jett Doll • 2010, Ladies of the 80s, Cyndi Lauper Doll • **2010, Alice in Wonderland, Johnny Depp Mad Hatter Doll • 2010, Barbra Streisand Doll • 2011, Grace Kelly Bride Doll • 2011, Grace Kelly To Catch a Thief Doll • 2011, Pillow Talk Giftset •**

Barbie as David Bowie, with makeup conceived by Pierre La Roche and the turquoise blue suit created by Freddie Burretti for the "Life on Mars?" music video shot in London in 1973 (2022).

2011, Elvis Presley Barbie Doll • 2011, Frank Sinatra Barbie Doll • 2011, Reba McEntire Doll • 2011, Tim McGraw & Faith Hill Dolls • 2011, Pirates of the Caribbean Captain Jack Sparrow Doll • 2011, Pirates of the Caribbean Angelica Doll • 2011, Grace Kelly the Romance Doll • 2011, Twilight Saga Eclipse Jane Doll • 2011, Bewitched Doll (vintage Barbie) • **2011, The Beverly Hillbillies Doll (vintage Barbie) • 2011, I Dream of Jeannie Doll (vintage Barbie) • 2011, I Love Lucy, Lucy and Ricky Giftset • 2011, Dynasty Krystle Carrington Barbie Doll • 2011, Dynasty Alexis Colby Doll •** 2011, Farrah Fawcett Doll • 2012, Elizabeth Taylor Violet Eyes Doll • 2012, Hunger Games Katniss Doll • 2012, Grace Kelly Rear Window Doll • 2012, William and Kate Middleton Royal Wedding Dolls • 2013, Elizabeth Taylor White Diamond Doll • **2013, Audrey Hepburn Roman Holiday Doll • 2013, Audrey Hepburn Sabrina Doll • 2013, The Wizard of Oz, Fantasy Glamour Dorothy Doll • 2013, Hunger Games Catching Fire Peeta Doll •** 2013, Hunger Games Catching Fire Katniss Doll • 2013, Hunger Games Catching Fire Finnick Doll • 2013, Hunger Games Catching Fire Effie Doll • 2013, Jennifer Lopez Red Carpet Doll • 2013, Jennifer Lopez World Tour Doll • 2013, Twilight Saga Breaking Dawn Part 2 Bella Doll as a Vampire • 2013, Twilight Saga Breaking Dawn

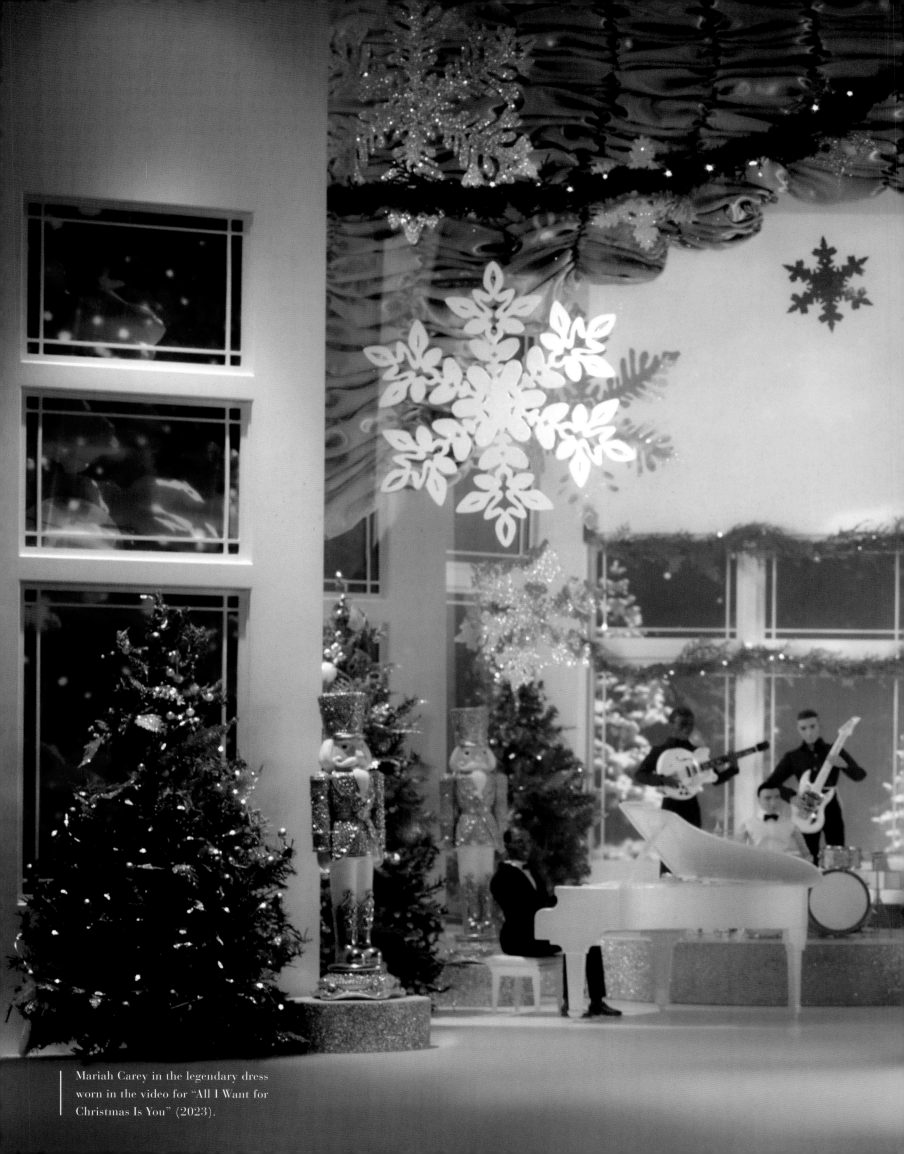

Mariah Carey in the legendary dress worn in the video for "All I Want for Christmas Is You" (2023).

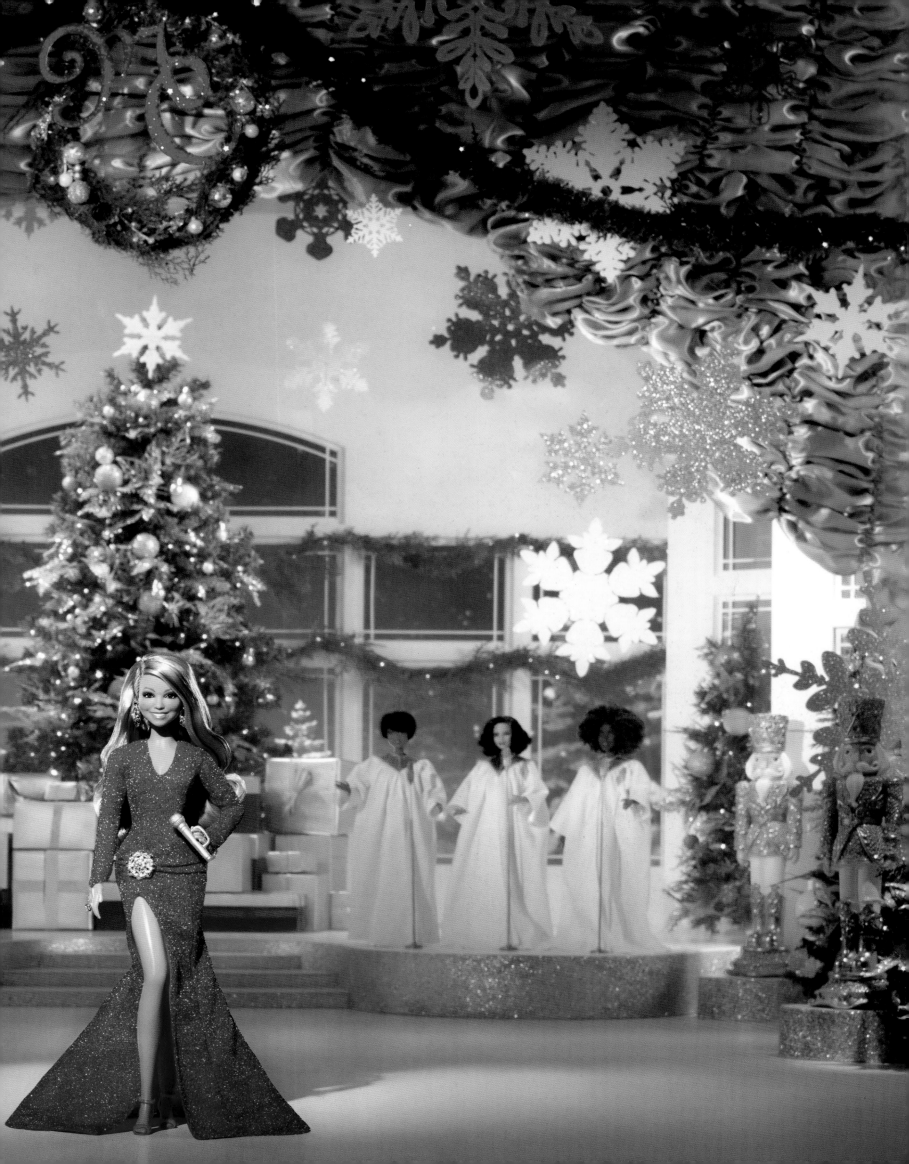

PART 2 GROOM EDWARD DOLL • 2013, Twilight Saga Breaking Dawn Part 2 Jasper Doll • 2013, Twilight Saga Breaking Dawn Part 2 Rosalie Doll • 2013, Twilight Saga Breaking Dawn Part 2 Emmett Doll • 2013, Twilight Saga Breaking Dawn Part 2 Carlisle Doll • 2013, Twilight Saga Breaking Dawn Part 2 Esme Doll • 2013, Catwoman Doll • 2014, The Wizard of Oz, Fantasy Glamour Wicked Witch of the West Doll • 2014, Gone with the Wind Scarlett O'Hara Doll • 2014, Gone with the Wind Rhett Butler Doll • 2014, Divergent Tris Doll • 2014, Divergent Four Doll • 2014, Fan Bingbing Doll • 2020, Star Wars • 2022, Tina Turner Doll • 2022, Gloria Estefan Doll • 2022, Queen Elizabeth II Platinum Jubilee Doll • 2022, Laverne Cox Doll • 2022, David Bowie Doll • *2023, STEVIE NICKS DOLL • 2023, BARBIE THE MOVIE – MARGOT ROBBIE AND RYAN GOSLING DOLLS •* 2023, Mariah Carey (in the legendary dress worn in the video for "All I Want for Christmas Is You") • 2023, Claudia Schiffer in Versace (in the Versace F/W 1994–1995 outfit)

All Barbie Fashion models were made from silk-stone, a soft plastic resembling porcelain, while the face, makeup and sophisticated taste were the same as those of the *Ponytail Barbie Doll* (1959). Barbie's hair was made with a better quality fiber, her shoes were each specifically right and left, and her wardrobe was perfect to a "T." Quite the opposite of this newfound classical look was the *My Scene Barbie* (2002) line: the head and feet were out of proportion, the doll's shoes were huge, and her wardrobe was inspired by the casual style of teenagers, including shorts and a street-style top. Barbie's look witnessed another sweeping change in 2004, with the appearance of new models that had a *larger* head—30% bigger—followed, in 2005, by *Barbie & Co.* which featured oversized feet and toenail polish.

But Barbie could not betray her original spirit, which was based on aesthetic research, style, and elegance. So there was a return to the fashion theme with the *Fashion Fever* (2004) line and, above all, the collectors' *Barbie Basics Dolls*, which came with a total black outfit (2010), or a total denim outfit (2011), all designed by Bill Greening. This new line featured twelve different face sculpts and hairstyles and a variety of skin tones.

Amy Winehouse had risen to the top of the charts with *Back to Black*, and Barbie, true to her nature as fashion icon and a reflection of contemporary society, interpreted better than anyone else this return to a "black code," which harked back to the 1964 *Black Magic Ensemble*, a much-celebrated symbol of timeless elegance that unquestionably contributed to turning her into The Icon.

Some *Barbie Basics* doll models
in their "total black" version (2010).

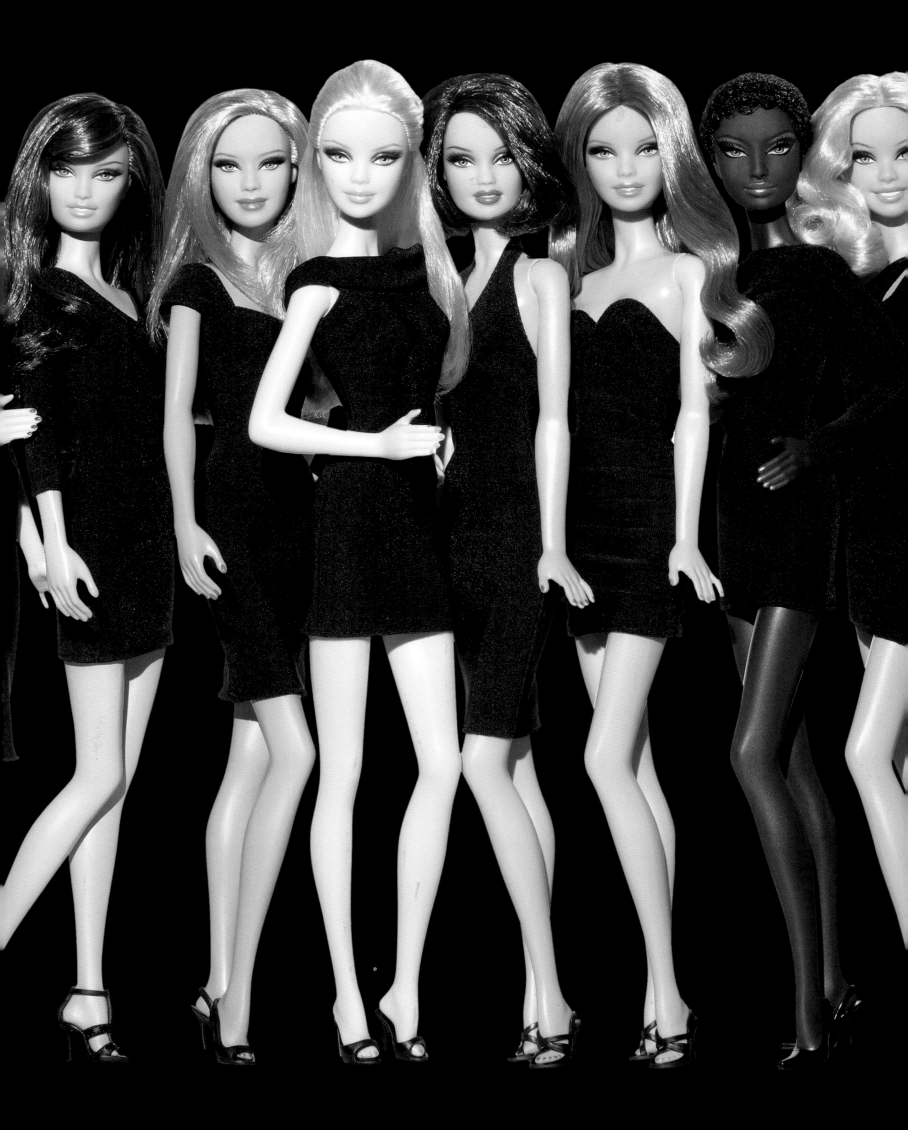

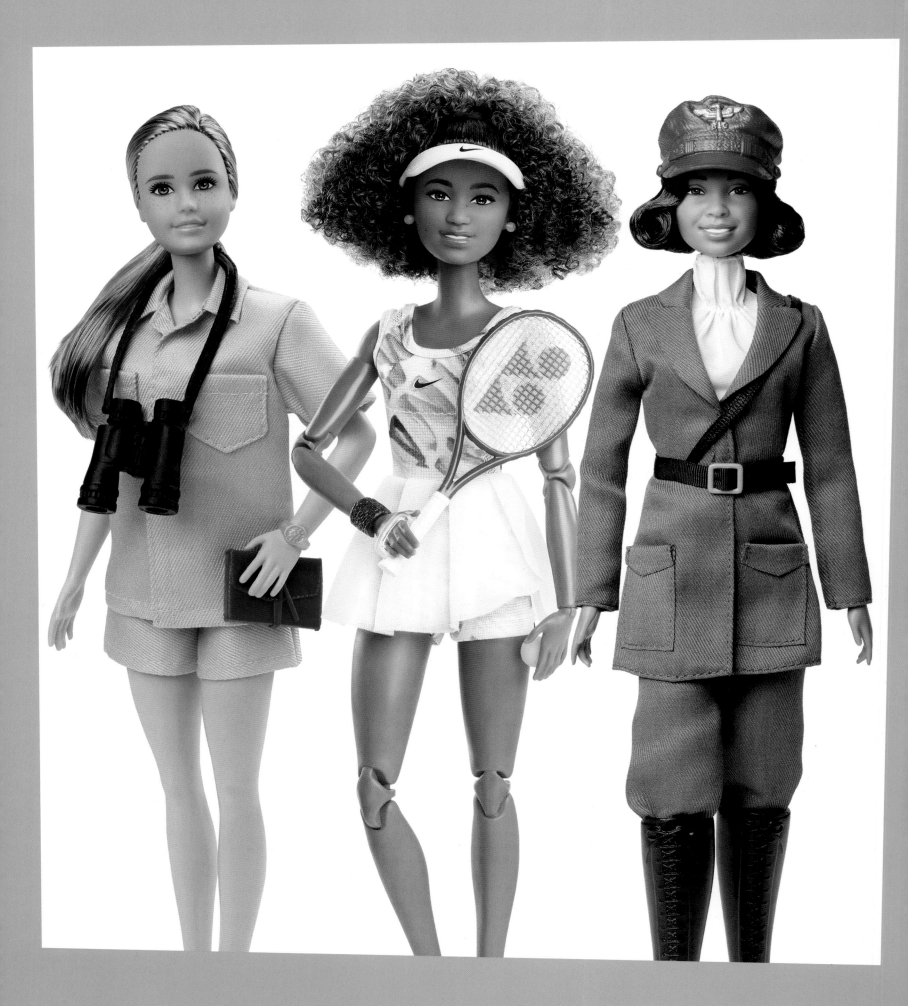

Role models

An unquestioned icon of style, Barbie has never forgotten that she is also a source of inspiration for little girls' sense of independence, a companion in their journeys of self-discovery. As a model of woman's liberation, faithful to her motto, "You can be anything," Barbie is a genuine crusader for creativity and independence. Since 2015, we have been witnessing a full-blown revolution in culture in Barbie's world. It has triggered a wide-ranging rethinking in favor of the importance of positive models for girls and young women, reminding us that "you can't be something you can't see." That led to the *Sheroes*, the *Inspiring Women*, and the *Role Model Dolls*, a line celebrating female figures from the contemporary world and from the past who dared to defy convention and go beyond the limits imposed by society. A genuine source of inspiration for everyone, women who inspire other women, but also people as a whole, these models for others were women who represented the great leaps forward in contemporary society.

Barbie Role Models

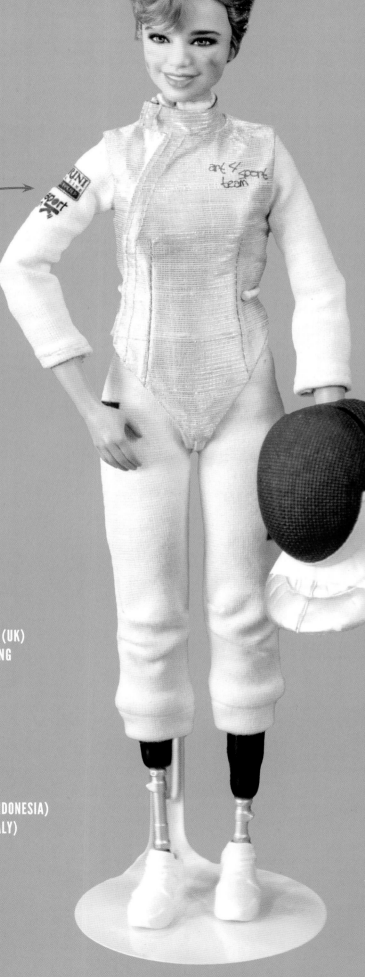

2023 BEBE VIO, PARALYMPIC ATHLETE
AND ACTIVIST (ITALY)
HÉLÈNE DARROZE, MICHELIN CHEF (FRANCE)
KATYA ECHAZARRETA, ELECTRICAL ENGINEER
AND PRESIDENT OF THE KATYA ECHAZARRETA
A.C. SPACE FOUNDATION (MEXICO)
HUI RUOQI, OLYMPIC VOLLEYBALL
CHAMPION (CHINA)
SUSAN WOJCICKI, YOUTUBE CEO (USA)
ANNE WOJCICKI, FOUNDER AND CEO OF 23ANDME (USA)
JANET WOJCICKI, PROFESSOR OF PEDIATRICS
AND EPIDEMIOLOGY (USA)
DR. MAGGIE ADERIN-POCOCK,
SPACE SCIENTIST (UK)
DR. ANTJE BOETIUS, RESEARCHER AND
PROFESSOR OF GEOMICROBIOLOGY (GERMANY)
YINUO LI, CO-FOUNDER OF ETU EDUCATION (CHINA)

2022 SHONDA RHIMES, FOUNDER OF SHONDALAND (USA)
ARI HORIE, FOUNDER AND CEO OF WOMEN'S STARTUP LAB
AND WOMEN'S STARTUP LAB IMPACT FOUNDATION (USA/JAPAN)
PAT MCGRATH, MAKEUP ARTIST AND FOUNDER OF PAT MCGRATH LABS (UK)
MELISSA SARIFFODEEN, CEO AND CO-FONDEUR OF CANADA LEARNING
CODE AND LADIES LEARNING CODE (CANADA)
ADRIANA AZUARA, FOUNDER OF ALL4SPAS (MEXICO)
DOANI EMANUELA BERTAIN, TEACHER AND FOUNDER
OF SALA 8 (BRAZIL)
JANE MARTINO (NEWTON), CHAIR AND CO-FOUNDER
OF SMILING MIND (AUSTRALIA)
LAN YU, FASHION DESIGNER (CHINA)
BUTET MANURUNG, FOUNDER AND DIRECTOR OF SOKOLA INSTITUTE (INDONESIA)
SONIA PERONACI, FOUNDER OF THE WEBSITE "GIALLOZAFFERANO" (ITALY)
TIJEN ONARAN, CEO AND FOUNDER DI GLOBAL DIGITAL WOMEN
AND CO-FOUNDER OF ACI DIVERSITY CONSULTING (GERMANY)
LÉNA MAHFOUF, DIGITAL CREATOR, VIDEOGRAPHER,
AND AUTHOR OF *ALWAYS MORE* (FRANCE)

2021
CLARA AMFO, RADIO BROADCASTER (UK)
SAMANTA CRISTOFORETTI, ASTRONAUT (ITALY)
MILENA BALDASSARRI, RHYTHMIC GYMNAST (ITALY)
CRISTINA FOGAZZI, "CYNICAL BEAUTICIAN" (ITALY)
DAME SARAH GILBERT, PROFESSOR OF VACCINOLOGY (UK)
AUDREY SUE CRUZ, PHYSICIAN AND BLOGGER (USA)
JAQUELINE GOÉS DE JESUS, SCIENTIST (BRAZIL)
KIRBY WHITE, PHYSICIAN (AUSTRALIA)
CHIKA STACY ORIUWA, CHILDREN'S
PSYCHIATRIST (CANADA)
AMY O'SULLIVAN, EMERGENCY
ROOM NURSE (UK)

2020
TERESA BONVALOT, OLYMPIC ATHLETE
(PORTUGAL)
AMANDINE HENRY, SOCCER PLAYER
(FRANCE)
MALAIKA MIHAMBO, LONG JUMP
ATHLETE (GERMANY)
SÜMEYYE BOYACI, SWIMMER
(TURKEY)
OLGA KHARLAN, FENCER (UKRAINE)

2019
LIRA (LERATO MOLAPO), SINGER,
COMPOSER, AND BUSINESSWOMAN
(SOUTH AFRICA)
YARA SHAHIDI, ACTRESS (USA)
NAOMI OSAKA, TENNIS PLAYER (JAPAN)
KELSEA BALLERINI, ACTRESS AND COMPOSER (USA)
ADWOA ABOAH, MODEL AND ACTIVIST (UK)
KRISTINA VOGEL, ATHLETE (GERMANY)
ELENI ANTONIADOU, SCIENTIST (GREECE)
ROSANNA MARZIALE, CHEF (ITALY)
ITA BUTTROSE, JOURNALIST (AUSTRALIA)
DIPA KARMAKAR, GYMNAST (INDIA)
GÜLSE BIRSEL, ACTRESS, WRITER,
AND SCREENWRITER (TURKEY)
TESSA VIRTUE, ICE DANCER (CANADA)
KARLA WHEELOCK, MOUNTAINEER, WRITER, AND LECTURER
(MEXICO)
MARIANA COSTA, BUSINESSWOMAN (PERU)
TETSUKO KUROYANAGI, TELEVISION PERSONALITY, JOURNALIST,
AND AUTHOR (JAPAN)
CHEN MAN, PHOTOGRAPHER (CHINA)
MELODIE ROBINSON, SPORTS JOURNALIST (NEW ZEALAND)
IWONA BLECHARCZYK, TRUCK DRIVER (POLAND)
LYASAN UTIASHEVA, JOURNALIST (RUSSIA)
MAYA GABIERA, SURFER (BRAZIL)
LISA AZULEOS, DIRECTOR (FRANCE)
ALBERTA FERRETTI, FASHION DESIGNER (ITALY)

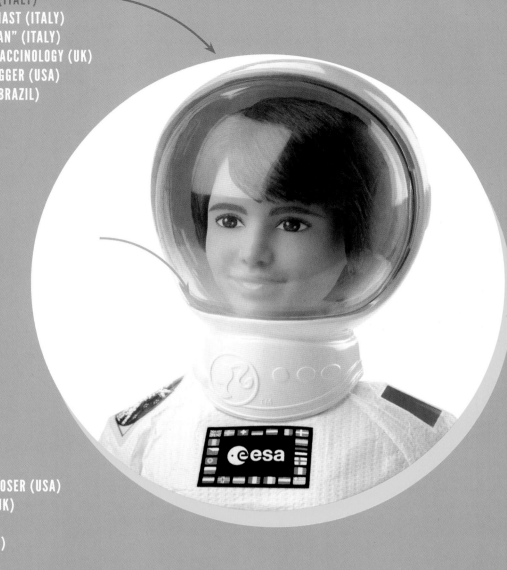

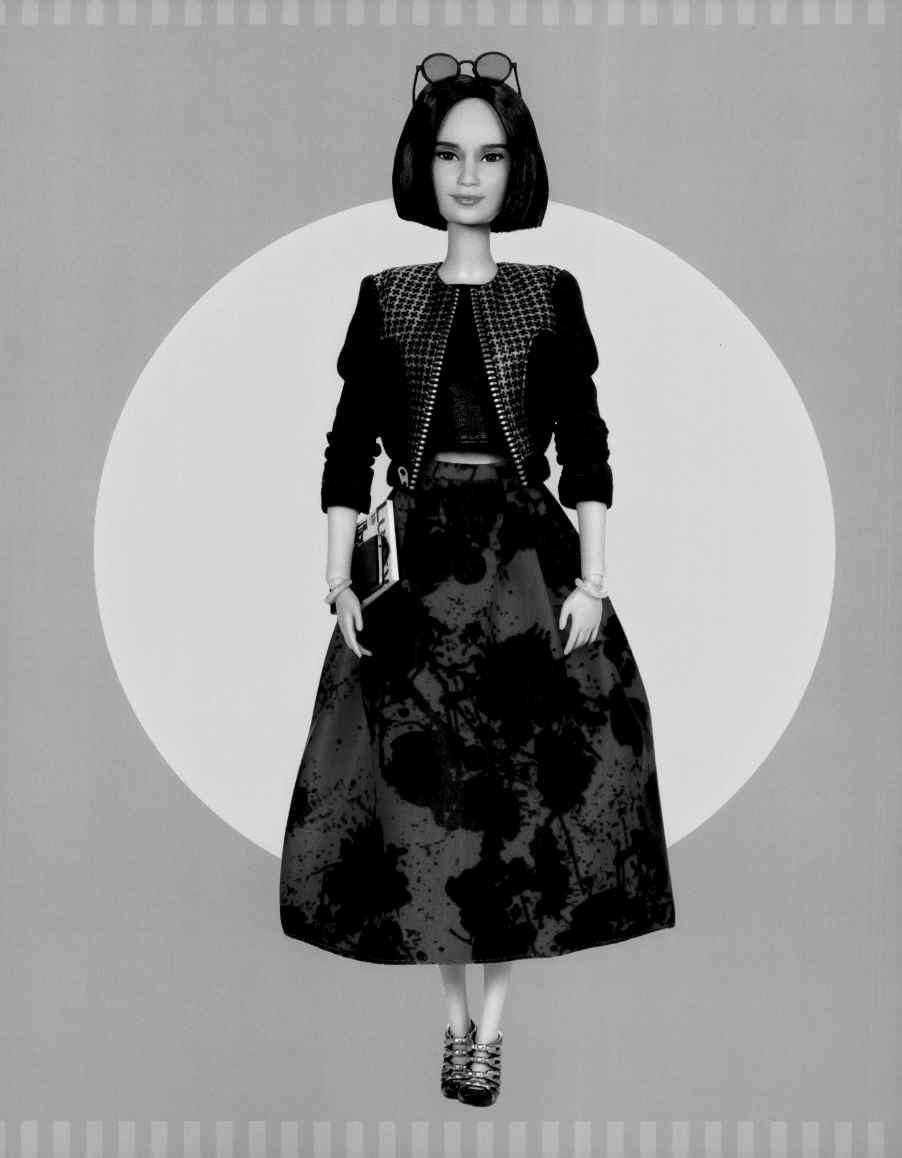

2018 SAVANNAH GUTHRIE AND HODA KOTB, JOURNALISTS (USA)
LAURIE HERNANDEZ, GYMNAST (USA)
PATTY JENKINS, DIRECTOR (USA)
CHLOE KIM, CHAMPION SNOWBOARDER (USA)
BINDI IRWIN, ACTRESS (AUSTRALIA)
NICOLA ADAMS, CHAMPION BOXER (UK)
ÇAĞLA KUBAT, WINDSURFER (TURKEY)
HÉLÈNE DARROZE, CHEF (FRANCE)
HUI RUOQI, CHAMPION
OF VOLLEYBALL (CHINA)
LEYLA PIEDAYESH, DESIGNER
AND BUSINESSWOMAN (GERMANY)
LORENA OCHOA, GOLFER
(MEXICO)
MARTYNA WOJCIECHOWSKA,
JOURNALIST (POLAND)
SARA GAMA, SOCCER PLAYER
(ITALY)
XIAOTONG GUAN, ACTRESS
AND PHILANTROPIST (CHINA)
YUAN YUAN TAN, PRINCIPAL
DANCER (CHINA)
VICKY MARTÍN BERROCAL,
BUSINESSWOMAN
AND FASHION DESIGNER
(SPAIN)

2017 IBTIHAJ MUHAMMAD,
FENCER (USA)

2016 ASHLEY GRAHAM, MODEL
AND ACTIVIST (USA)
GABBY DOUGLAS, GYMNAST (USA)
MISTY COPELAND, CLASSICAL BALLET DANCER (USA)
ABBY WAMBACH, SOCCER PLAYER (USA)

2015 ZENDAYA, SINGER AND ACTRESS (USA)
AVA DUVERNAY, DIRECTOR (USA)
EMMY ROSSUM, ACTRESS (USA)
EVA CHEN, EDITOR-IN-CHIEF (USA)
KRISTIN CHENOWETH, ACTRESS AND SINGER (USA)
SYDNEY "MAYHEM" KEISER, DESIGNER (USA)
TRISHA YEARWOOD, SINGER, AUTHOR, AND ACTRESS (USA)

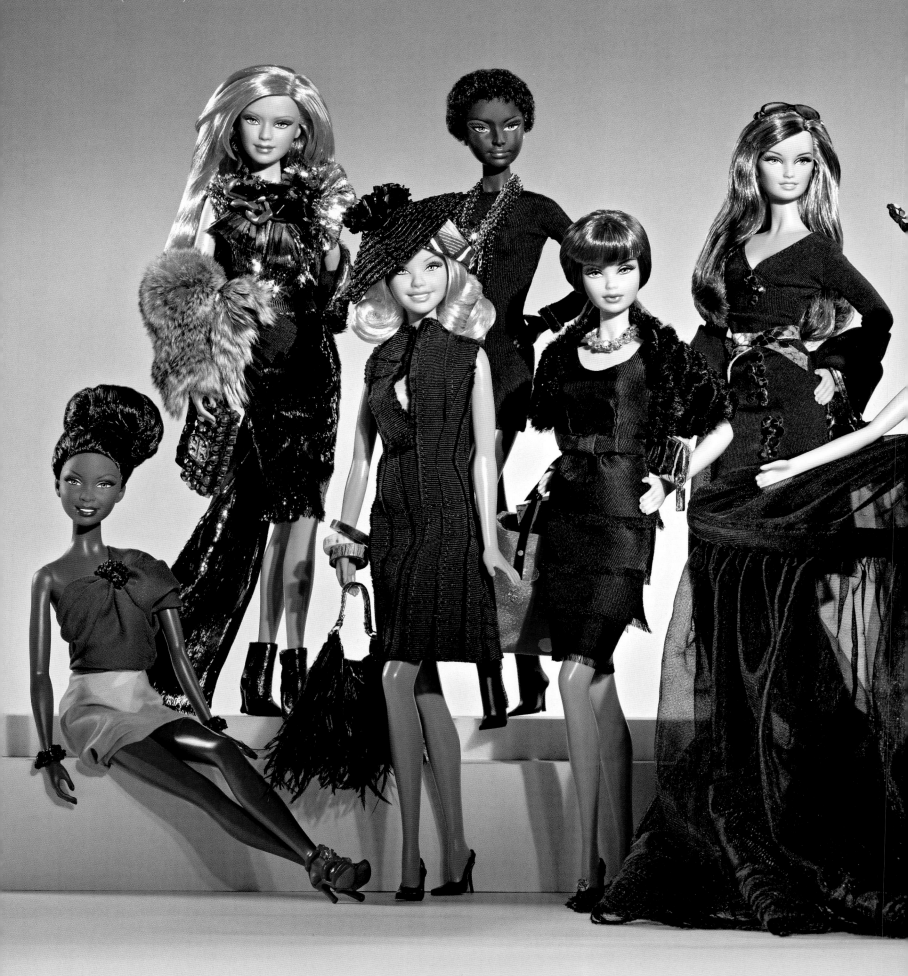

Barbie Basics dolls personalized in 2010
chosen by the Council of Fashion Designers of America
(CFDA): Deborah Lloyd (Kate Spade),
Isaac Mizrahi, Rachel Roy, Tory Burch, Alexis Bittar,
Betsey Johnson, Devi Kroell, Justin Giunta
(Subversive), and Monica Botkier.

Selected Bibliography

www.BarbieDB.com

1959–2023, *Mattel Catalogues of Toys*

1973, C. Fox, *Le bambole*, Milan

1976, Dolly & Gloria, *La casa di Barbie*, Florence

1976, Dorothy S., Elisabeth A., Evelyn J. Coleman, *Collector's Book of Dolls Clothes*, New York

1977, S. De Wein, J. Ashabraner, *The Collector's Encyclopedia of Barbie Dolls and Collectibles*, Paducah (Kentucky, USA)

1980, S. St. John De Wein, *Collectible Barbie Dolls 1977–1979*, privately printed

1980, S. St. John De Wein, J. Ashabraner, *Collectors Encyclopedia of Barbie Dolls*, Paducah (Kentucky, USA)

1983, P. & S. Manos, *The World of Barbie Dolls*, Paducah (Kentucky, USA)

1985, F. Theimer, *Barbie: poupée de collection*, Paris

1986, M. Tarnowska, *Poupées de Mode*, Paris

1987, S. Farago, B. Dennison, F. Farago, *The Magic and Romance of Art Dolls*, Los Angeles

1987, BillyBoy*, *Barbie. Her Life & Times*, New York

1988, M. Tosa, *Effetto Bambola*, Milan

1990, S. Sink Eames, *Barbie Fashion, volume 1, 1959–1967*, Paducah (Kentucky, USA)

1990, M. Tosa, *Le bambole*, Milan

1992, J. Blitman, *Vive la Francie. An Illustrated Guide to Francie's Wardrobe*, Los Angeles

1993, M. Tosa, *Bambole*, Milan

1994, *Barbie Bazar. Mattel & Christmas Catalog Reprints of Barbie Doll 1959/1965*, Kenosha (Wisconsin, USA)

1994, R. Handler and J. Shannon, *Dream Doll. The Ruth Handler Story*, Stamford (Connecticut, USA)

1994, W. Hellmann, *Barbie. Künstler und Designer gestalten für und um Barbie*, Hamburg

1994, L. Jacobs, *Barbie: What a Doll*, New York

1994, L. Jacobs, *Barbie in Fashion*, New York

1994, K. Kimura Shibano, *Barbie in Japan*, Kenosha (Wisconsin, USA)

1994, M.G. Lord, *Forever Barbie. The Unauthorized Biography of a Real Doll*, New York

1994, K.B. Westenhouser, *The Story of Barbie*, Paducah (Kentucky, USA)

1995, V. Steele, *Art, Design and Barbie: the Evolution of a Cultural Icon*, New York

1994, L. Jacobs, *Barbie*, Milan

1995, K. Westenhouser, *Story of Barbie*, Paducah (Kentucky, USA)

1995, E. Rand, *Barbie's Queer Accessories*, Durham

1996, J. Blitman, *Barbie and Her Mod, Mod, Mod World of Fashion*, Los Angeles

1996, J. Blitman, *Francie & Her Mod, Mod, Mod World of Fashion*, Los Angeles

1996, S. Deutsch, *Barbie, the First 30 Years: 1959 through 1989*, Paducah (Kentucky, USA)

1996, J. Fennick, *The Collectible Barbie Doll*, London

1996, G.A. Mandeville, *5th Doll Fashion Anthology Price Guide*, Grantsville (Maryland, USA)

1996, J.M. Augustyniak, *Barbie Doll Boom*, Paducah (Kentucky, USA)

1996, M. Marcie, *Ultimate Barbie Doll Book*, Krause Pubns Inc

1997, M. Tosa, *Barbie. I Mille Volti di un Mito*, Milan

1997, *Una Barbie oggi per salvare una donna domani*, catalogue of Christie's Milan auction

1997, P.C. Olds, Z.R. Olds, *The Barbie Doll Years 1959–1996*, Paducah (Kentucky, USA)

1997, J. Sarasohn-Kahn, *Contemporary Barbie Dolls 1980 and Beyond*, Norfolk (Virginia, USA)

1998, V. Steele, *Barbara Millicent Roberts. An Original*, photographs by David Levinthal, New York

1998, M.F. Hanquez-Maincent, *Barbie poupée totem. Entre mère et fille, lien ou rupture?*, Paris

1999, F.M. Rogers, *Barbie Culture*, London

2000, I. Germano, *Barbie. Il fascino irresistibile di una bambola leggendaria*, Rome

2000, *Barbie. Guida completa fashion*, Milan

2003, J.T. Banks, *Naked Barbies, Warrior Jones, and Other Forms of Visible Gender*, Urbana (Illinois, USA)

2005, A. Scacchi, "Barbie da fidanzata d'America a icona pop," in *Miti americani oggi*, edited by C. Ricciardi, S. Vellucci, Reggio Emilia, pp. 237–246

2007, K. Toffoletti, *Cyborgs and Barbie Dolls: Feminism, Popular Culture and the Posthuman Body*, London

2008, E. Cianfanelli et al., *Barbie sogna Caterina de' Medici*, Florence

2008, N. Bazzano, *La donna perfetta. Storia di Barbie*, Bari

2010, R. Gerber, *Barbie and Ruth: The Story of the World's Most Famous Doll and the Woman Who Created Her*, New York

2015, M. Capella, *Barbie. The Icon*, Milan

2016, A. Monier, *Barbie*, Paris

2016, D. Carvajal, *With Museum Shows in Europe, Barbie Gets Her Moment With the Masters*, in the *New York Times*, March 11 (www.nytimes.com/2016/03/11/arts/design/with-museum-shows-in-europe-barbie-gets-her-moment-with-the-masters.html)

2021, M. Royer, *My Vintage Barbies: A Comprehensive Reference Guide of Barbie Through the Vintage Years 1959–1979 and Beyond*, Oregon

2023, C. Spencer, *Dressing Barbie: A Celebration of the Clothes That Made America's Favorite Doll and the Incredible Woman Behind Them*, New York

Photo Credits

For the invaluable collaboration, the author thanks Luisa Bianchi
(Elle2Elle communication agency), Mario Paglino, Gianni Grossi, and
Antonio Russo.

Library of Congress Control Number: 2024937551

ISBN: 978-1-4197-7876-6

Text by Massimiliano Capella
English translation by Sylvia Adrian Notini and Antony Shugaar
Cernunnos logo design: Mark Ryden

Originally published in Italian in 2024 by 24 ORE Cultura Srl, Milano

Printed and bound in China
10 9 8 7 6 5 4 3 2 1

Cernunnos books are available at special discounts when purchased
in quantity for premiums and promotions as well as fundraising or
educational use. Special editions can also be created to specification.
For details, contact specialsales@abramsbooks.com or the address below.

ABRAMS The Art of Books
195 Broadway, New York, NY 10007
abramsbooks.com

Barbie Barbie Barbie Barbie B
bie Barbie Barbie Barbie B
Barbie Barbie Barbie Barbie B
bie Barbie Barbie Barbie B
Barbie Barbie Barbie Barbie B
Barbie Barbie Barbie Barbie B
bie Barbie Barbie Barbie Barb
Barbie Barbie Barbie Barbie Barbie

Following pages
Barbie Looks™ (2023).

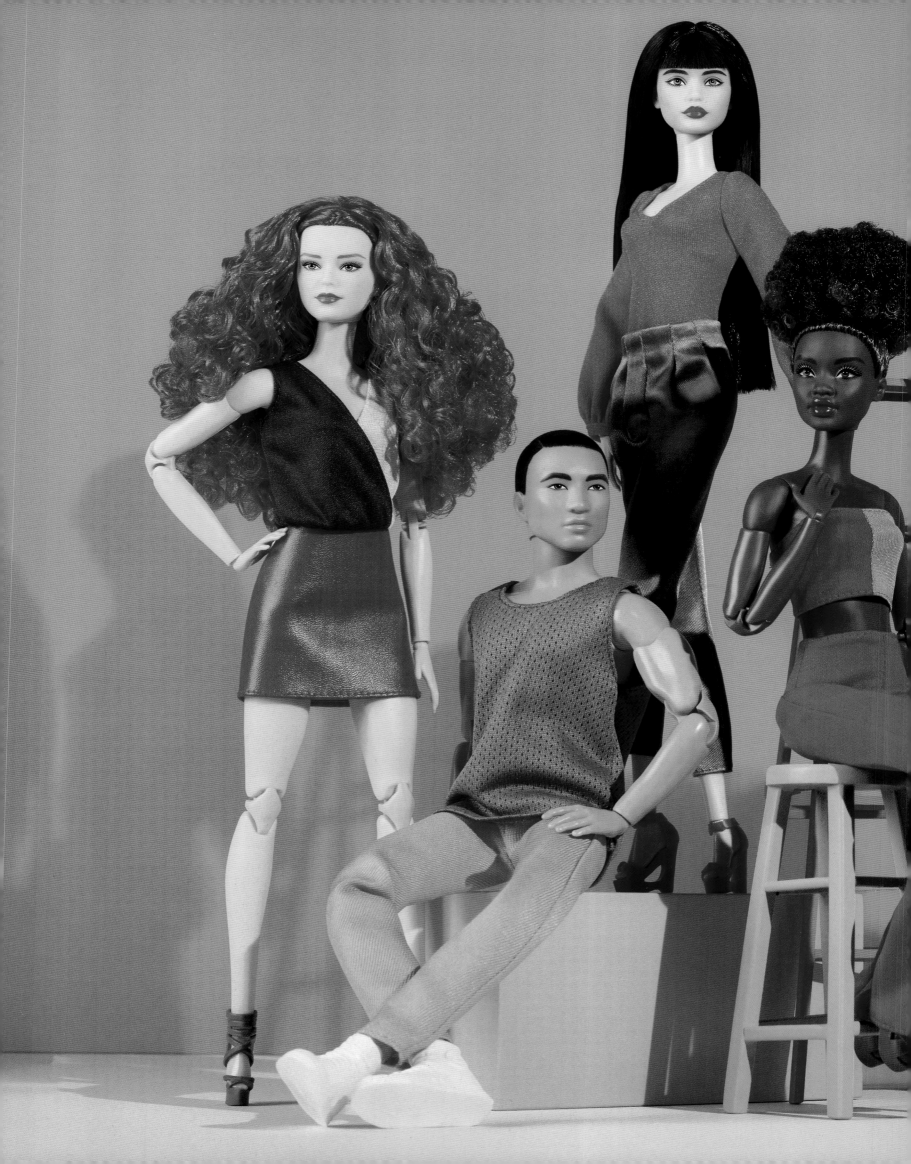